ORBIT

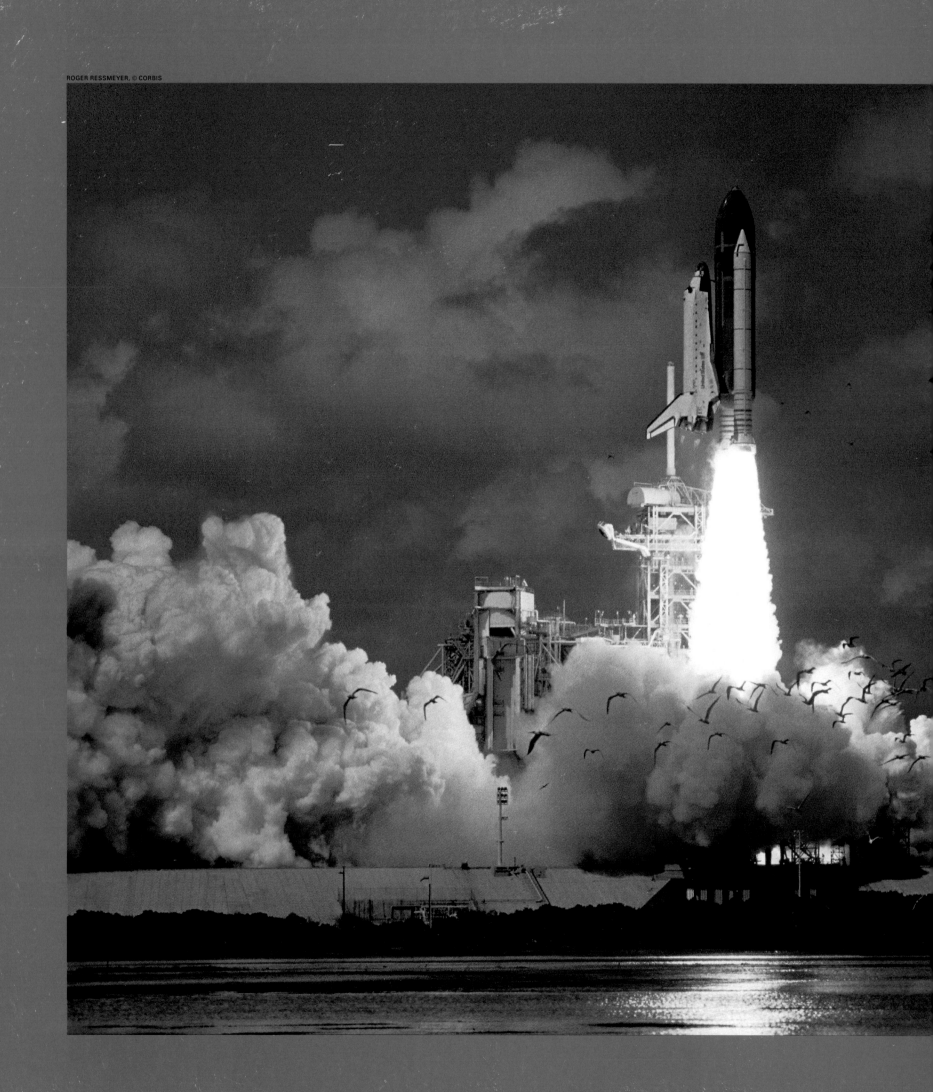

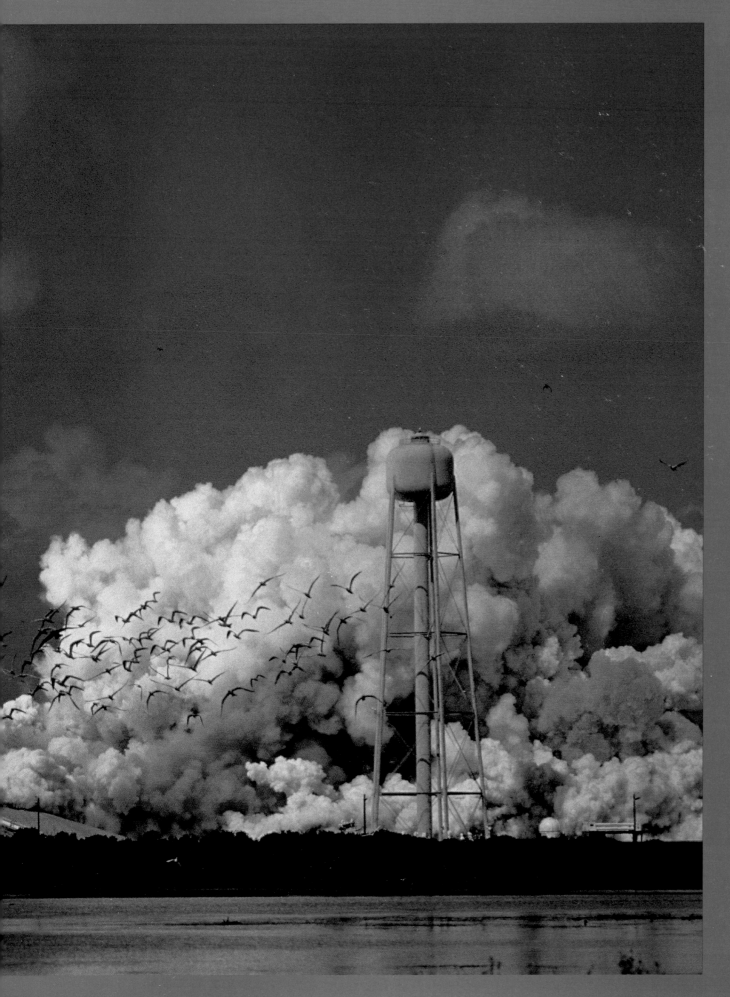

Discovery *leaves Earth. All of the space photographs in this book were taken by astronauts using ordinary cameras held in their hands. If you were aboard and were pushed into orbit by seven million pounds of thrust from five rockets, you would see out the window what the photographs in this book show. Of the 337 people who had traveled into space by the time this book was published, 209 of them were on a Space Shuttle.*

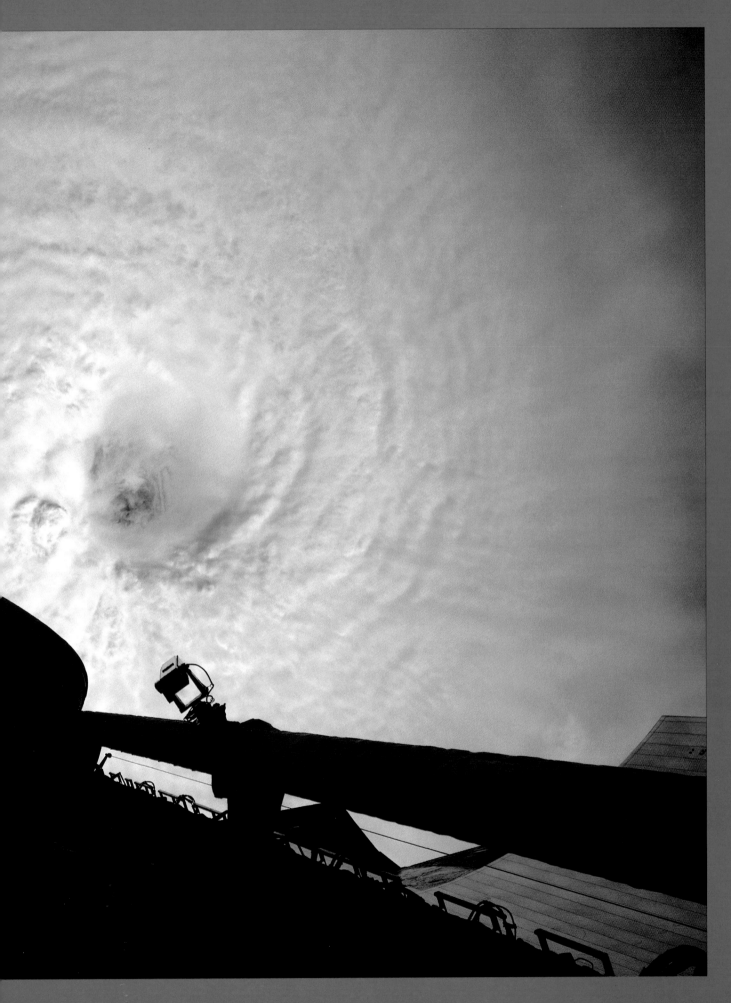

Columbia *was 185 miles above the Indian Ocean when a member of her crew grabbed a camera to record 250-mile-wide Cyclone Litanne behind the Shuttle's tail. The 11 windows on the Shuttle allow astronauts to photograph the world in a way not possible from smaller spacecraft. Photography is not scheduled. Astronauts use their free time to share their views from orbit with people on the ground and to photograph areas of special interest to scientists.*

This book is dedicated to the men and women who have committed their careers to making spaceflight possible and to those who have given their lives while pursuing our shared dream.

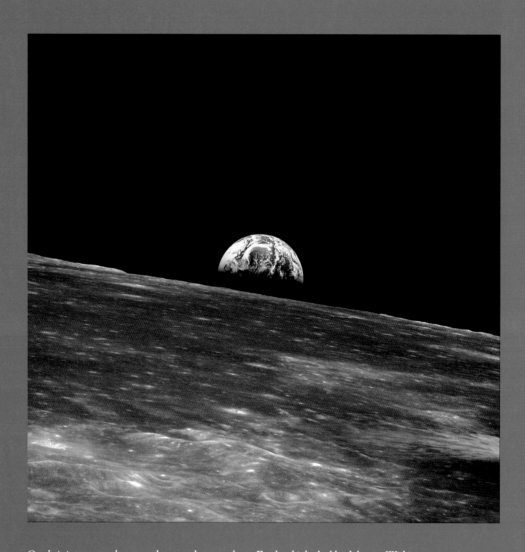

On their journey to the stars, the second crew to leave Earth orbit looked back home. Within a generation or two, we may be able to use new telescopes to discover whether planets like ours exist nearby in our galaxy.

NASA Astronauts Photograph the Earth

ORBIT

Jay Apt, Michael Helfert,
Justin Wilkinson

Edited by Roger Ressmeyer

NATIONAL
GEOGRAPHIC
SOCIETY

ORBIT: NASA ASTRONAUTS PHOTOGRAPH THE EARTH

EDITOR Roger Ressmeyer
EDITORIAL COORDINATOR Jay Apt

BY Jay Apt
Michael Helfert
Justin Wilkinson

THE NATIONAL GEOGRAPHIC SOCIETY

Reg Murphy PRESIDENT AND CHIEF EXECUTIVE OFFICER
Gilbert M. Grosvenor CHAIRMAN OF THE BOARD
Nina D. Hoffman SENIOR VICE PRESIDENT

PREPARED BY THE BOOK DIVISION

William R. Gray VICE PRESIDENT AND DIRECTOR
Charles Kogod ASSISTANT DIRECTOR
Barbara A. Payne EDITORIAL DIRECTOR

STAFF FOR THIS BOOK

Leah Bendavid-Val EDITOR
David Griffin ART DIRECTOR
Roger Ressmeyer DIGITAL IMAGING
Thomas B. Allen TEXT EDITOR
Joyce B. Marshall SENIOR RESEARCHER
Carl Mehler MAP EDITOR
Lise Sajewski RESEARCHER
Kevin G. Craig EDITORIAL ASSISTANT
Lewis R. Bassford PRODUCTION PROJECT MANAGER
Meredith C. Wilcox ILLUSTRATIONS ASSISTANT
Louis J. Spirito MAP RESEARCH AND PRODUCTION
John S. Ballay MAP PRODUCTION
3DI Geographic Technologies MAP PRODUCTION
Tibor G. Tóth MAP RELIEF
Peggy J. Oxford STAFF ASSISTANT

Martha C. Christian CONSULTING EDITOR

MANUFACTURING AND QUALITY MANAGEMENT

George V. White DIRECTOR
John T. Dunn ASSOCIATE DIRECTOR
Vincent P. Ryan MANAGER

Diane Coleman INDEXER

Digital scanning and image processing by Corbis Corporation

Visit the Society's Web site at
http://www.nationalgeographic.com or
GO NATIONAL GEOGRAPHIC on CompuServe.

Library of Congress CIP Data
Apt, Jay 1949-
 Orbit: NASA astronauts photograph the earth / by Jay Apt, et. al.
 p. cm.
 Includes index.
 ISBN 0-7922-3714-5 (reg). -- ISBN 0-7922-3715-3 (deluxe)
 1. Space photography. 2. Earth--Photographs from space.
 I. Helfert, Michael II. Wilkinson, Justin III. National Geographic Society
 TR713.O73 1996
 910'.22'2--dc20 96-24428
 CIP

ABOUT THE AUTHORS

Jay Apt, an astronaut since 1985, was preparing for his fourth Space Shuttle mission when this book was going to press. On his first mission in 1991, he and *Atlantis* crewmate Jerry Ross made two space walks, one an unscheduled repair of a balky scientific satellite, the other to test equipment for the International Space Station. He was aboard *Endeavour* as her flight engineer during a 1992 U.S.-Japanese scientific mission. On his 11-day mission on board the *Endeavour* in 1994, the crew, making a special study of Earth, brought home to research scientists the equivalent of 26,000 encyclopedia volumes of data. He holds an A.B. from Harvard University and a Ph.D. in physics from the Massachusetts Institute of Technology.

Michael Helfert, a senior scientist at NASA's Lyndon B. Johnson Space Center from 1985 through 1994, has been chief scientist for the Earth observations made by 18 Space Shuttle missions. He is director of the Southeast Regional Climate Center, and is the South Carolina state climatologist. He earned his B.A. and his Ph.D. in geography at the University of Texas.

Justin Wilkinson, a geographer, is a senior scientist with the Space Shuttle Earth Observations Project. He is the author of *Paleoenvironments in the Namib Desert* as well as 22 articles in scientific journals on geology, geomorphology, and climate change. He is an enthusiastic teacher of college geography courses. His B.A. and M.A. were taken at the University of the Witwatersrand, and his Ph.D. in geography is from the University of Chicago.

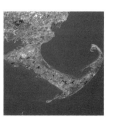

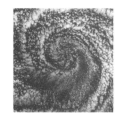

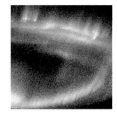

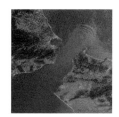

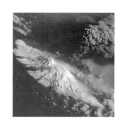

ORBIT

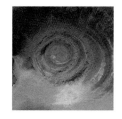

Window On the Earth

SOCRATES SAID THAT IF WE COULD RISE ABOVE THE EARTH, we would realize "this is ... the true Earth"—and only then would we fully understand the world in which we live. Now, in our time, 25 centuries after Socrates, we have built ships that fly hundreds of miles above the planet. Astronauts, cosmonauts, researchers on special missions, a few ordinary citizens, and a television reporter have shared the experience of spaceflight. Almost without exception, they have spent their off-duty time looking at the Earth and photographing it with handheld cameras. John Glenn talked NASA into letting him carry a camera on the first United States flight into orbit, and no astronaut has been without a camera since. Astronaut Jerry Ross is fond of saying, "Memories of spaceflight are fleeting. What you have left when you get back are your pictures." By taking photographs up there, astronauts share the sense of Earth that they come to have in orbit.

Endeavour and her crew of seven (including author Jay Apt) leave Earth for nine days in September 1992. In off-duty hours the astronauts pointed their cameras out the Shuttle's large windows. They brought back 5,900 photographs of Earth; ten appear in this book.

Successive generations of astronauts have imparted to one another and to the people on Earth that there is something more in this photography than just the startling beauty of our planet. What began on the earliest Mercury missions as an informal activity with scientific applications now has more definition. These pictures have a tightly focused, scientific purpose: to document what our home looks like and how it has changed in the last third of a century. The photography finds frequent applications in serious scientific study, since the regular series of pictures predates the era of continuous monitoring of the Earth by robot satellites (and is far cheaper as well—a single Landsat photograph may cost a scientist $5,000).

The authors of this book are an astronaut, Dr. Jay Apt (a physicist who was about to fly his fourth spaceflight as this book was going to press), and two scientists who study the Earth through astronaut photography, Dr. Mike Helfert and Dr. Justin Wilkinson, both geographers. Our purpose in writing this book is to share with you some of the most important and beautiful photographs taken since humans first left Earth. At the same time we want to give you a feeling for some of the history and science captured in each image.

After two to seven years of general training, astronauts ready themselves for a specific space mission by working intensively for a year. Preparation includes classroom and field studies in geology, meteorology, oceanography, and ecology—at first on a general level and then for the mission itself: the specific targets and mission themes for Earth observations. Scientists from around the world come to give lectures on such topics as plate tectonics or atmospheric dust and to tell astronauts how photographs from space can help to solve particular scientific problems.

At the Johnson Space Center in Houston, a few scientists in the Flight Science Branch teach most of the classes, collect requests for specific pictures from other scientists, and catalog the thousands of photos taken on each mission.

Prior to each mission these scientists suggest areas that their orbiting colleagues can study. Astronauts sometimes write their own computer programs to tell them exactly when they will be over specific areas of interest. The Johnson Space Center group prepares prioritized lists of specific areas ("sites") for each Space Shuttle mission, selecting from a list of 1,800 observation sites, each of which has some special scientific significance.

The underlying objective of the astronauts' Earth photography is to gain an understanding of changes in Earth's environment. Such changes—whether of Earth's atmosphere, its land surfaces, or its bodies of water—can be understood only by patiently collecting photographs of the same area during several spaceflights. One site's time series, such as that for the Nile Delta of Egypt, may include photographs from a Gemini or Apollo flight from the mid-1960s, a Skylab mission from 1973-74, and numerous Space Shuttle missions from 1981 to the present.

Each Space Shuttle mission is viewed by both astronauts and scientists as providing new observations in a long-term project. Training on the ground introduces crews to what they should expect when they look down toward the Earth's surface or at its atmosphere. This training allows the orbiting photographer to recognize the abnormal, the unexpected—new phenomena or old phenomena in new places. These data come back to Earth in a dramatic form, as color pictures that are often immediately understandable to scientists. There is a great benefit in having intelligent observers in space. They can act independently, think about the meaning of their unique views by using what they learned in their classes, and, while they are "in the field," filter data on the spot for its scientific significance.

The two components of this activity—the ground-bound scientist and the astronaut in orbit—are thus partners with the common goal of providing, through this photography, a meaningful history of the Earth for all of humankind and for all generations to come.

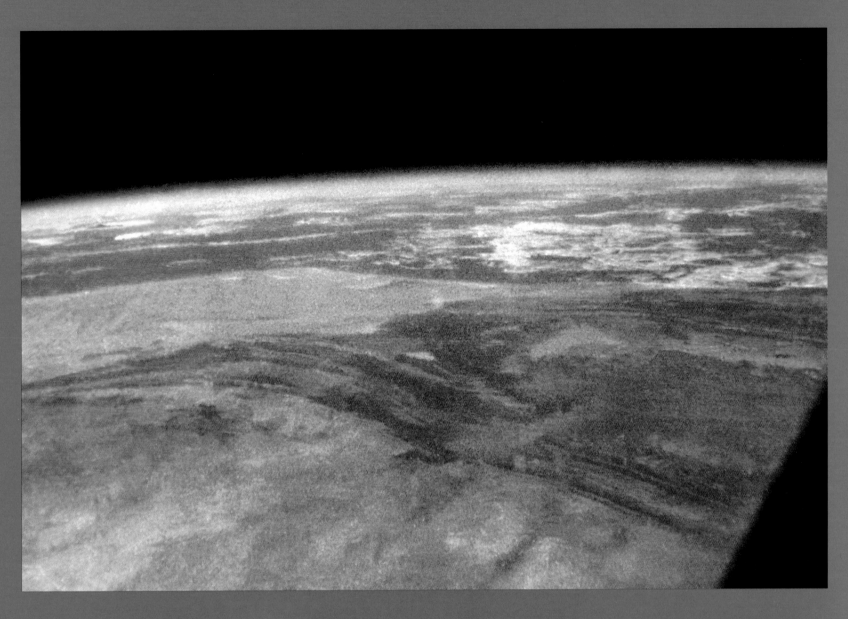

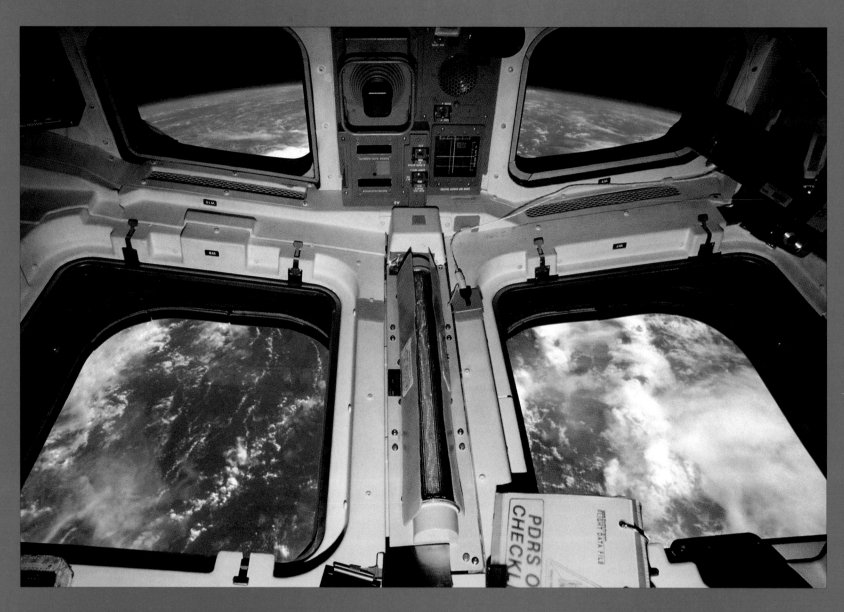
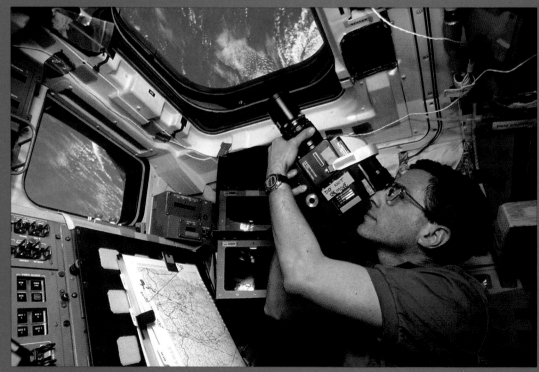

The Space Shuttle has 11 windows. On many missions, the Shuttle flies with its top facing "down," so most of the windows face Earth, providing stunning views from several different angles. Sometimes a spotter is stationed at a forward window to call out when a site is coming into view. The astronauts take light meter readings because automatic exposure meters are usually fooled by clouds. Author Jay Apt (opposite) used a detailed map to help locate an area of particular interest to researchers before aiming a Hasselblad camera.

While the Shuttle is in orbit, the scientists of the Flight Science Branch prepare for the crew a daily fax updating areas of particular interest that will be visible from the Shuttle windows. The ground scientists also sometimes fax up hours-old satellite images that pinpoint locations of such short-lived phenomena as a typhoon closing in on Madagascar or pollution over the Po River Valley of Italy. Or there may be such messages as these: A German scientist in Borneo asks for confirmation of an outbreak of forest fires in that country. The Smithsonian Institution science network reports a volcanic eruption on a remote Pacific island. The National Oceanic and Atmospheric Administration's Space Environment Center in Colorado sends an advisory about an unusually strong Southern Hemisphere aurora that may be visible during a nighttime overpass through that region. Some of the results of this international teamwork are presented in this book. This is operational, cooperative science at its finest. We hope that this team will continue this long series of observations on the international space station, as part of NASA's Mission To Planet Earth.

We prepared this book as intensively as we prepare for a mission. Jay bought a laser video disc player and wired it to his home computer. The player allowed him to view each of the 145,000 photographs from the first 56 Space Shuttle missions stored on two marvelous discs published by the Image Sciences Division at the Johnson Space Center. He looked at copies of each of the 105,000 additional photographs stored on film. Meanwhile, Mike and Justin went through the slides that they use in teaching and research. Every Saturday for more than a year, we got together to compare notes and select the best slides. (We worked at nights and on weekends to follow government rules about outside activities, even though we get no royalties from this project, again per regulations.) We came down to a collection of 1,100 photos that we shared with photographer Roger Ressmeyer. Jay and Roger then showed

480 of these to Leah Bendavid-Val, David Griffin, and Tom Allen at the National Geographic Society, and together we made the final selection for this book.

All of us have had the experience of seeing a photograph badly reproduced. We thought long and hard about how to avoid that problem with these beautiful pictures. NASA cannot lend out the original film for fear of damaging it, and copies, or copies of copies, usually must be used in a book. We decided that the only way to give you photographs that match what you would see out our windows was to transfer the original film data to a computer and print this book directly from the computer. This is an expensive process, and Corbis Corporation, recognizing the historic importance of the pictures taken from orbit, brought a scanning machine to Houston and digitized the original film. This is the first time the process (see page 221) has been used for a book.

When it came time to write the text, we divided up the captions equally among the three authors. Each of us assembled the research for his captions. The final draft was written by Jay, because we felt that his voice was the best to give you the feeling that you are floating in the Shuttle, looking out its great windows at the Earth. Jay also wrote the introductions to each chapter.

Each of the space photographs in *Orbit* was taken by an astronaut using one of the handheld cameras we carry aboard. (See page 219 for a description of the cameras and pages 218-222 for technical information on the photos.) The vast majority of the photographs are not suggested by messages sent up from the ground; astronauts recognize when good lighting conditions present great viewing of a site in which scientists will be interested. Most astronauts take a camera with them when they fly aircraft, and it was natural that they would want to take cameras into space. In fact, John Glenn was only a few minutes into his first orbit when he pulled out a 35-millimeter camera and took the photograph of North Africa that appears on page 13. No astronaut has gone into orbit without a camera. So we have

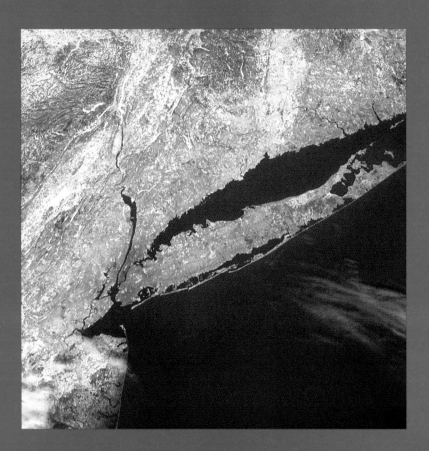

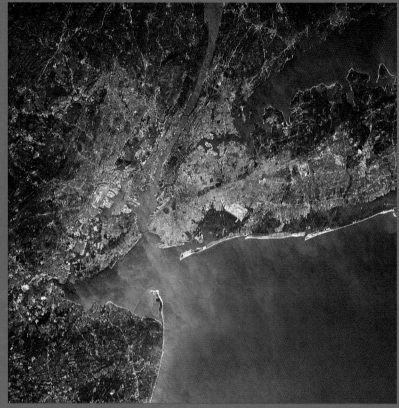

It is sometimes difficult to appreciate the scale of what is seen out the Space Shuttle windows. These photos show New York City at different times and from different angles. March snow highlights the contours of the land in the photo above. A closer view the following November (above, right) shows more detail, but covers less territory. The night exposure (opposite) shows individual city streets, dark parks and airports, and even bridges. Author Jay Apt took the night photo using ASA 800 film and an f/1.4 lens by holding the shutter open for four seconds while panning the camera by hand to remove the blur due to the Shuttle's speed. A completely different view is in the photograph to the right. All of southern New England, from Cape Cod in the foreground to west of the Hudson, is caught in the glint of the afternoon sun. It is easy to imagine the glaciers dumping their load of bulldozed land right before our eyes to form Long Island, Cape Cod, and the islands.

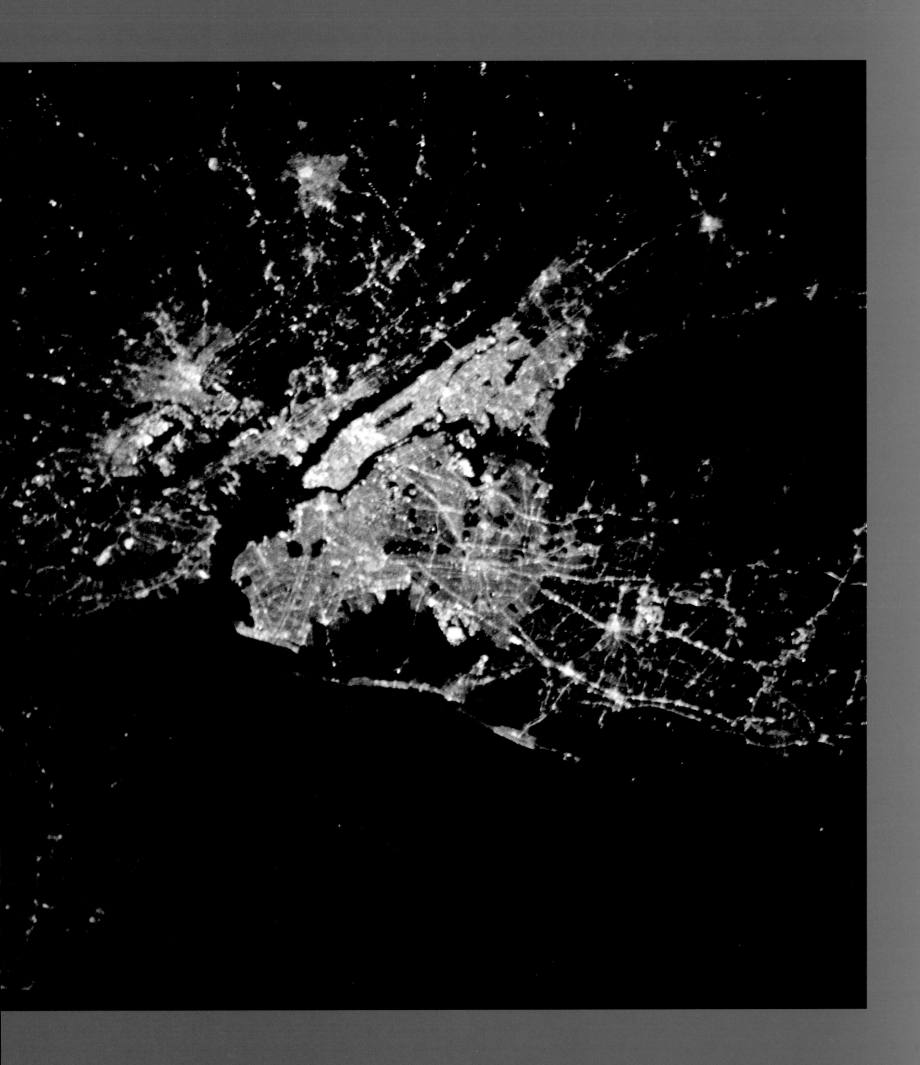

a continuing record, spanning more than a third of a century, of how astronauts view the Earth.

The magic of these photographs is that they were all taken by a person to record something he or she thought was interesting. The photos astronauts take by hand are far more than snapshots. Because our spacecraft fly much closer to the ground than do weather satellites or crop-mapping satellites, we can photograph small details on the ground. Jay has seen from orbit the towers of the Golden Gate Bridge and lights of individual streets in Buenos Aires, even though his eyes are worn from three decades of squinting into the sun from airplane cockpits. Reconnaissance satellites see smaller details, but often do not see the broad sweep of the land. Astronauts can tilt the camera to compose a photograph or to catch fine details highlighted by the glint of the sun. The same cameras and often the same films have been used since the 1960s, so scientists can easily detect changes in the land, water, or atmosphere, and then measure them precisely.

After each mission, special bags containing the exposed film are rushed to Houston, usually on the same planes carrying the astronauts home. The photo laboratory at the Johnson Space Center works all night to develop the film, and the first duplicate rolls of transparencies are usually ready at 5 a.m. For the crew, it is a time of anticipation and anxiety, waiting to see if they properly used their training. Here is how Jay recalls this time: "I was on the 'night' shift on my second and third missions, so I was already at the lab when the first film appeared in the viewing room. On STS-47, my second flight, our windows were pointed into the sun most of the time, and I was very disappointed with the film when I first saw it. I had badly underexposed an entire roll of a hundred frames over North Africa, shot with our best camera. I went home that night tired and discouraged. Later, I went through all the film frame by frame, consulting a computer to locate shots taken over unfamiliar terrain. It turned out that we actually got some wonderful pictures.

Our experiments with high-speed film had resulted in excellent photos of the aurora australis, and we had taken the first photos of many regions in Asia. Our commander, Hoot Gibson, had taken a terrific shot of Paris.

"On STS-59, we had better lighting conditions, and we had all worked hard to make sure our exposures were correct without fail. I had selected our camera lenses for consistency of shutter speed, and the entire crew had practiced using light meters until we could quickly determine the correct exposure. The morning after we landed was a very good one at the photo lab!"

What are the ideas that stay with us now that we have looked at all the pictures astronauts have taken of Earth? When the three of us get together, we talk about food, good friends, and the Earth. Not necessarily in that order. A conversation with good bourbon to keep us awake tends to touch on many topics, and we would like to share a few of them with you.

We all have formed mental images of particular areas by looking at maps. We get used to seeing north at the top of a map, for instance. Photos from space do not have that orientation (and neither do photos in this book). Map images changed forever for the three of us after seeing just-developed photographs rushed out of the lab. Examples in this book of the kind of photographs that reform our images of the geography of Earth: the Nile Delta, Lake Geneva, Italy, the Persian Gulf, India and Sri Lanka, all of Mexico, and the barrier islands off Cape Hatteras. For us, people who have used and enjoyed maps all our professional lives, the planet becomes three-dimensional in a way that maps cannot imitate.

After looking at thousands of photographs of Siberia, we have no doubt that the swamps and tundra east of the Ural Mountains make for a hard life for the villagers along the Trans-Siberian Railroad. We talk about how looking at many photos of the same area from different perspectives has changed our mental image in more subtle ways. For

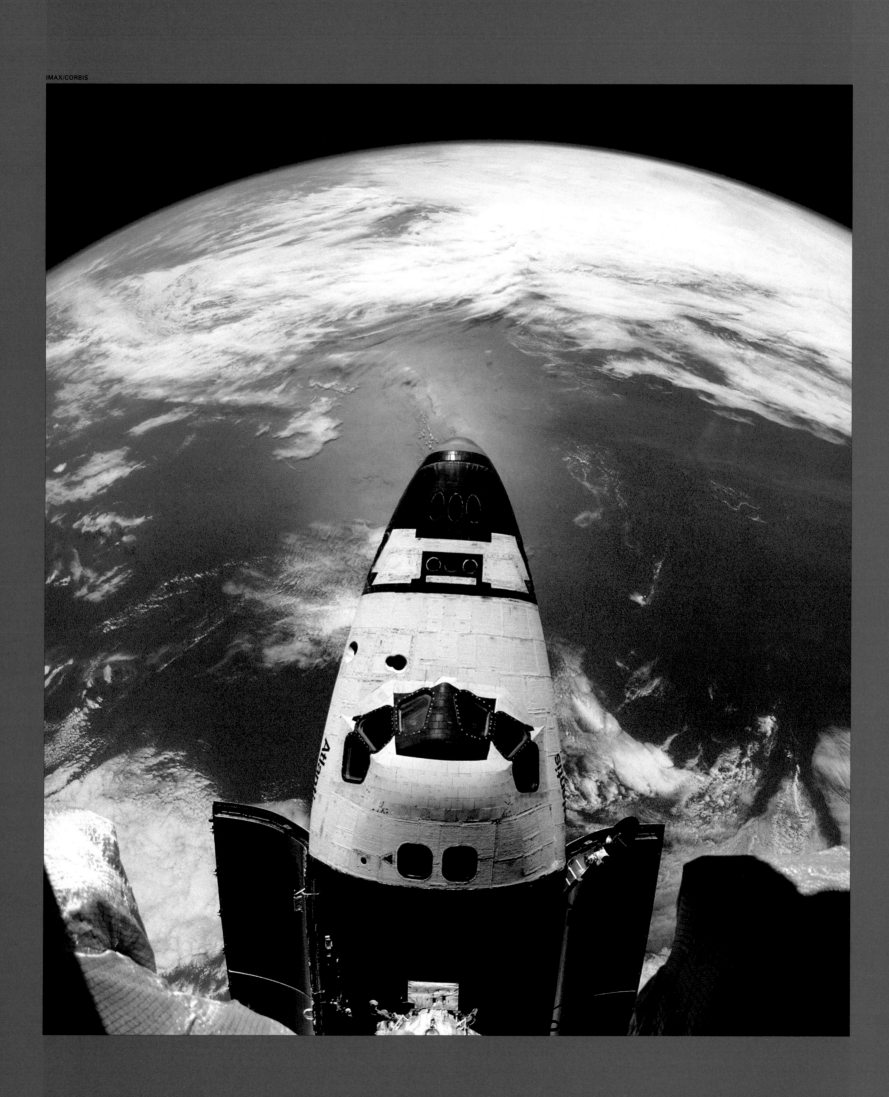

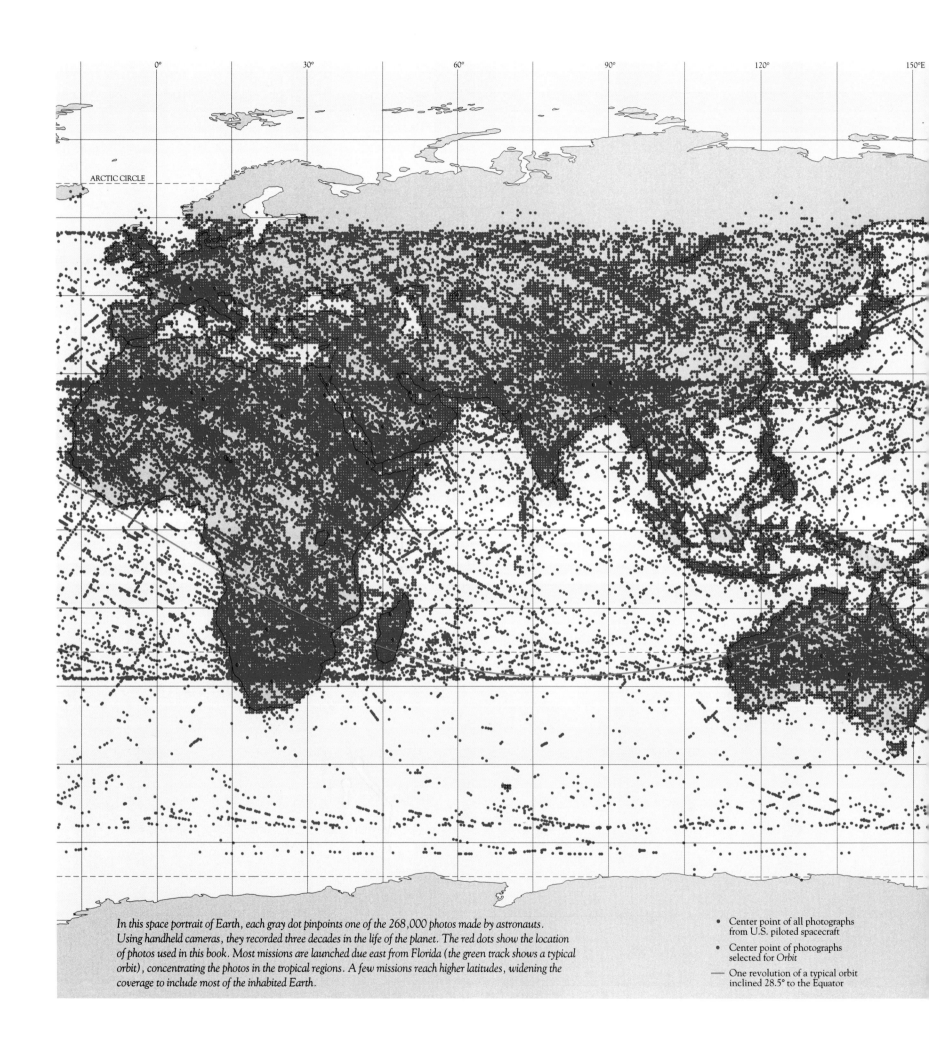

0° 30° 60° 90° 120° 150°E

ARCTIC CIRCLE

In this space portrait of Earth, each gray dot pinpoints one of the 268,000 photos made by astronauts. Using handheld cameras, they recorded three decades in the life of the planet. The red dots show the location of photos used in this book. Most missions are launched due east from Florida (the green track shows a typical orbit), concentrating the photos in the tropical regions. A few missions reach higher latitudes, widening the coverage to include most of the inhabited Earth.

- Center point of all photographs from U.S. piloted spacecraft
- Center point of photographs selected for *Orbit*
— One revolution of a typical orbit inclined 28.5° to the Equator

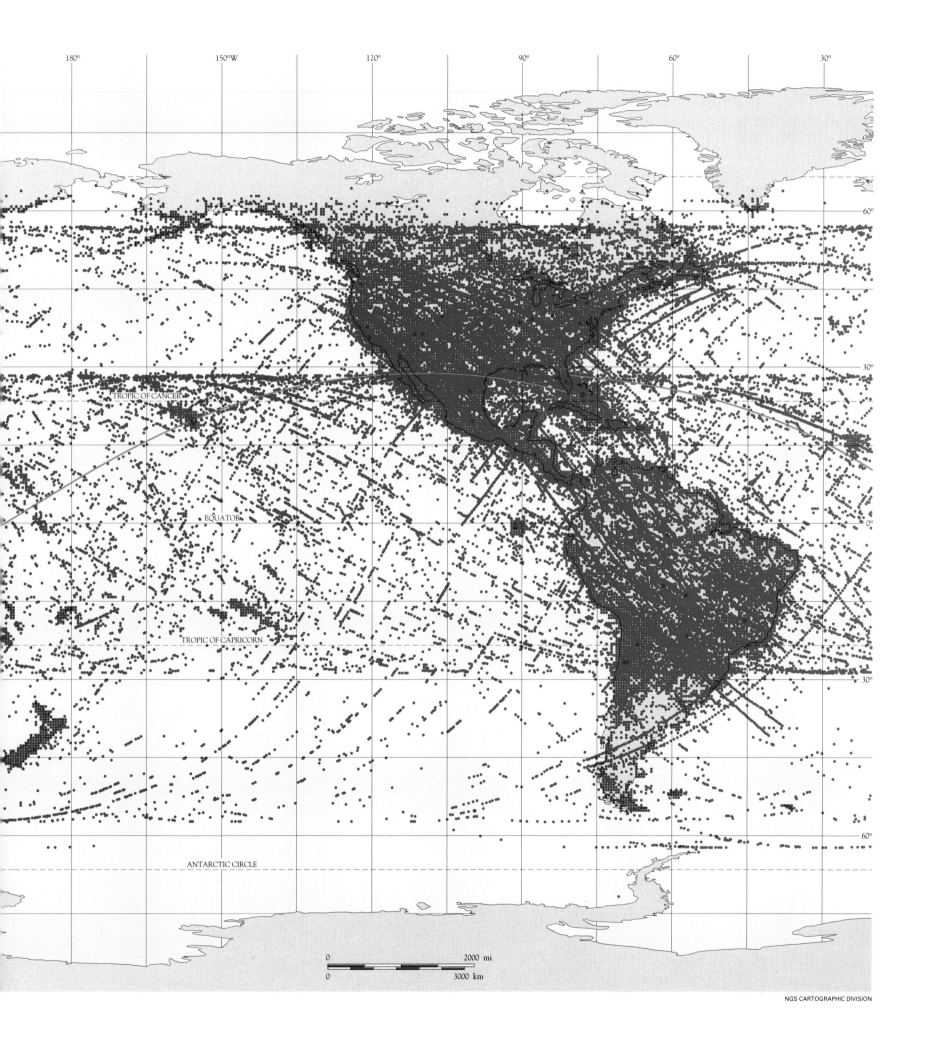

60°

30°

TROPIC OF CANCER

EQUATOR 0°

TROPIC OF CAPRICORN

30°

ANTARCTIC CIRCLE

60°

0 2000 mi

0 3000 km

example, rivers do not flow to the sea over the same piece of ground for very long; we can build up an image of the Mississippi sweeping back and forth over southern Louisiana and southeast Texas many, many times. The Yellow River in China has changed its course in the same way, and its mouth moved 90 miles north in one great flood in 1852; we can see its old river delta in a few photographs.

Great steady forces created most of the rocks around us. Slow accumulation of mud or sand in lakes or at the mouths of rivers create thick piles that form sedimentary rocks through the ages. People in general feel that the way things are now is pretty much how things have always been, and how they will always be. What we see in these photographs is dramatic evidence that this equilibrium is occasionally shattered. A hurricane strikes, knocking down much of the forest on a large island. A volcano that has been silent for tens of generations violently explodes, sending aloft dust that obscures the sun for months. A small asteroid blows a huge hole in the land. Natural changes are sometimes abrupt, and we can see the evidence in some of our photographs. (Some examples: the volcanoes on pages 99 and 130-131, volcanic dust on page 128, and immense forest fires on pages 134-135.)

These occasional huge variations are only a part of the story. Earth is located in a very narrow zone of comfortable temperatures, between the oven-hot greenhouse of Venus and the frozen canyons of Mars. Small changes can bring an end to a spell of good climate. Only 9,000 years ago, North Africa had huge flowing rivers. (We can see them beneath the sand with a radar "camera" carried by the Shuttle.) Then the climate changed, turning the region from breadbasket to desert.

Droughts can last hundreds of years, destroying civilizations as far apart as Mesopotamia and the Yucatán. Glaciers have covered vast areas of Earth for most of human history. Ten thousand feet of ice covered the American Midwest not so long ago. We are in a long warm interlude, and our scientists are working hard to discover when our luck will run out and what we can do about it.

People can make good and bad decisions on how to use the Earth. We do not see any global problems from space, except the craters left by huge meteorites. (We cannot see the decrease in the ozone that protects us; that requires special equipment.) We do see plenty of regional problems that present tremendous opportunities for collective action. The Aral Sea, once the fourth largest lake on Earth, did not have to shrivel and die. The rivers of Madagascar have become choked with soil washed off newly cleared land by monsoons. Algae blooms do not have to continue to choke out the rich fishing in Florida Bay. The lakes of Siberia are now colored with industrial waste, but they can be cleaned up. The rivers of Eastern Europe can be purified by new businesses that are making money rising to the challenge.

The lessons of the Oklahoma Dust Bowl have been applied to new farms halfway across the world, where belts of trees planted in rows have greatly reduced soil erosion. The desert is now blooming in Saudi Arabia, but the underground rivers that irrigate the desert must be carefully managed, lest they soon run dry. The United States has the best environmental record in the world. Entire new industries have sprung up to manufacture devices to clean the air and water, and to prevent pollution in the first place. We see this great success from orbit, and we see the vast opportunities to apply this expertise around the world.

Natural change and human change are both large unknowns in the future of the Earth. In the next few decades, people will have to decide hundreds of issues, balancing immediate human needs against longer-term human needs. These decisions always favor short-term goals. It is only through a study of history—and by looking at photographs like these and reading the results of scientific studies—that people can understand the long-range fate of the only home we have until our children cross the gulf to the stars.

Africa

Africa

Canary Islands and the Sahara

The Canary Islands are often the first sight of land for space travelers launched due east from Cape Canaveral. The Canaries were a jumping-off point for the great explorations of the 15th century. Columbus on his first and second voyages to the Western Hemisphere stopped here. His sailors used the same trade winds that propel the dust in the right of the photograph. The strength of the easterly winds creates these turbulent eddies.

ON MOST SHUTTLE FLIGHTS, IT WORKS OUT THAT NORTH Africa is the first place that we see when we wake. For 20 minutes before the workday begins, each member of the crew seems to be glued to a window. The incredible change from Africa's huge deserts to its lush grasslands fascinates us.

As we fly south over the Sahara, we all strain to see Lake Chad, which is between the northern deserts and the green portion of equatorial Africa. Its level is a good indicator of how wet or dry this boundary region, called the Sahel, has been. It was mostly cloudy during my first flight: a good sign for those living below. On my second flight, 17 months later, we could see that the level had risen: the drought in the Sahel had abated for the moment.

The boundary between vegetation and desert moves with the seasons, as the sun's path progresses north and south. The boundary changes on longer time scales as well. During our lifetime, the Sahara has moved farther south. During a 20-year period of drought the band of rain never reached as far north as it had previously. For reasons still not understood, the drought was interrupted in the early 1990s. But it returned with a vengeance in 1993, a dry year.

On still longer time scales, the pattern changed even more: 9,000 years ago rivers larger than the Nile flowed through the Sahara and the Saudi Arabian Deserts. A radar "camera," taken into space by the Shuttle, discovered dry river beds hidden by thin sheets of sand; later ground expeditions found evidence of very ancient human habitation along the river banks. Lake Chad was once 50 times its present size. Long ago, the Namib Desert extended as far north as the Congo, and today residents of Brazzaville sweep Namib sand off their homes each morning. As the climate changes, people migrate, following Africa's band of green.

One orbit (90 minutes) after we wake, our path crosses the Africa of childhood stories: the Serengeti Plain, 350 miles from the east coast. My wife and I spent our honeymoon there, and I remember places that resemble Montana, but with giraffes and rhinoceroses. From orbit, the great crack known as the Rift Valley seems as if it could break apart at any moment, sending East Africa careening northeastward into Asia. This area is often cloudy, covered by a band of violent equatorial thunderstorms that give life to the land below.

All the evidence points to Africa's green heart as the place where humans first evolved. As we fly over this region, we look down and see the area near Olduvai Gorge where Louis and Mary Leakey found the bones of some of our earliest hominid ancestors. Africa's first great civilization arose along the Nile, tens of thousands of years after people had migrated out from the fertile center of Africa.

Egypt's Pharaoh Necho II (who ruled from 610 to 595 B.C.) paid Phoenician sailors to circumnavigate the continent. Their discovery—the Sahara did not occupy the entire continent—was lost for 2,000 years. No one dared bet that provisions could be obtained on land for a circumnavigation until 1497, when Vasco da Gama did it on his way to India, culminating a generation of probes made ever farther southward. Rediscovery of the green heartland was very difficult, since all of Africa's rivers have impassable rapids quite near the coast. Arab slavers entered overland from the east many centuries before the first Europeans penetrated from the African coasts.

From our spacecraft, we can see the great folds of the Atlas Mountains in the north and the Cape ranges in the south. As in the Appalachians and the Himalaya, the Earth here has been squeezed by the pressure of the forces that drive the continents together in enormous collisions. The Red Sea and the long, deep lakes of East Africa are evidence that the continent is being cracked and broken apart.

At night on each flight, we floated in the windows, watching Africa with her clouds clearly outlined by moonlight, seeing lightning and the lights of cities passing below. What are the hundreds of small lights we see everywhere? Fires! By day, the smoke from the fires can be seen from Zaire to Madagascar. Africa is being burned to clear land for agriculture. The consequences are easy to see from our windows. In Madagascar, for example, the rivers are clogged with mud washed down from newly barren hills. The land can be farmed for only a few seasons before it is washed into the Indian Ocean.

Flying over Africa I think about changes. Change in the Earth itself, when I fly over the volcanoes with their black rock in the middle of the orange desert, or when I fly over the Gulf of Aden, which someday will be a new ocean. Change in the climate, and a realization of what a small perturbation in the air currents can do to millions of humans living on the edge of the green band. Change to the Earth done by humans, change that can be seen from hundreds of miles above the Earth.

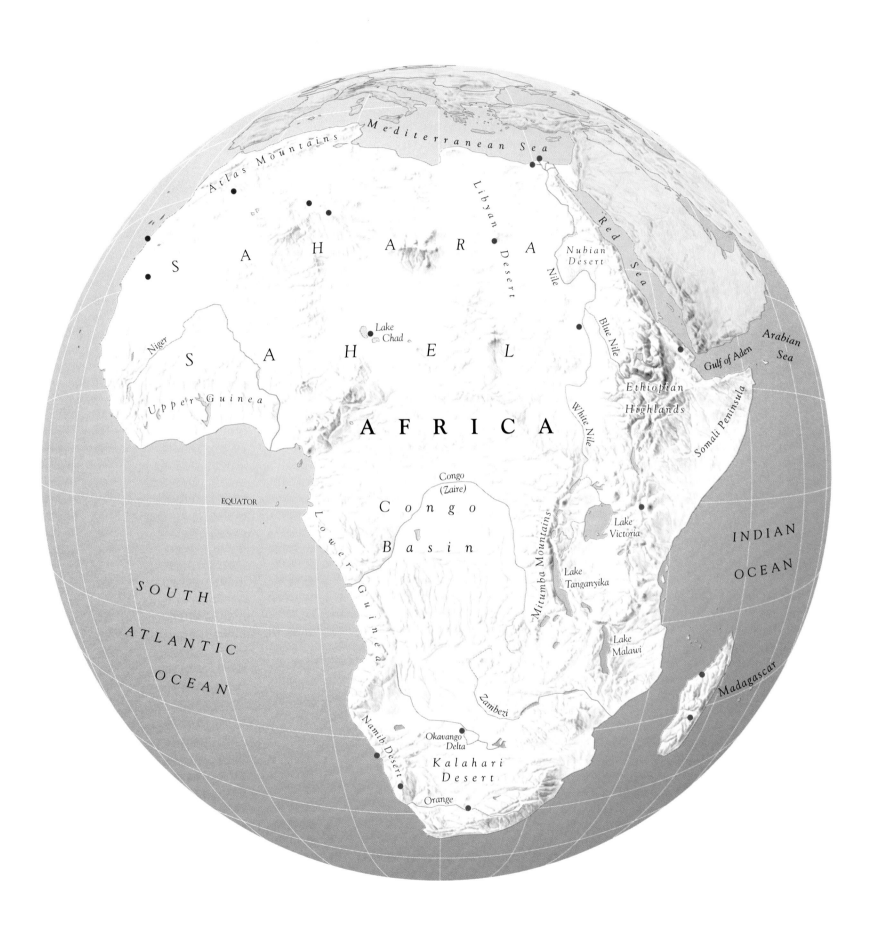

Atlas Mountains

Mediterranean Sea

S A H A R A

Libyan Desert

Nubian Desert

Red Sea

Niger

S A H E L

Lake Chad

Nile

Blue Nile

Gulf of Aden

Arabian Sea

Upper Guinea

AFRICA

White Nile

Ethiopian Highlands

Somali Peninsula

EQUATOR

Congo (Zaire)

Congo Basin

Lower Guinea

Mitumba Mountains

Lake Victoria

Lake Tanganyika

INDIAN OCEAN

SOUTH

ATLANTIC

OCEAN

Lake Malawi

Zambezi

Madagascar

Namib Desert

Okavango Delta

Kalahari Desert

Orange

● Center point of photograph

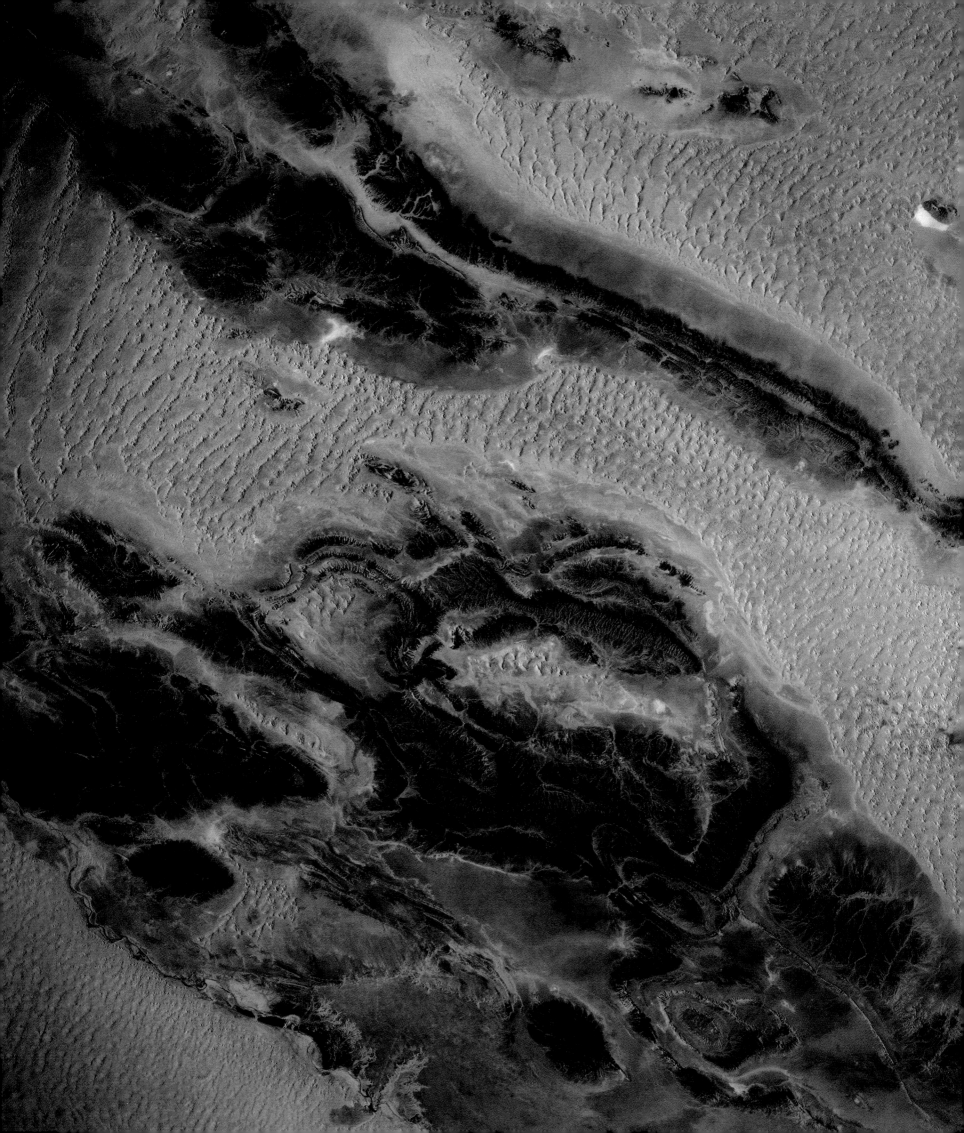

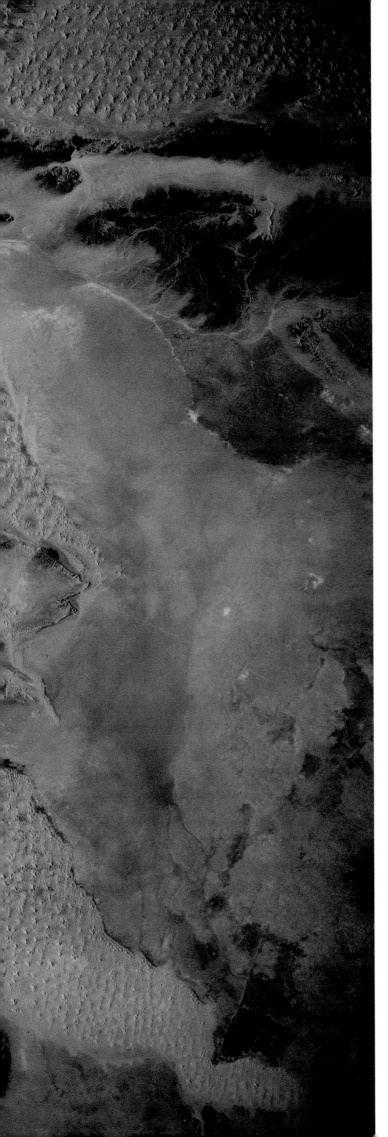

THOMAS J. ABERCROMBIE

Kahal Tabelbala, Algeria

On my first spaceflight I was surprised to find that the Sahara is not a uniform sea of sand. A thin coat of oxidized rock—called desert varnish—produces amazingly varied colors amid the imposing mountains. Whirling winds sculpt rows of dunes (left) at Kahal Tabelbala, Algeria. When the wind comes predominantly from one direction, the sand forms into knife-edge ridges, such as those above, at Erg Bouharet in Algeria.

•pp 28-29
p 24

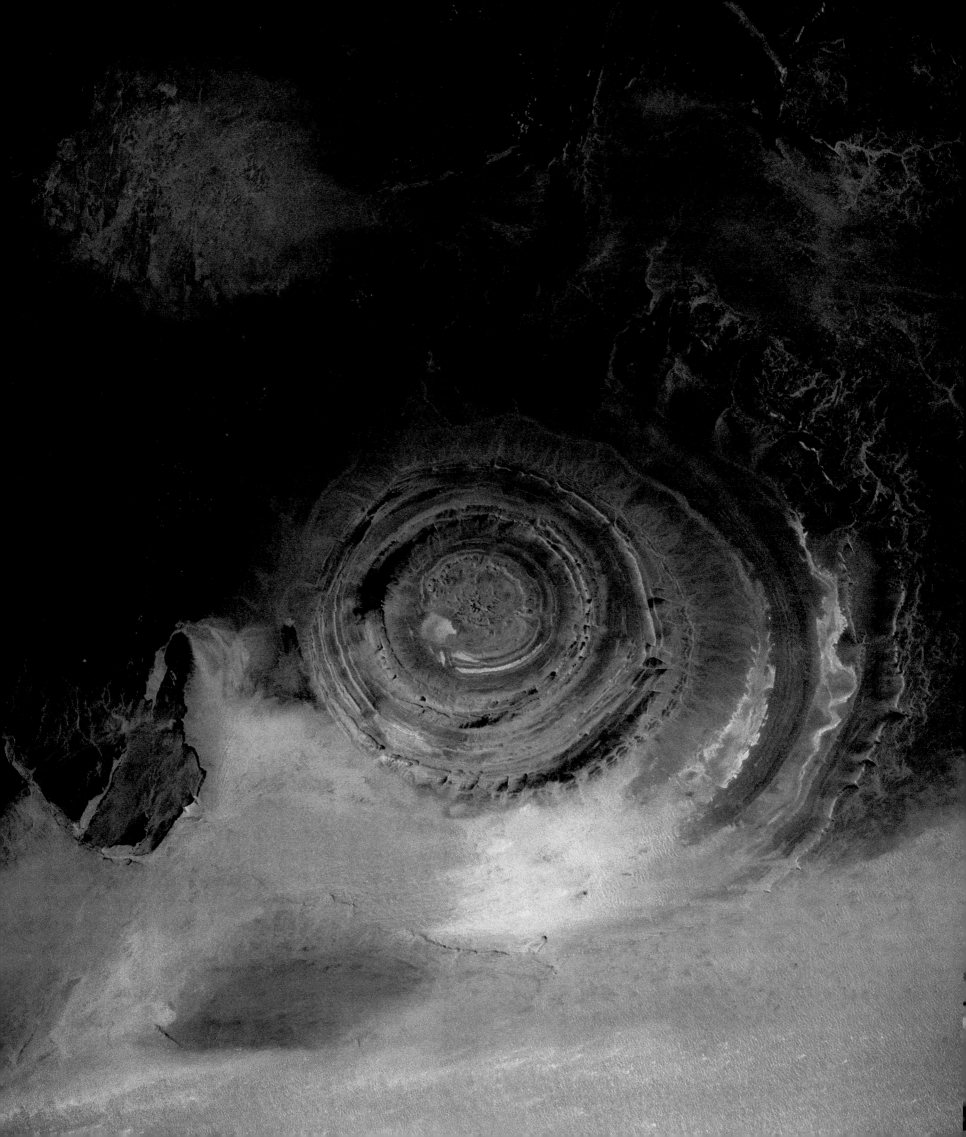

Mauritania's Bull's-Eye

This 25-mile-wide structure in central Mauritania is neither an open-pit mine nor a crater left by a meteorite's impact. Rather, it is a series of layered rocks that are being sandblasted into view by fierce Saharan winds. For space travelers, this is one of the most dramatic landmarks in the western Sahara.

Hundreds of millions of years ago, these layered rocks were formed from sediments accumulated beneath the waves of advancing and retreating continental seas. Then as forces deep within the Earth slowly pushed upward, a large, broad dome formed, and the hardened layers became exposed to wind erosion. The result is the 300-foot-deep landmark.

Subtle variations in the hardness of each unique layer resulted in uneven weathering and produced a pattern of concentric ridges and depressions. The broad yellow area across the bottom of the photo is a thin sand sheet drifting across the edge of the bull's-eye.

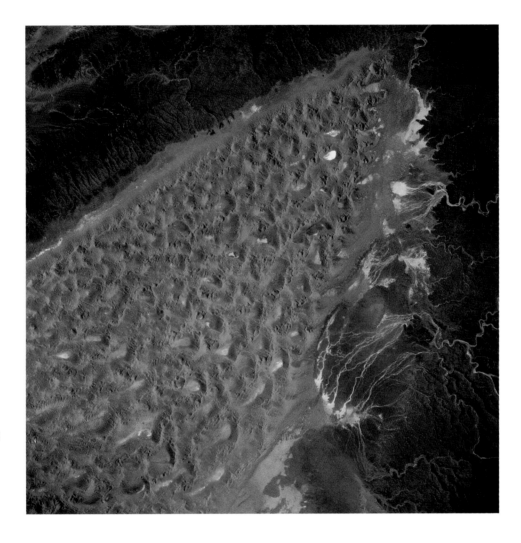

Tifernine Dune Field, Algeria

Iron and manganese color the desert rock dark-gray here in eastern Algeria. Iron glittering in sand grains produces the reddish color that predominates in the dunes. Occasionally, huge floods wash down the dry river valleys to the right of the photograph. One such flood, 200 miles to the south, destroyed the town of Tamanrasset in 1922. During the cold "little ice age" from the 16th to the 19th centuries in Europe, the desert here was much wetter than it is today, and these rivers probably ran often.

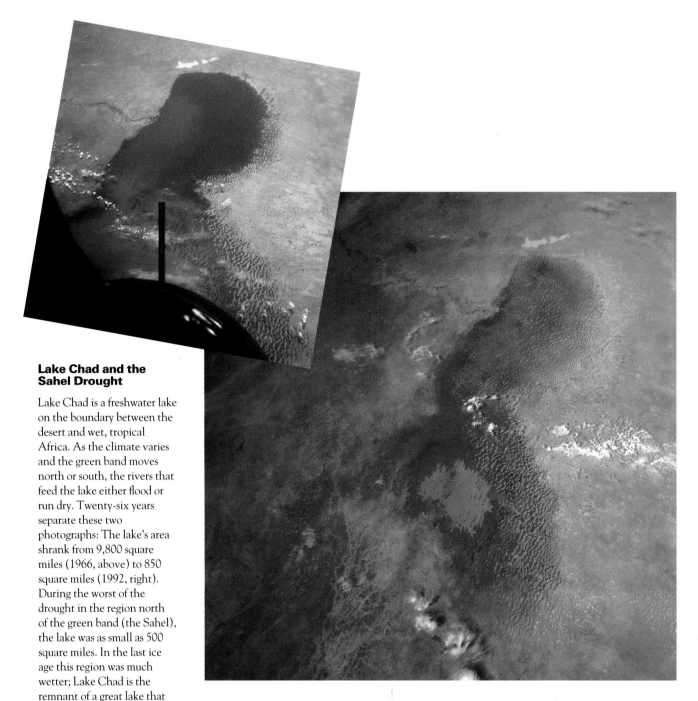

Lake Chad and the Sahel Drought

Lake Chad is a freshwater lake on the boundary between the desert and wet, tropical Africa. As the climate varies and the green band moves north or south, the rivers that feed the lake either flood or run dry. Twenty-six years separate these two photographs: The lake's area shrank from 9,800 square miles (1966, above) to 850 square miles (1992, right). During the worst of the drought in the region north of the green band (the Sahel), the lake was as small as 500 square miles. In the last ice age this region was much wetter; Lake Chad is the remnant of a great lake that once filled the 400,000-square-mile basin that contains most of the country of Chad.

Jabal Arkanu and Jebel Uweinat

These dark rock masses that stick up about 6,000 feet out of the lighter-colored sand flats are in one of the most remote parts of the Sahara Desert. They lie close to the point where Libya, Egypt, and Sudan meet, 700 miles southwest of Cairo, 500 miles west of the Nile's Aswan High Dam.

Parts of these dark masses are the roots of relatively young volcanoes that lie upon ancient rocks. The rocks were lifted to the surface of North Africa by plumes of hot magma that rose from deep in the crust. Thin sheets of sand—often less than six feet thick—cover many parts of the Sahara Desert. A radar "camera" that flew aboard four Shuttle missions could "see" right through this sand sheet. Using the radar, scientists discovered dry river channels buried beneath the sand near Jabal Arkanu in Libya. As recently as 9,000 years ago, many of these hidden rivers flowed. One theory is that originally, millions of years ago, they coursed all the way across the Sahara from near the Red Sea in the east to the Atlantic Ocean in the west. Much later, but before the climate changed to extremely arid (about 5,000 years ago), people lived on the banks of these rivers, using stone tools that scientists have found beneath the sand.

pp 34-35
p 33
p 32

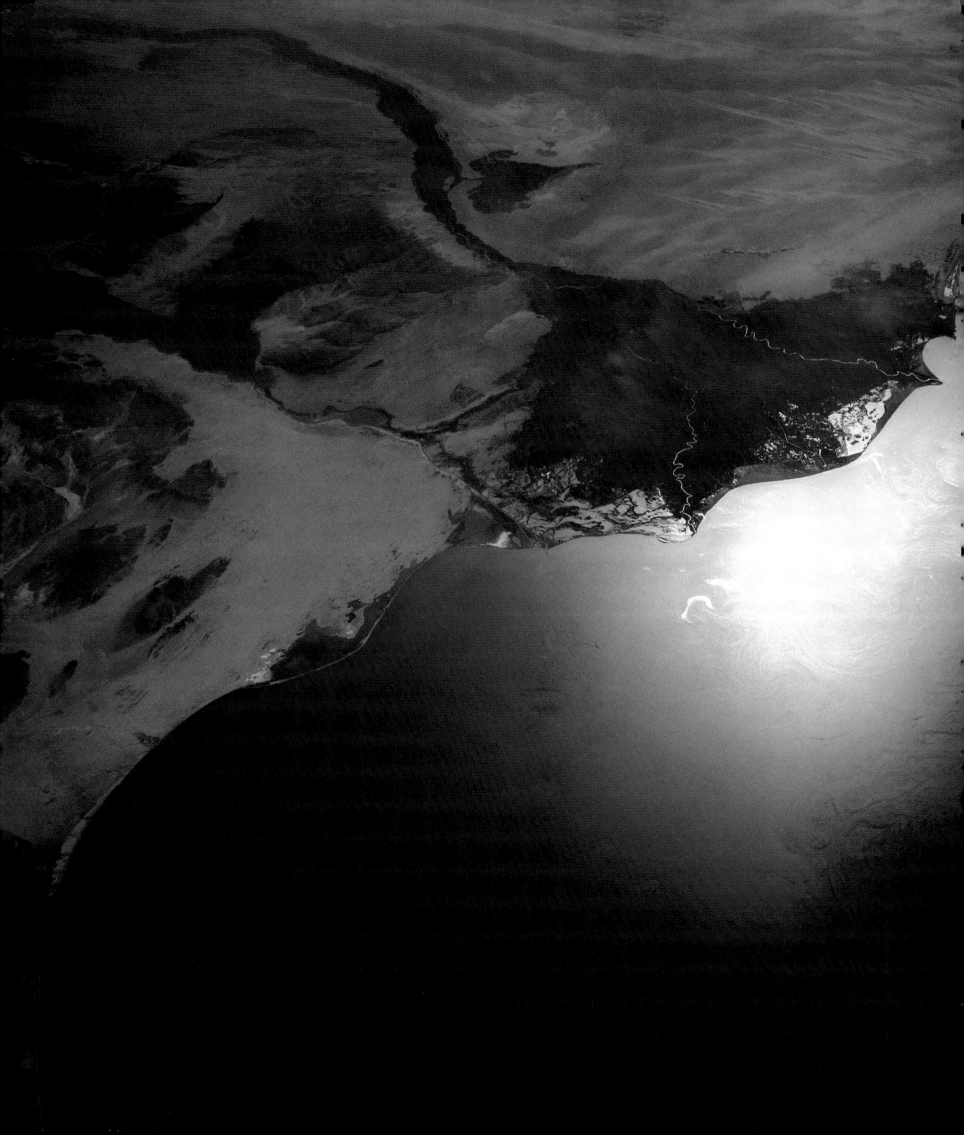

The Nile Delta and the Gulf of Suez

The Nile Delta was about three-quarters its present size at the time of the First Dynasty of the Pharaohs. As the two Niles brought sediment downstream from Ethiopia (the Blue Nile) and from central Africa (the White Nile), the delta built farther out into the Mediterranean Sea. The Nile Delta continued to grow until 6,000 miles of irrigation canals were dug in the delta to divert the waters of the Nile to farms. This coincided with a period of dam building in Egypt and Sudan that ended with completion in 1971 of the High Dam at Aswan, which provides about half of Egypt's electricity.

The dam created Lake Nasser—and changed the Nile. The Nile no longer flushes away freshwater snails, carriers of schistosomiasis, a visceral parasitic disease. Water hyacinths were formerly impeded by the flooding of the Nile. Now the disease spreads and water hyacinths clog canals and waterways as far north as the delta, even as a stable water flow from Lake Nasser helps Egypt feed its exploding population.

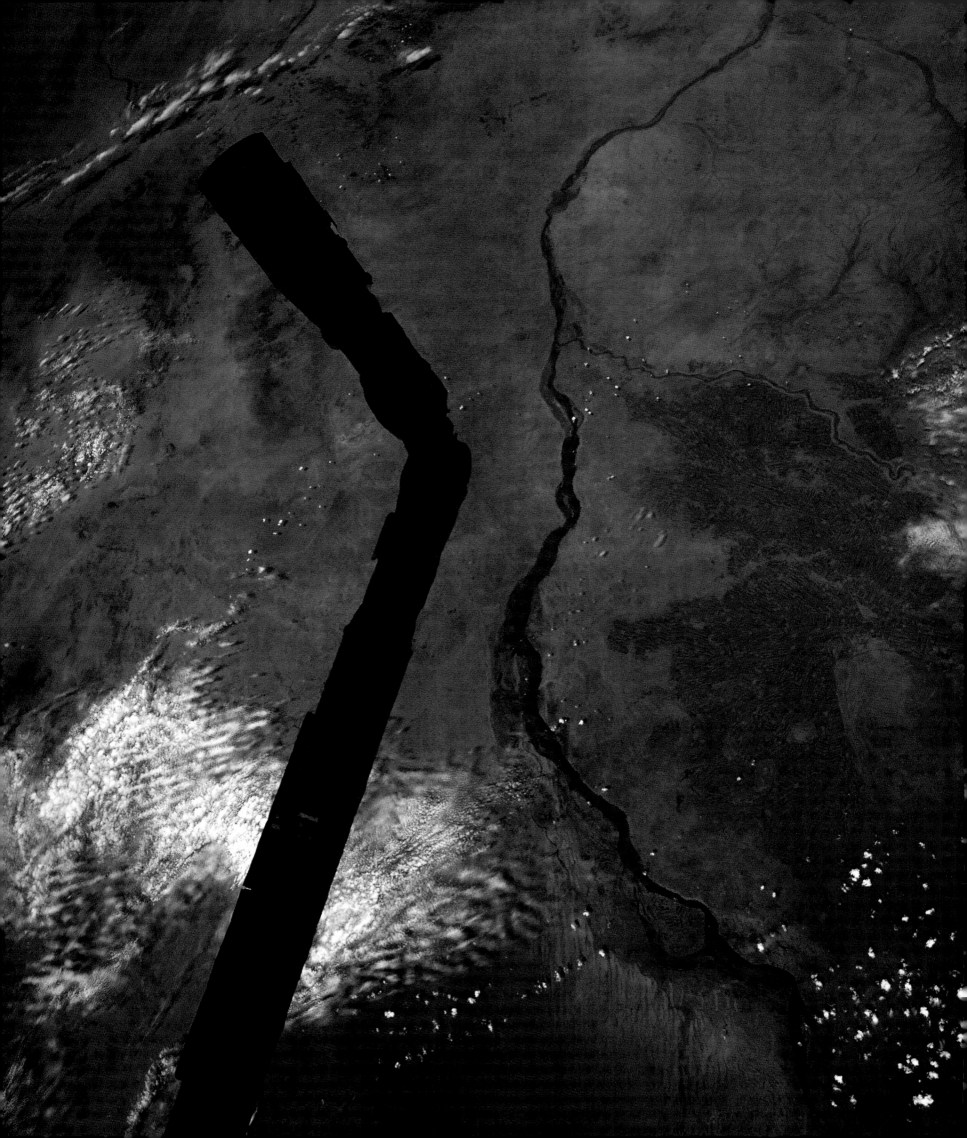

Khartoum

LEFT

Khartoum, the capital of Sudan, sits at the junction of the two Niles. The shorter Blue Nile, with its sources in the highlands of Ethiopia, appears as a narrow line in the middle right.

The light-tan levees of the Blue Nile separate the river from the irrigated farming of the El Gezira Project to the west. The wider White Nile River bounds the western edge of Sudan's irrigated cotton fields. Barely discernible stripes mark alternating fallow and planted fields; the practice increases fertility.

Alexandria and the Western Nile Delta

Irrigation canals and the Aswan High Dam have trapped much of the sediment that annual Nile floods once carried to the Mediterranean Sea. What was a building delta a century ago is now eroding in places by as much as 250 feet each year. The light-blue areas in this 1990 photo, much more noticeable in photos since the 1980s, are shoals, visible because the Nile's mud no longer covers them.

A dense system of pump-driven and gravity-fed irrigation canals leads to the dark-green fields in the photo. To the left, the land slopes up, so desert farmers must dig deep wells, one in the center of each large circular farm seen in the photograph. As over-irrigation has increased the salt in the soil, more and more of these desert farms have appeared in our photos.

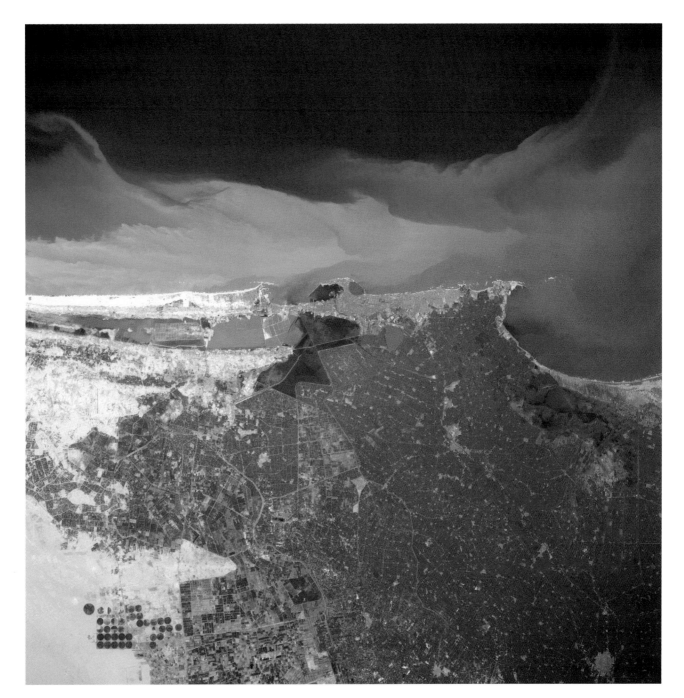

p 37

p 36

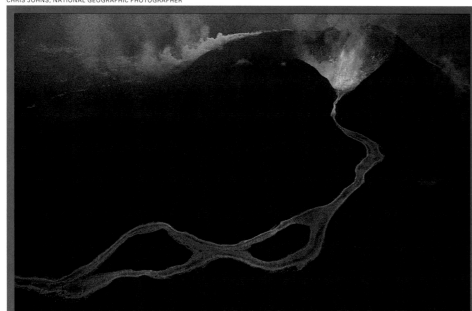

Where Africa Splits

The crew of *Endeavour* took this majestic view in December 1993 from an altitude of 361 miles. Her crew composed this frame just before beginning a delicate rendezvous with the Hubble Space Telescope. The Horn of Africa is at right, the southern extremities of the Arabian Peninsula are on top, the Red Sea is at left. We are looking eastward down the Gulf of Aden and into the Arabian Sea. The gulf coastlines are crudely parallel, revealing the slow and persistent process of plate tectonics, the movement of giant pieces of continental rocks and submerged seafloor.

A titanic upwelling of liquid rock has pushed the land upward, creating many volcanoes at the heart of the triple junction (center of large photo). The volcano in the photo above left shows the extent of the upwelling. It is in the Virunga Mountains near Goma in Zaire.

Three huge cracks have appeared, and the land looks like the crust of a cooling angel food cake. Two of the cracks, or rifts, have filled with water, forming the Red Sea and Gulf of Aden. The third rift is still incomplete, and is marked by the long, deep lakes of East Africa. These lakes are actually chasms up to 5,000 feet deep. As the rifting continues over millions of years, the Horn and much of East Africa may become separate islands. Only here and in Iceland can typical seafloor spreading processes be studied on dry land.

If we could dry out the oceans, this is what thousands of miles of mid-ocean seafloor would look like.

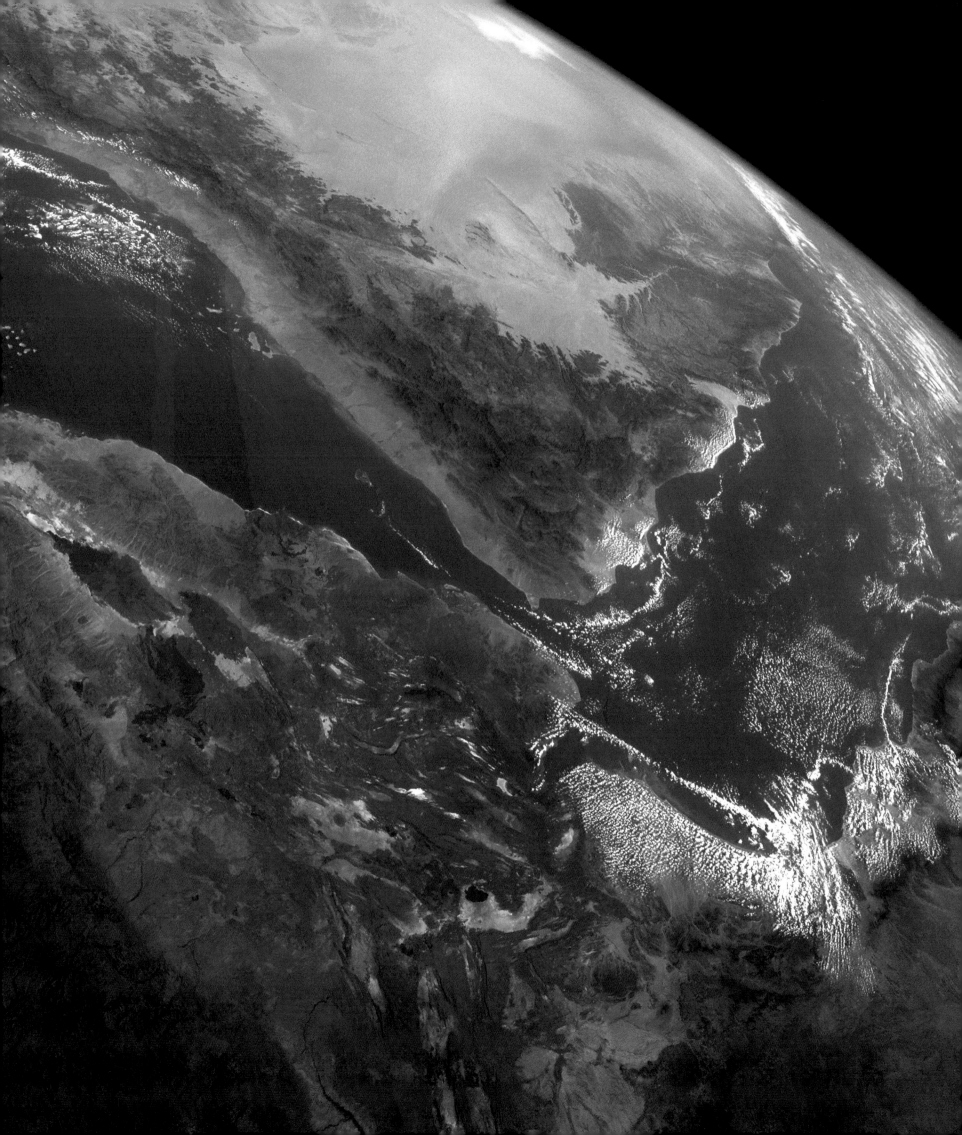

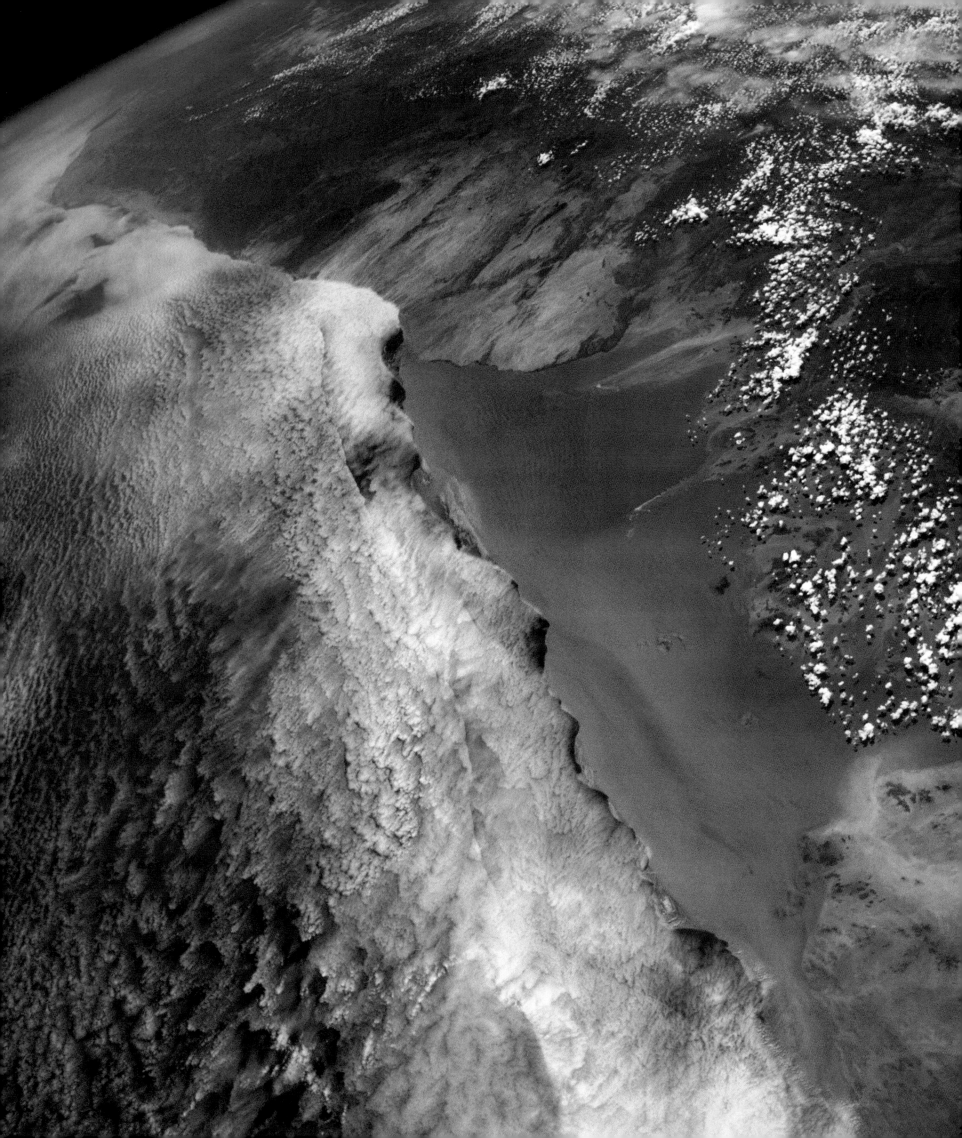

Namib Sand Sea

The Namib Desert is a spectacular sight seen on every Shuttle mission. Its colors sparkle from orbit like the abundant diamonds found in the southern part of this great desert. It is so beautiful that once, while on a spacewalk, I paused from my work to study the colors at sunset.

The cold Benguela Current in the Atlantic Ocean moves north (toward the top of the photo) along the coast of Namibia. The current causes intensely dry climates along the shoreline. Only twice in the past 60 years has enough rain fallen for plants to grow. This is still called the "Skeleton Coast," since shipwrecked sailors have little chance of surviving on this dangerous shore.

Few people (mostly diamond miners and armed guards) live here. Ranching begins in the higher country, where clouds can form and rain creates pastureland (upper right half of the photo).

The cold ocean current and warm overlying air create moist fog that rolls inland, nurturing life on the dunes.

The dune-living tenebrionid beetle stands on its head and presents its back to the fog-laden breeze. Droplets condense and then roll down grooves, draining into the beetle's mouth.

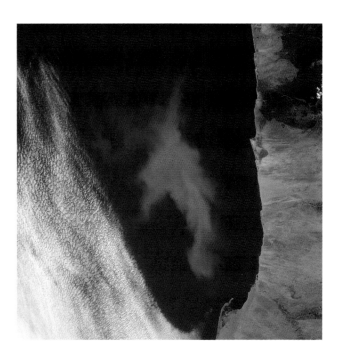

Namib Desert and Plankton Bloom

The barren Namib Desert lies next to rich offshore fishing grounds, an ecosystem based on nutrients in the cold water of the Benguela Current, which surges up from the depths of the Antarctic Ocean. Here a light-blue bloom of plankton, base of the food chain, appears between the desert and a white fogbank. Just as the sea provides fog-moisture for desert plants and animals, dust blowing off the desert may provide nutrients for the plankton.

Ever since North American whalers came here in the 1700s, Walvis Bay (enclosed by the hook of sand in the middle of the photo) has been a refuge for sailors. The bay is Namibia's main gateway to the Atlantic.

p 41
pp 40-41

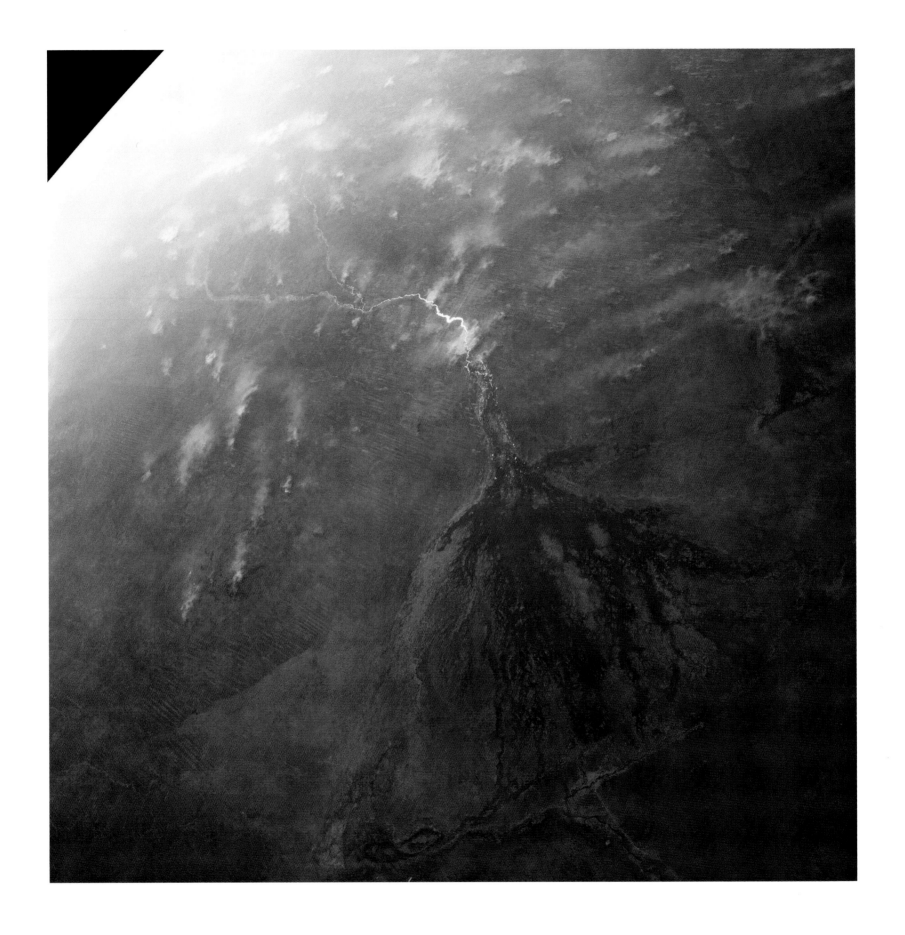

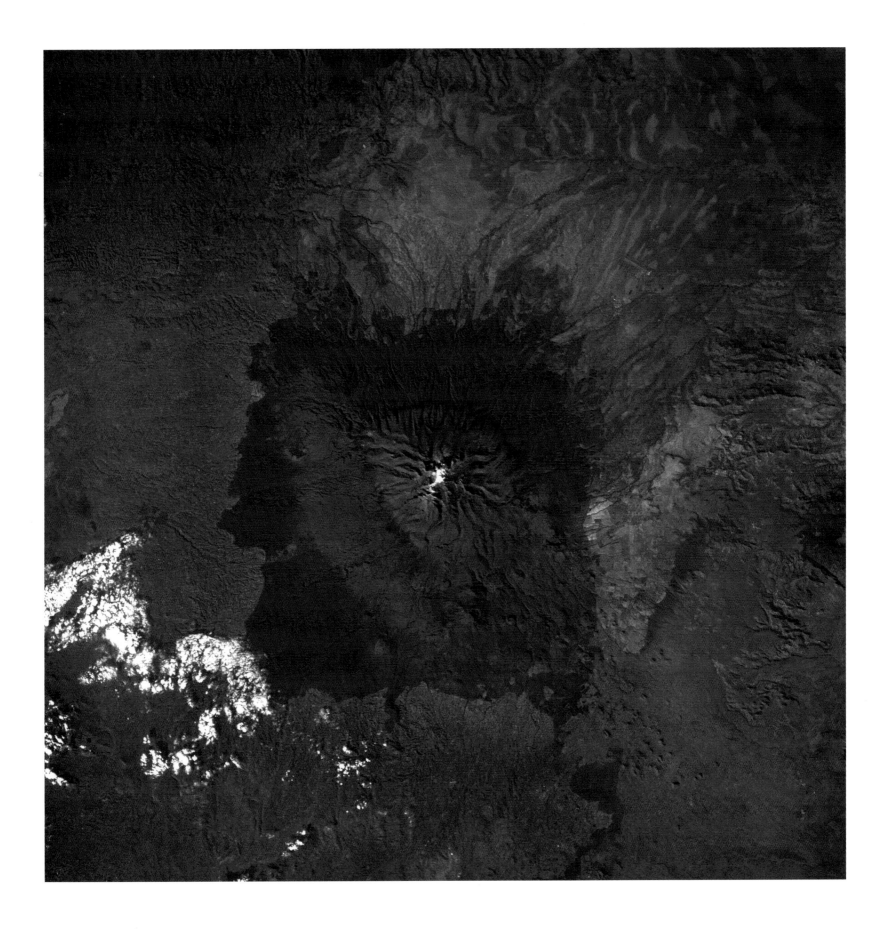

The Fires of Botswana
PAGE 42

The swamps of the Okavango River Delta on the edge of the Kalahari Desert of Botswana (the dark-green fingers near the center of the photo) suffer habitat loss as forest is burned for cattle pasture. So many fires are blazing in this photo (taken in August 1991) that a pall of smoke obscures the distant terrain. South and east of the Okavango region, diamonds have been discovered. Plans, abandoned in 1991, called for water to be channeled from the swamp for the mines, threatening the swampland habitat. A few thousand years ago Africa was wetter and this area was under a permanent lake.

Mount Kenya
PAGE 43

Mount Kenya, known to local people as Kirinyaga, rises some 10,000 feet above the plains to an altitude of 17,058 feet. From the Shuttle, the mountain is a green patch in the yellows and browns of a semidesert.

The mountain's glaciers have dramatically retreated since 1963. About 16,000 years ago, the mountain rain forest spread out across most of the brown plains in this photograph.

Tourist traffic and logging have degraded the ecosystem. A new conservation plan aims at reconnecting local people with a mountain they consider sacred, helping them and the ecosystem.

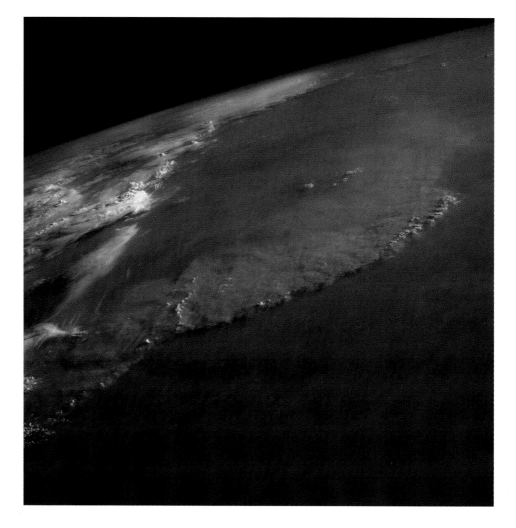

Dust Storm in the Sahara
LEFT

The leading edge of this great dust storm covered several hundred miles of Algeria and Libya one afternoon in May 1992. Dust storms develop in the same type of unstable air that causes thunderstorms in a humid environment. Dust storms, which usually form in spring, can carry dust thousands of miles.

Southern Africa

Africa is the easiest continent on which to see the most important feature of Earth's climate: the division into wet and dry zones. At the Equator, the sun heats the ground, which heats the overlying air. The air then rises, forming the clouds seen over equatorial Africa. These clouds provide rain to turn the soil into the wide expanse of green vegetated land in the photo. As the air cools and becomes drier, its density increases and it begins to descend. Like a fountain, the air spills north and south, eventually descending at roughly 30 degrees north and south latitude. This whoosh of dry descending air suppresses the formation of clouds, dooming most lands at these latitudes to be deserts.

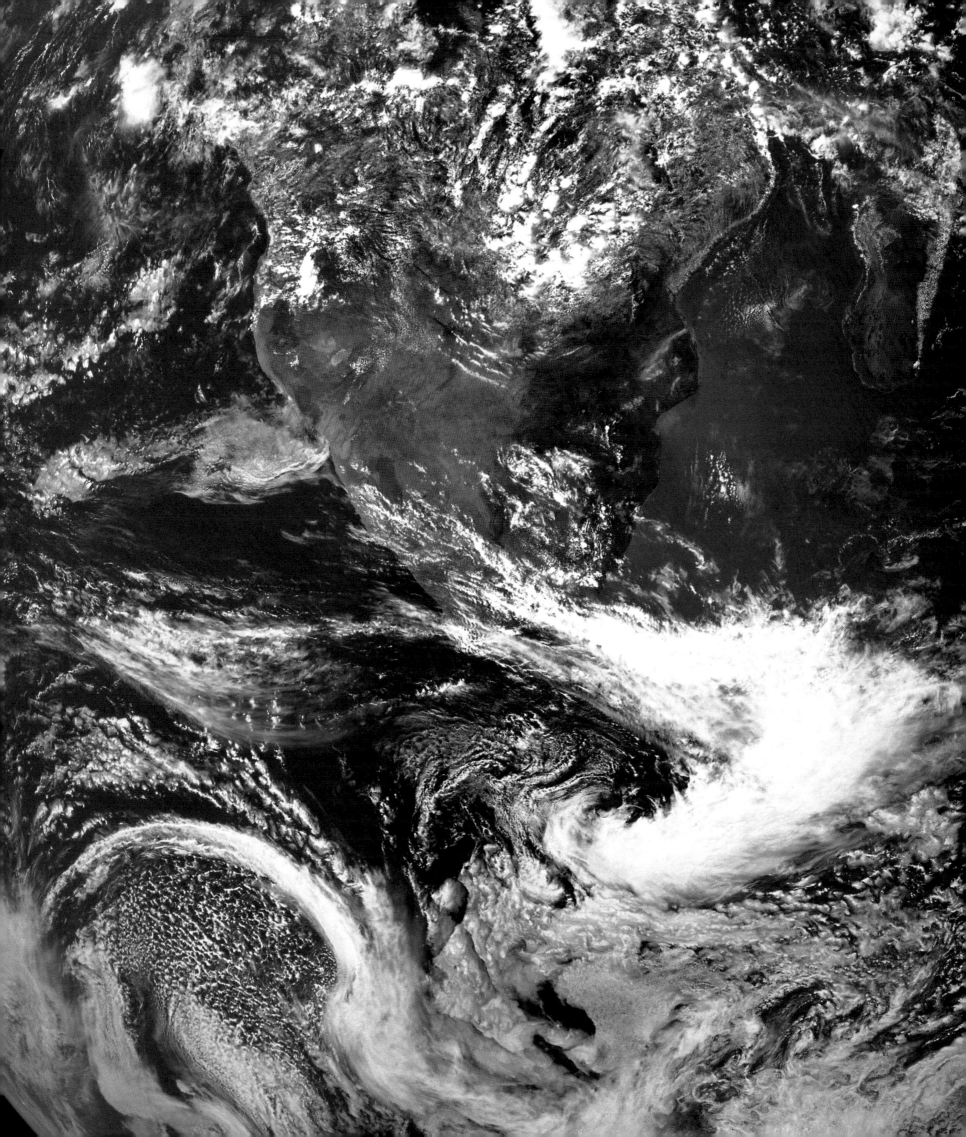

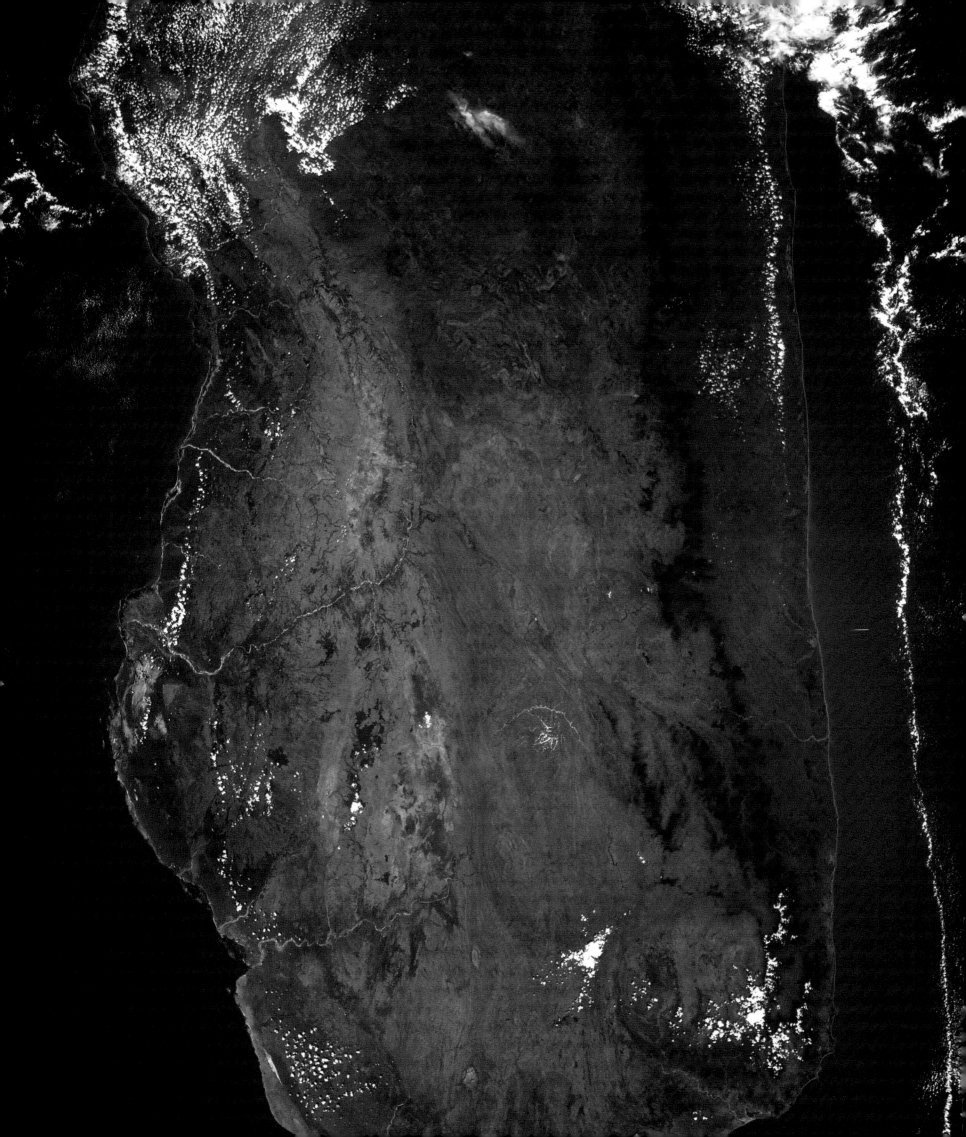

Madagascar's Burning Forests

Madagascar, an island nation slightly smaller than Texas, lies 250 miles to the east of Africa. In 1900, forest covered over 70 percent of the island. Today less than 8 percent of the forest remains. Madagascar's economy is based on agriculture (rice and coffee) and cattle ranching. Although there is one large fertilizer plant in the country, its product is inaccessible to most of the farmers, who simply move on when the soil is exhausted. They clear new land by burning trees and brush. Here on Madagascar's southern plateau, near Isalo, only bunchgrass and fire-resistant palms have survived the farmers' fires (right).

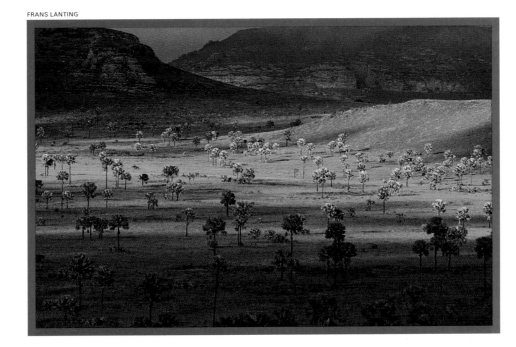

FRANS LANTING

Madagascar's Betsiboka River

FOLLOWING PAGES

When the farmers clear the land of trees and brush, the soil is directly exposed to the region's heavy monsoon rains. In a few short years the soil washes into the rivers. Eroded red topsoil has choked the Betsiboka River's mouth. The estuary across the middle of the photograph is now more than half filled with forested islands in what was a deep channel of blue water open for seagoing ships. Brown soil-carrying water contrasts with the deep blue of seawater near the mouth of the estuary. The muddy discharge from the river hampers the port of Mahajanga, seen on the peninsula at lower right in this photo taken from *Discovery* in 1984.

An island at the delta's seaward edge has appeared since 1985, when it began to emerge as a tidal mudflat. Shuttle photographs have recorded its transformation into a forest-covered island.

pp 48-49

p 46

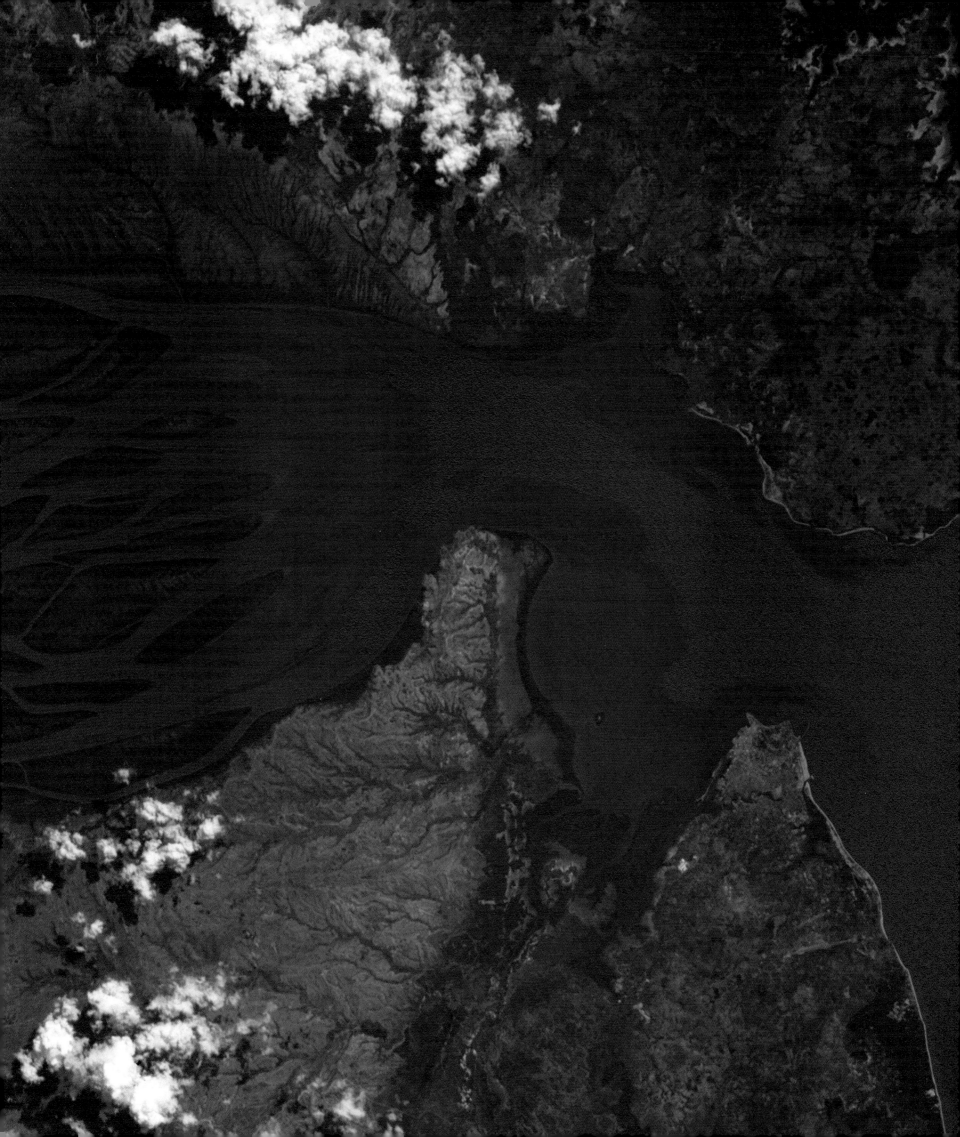

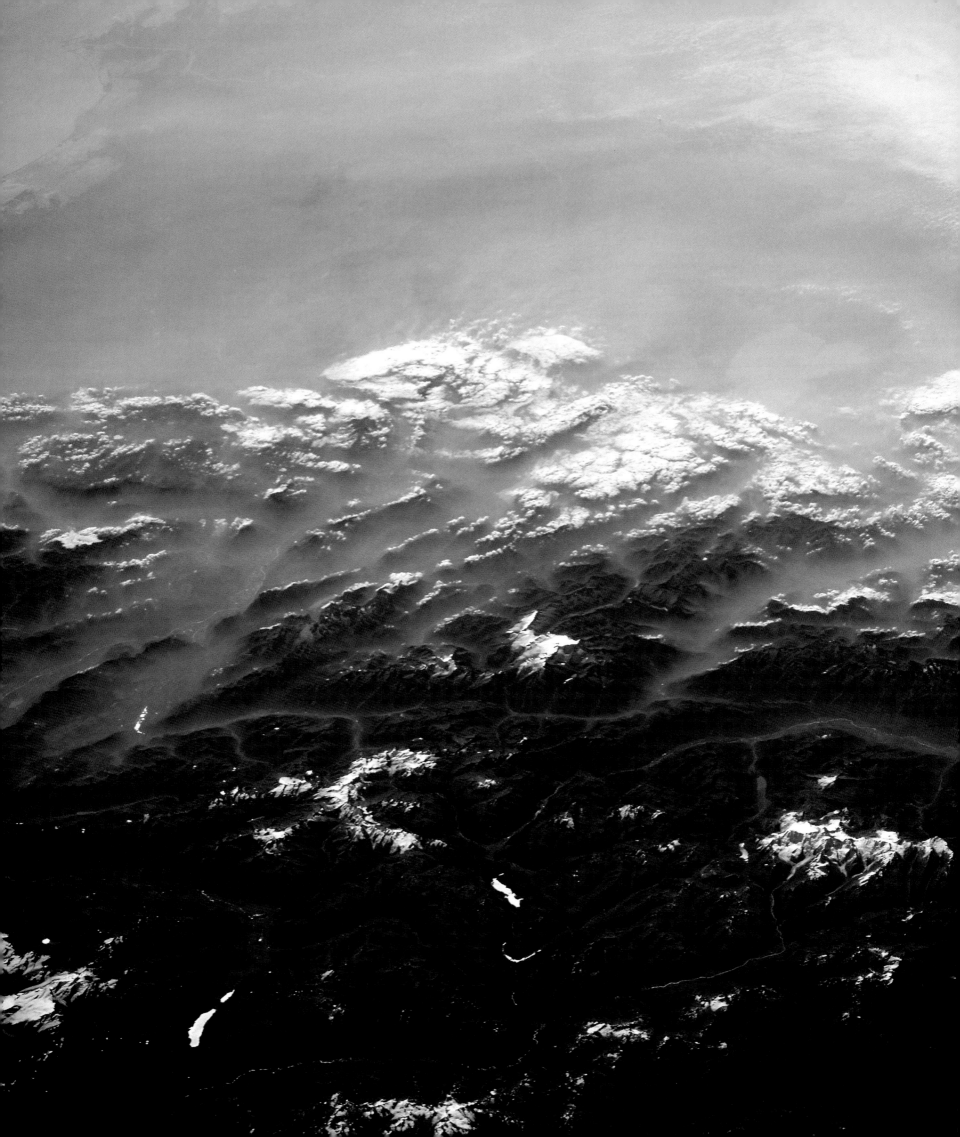

Europe and Middle East

Europe an

Midd

The Alps

Smog hangs over northern Italy in the middle of a common summertime inversion. The 10,000-foot peaks south of Innsbruck, Austria, are in the foreground. During our entire nine-day voyage aboard *Endeavour* in September 1992, smog concealed the industrial and agricultural heartland of Italy's Po Valley.

OUR SHIP CROSSES EUROPE IN ONLY FOUR MINUTES, BUT what a sweep of history lies below us in this small place! Our most northern spaceflights take us as far as Edinburgh, Copenhagen, and Moscow. On most days, clouds block our view for the short time we are over Europe. But on my third mission, we got lucky: Scotland, Denmark, Sweden, and most of the Baltic were clear. From orbit, northern Europe seems to be almost completely covered with farms. Most European field patterns, as seen from space, are very similar until we fly over the long-socialized agriculture in the large fields of the Russian Plains. Some farms cluster around a central village, especially in Eastern Europe, portions of France, and Germany. In other locations, the rural settlements are so scattered and small that it is difficult to see anything but field edges adjoining field edges. Forest cover throughout Europe is increasing as Europeans aggressively seek to reforest their lands.

After flying over northern Europe, we passed over the Swiss Alps and Italy on the next orbit. Unlike many of the world's other major mountain ranges, the Alps are crisscrossed by a large number of low passes, which have allowed relatively easy interchanges between countries. On my second mission, in the summer of 1992, we had seen nothing of Italy, for a dense coating of smog smothered all but the highest peaks. During our first orbit over Italy on a 1994 spaceflight, the entire boot was clear in fine April weather. We saw surprisingly small towns that disturbed the dark green forests very little. Then we flew over Mount Vesuvius near Naples and Mount Etna in Sicily and were astonished to see dense groups of farms and towns climbing high up the slopes of these active volcanoes.

Just to the east, we saw the shattered remains of the volcanic island of Santorini, destroyed by a tremendous blast in about 1650 B.C. at the height of Minoan Bronze Age civilization.

Important as it was in the history of civilization, the Mediterranean itself has had an erratic history. Five to six million years ago less rain fell in Europe than in our time. Less water flowed into the Mediterranean from surrounding river basins, and the narrow shelf in the Gibraltar region cut off some flow of water from the Atlantic when world sea levels dropped. Geological movements may at times also have partially blocked flow through the strait. The Mediterranean Sea dried locally, leaving shallow salt lakes in hot depressions, thousands of feet below present sea level. Salt accumulated at the lowest points in the temporarily shallow and briny Mediterranean.

All spaceflights fly over the Middle East. It is at a low enough latitude so that we cross it even on missions launched due east from Cape Canaveral. After my first mission, I became interested in how civilization could have developed in such a desolate climate. We were taught in school that the Fertile Crescent (between the Tigris River in Iraq and the Nile in Egypt) was where agriculture began in the ninth millennium B.C. and where urban societies arose in the fifth millennium B.C. The climate back then may not have been as hostile as today's. The ratio of certain isotopes of oxygen reveals that the temperature here has changed abruptly several times in the past 10,000 years. Rainfall and lake levels decreased at those same times. Some researchers suspect that changes in climate may have played a role in the sudden ending of major Mesopotamian civilizations around 2000 B.C. The Sinai mountains, in Moses' time, may have remained green.

The Red Sea and Gulf of Aqaba lead our eye to the Dead Sea. Over the short time that we have been taking photographs from orbit, the use of the water flowing into the sea from the Jordan River for irrigation and drinking has lowered the sea's level and split it in two. The Dead Sea is the lowest water body on Earth. Since 1960, the level of the Dead Sea has fallen by about 40 feet. Its current rate of decline has accelerated to about two feet per year, due primarily to diversions of the Jordan River for consumption in Israel and Jordan. The Jordan River streamflow has been reduced by 75 percent from its pre-1960 amount. The water level has fallen so much that the sea has divided into two basins; one has dried up, the other is about 1,200 feet below mean sea level.

Plans for canal systems linking the Dead Sea with the Mediterranean and the Red Sea were advanced—and later shelved—by the Israeli government. The proposed project would have taken advantage of the hydraulics of the very low Dead Sea basin for power generation.

Water makes the difference between lands in the Middle East that are breadbaskets and ones that are barren. The desert of Saudi Arabia is blooming, irrigated from underground aquifers by deep wells. Just as the oil under the sands is finite, the water will not flow forever; estimates in most places are that it will last less than 50 years.

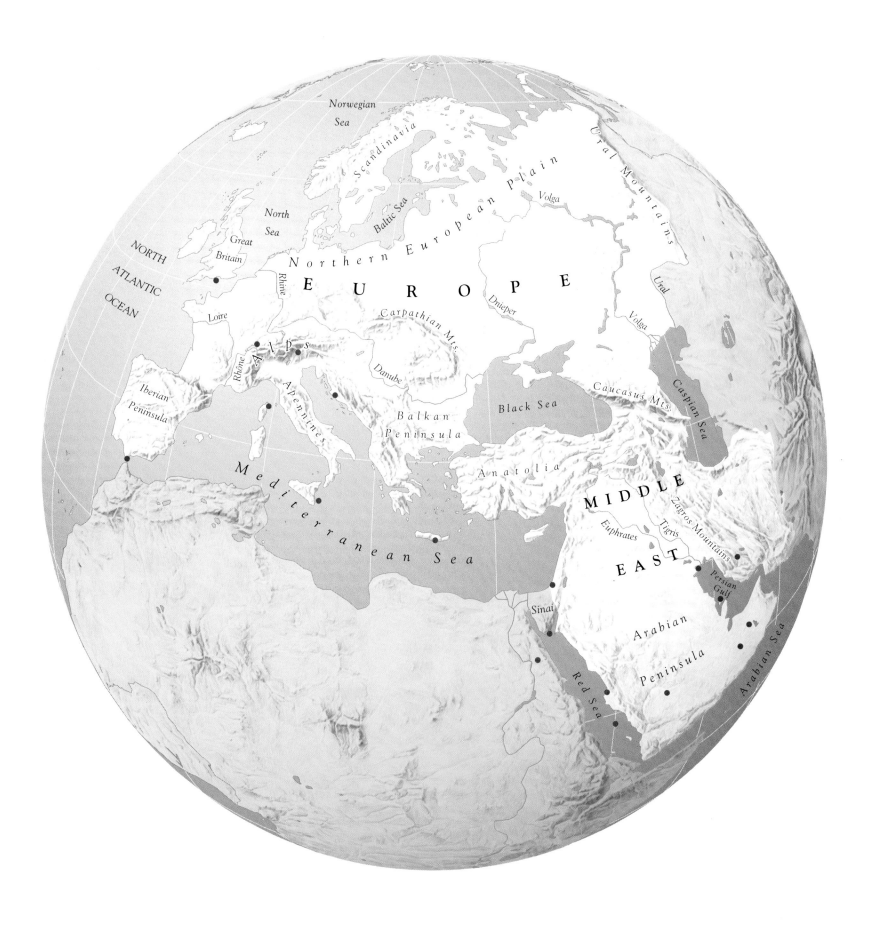

Norwegian Sea

Scandinavia

Ural Mountains

North Sea

Baltic Sea

Volga

NORTH

Great Britain

NORTHERN EUROPEAN PLAIN

EUROPE

ATLANTIC

Rhine

Ural

OCEAN

Loire

Dnieper

Carpathian Mts.

Volga

Alps

Danube

Caucasus Mts.

Caspian Sea

Rhône

Apennines

Balkan Peninsula

Black Sea

Iberian Peninsula

Anatolia

Mediterranean

MIDDLE

Zagros Mountains

Euphrates

Tigris

Sea

EAST

Persian Gulf

Sinai

Arabian

Red Sea

Peninsula

Arabian Sea

● Center point of photograph

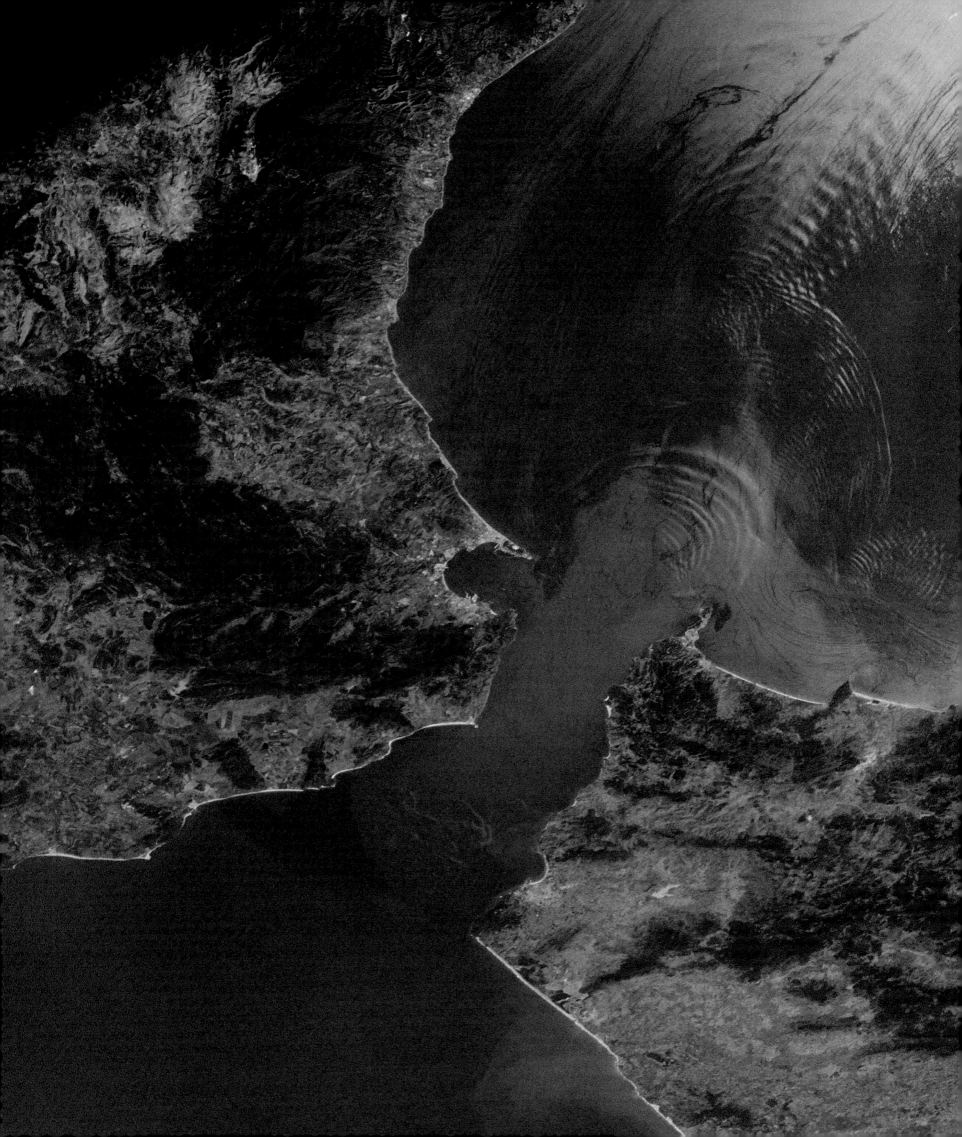

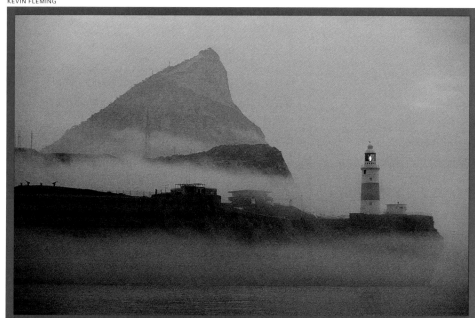

The Strait of Gibraltar

Only eight miles separate
Europe from Africa at this
relatively shallow strait. The
Rock of Gibraltar (above),
British territory since 1704, is
the sharp point of land on the
north side, joined to Spain by
a mile-long isthmus. Packets
of waves can be seen
expanding eastward from the
strait into the Mediterranean.
The waves are triggered by
tidal pulses of water that enter
the Mediterranean. Two less
prominent packets of waves,
due to earlier tides, can be
seen farther from the strait.
The waves ruffle the surface
by only inches; their real
power is many feet below.

Isle of Wight, England

Visible in this 30-mile-wide scene are Newport, at the head of the Cowes estuary in the middle of the Isle of Wight; Southampton, the great Cunard Line passenger port; and the modern yachting port of Cowes. Just off the top of the image is the Royal Navy port of Portsmouth. The history of England was nearly changed in this narrow channel in 1545. A French invasion force—larger than the Spanish Armada of 1588—attacked the English fleet at Portsmouth. The battle ended in a draw after fierce fighting on Wight. The French burned several villages before being driven back. King Henry VIII watched the battle from a castle at Portsmouth.

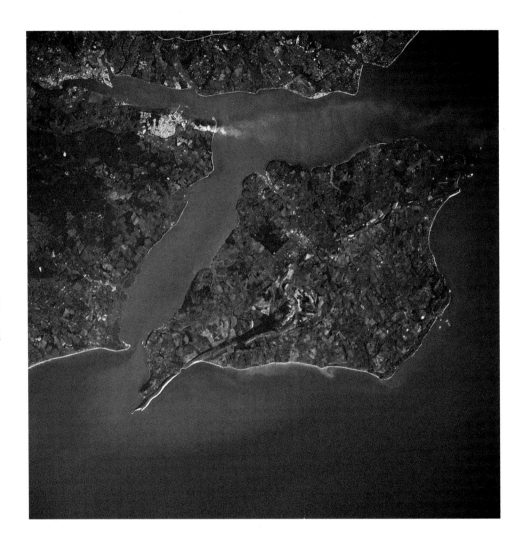

Corsica

Smoke rises from forest fires on the Mediterranean island of Corsica. The summer of 1985 in the region was unusually dry and hot. Persistently strong, low-humidity winds fanned forest fires from Portugal to Greece.

Mediterranean forest fires usually feed on ground litter. Native trees—particularly oaks and pines—have adapted to fire and usually are not fatally damaged. In French, Spanish, and Portuguese forests, foraging by horses, donkeys, and llamas controls the profusion of ground litter, reducing fire danger. Corsica's rugged terrain, with elevations of 3,500 to almost 9,000 feet, challenges firefighters trying to get to the fires.

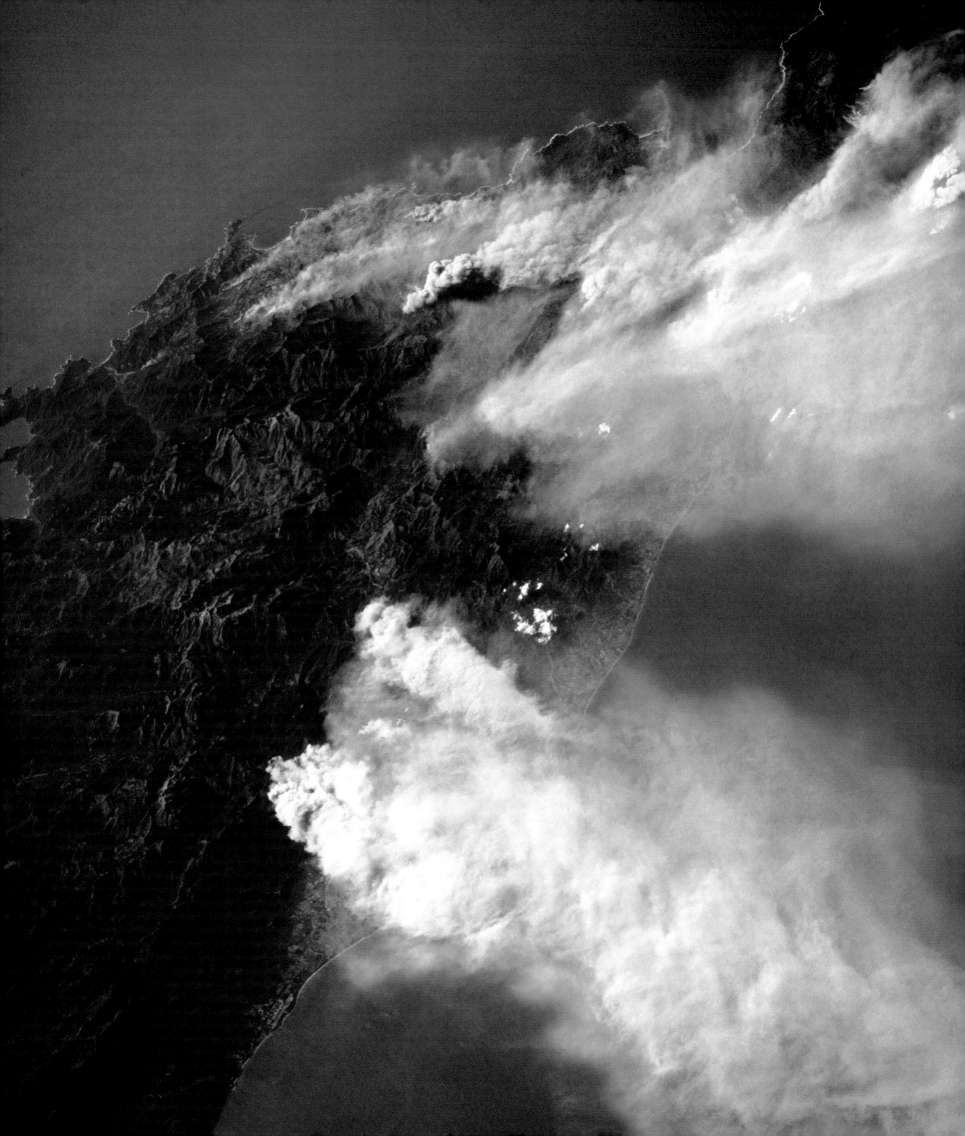

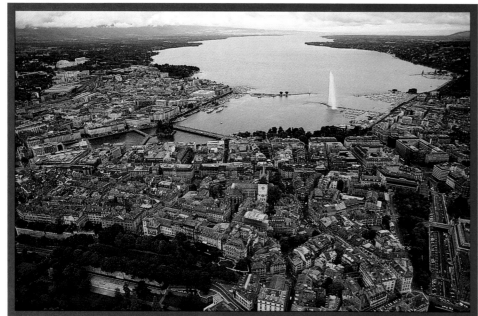

ENRICO FERORELLI

Lake Geneva and the Western Alps

Lake Geneva is the largest of the lakes in this photograph. The city of Geneva lies at the western (top) end of the 45-mile-long glacial lake. (In the photo at the left, the view is toward the northeast.) The Rhône River flows through the valley in the center of the photograph and into the eastern end of the lake, exiting into France at the top of the photo. Mont Blanc rises to 15,771 feet just to the left of the right-angle bend in the Rhône. To the right (east) of Lake Geneva are the Bernese Alps; the Pennine Alps to the south mark the Swiss border with Italy. Throughout the mountains are numerous high pastures.

The Alps were built when Italy, a piece of Africa, collided with Europe, destroying an intervening oceanic plate and folding mountains from France to Yugoslavia. This was a recent event: The Urals in Russia were created 250 to 300 million years ago by an earlier collision. But the rugged Alps are between 2 and 65 million years old.

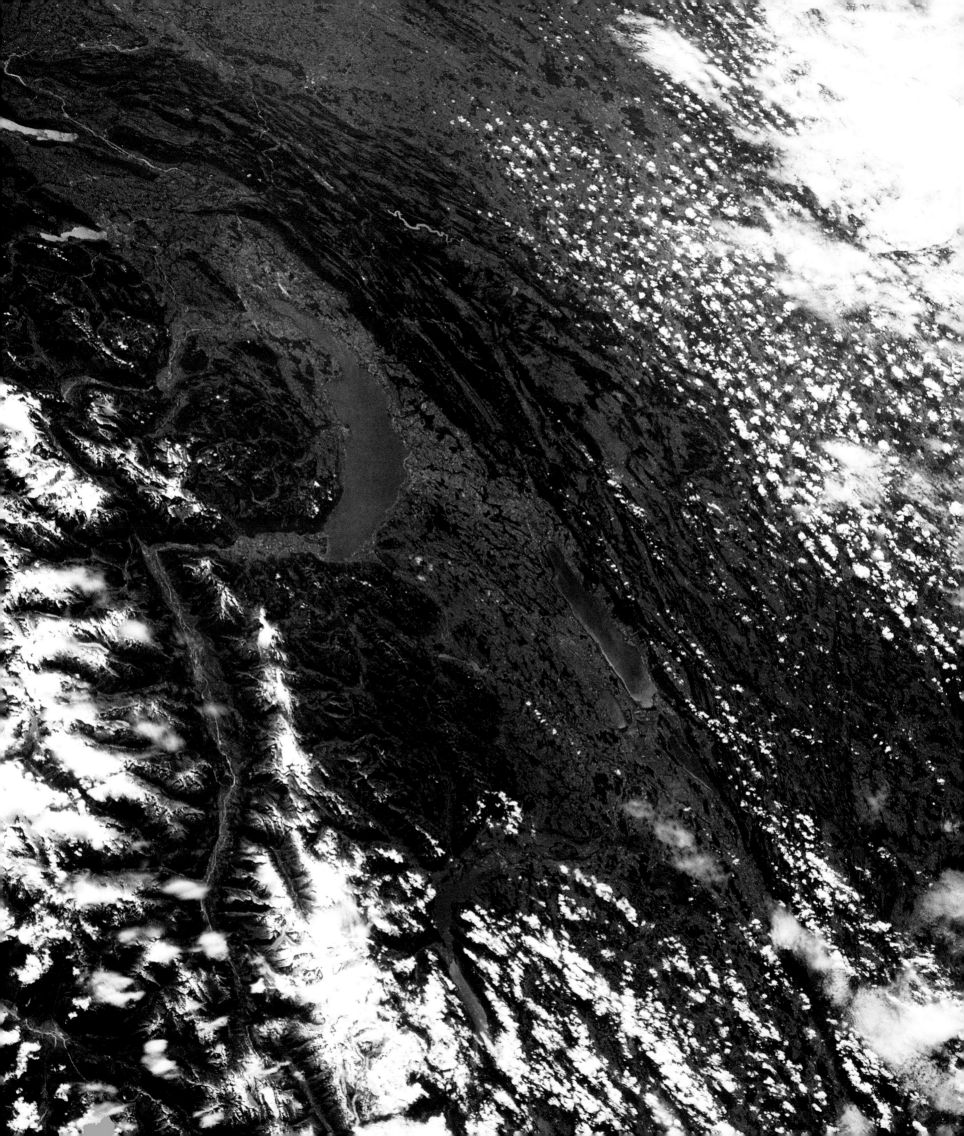

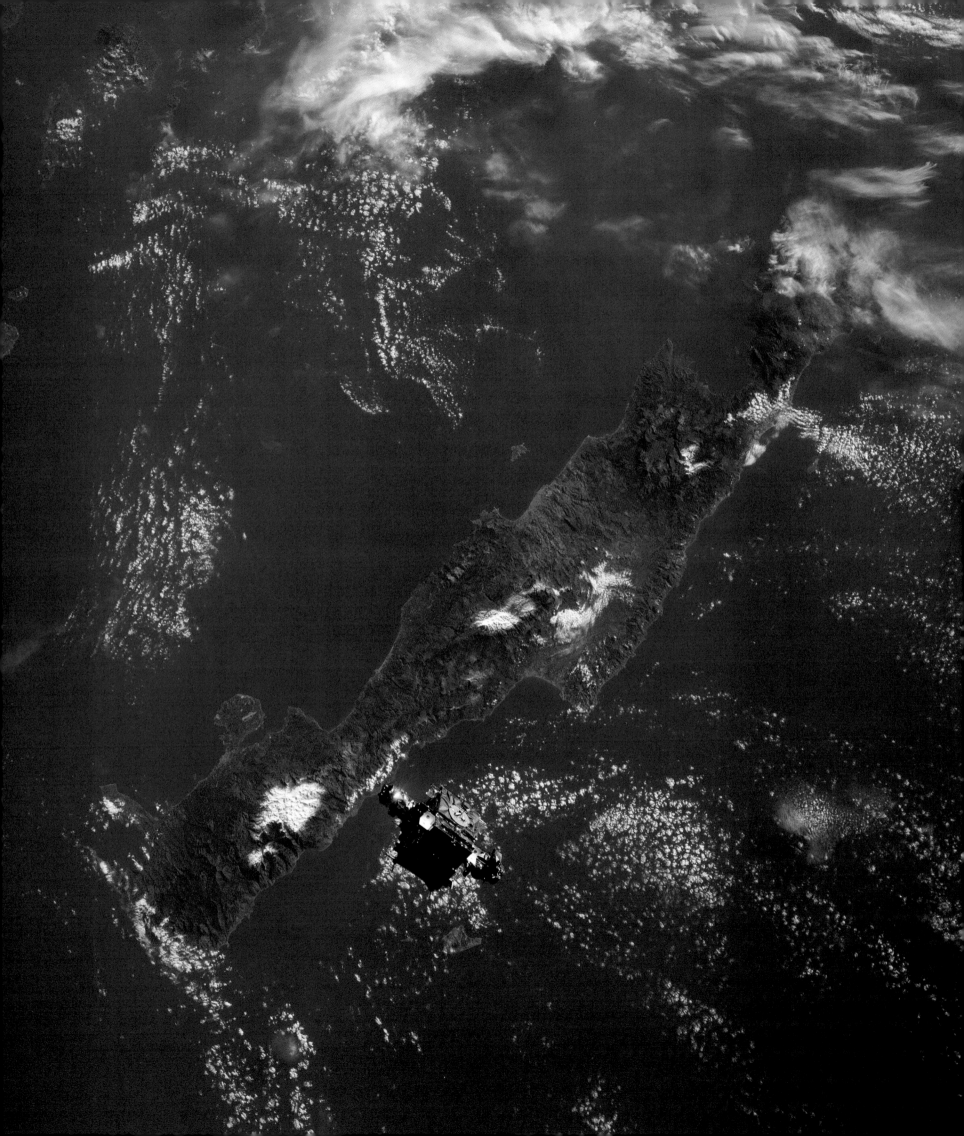

Springtime in Crete
LEFT

In an age when iron was almost unknown and tools and weapons were made of bronze, the first great civilization in Europe arose on Crete 5,000 years ago. The civilization was robust enough to withstand the titanic explosion of the island of Santorini (under the cloud at the top of the picture) in about 1650 B.C. Invaders from Greece ended 1,000 years of Minoan rule in 1450 B.C.

Crete's 8,000-foot peaks were covered with snow when *Discovery* flew overhead in April 1993. I wonder what the Minoans would have thought of the small astronomical observatory released over their island by the Shuttle's crew.

Sicily and Toe of Italy

In this panorama looking north, triangular Sicily is separated from Italy by the narrow Strait of Messina. A plume of volcanic smoke from Mount Etna, near the middle of the view, can be seen against dark water just below the tip of the boot. Vesuvius, which inundated Pompeii with hot volcanic ash in A.D. 79 and last had a major eruption in 1944, lies on Italy's west coast at the top of the view near the clouds. A sinuous line of light-blue plankton bloom, fed by phosphate runoff, weaves along the south coast of Sicily and extends into the Mediterranean (foreground), which has been severely polluted by coastal towns and by rivers flowing from factories far inland. Vigorous international efforts are helping to reduce pollution.

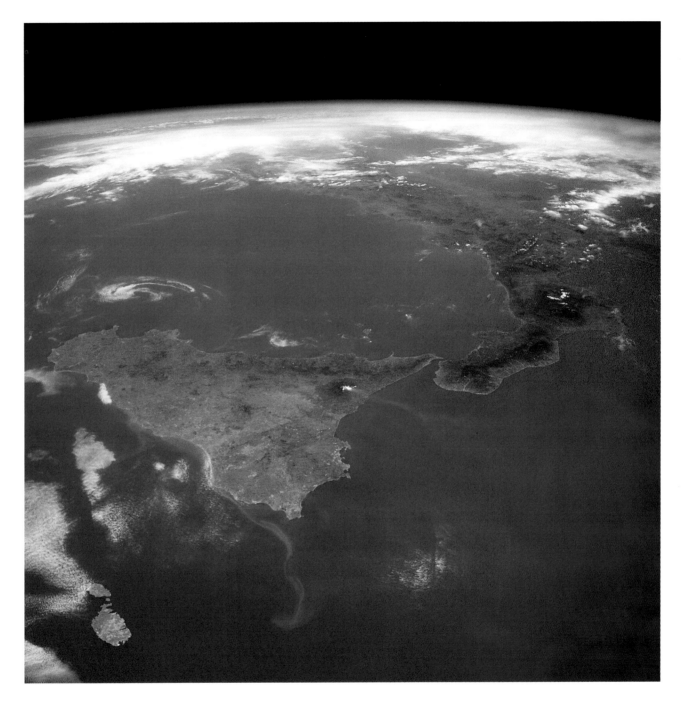

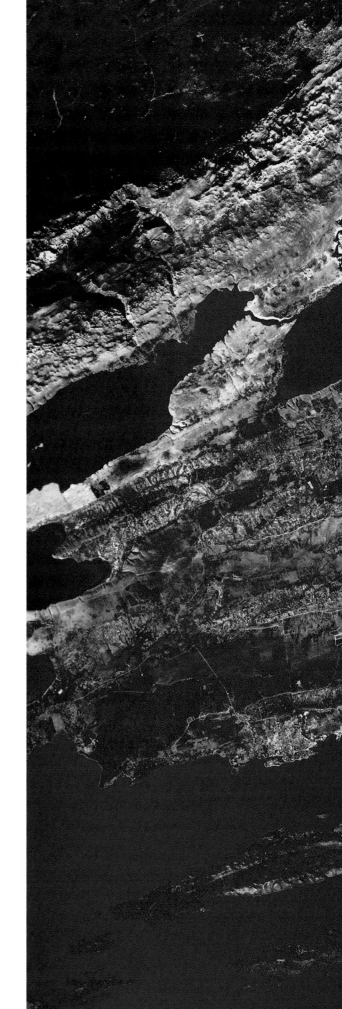

Dalmatian Coast

The landscape of coastal Croatia is dominated by high coastal ridges in the area shown in this photo and by narrow islands that lie parallel to the coastline. Parts of the Velebit Mountains (left, top) reach above 5,000 feet. The rugged coast has isolated settlements like the walled city of Kotor (left photo). A measure of this remoteness is the fact that three distinct Latin-related languages or dialects evolved on the mainland and on the islands. Two are now extinct.

The soil here is thin and is found in widely dispersed pockets. Enormous cave systems have developed in the limestone. Since World War II people have moved from these poor mountain farms to cities like Zadar (on the mainland, left, opposite the long island).

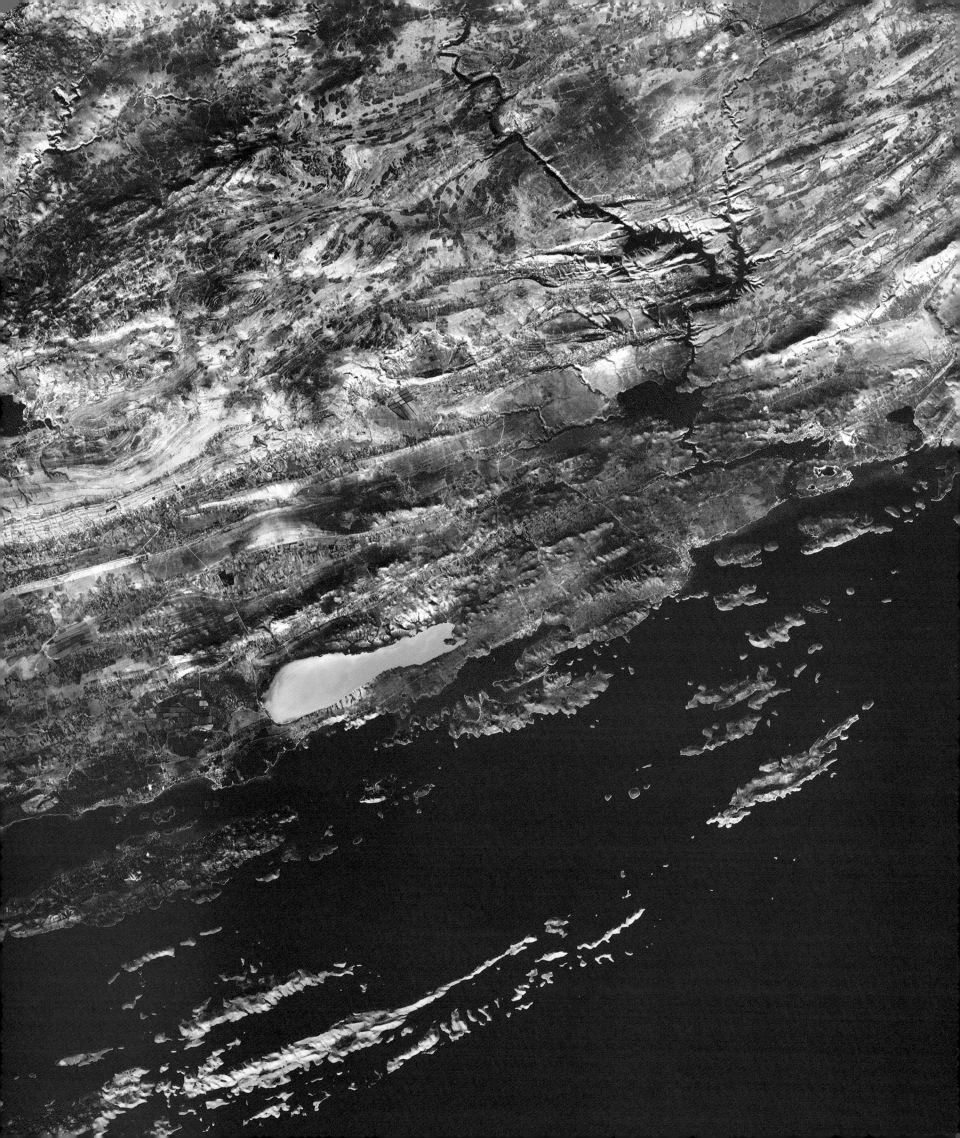

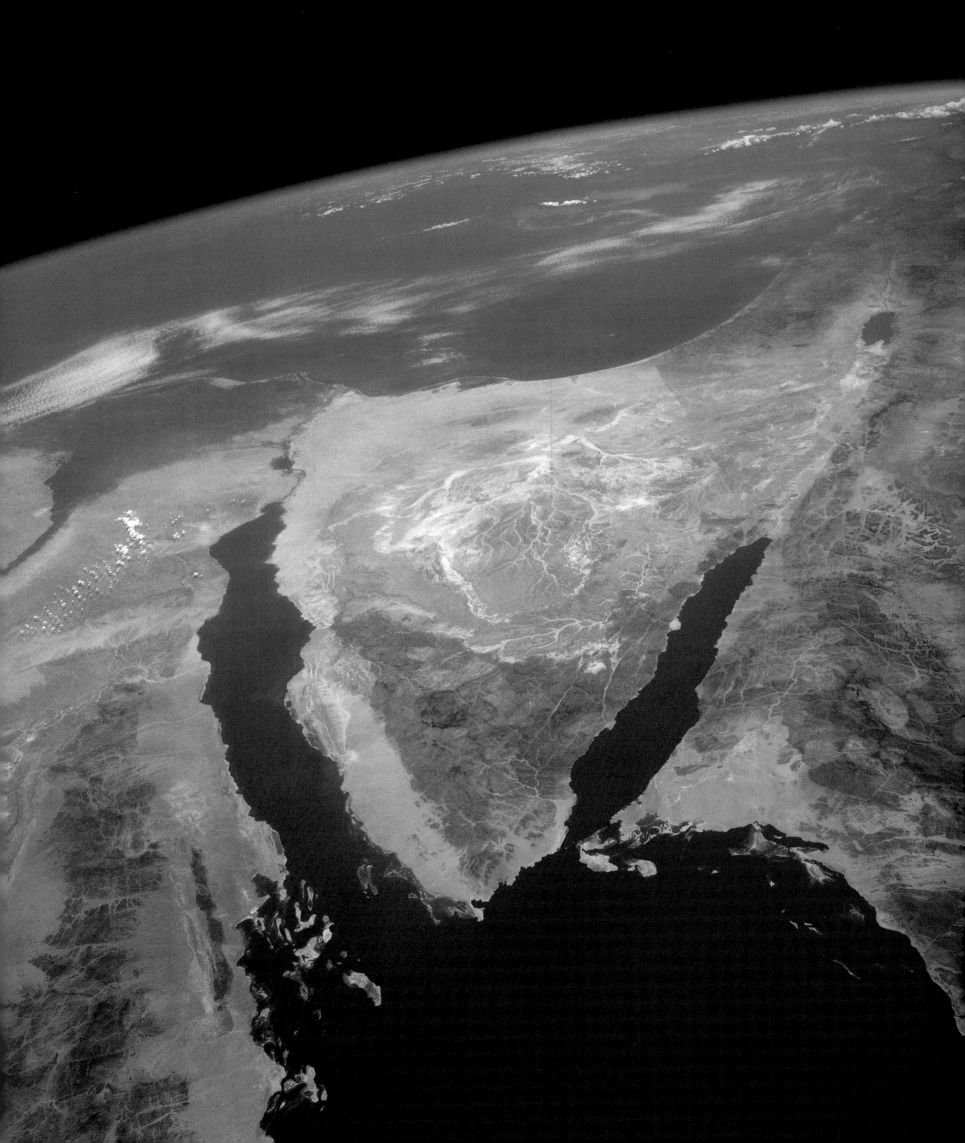

The Middle East

LEFT

This view north from over the Red Sea includes most of the major cities of Egypt, Israel, Jordan, and Lebanon. The Sinai Desert of Egypt is in the center, bounded by the Suez Canal and Gulf of Suez on the left, with the knifelike thrust of the Dead Sea Rift cleaving the Sinai Peninsula away from Saudi Arabia. The rift extends northward through the Gulf of Aqaba on the right and continues north into Lebanon. Beyond the dark-blue waters of the eastern Mediterranean, top right, lie Cyprus and the southern coast of Turkey.

The Gaza Strip

International borders have become easier to see from space in recent decades, particularly in areas where cultural and economic differences lead to different land use. Here the razor-sharp vegetation boundary is the border separating southern Israel from the Sinai. Grazing to the west (the lighter areas of the Sinai and the Gaza Strip) has removed most vegetation. North of the border, Israeli irrigation, which uses the Jordan River, produces darker farm fields.

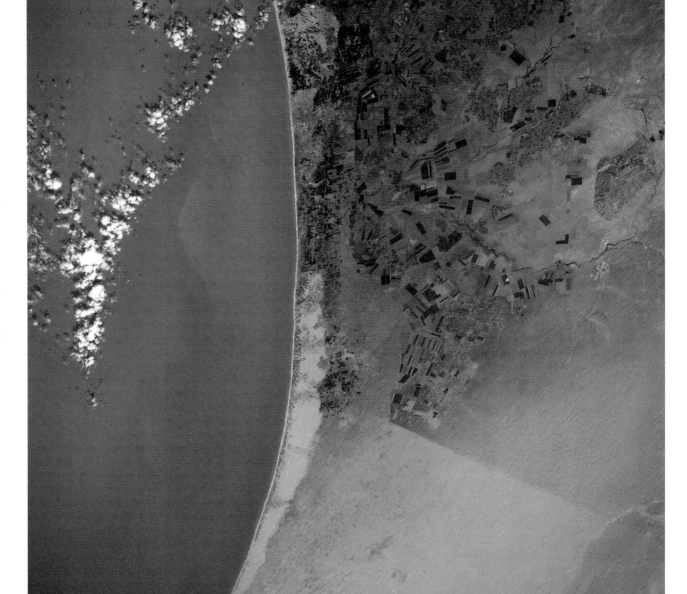

Farming the Desert

Each of these green circles is 200 acres of farmland. A deep well in the center of each circle pumps water from 1,000 to 4,000 feet underground. The Saudis can grow wheat and animal feed 250 miles from the Red Sea because of a large capital investment for roads, wells, irrigation equipment, seeds, fertilizer, and power. Desalination plants treat the hot, mineralized water before it is sprayed onto the crops.

Center-pivot irrigation began in earnest in the early 1980s. By early 1989, astronaut photography showed that the area under cultivation had tripled. The number of farms continues to grow despite a plague of desert locusts in 1993.

Saudi Arabia is the only major country in the Middle East with a surplus of food. Scientists are not sure how long the deep underground reservoirs of water will last, but estimates are in the range of 50 years.

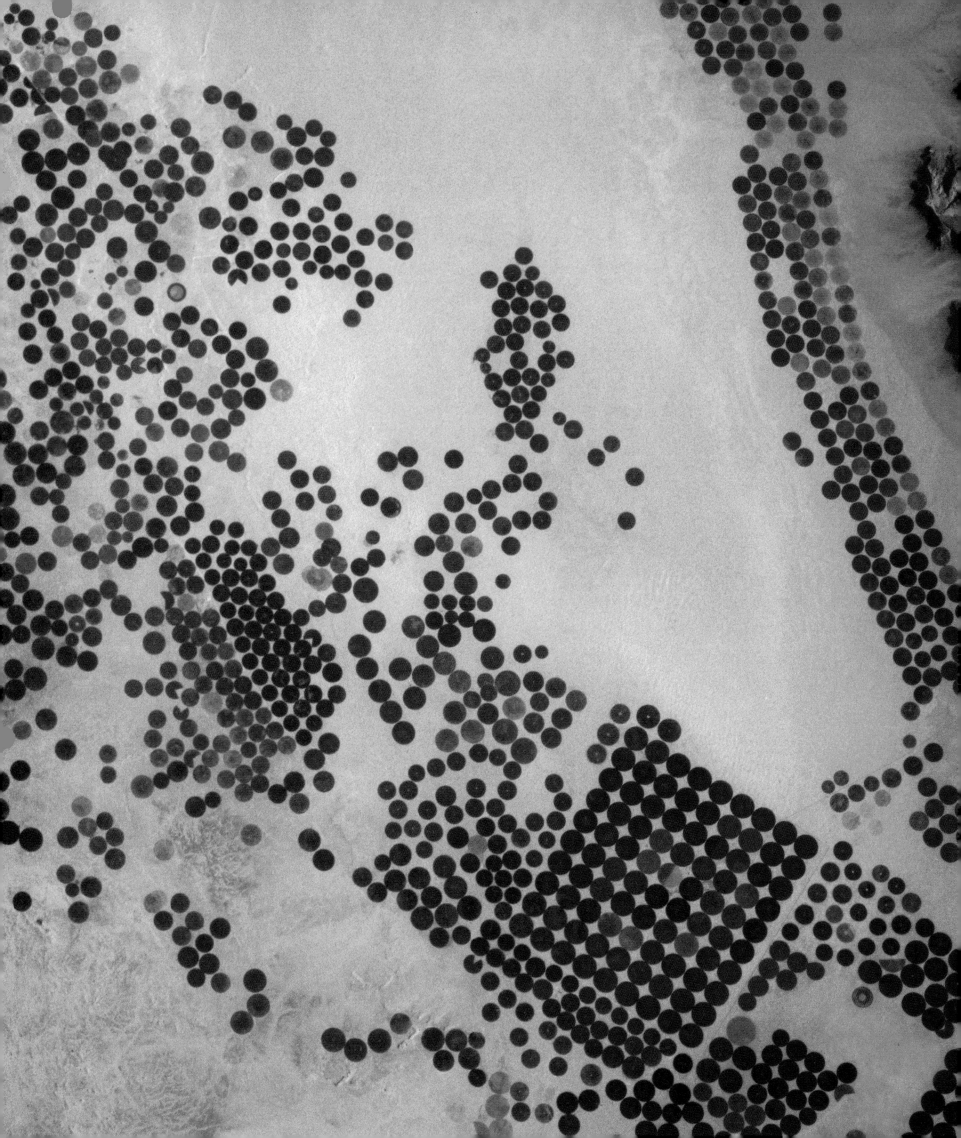

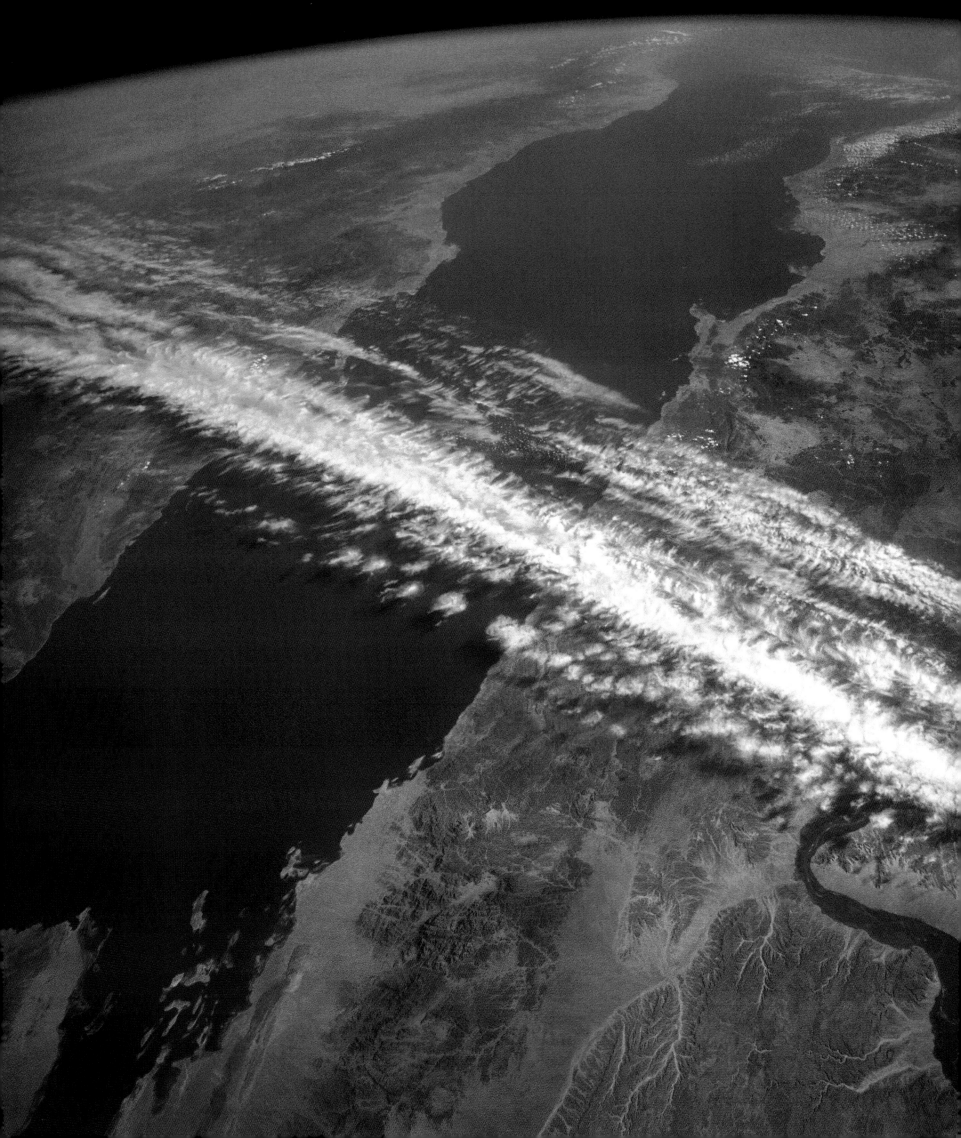

The Red Sea

Viewed from 170 miles above, the Earth seems to be splitting apart before our eyes. Below the surface, magma is rising, cracking the land and parting the Red Sea. Since 1966, when the crew of *Gemini 12* took this photo, the Red Sea has widened by nearly two feet. Copper and tin ores concentrated by the rift's magma provided materials for the Bronze Age. South is at the top, with Egypt, the Nile, and Sudan to the right. Saudi Arabia is across the Red Sea to the left, with the tip of the Sinai Peninsula at the lower left. A 100-mile-per-hour jet stream has lined up the high clouds in the center of the picture. Mecca and the Red Sea port of Jiddah are at the top of the photo (to the south of the jet stream). The curve of the Nile is at Luxor. The Nile floods deposited fertile soil along the river that nourished the crops in the dark-colored area. Five years after this photograph was taken, Soviet and Egyptian workers completed the construction of the Aswan High Dam. (See pages 34-35.)

Saudi Arabia's Al Kidan Dune Field
FOLLOWING PAGES

Winds not only heap up sand into dunes, but also generate regular and beautiful patterns of sand dunes. The two photos on the following pages show the vast Al Kidan dune field in eastern Saudi Arabia, where rain almost never falls. The characteristic shark-tooth pattern of Al Kidan shows up well in these views at a low sun angle. The pattern is made up of straight lines and the shark-tooth V-shapes. This multiple pattern indicates that winds have probably shifted in the course of time, blowing at first roughly parallel to the straight dunes, and then later toward the points of the V's.

Crews can recognize which desert they are flying over because the deserts have broadly different dune patterns. This one lies in a low basin; occasional floods have washed sand down into these lowlands from hills bordering the Persian Gulf.

pp 68-69 · p 70 · p 71

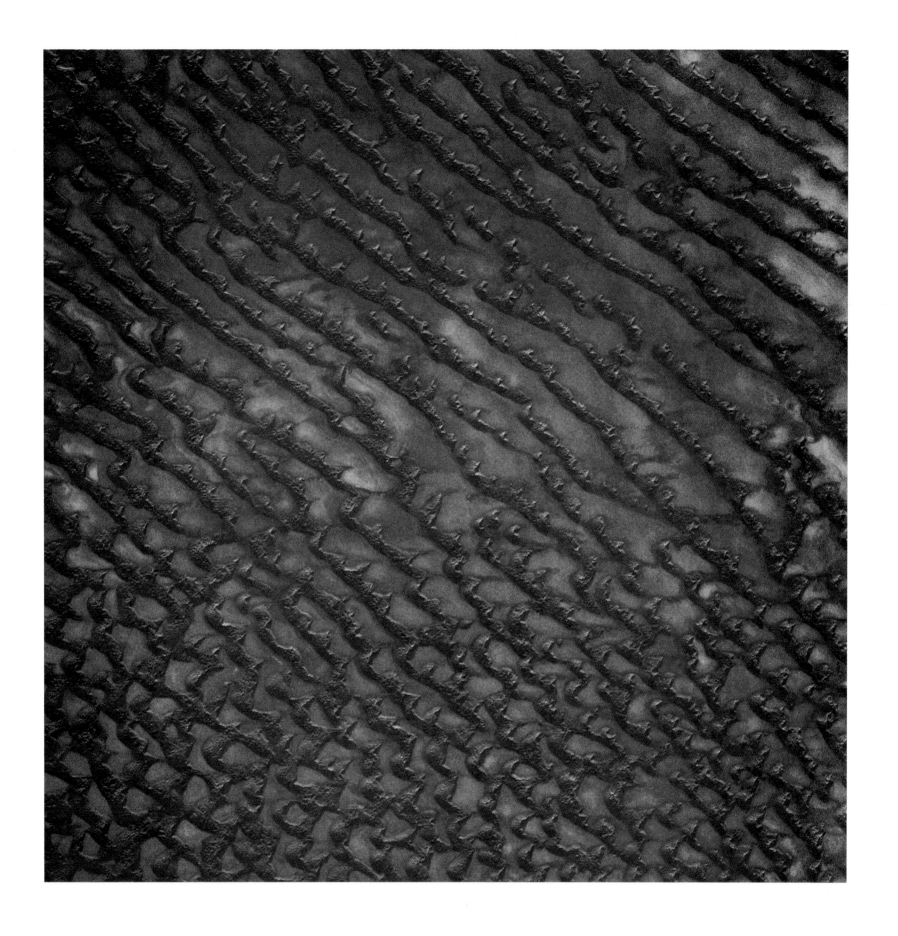

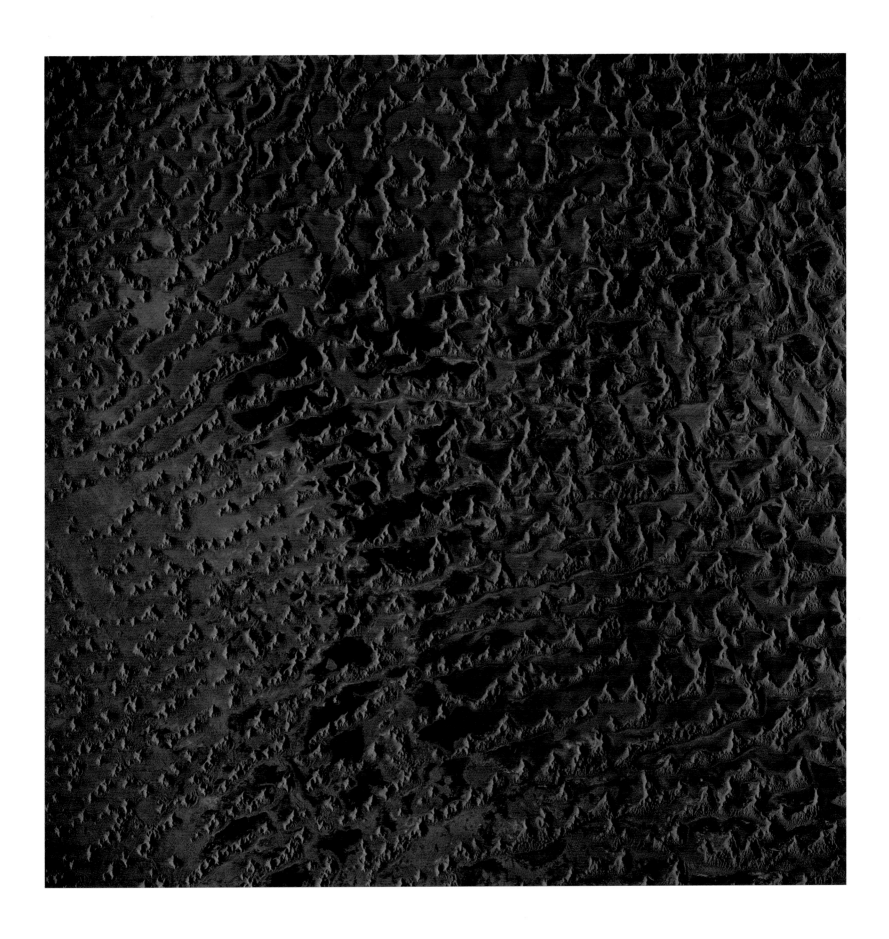

EUROPE AND MIDDLE EAST 71

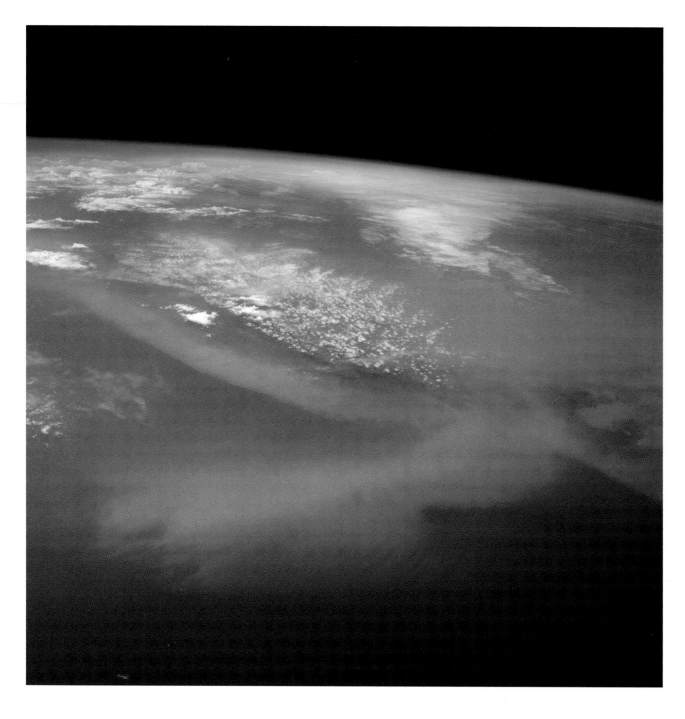

Dust Storms in the Red Sea

Two views taken over the same part of the Red Sea two years apart show plumes of yellow dust contrasted against the dark blue of the clear seawater. The thick plume in the photo at left is often captured by astronauts on film at this exact location (off Sudan). Hot, strong winds whip up dust from the Sahara. The dust is then channeled regularly through a gap (on the right side of the photo) in the hills along the coast of the Red Sea. Dust can blow out of the Sahara in any direction when conditions are right. Israeli soils often contain a large amount of deposits from the Sahara, one of the planet's major sources of wind-borne dust. A more unusual feature is the thin, elegant swirl of sand or smoke (photo at right) blowing into the same part of the Red Sea, but from the Arabian coast. The swirl is unusual because of its narrowness and its sudden change from a straight line to a tight vortex.

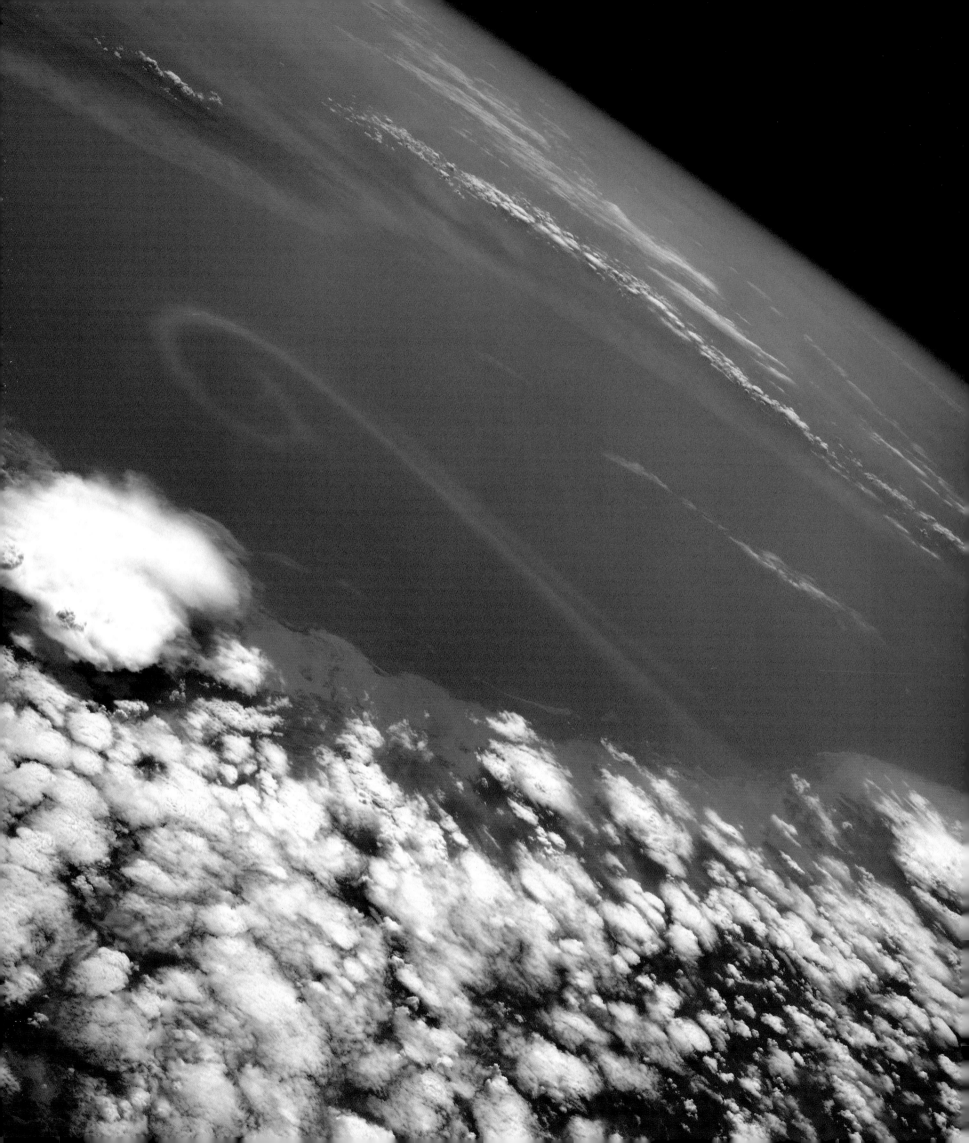

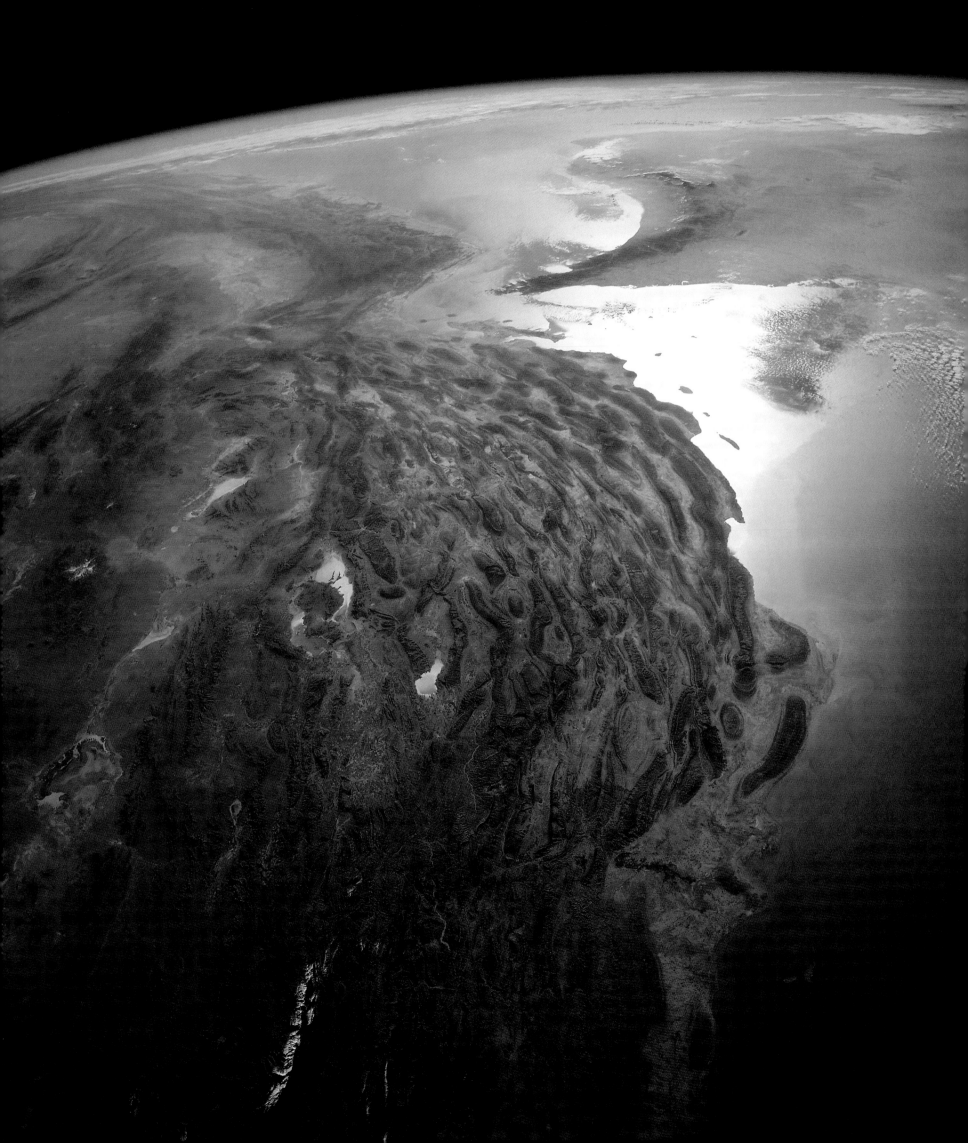

The Zagros Mountains and Strait of Hormuz
LEFT

Iran's steel-gray Zagros Mountains rise in the foreground in this view that looks south along the shallow Persian Gulf into the Gulf of Oman and the Arabian Sea. December snow lies on the 14,000-foot northern peaks of the Zagros. Oman's low Akhdar Mountains point to the Strait of Hormuz, gleaming in the sun. The flat sands of the United Arab Emirates offer no farmland but hide oil. A radar "camera" carried aloft by *Endeavour* revealed ancient trade routes beneath the sands of Oman. In the distance, to the left, the first folds of the Makran Range show us how Asia crumpled as it converged with Arabia.

Dhahran, Bahrain

Through the Strait of Hormuz passes almost 20 percent of the world's oil. Much of it is loaded at the ports of Dhahran, Saudi Arabia (docks at the top of the photo), and Al Muharraq in the tiny island nation of Bahrain (lower). Gulf currents, pipelines, oil slicks, and causeways appear in the glint of the noon sun. North is to the right in this view.

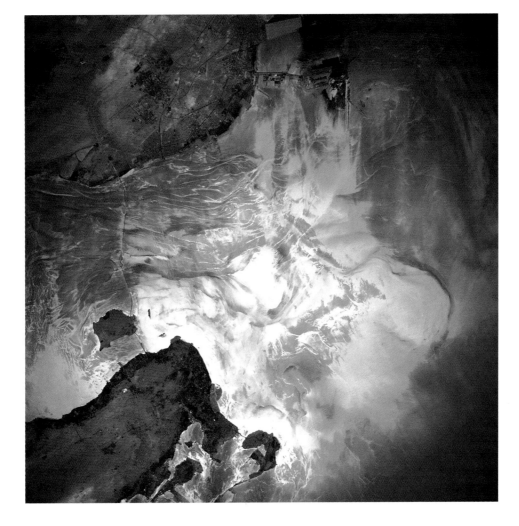

The Aftermath of the Gulf War
FOLLOWING PAGES

When Saddam Hussein's troops retreated from Kuwait in February 1991, they set afire hundreds of oil wells. In April aboard *Atlantis*, we were the first flight up after the war. There were more than 450 individual fires in the Sabriyah field to the north (right) and the Ahmadi field to the south of Kuwait City. Soot from the plumes stained the sand near the fires and can still be seen today.

Fortunately, most of the heavy smoke did not get into the jet stream in the upper atmosphere. Nearly all of the soot stayed in the region, although some traveled as far away as the Himalaya.

Jerry Ross and Ken Cameron got up early (at midnight Houston time) the day we released the Gamma Ray Observatory to take this picture.

p 74

pp 76-77

p 75

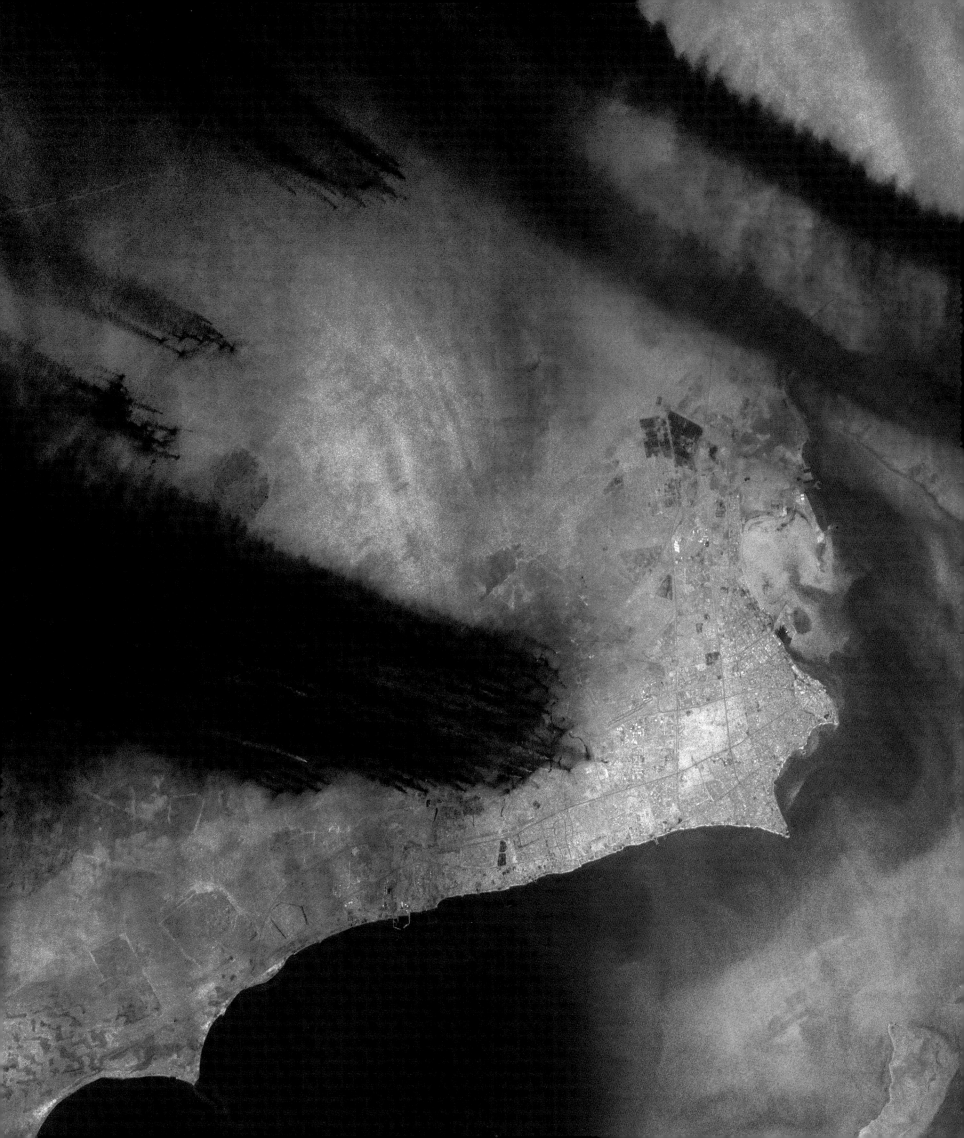

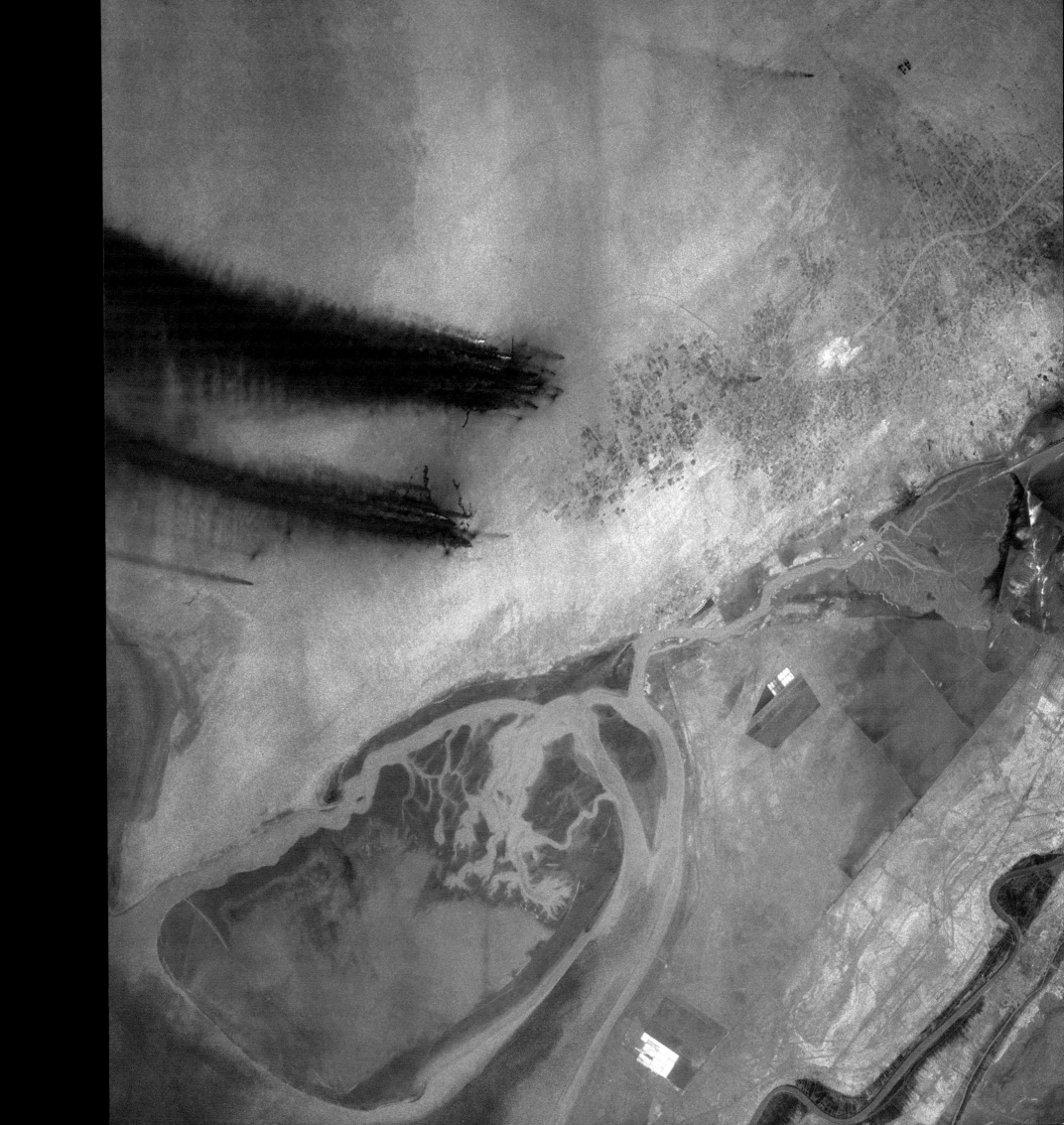

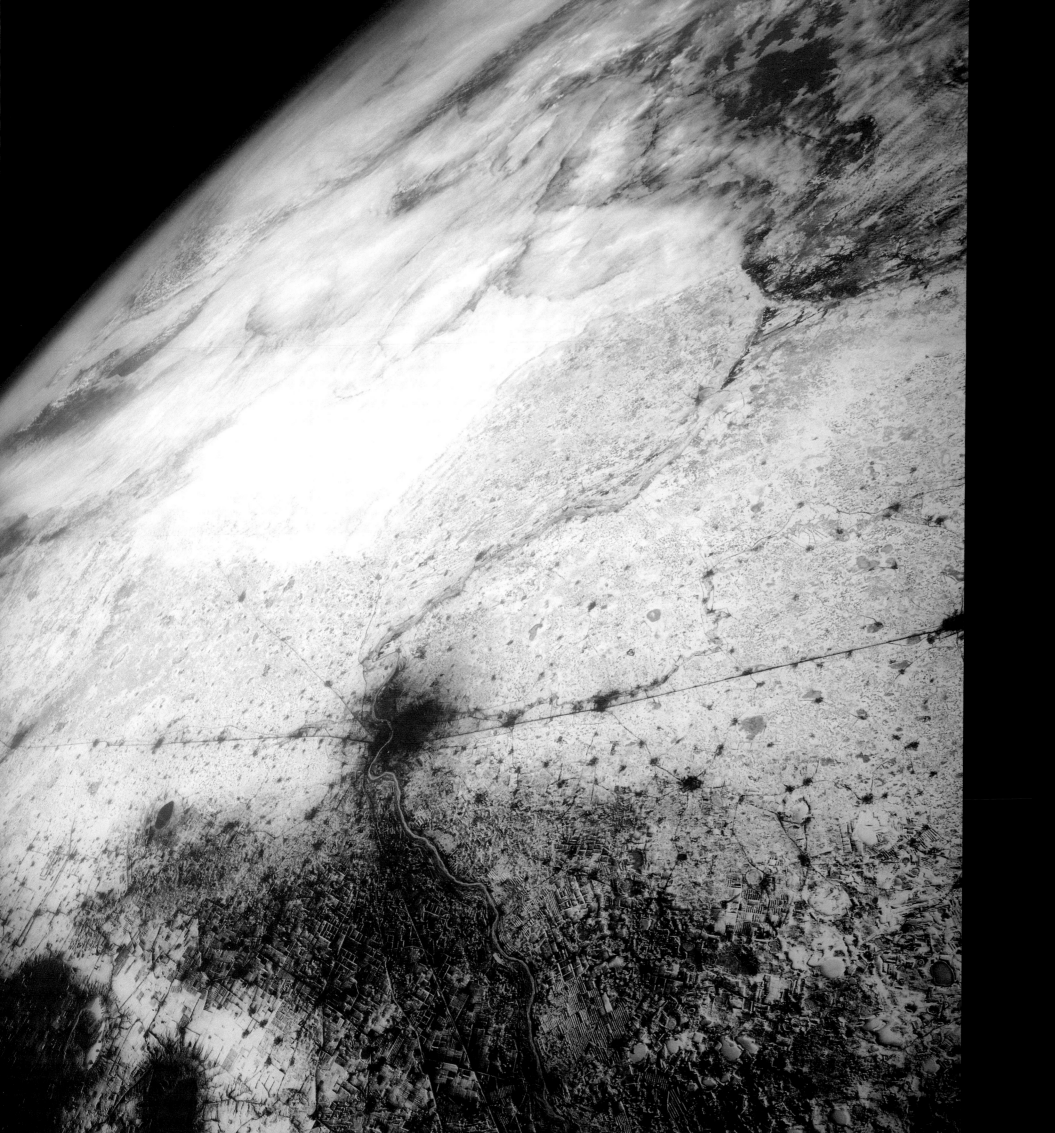

Asia

Asia

Trans-Siberian Railroad

The Trans-Siberian Railroad draws a line through the April snow east of the Ural Mountains. The gray city of Omsk lies at the junction of the railroad and the Irtysh River. When Germany invaded the Soviet Union in June 1941, the 5,800-mile-long railroad made it possible for industry to relocate out of the invasion path to towns such as Petropavl, Kurgan, and Chelyabinsk (to the left, or west, of Omsk in this photograph). Small towns dot the line at just the interval a coal-fired train could go before refueling. After the railroad was electrified, a 1974 spur was opened to the rich mineral deposits of far-east Siberia.

"HOW AM I EVER GOING TO FIND MY WAY AROUND ASIA?" I asked Dr. Justin Wilkinson as he began to prepare our crew for observations of the Earth on my second mission. By the next class he had prepared a map showing landmarks to guide us. The Sea of Azov at the top of the Black Sea has a distinctive hook-shaped pattern of sand spits. The Caspian Sea is an excellent landmark, with the sea's square southeast corner, the delta of the Volga River at the top of the Caspian, and a shallow gulf on its eastern shore. Next comes copper-blue Lake Balkhash in Kazakstan and then long, silvery Lake Baikal in Siberia. They both have unforgettable shapes. Finally, the Amur and Yellow Rivers both have snakelike coils that we can quickly recognize.

On my first spaceflight, I flew no farther north than the glorious Himalaya. Our crew celebrated our second successful spacewalk by eating dinner above the roof of the world. On another night, I was the only one to stay up late, and I shot photo after photo of Tibet with the sun low in the sky and the shadows long. Central and northern Asia were a mystery to me, however. On my second and third flights, I was on the flight deck for a 12-hour shift when it was night in Houston and day in Asia. We flew over almost the entire continent. Using Justin's landmarks, I found my way around.

I can orient myself when I look out our windows over Asia by keeping two ideas in mind. First, the Himalaya were created when India pushed into Asia. Wrinkles and cracks in the Earth due to this collision reach 1,700 miles north, forming the huge Tarim Basin north of Tibet (the Taklimakan Desert) and creating the mile-deep Lake Baikal in eastern Siberia. Second, the north-south Ural Mountains are a boundary between European-looking farmland and cities to the west and swamps and tundra to the east. The wet country ends only at the high mountains to the west of Lake Baikal.

After a few days of orbiting over Asia, I was able to look up from my work and know precisely where we were. I could take photos of areas for which there were no good photographs. We found features as small as the plume of smoke from a cellulose plant at the south end of Lake Baikal.

We spent several passes looking for the Great Wall of China with no luck. Although we can see things as small as airport runways, the Great Wall seems to be made largely of materials that have the same color as the surrounding soil. Despite persistent stories that it can be seen from the moon, the Great Wall is almost invisible from only 180 miles up! Because of nearly continuous smog over Beijing, there is no good photograph of the Chinese capital from the Space Shuttle. Many of the great cities of coastal China hide from our cameras under a similar blanket of smoke from soft-coal fires.

Three out of every five people on Earth live in Asia. The fate of the planet may well depend on how fast the enormous population in Asia expands. In prosperous Japan, the population doubles every 277 years. In China, population will double every 62 years. And 36 years from now India will have twice as many people to feed.

Even in the most inhospitable part of China, the Taklimakan Desert in far northwestern Xinjiang Province, there are cities and farms. During one orbit, the sun reflected off irrigation canals in the desert.

Korea is easily recognizable. The peninsula has long scratches in its surface that do not appear anywhere else in Asia. They are interrupted only by a circular feature north of Seoul that one of my crewmates, Dr. Tom Jones, recently identified from Shuttle photography. It is a puzzling feature that geologists are now studying.

Asia's eastern border is on the Pacific's Ring of Fire, and north of China is the ring's most colorful land: the Kamchatka Peninsula. I saw it first in late summer, and I marveled at the variety of colors in its soil. In fact, except for Kamchatka, you see all the colors on the Earth's surface by orbiting between Florida and Australia. But Kamchatka is worth the trip up north.

The peninsula in winter seethes under the snow and gives hints of its power with yellow deposits of sulfur near the tops of its volcanoes. As plate movements shove the ocean floor under the eastern edge of Asia, the floor is forced down into the hot mantle of the Earth, where it melts. Since this crust is made of lighter material than the semifluid rock of the mantle, the crust floats up, piercing the surface in volcanoes. The magma from Earth's upper mantle is forced up and out, giving us spectacular views from space. This area has a long history of violent connections to the Earth's interior. Two hundred and fifty million years ago a flood of volcanic eruptions in Siberia lasted for a million years. Its sulfur clouds changed the environment enough to kill as many as 90 percent of oceanic species and 70 percent of land vertebrates.

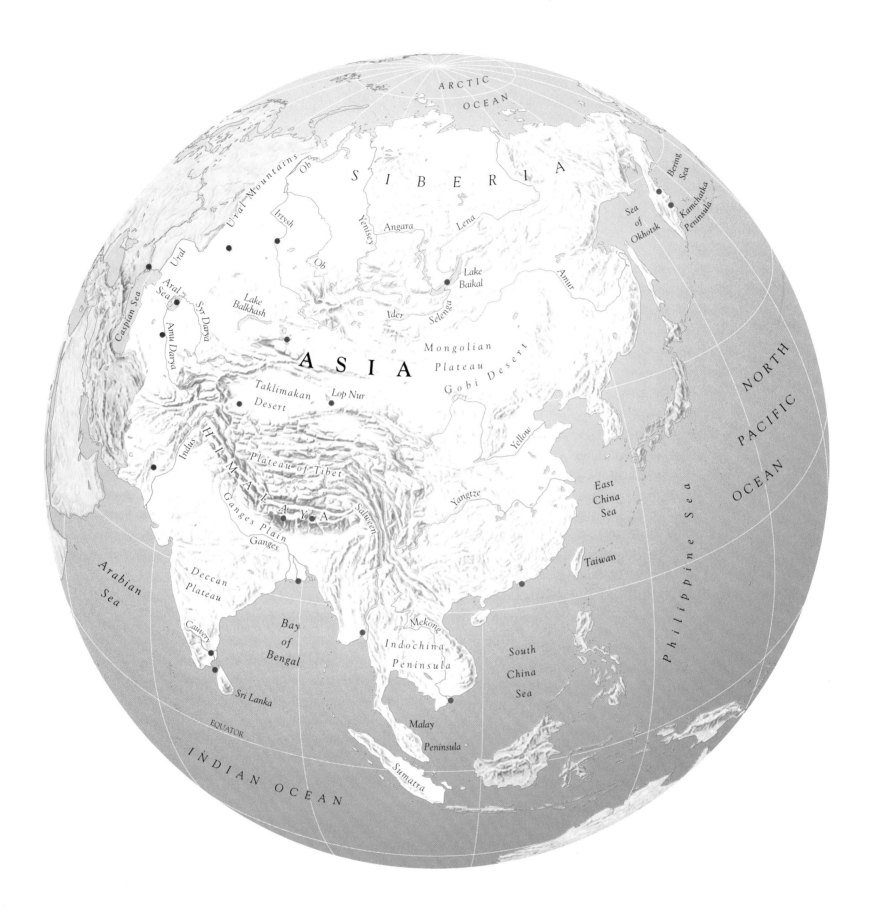

ARCTIC OCEAN

SIBERIA

Ural Mountains
Ob
Irtysh
Yenisey
Angara
Lena
Bering Sea
Sea of Okhotsk
Kamchatka Peninsula

Ural
Ob
Lake Baikal
Amur

Caspian Sea
Aral Sea
Lake Balkhash
Syr Darya
Ider
Selenga

Amu Darya

ASIA

Mongolian Plateau
Gobi Desert

Taklimakan Desert
Lop Nur

NORTH PACIFIC OCEAN

Indus
H I M A L A Y A
Plateau of Tibet
Yellow
Yangtze
Salween

East China Sea

Philippine Sea

Ganges Plain
Ganges

Taiwan

Arabian Sea

Deccan Plateau

Bay of Bengal

Mekong
Indochina Peninsula

South China Sea

Cauvery

Sri Lanka

EQUATOR

Malay
Peninsula

I N D I A N O C E A N

Sumatra

● Center point of photograph

Space Station *Mir*

Russia's seventh space station was assembled in orbit from pieces launched from the Asian spaceport of Baikonur in Kazakstan, east of the Aral Sea. Soviet and Russian cosmonauts have spent a total of over 44 years aboard space station missions, starting with *Salyut 1* in 1971. Dr. Valeriy Vladimirovich Polyakov holds the endurance record; he stayed aboard *Mir* for 14½ months to conduct medical research.

Mir is a Russian word meaning "peace" or "world," and it has indeed become the symbol for peace between the two spacefaring nations.

Veteran American astronaut, medical doctor, and electrical engineer Norman Thagard replaced Dr. Polyakov aboard *Mir* in March 1995. Crew members of the United States Space Shuttle *Atlantis* took this photograph four months later, as they prepared to join their ship to *Mir*. For a few days, six Americans and four Russians shared the two ships. Then Thagard and his two Russian crewmates returned to Earth aboard *Atlantis*.

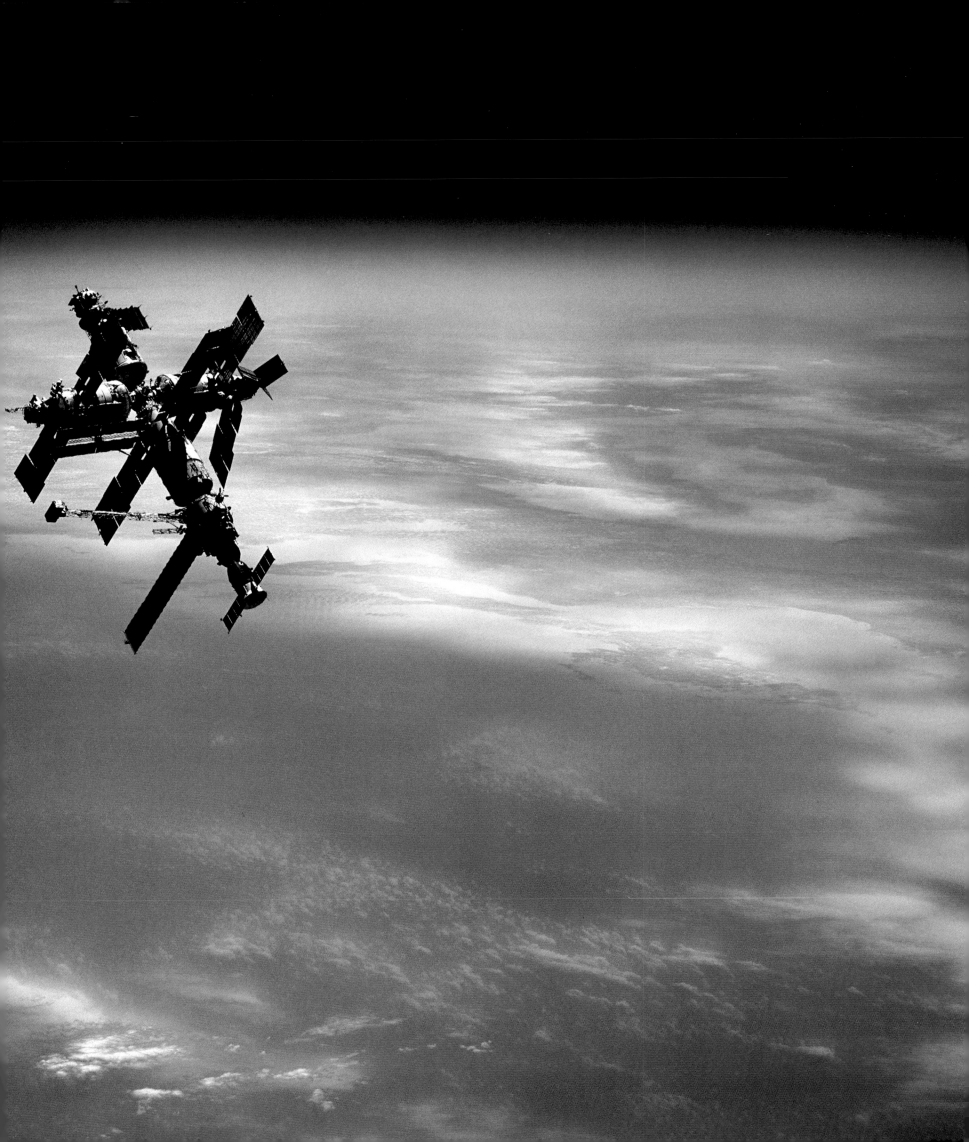

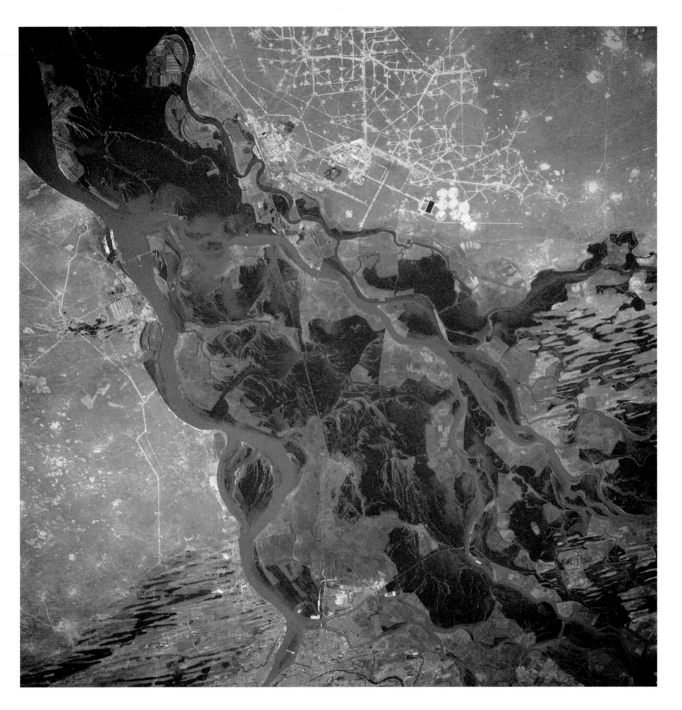

Lower Volga in flood

Heavy snow in the last few winters has caused the level of the Caspian Sea to rise by six feet. The muddy Volga surged over its banks toward the rich oil fields of the region. The light-tan dots are clearings around the wellheads. Sharp Space Shuttle photographs allow scientists to study the effects of this sudden rise. Oil fields and ship channels have been damaged by the flooding. Space Shuttle photographs taken in 1994 showed that the Caspian Sea east of the Volga delta has moved inland up to 60 miles.

Kazakstan in Winter

The town of Qostanay lies on the Tobol River, 800 miles northeast of the Volga River Delta. Like most rivers east of the Ural Mountains, the Tobol flows to the north. It joins the river Ob in the Siberian marshland, finally draining into the Arctic Ocean. This photograph captures a 30-mile-wide stretch of countryside. Even in April, the snow is piled high against the tree rows in the collective farms outside Qostanay. In the 1950s, when the giant farms first came to northern Kazakstan, dust storms carried the newly tilled soil into the Pacific. Farmers planted these dense rows of trees on the edges of their fields as windbreaks in a very successful effort to stabilize the soil.

p 84 p 78

p 85

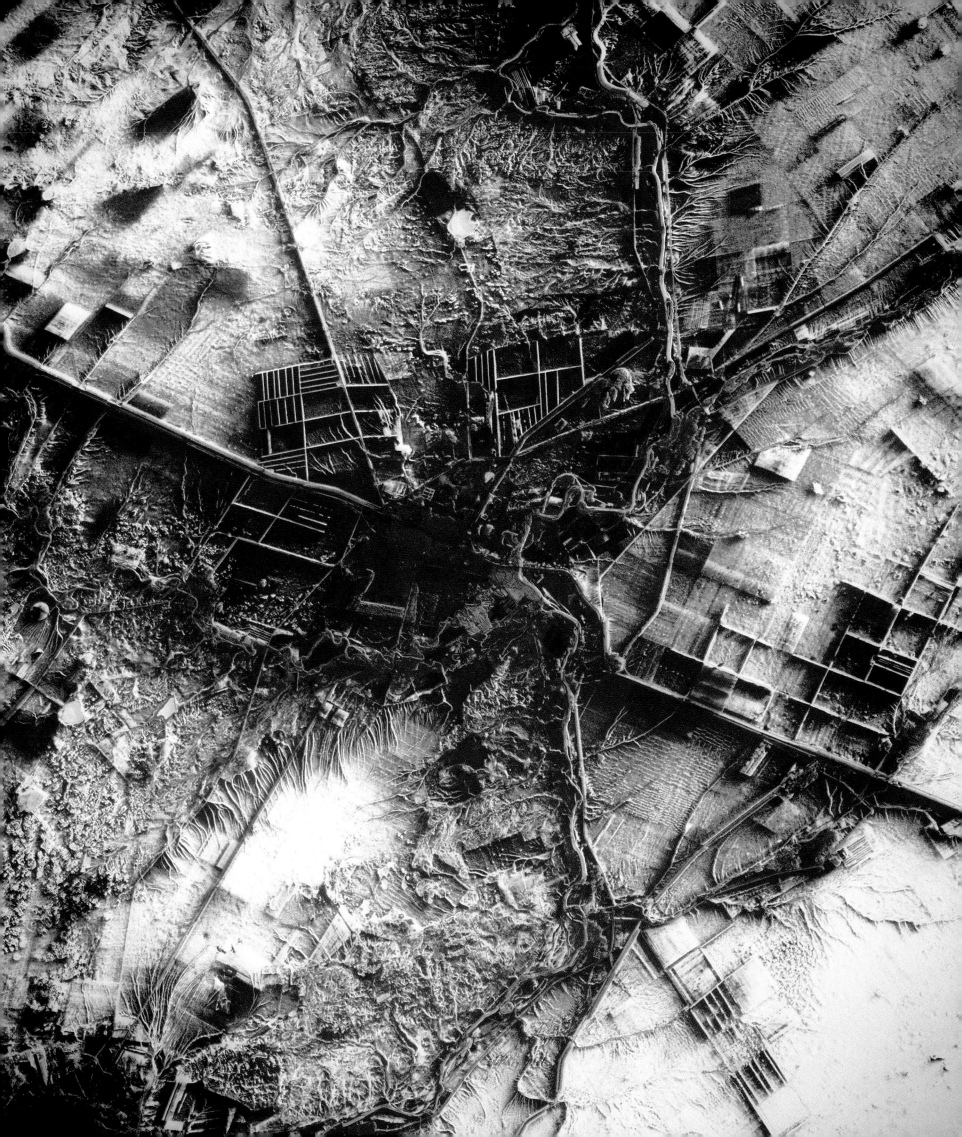

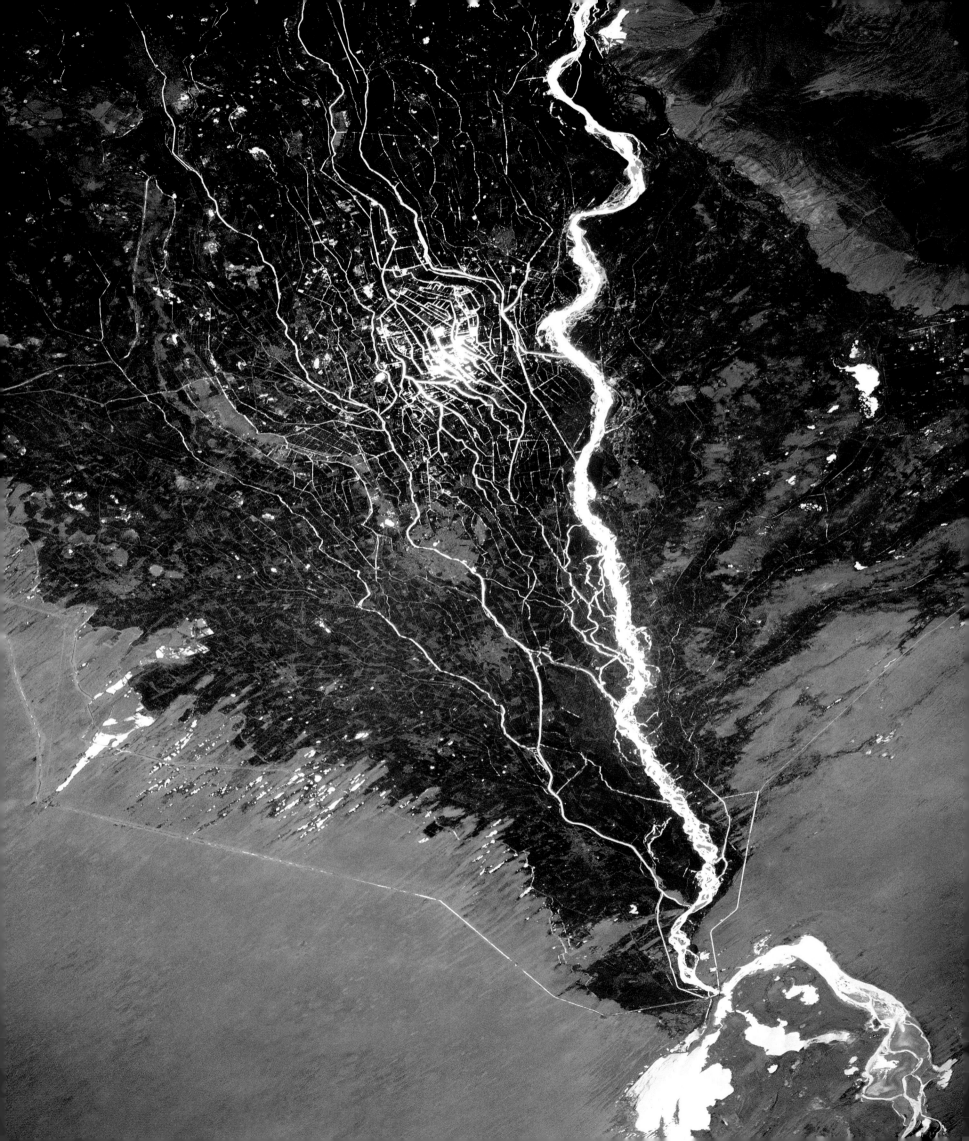

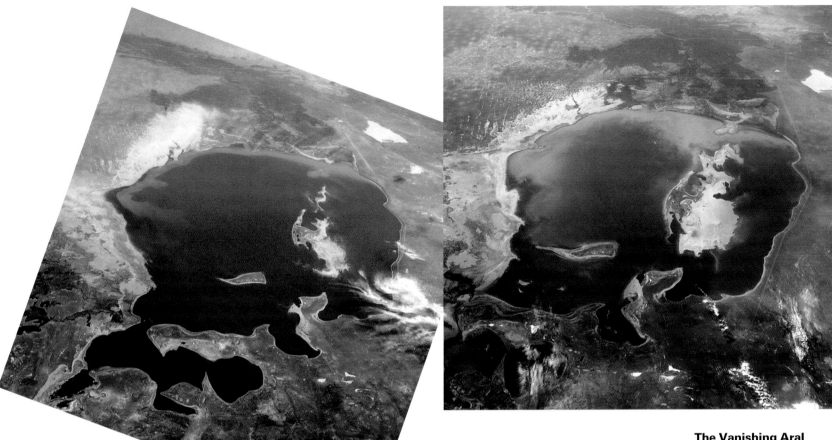

Irrigated Cotton on the Amu Darya River
LEFT

Sunlight glints off the many irrigation canals and drainage ditches linked to the Amu Darya River. The glacier-fed river, which rises in the Pamirs of Tajikistan, has sustained agriculture in the desert south of the Aral Sea at least since Alexander the Great's expeditions took samples of plants here in 329 B.C. Since 1926, the Amu Darya's water has been used intensively for irrigation of crops ill suited for sustainable desert agriculture. Cotton, one of the most water-demanding crops, is the primary product around the delta of the Amu Darya. On the sides of the photo, the sand dunes are soaking up salty runoff water laced with the pesticides and fertilizer that cotton also demands. To the west, Lake Sarykamysh has now been turned into a giant holding pond for polluted water.

The Vanishing Aral

These photographs document the drying up of the Aral Sea over the course of seven years. At left is a 1985 photograph of the basin of what once was the world's fourth largest lake. The 1992 photograph at right shows changes produced by overuse of the Amu Darya River for irrigation (the dark area to the south, at the top of both photographs). Freshwater flow into the Aral Sea is about 25 percent that of the 1960s. The area of the Aral Sea has shrunk by nearly 50 percent, and its salinity has increased four times. The shoreline's retreat exposed loose salt deposits mixed with pesticides and fertilizers. Borne on fierce winds, this white toxic dust, visible in both photographs, produces health problems for humans and livestock. Incidences here of lung cancer, respiratory ailments, and intestinal disorders are now among the highest ever recorded.

p 87
p 86

GALEN ROWELL

West Pakistan

This grand sweep of bent mountains resulted from the movement of the Indian tectonic plate plowing relentlessly northward into the continent of Asia. The buckling, crumpling, and fracturing of rocks generated by this movement appear as the parallel ridges of the Sulaiman Range, which cover the bottom of the view. Convergence of Arabia with Asia created the Makran Ranges, which fold tightly across the top of the photo. These mountains lie in arid western Pakistan. The dark area at top left is the intensively farmed Indus River Valley, which lies on the Indian plate. In this south-looking view, the Arabian Sea stretches across the horizon, more than 350 miles from the ridges in the foreground. Since first colliding with Asia about fifty million years ago, India has continued to bulldoze the collision line northward 1,250 miles. The Indus River Valley (left) has supported agriculture in this desert zone for millennia, supplying meltwater from snow and ice in the Himalaya.

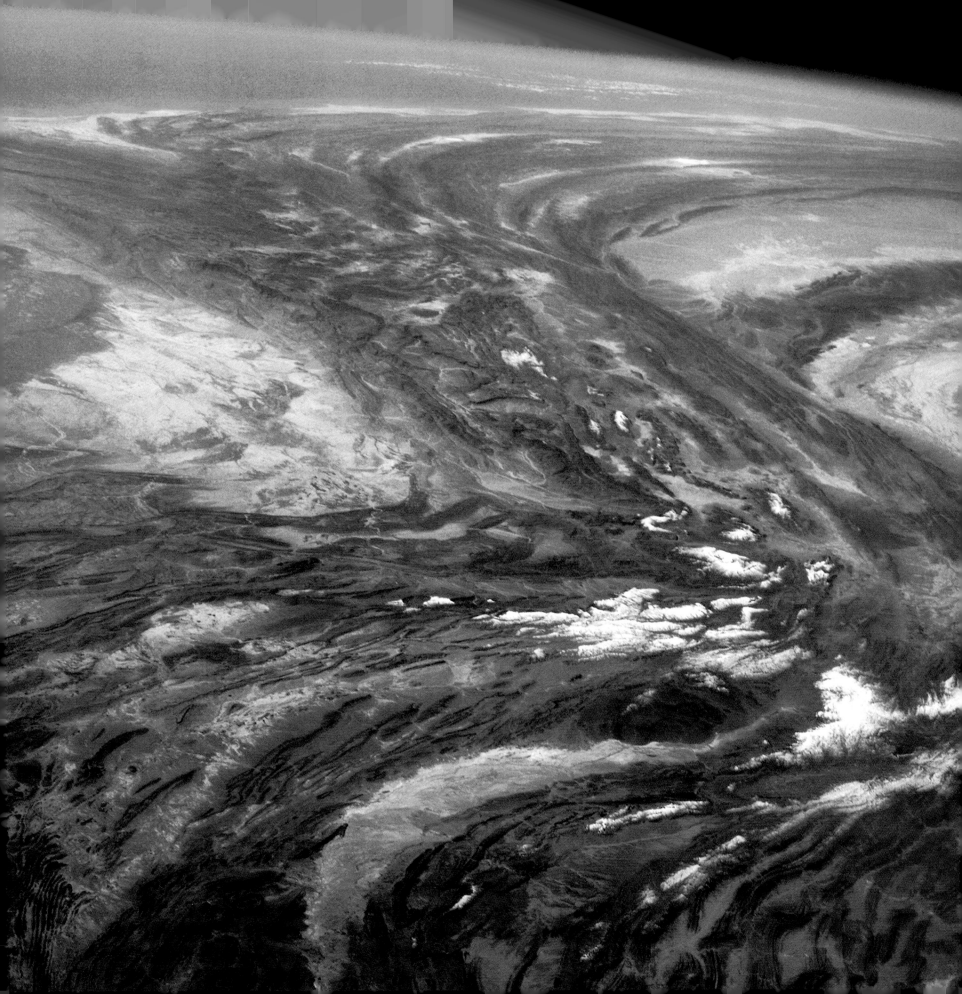

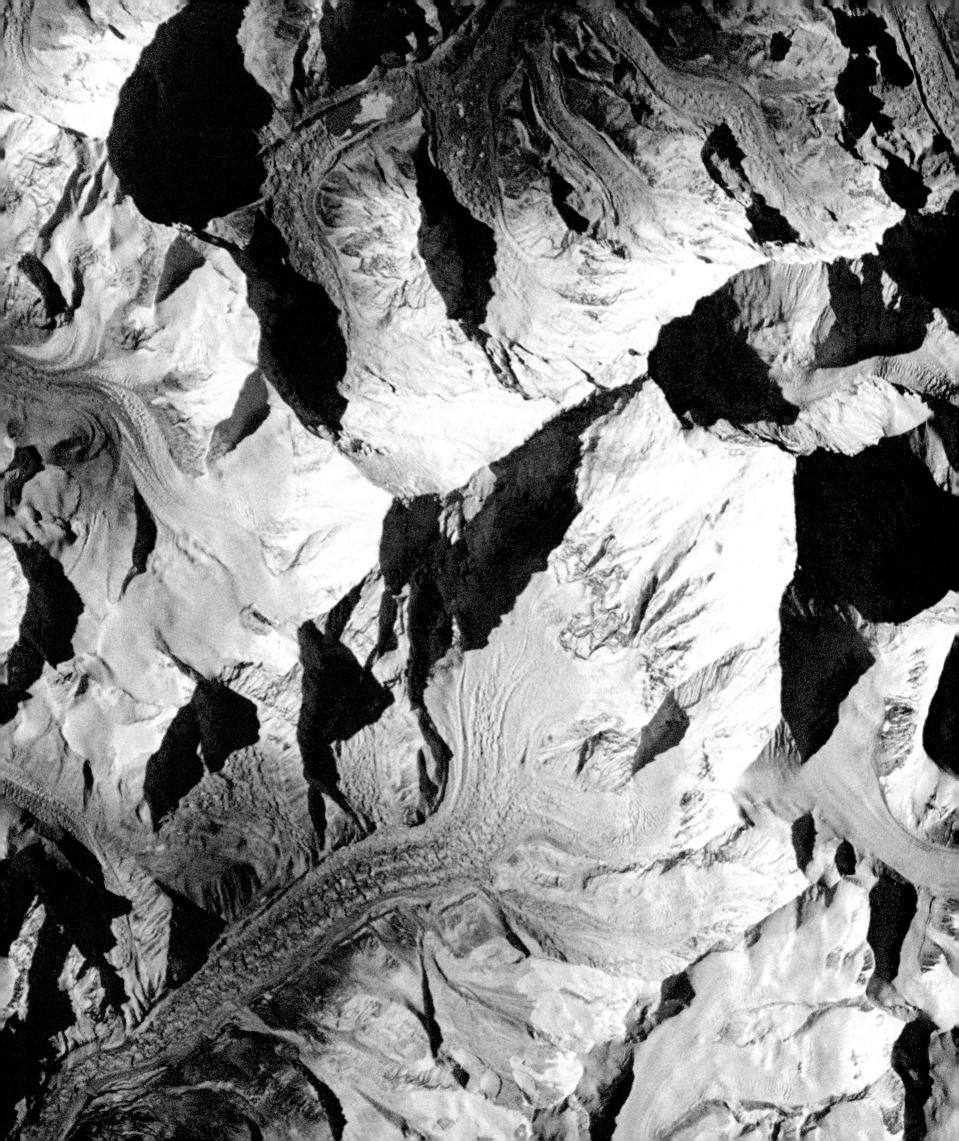

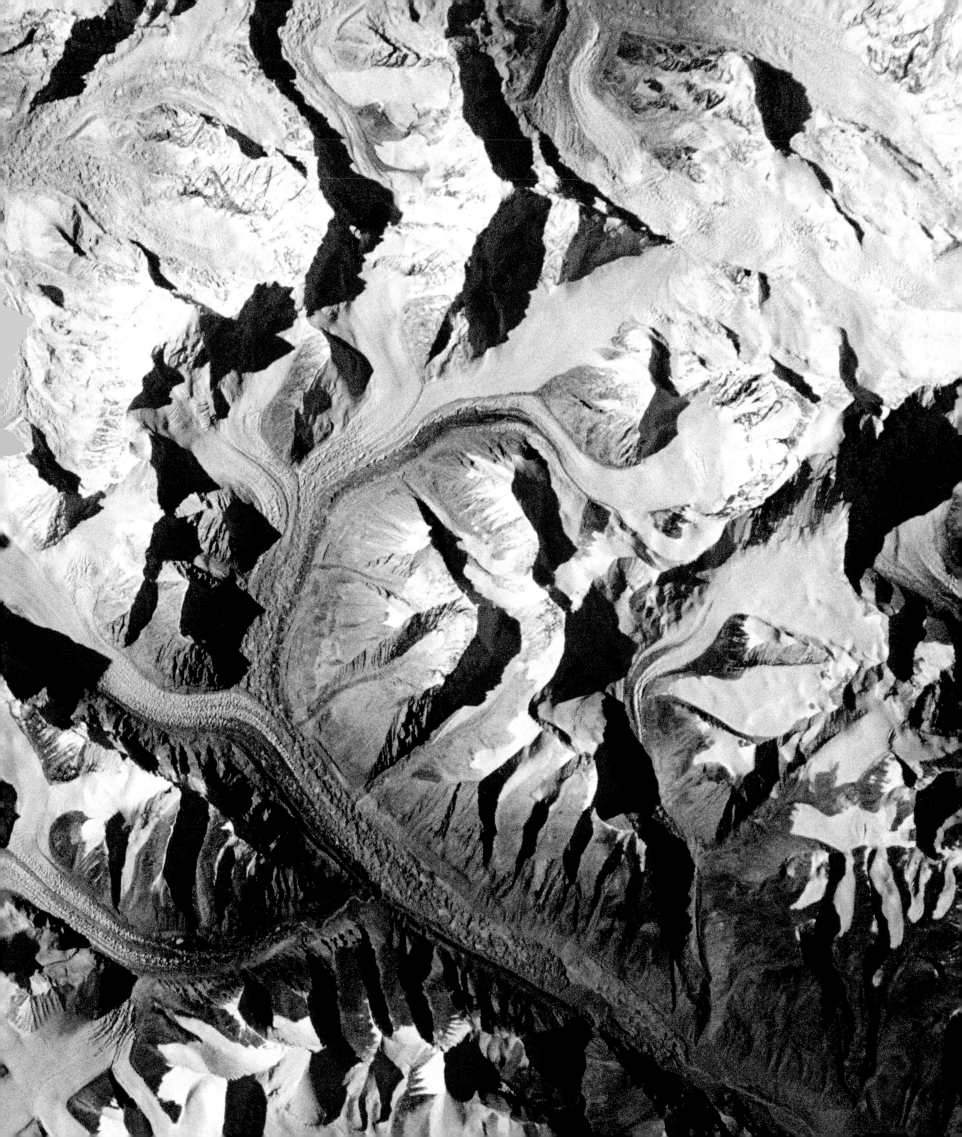

Mount Everest
PRECEDING PAGES

Mount Everest, the planet's highest peak, is the triangular massif, top, left of center, much larger than the other peaks, with its north face casting the largest dark shadow. The Himalaya, pushed up in the past 50 million years, are not yet worn down by the elements. The sharp ridges are produced by ice erosion in neighboring valleys. The stream lines in the glacier ice show that the ice is flowing slowly away from Everest, toward the bottom left and right. These are the Kangshung and Rongbuk Glaciers, both in Tibet.

Edmund Hillary and Tenzing Norgay were the first to reach the summit, approaching via the Southeast Ridge (sharp ridge leading from the top left of the summit) on May 29, 1953. Expeditions had previously failed via the Northeast Ridge, the prominent line near the center of the view. Astronaut Scott Parazynski was scheduled to be a member of an expedition on the mountain the month this photograph was taken. Instead, he was in space taking the picture.

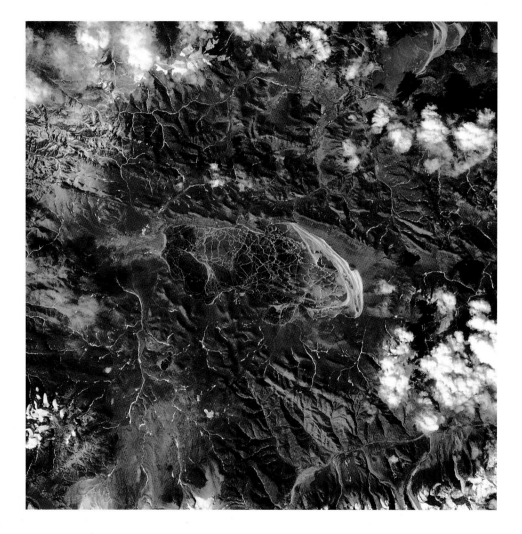

Lake P'u-Mo Ts'o, Tibet
LEFT

Cracks in the ice of Lake P'u-Mo Ts'o give the sense of a surface of crystal. The lake lies on the Tibetan Plateau at 16,530 feet above sea level. The air is always clean over Tibet, and often cloudless, compared with the Ganges Plain to the south, which is usually dusty and smoggy even on days of fine weather. So the Tibetan Plateau always looks spectacular to orbiting crews. Melting snow and ice from ice fields on the Himalaya to the south supply the lake with water, much of which evaporates in the dry air.

The Dzungarian Gate

The rugged, snow-topped Dzungarian Alatau Mountains, in the middle of the view, form the boundary between China and the old Soviet Union. Breaking through the Alatau is a prominent gap known as the Dzungarian Gate (left center), with Lake Alakol on the west (bottom) and the dry white lake bed of Lake Ebinur on the east side (top left). For centuries travelers on the Silk Road between east and central Asia have passed through the gate. Genghis Khan first attacked central Asia from Mongolia through this and other passes in 1219. The Mongol army rampaged as far west as Germany, Austria, and Croatia in 1240 and 1241.

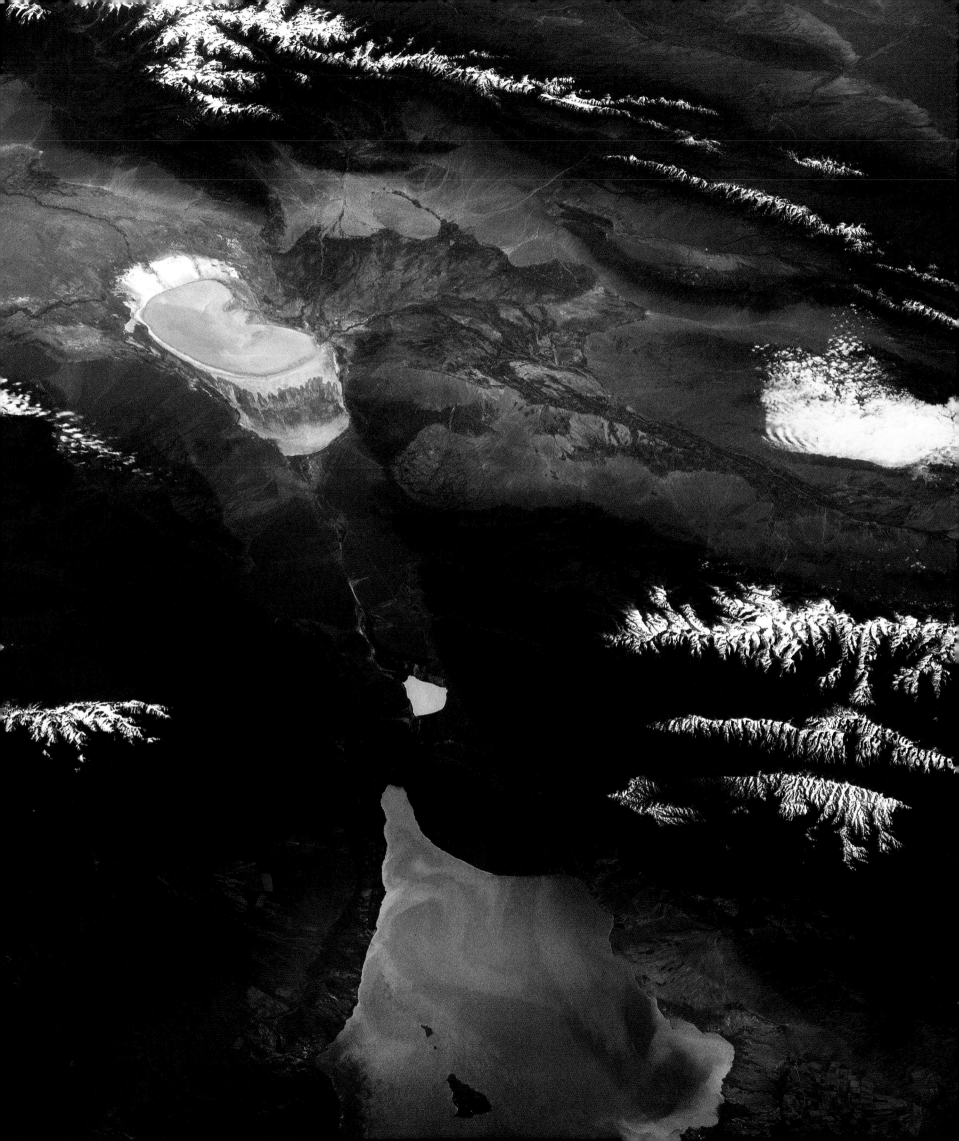

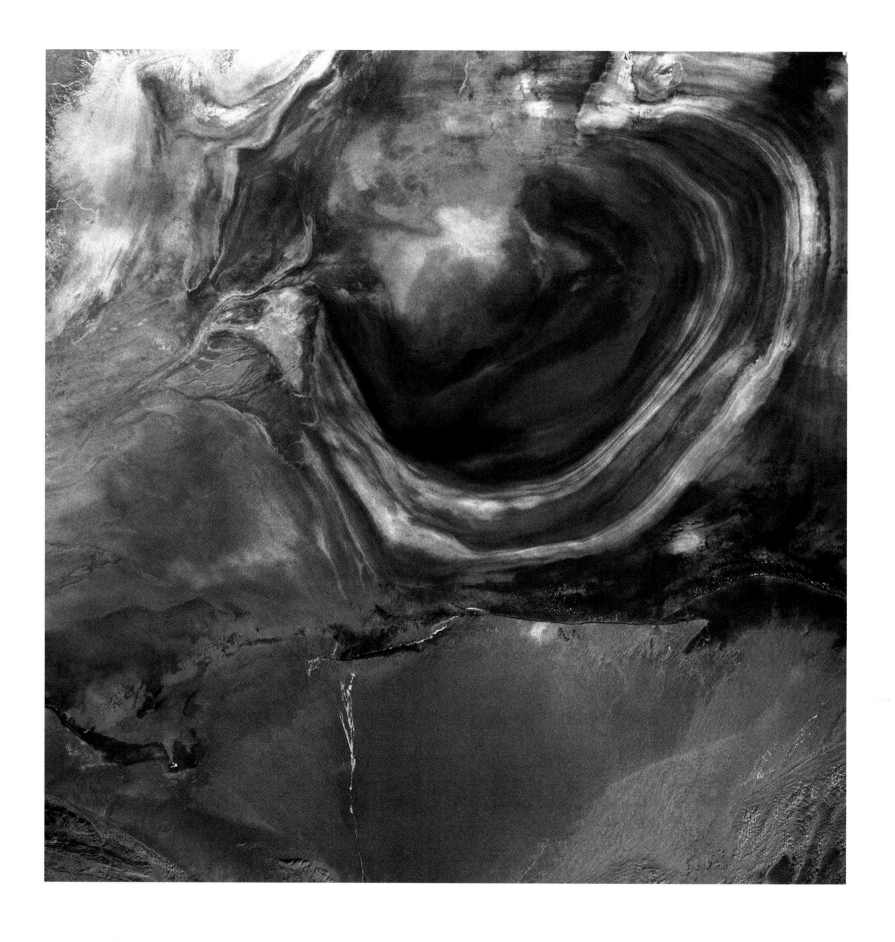

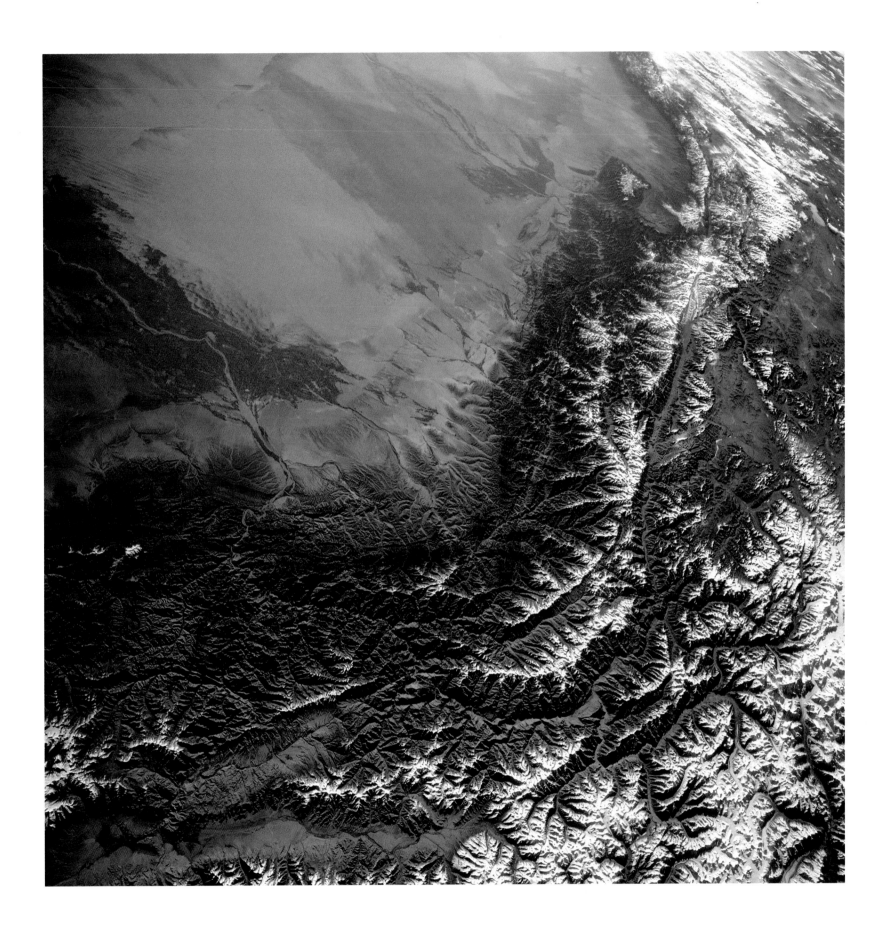

Lop Nur
PAGE 94

The nested rings of this ear-shaped dry lake are well-known visual cues for astronauts as we look for points to recognize in vast inner Asia. Lop Nur, in China's Xinjiang Province, marks the end of the Taklimakan Desert. The concentric lines that look like tree rings are successive beaches formed as the lake dried and became smaller and smaller. The lowest points in the middle contained water until the 1960s, when the Tarim River was dammed for irrigation. Now no water reaches Lop Nur. The local Uygur people fled in the 1920s after an epidemic of plague. The Chinese government tests nuclear weapons in this area.

The Taklimakan Desert
PAGE 95

North of the Plateau of Tibet lies the Tarim Basin, an arid, forbidding land. The Silk Road, a caravan trade route, crossed here. In this east-looking view, the dark Kunlun Mountains of Tibet meet the sandy low country of the Taklimakan Desert. Woolen products, silver, and gold moved to China from Europe, and silk moved to the west. The route stretched 8,000 miles, from Cádiz in Spain through to central China. Goods changed hands many times, and few traders ever traveled the whole way.

SARAH LEEN

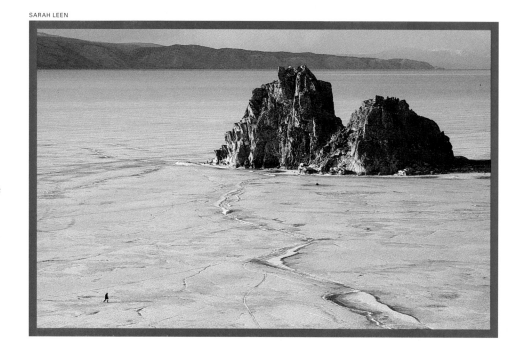

Lake Baikal

In the distance, I could see contrails of jet airliners crossing over the navigation beacon at Irkutsk on the Angara River. "Baikal is coming up!" I said to my two crewmates on the flight deck of *Endeavour*. Dr. Tom Jones passed me a camera with our widest angle lens, and I jammed myself in a corner of a window to take this photo of the entire 395-mile-long crack in the Earth. Twenty-five million years ago tectonic forces opened up a rift 29,000 feet deep, and the largest lake on this planet has been here ever since; erosion has filled the bottom with sediment four miles thick. Lake Baikal contains one-fifth of the world's fresh water.

Olkhon Island (photo at left) attests to the ruggedness of the land created when the Earth split here. (The long island is near the left center of the lake in the photo at right.)

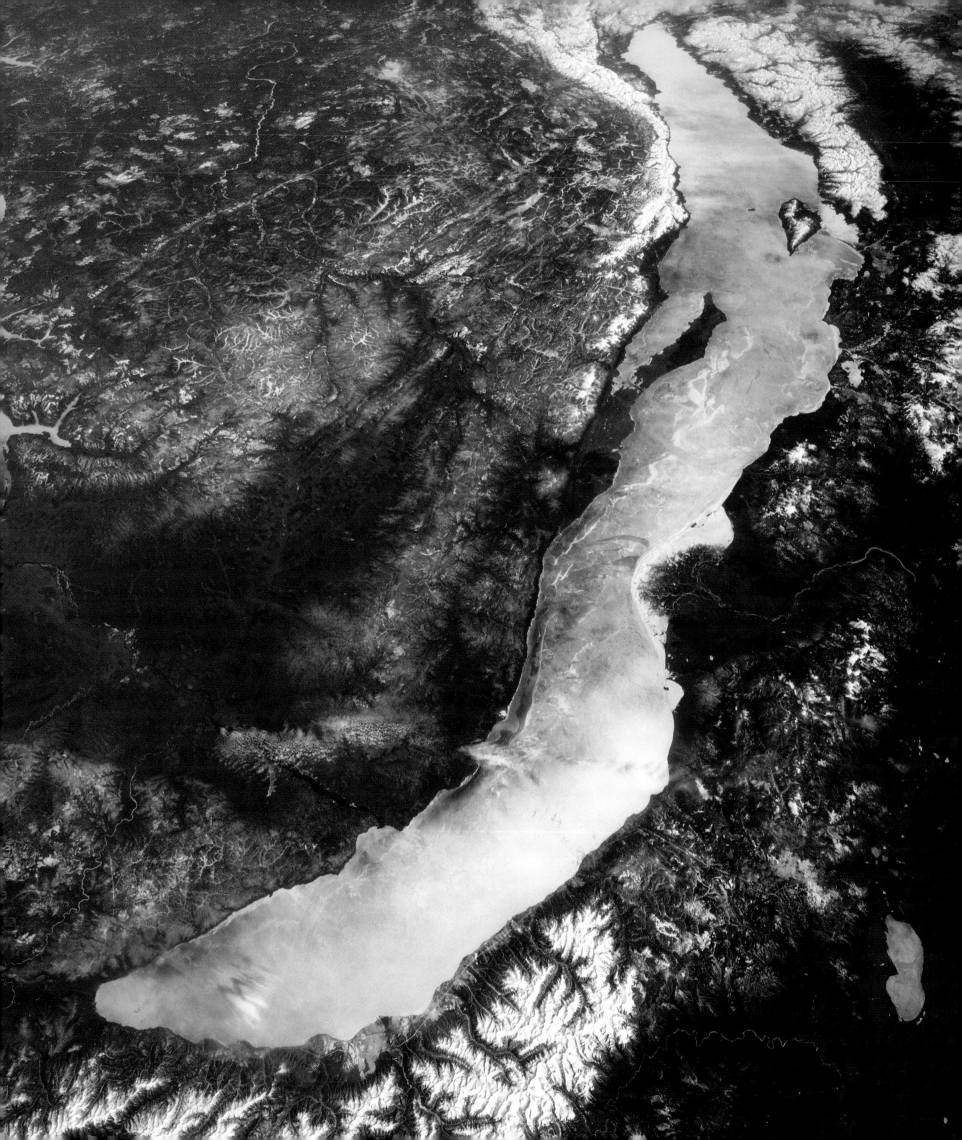

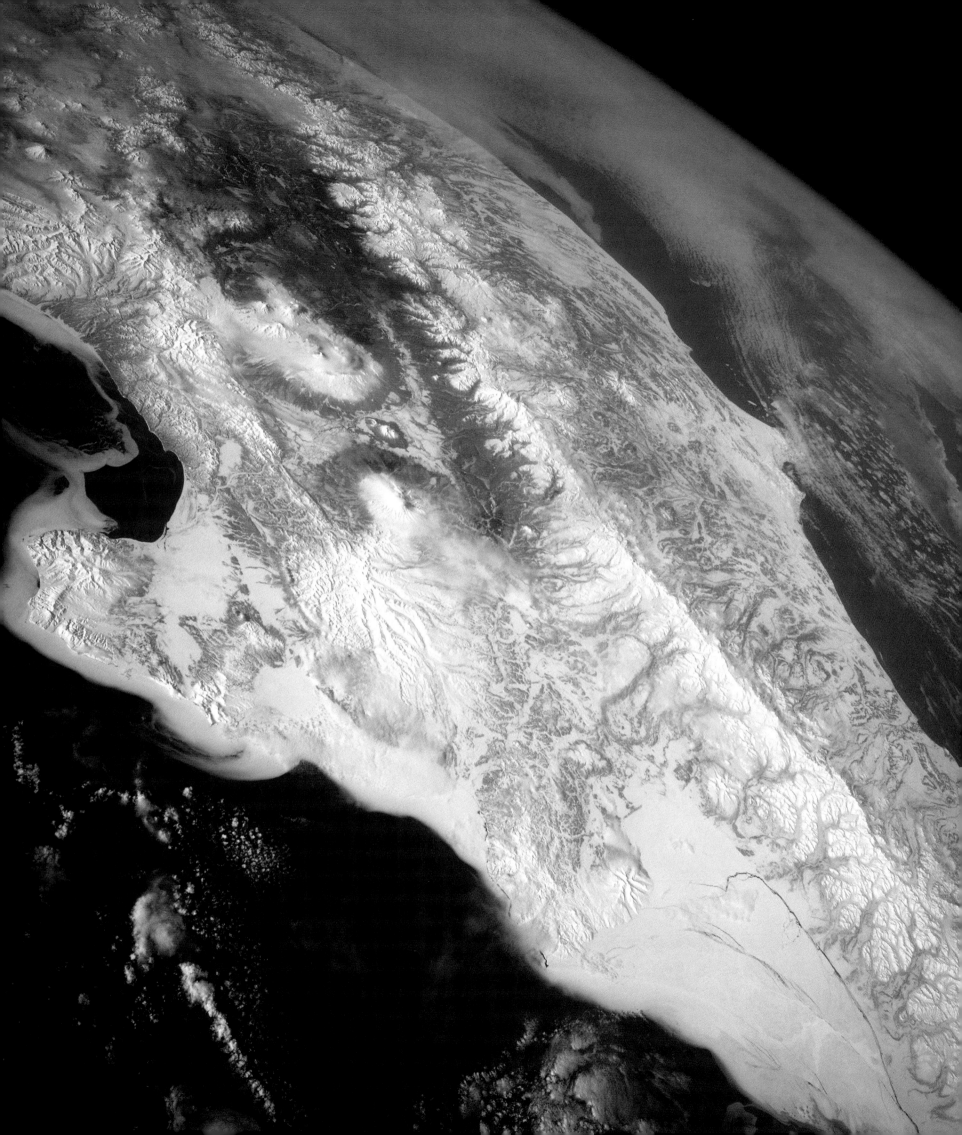

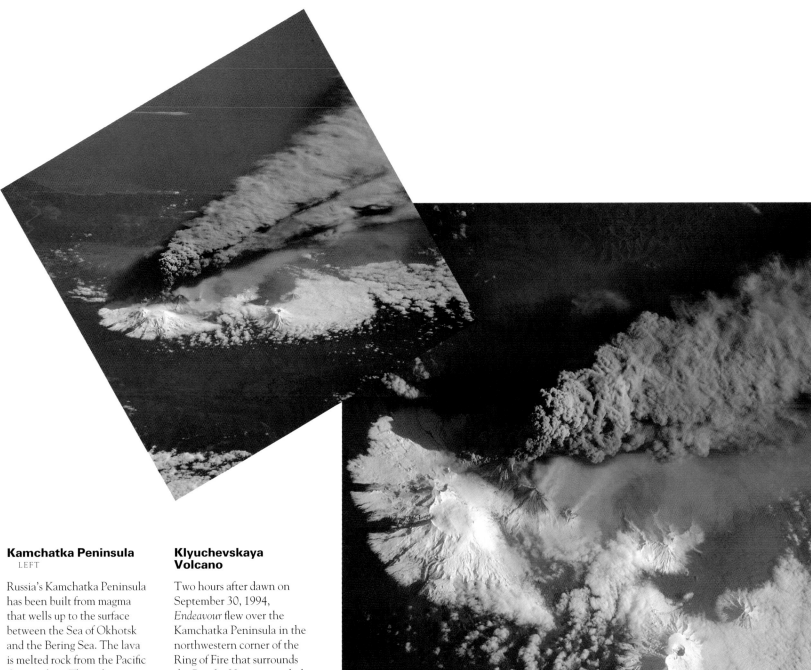

Kamchatka Peninsula
LEFT

Russia's Kamchatka Peninsula has been built from magma that wells up to the surface between the Sea of Okhotsk and the Bering Sea. The lava is melted rock from the Pacific Ocean plate. The volcanoes of Kamchatka are a quiet echo down the canyon of time of a huge outpouring of lava in Siberia long ago. An area a thousand miles on a side was covered with a layer of volcanic ejecta that was about a quarter mile thick.

Klyuchevskaya Volcano

Two hours after dawn on September 30, 1994, *Endeavour* flew over the Kamchatka Peninsula in the northwestern corner of the Ring of Fire that surrounds the Pacific. Her crew took the first photographs of the largest eruption of Klyuchevskaya in the last 40 years. Ash and gas soon rose to 65,000 feet, and 150-mile-per-hour winds carried the corrosive ash as far as 640 miles from the volcano into the North Pacific air routes that are used by 70 flights each day. Passenger and freight aircraft stayed on the ground or flew longer routes for the next three days.

Klyuchevskaya's 15,584-foot summit lies near the north end of a belt of a score of active volcanoes that average three to five eruptions each year.

p 98
p 99

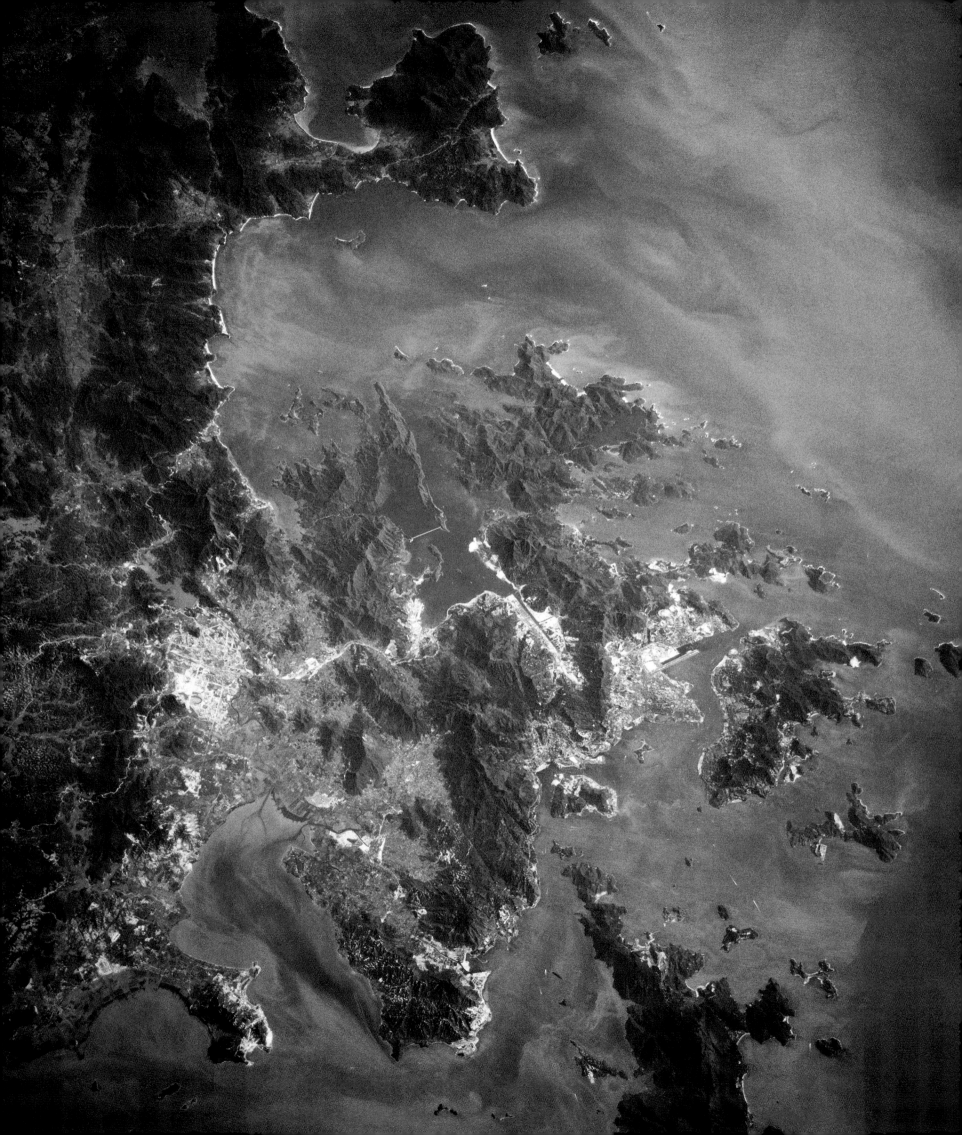

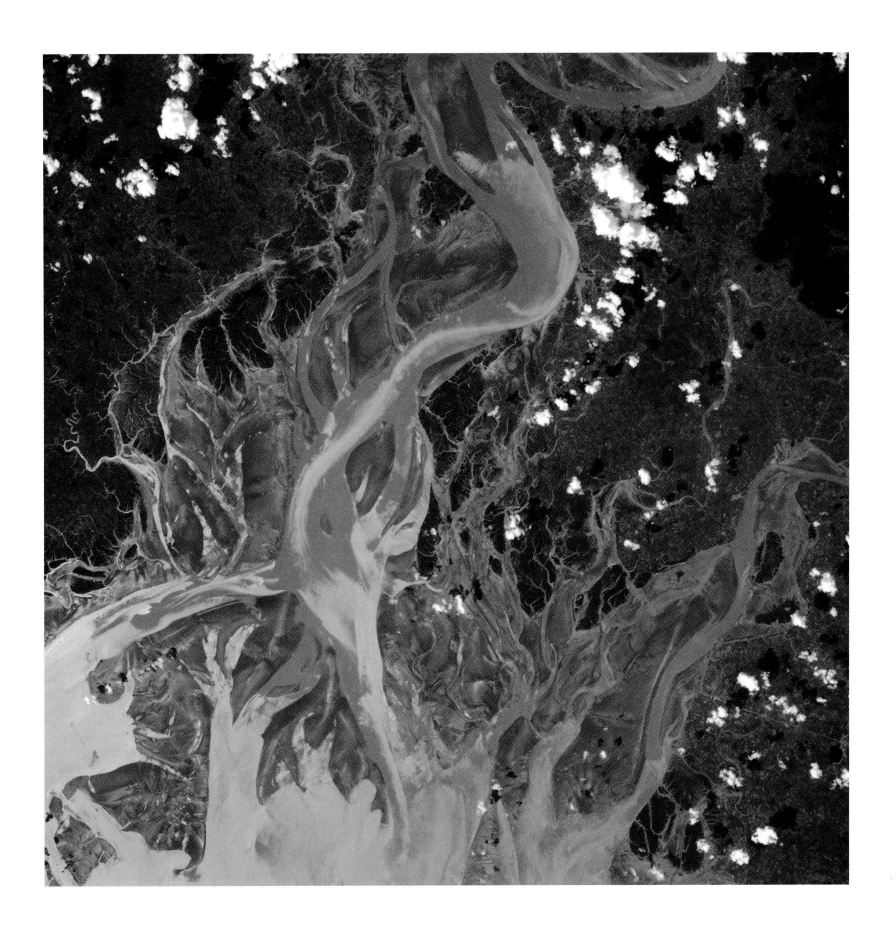

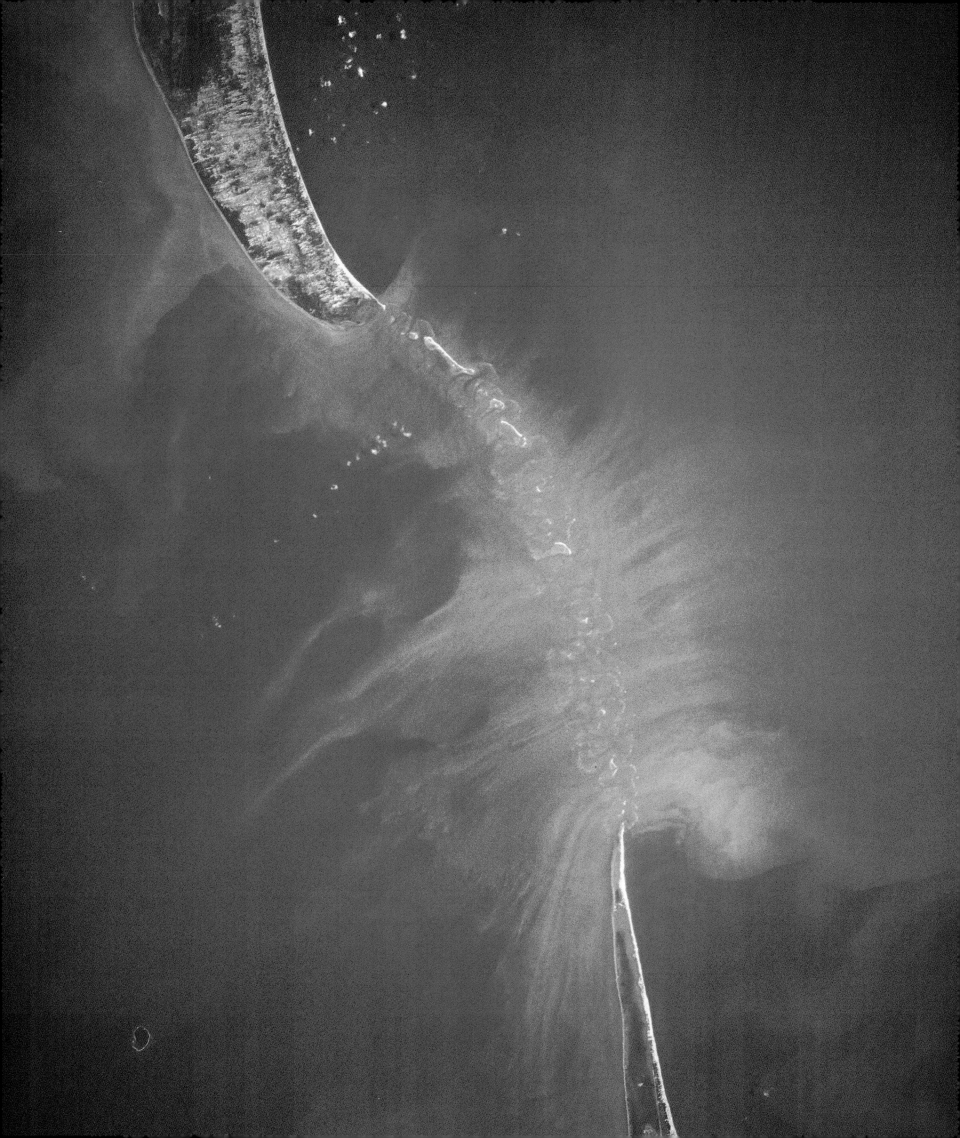

The Palk Strait
LEFT

Several thousand years ago, a narrow sand spit connected India and Sri Lanka (Ceylon). A slight rise in the sea level flooded the land bridge. All that remains is a 30-mile-long necklace of sand banks and very shallow channels (four feet deep at their deepest points). Sand just under the surface appears as light-blue. In the Hindu epic *Ramayana*, Rama built this as a causeway for his monkey army going to rescue his wife Sita from a demon king on Sri Lanka. In Muslim legends, Adam crossed this bridge to Adam's Peak, on Sri Lanka, where he stood for 1,000 years.

India and Sri Lanka

This spectacular view of the southern part of India and Sri Lanka (bottom right) shows the gentle air movements produced by the land's daily cycle of cooling and warming. The cloud-free zone surrounding the subcontinent marks the outflow of dry monsoon winds. A line of clouds, parallel to the coastline, shows where the land air meets the cloudier sea air. The beginnings of a sea breeze can be detected just inland of the coast, where another line of clouds separates clear air from cloudy air over the continent. Coasts are generally pleasanter places to live in the tropics due to these winds, and all of India's vast coastal cities enjoy the cool sea breeze. India will surpass China as the world's most populous nation by the middle of the next century.

The Mouths of the Ganges
FOLLOWING PAGES

The dark mangrove forests of the Sundarbans Biosphere Reserve are under the joint management of India (top) and Bangladesh (bottom). These forests are home to a large population of Bengal tigers. The thick, spider-legged mangrove trees at the head of the Bay of Bengal act as a protective barrier against storm surges created by ferocious tropical cyclones sweeping north out of the bay into this low-lying region. The forests are surrounded by densely packed populations and are the source of fuelwood, game, and fish.

Comparison of astronaut photography of the 1960s to that of today shows that the Sundarbans forested area is relatively stable, and in some coastal areas the forests may be expanding.

At least 300,000 people died in the low-lying deltas of Bangladesh in 1970, drowned by the storm surge from a giant cyclone. The monsoon flood of 1988 squeezed Bangladesh's 108 million people into a dry area the size of Houston, Texas.

pp 106-107
p105
p 104

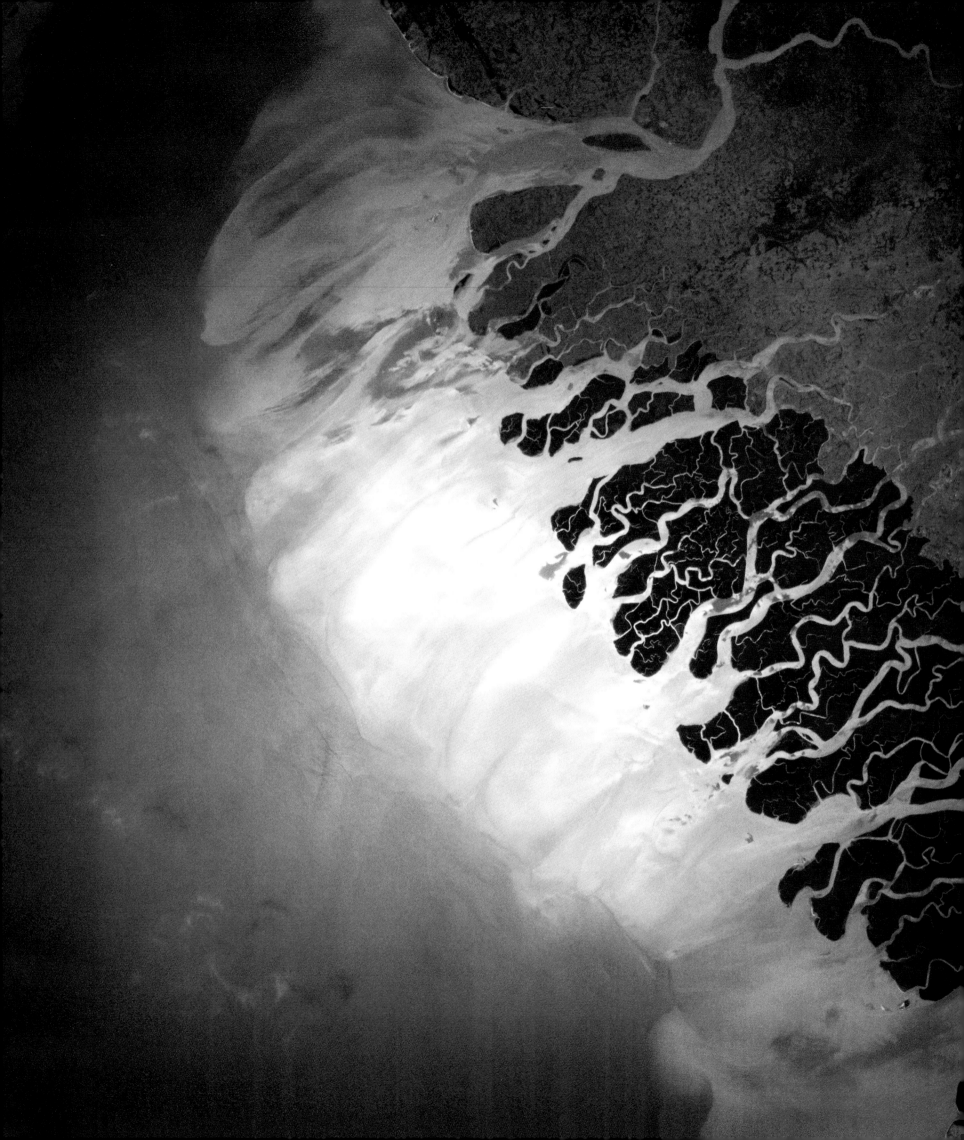

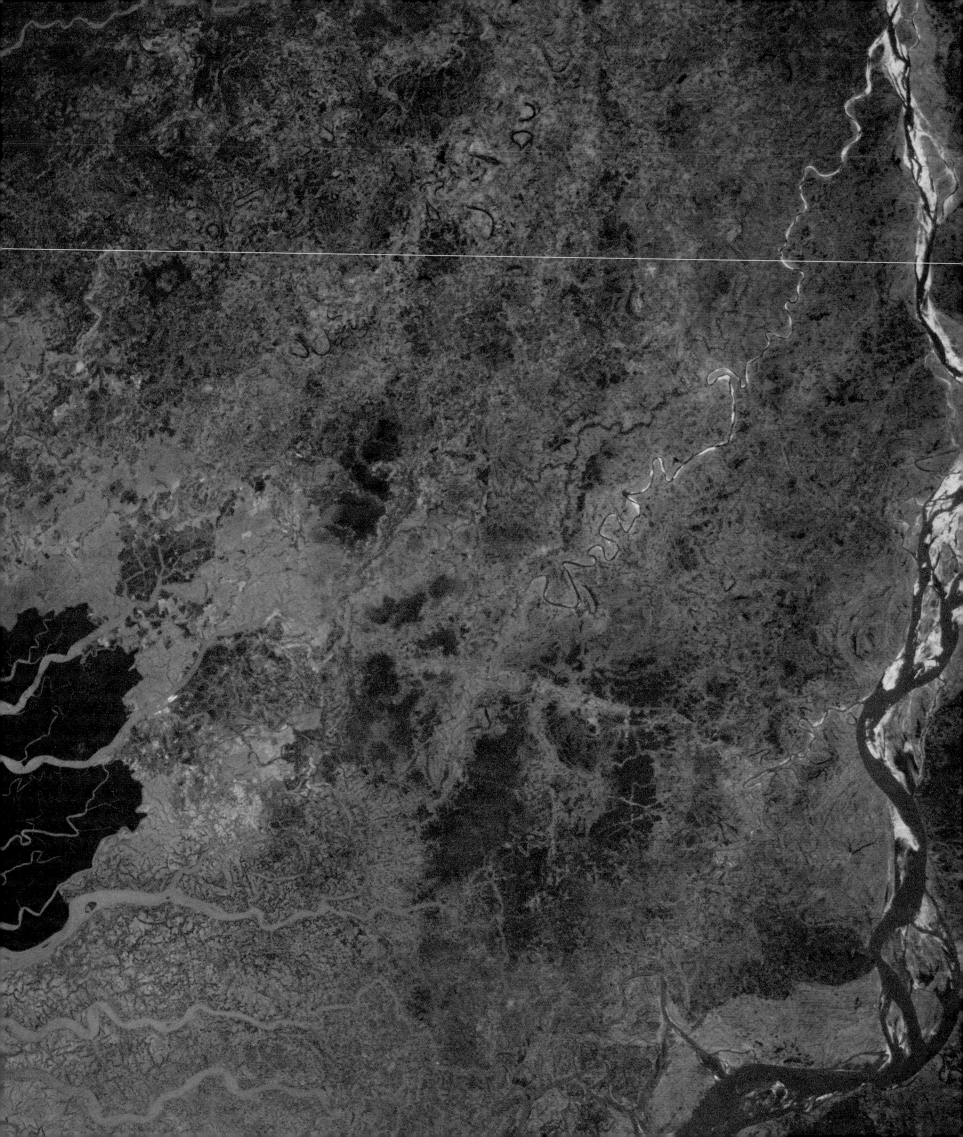

The Aurora

A violent event called an auroral substorm has just started. A moment before, three quiet arcs had been moving north. Suddenly the one in the lower left blazed enormously brighter. The bright spot marks the "footprint" of a giant tube of electric current flowing downward. Substorms often start around local midnight and spread to fill the entire sky, as seen from the ground. They are accompanied by a dramatic reconfiguring of the Earth's magnetic field far out in space. The bright vertical lines mark the direction of the field down which accelerated electrons are flowing.

This is the southern aurora, or aurora australis, as are all of the photos in this chapter.

I have been lucky enough to be aboard 2 of the 24 U.S. space missions that have flown through the aurora. Here is what I recorded after one aurora pass aboard *Endeavour*:

"... Beautiful comma-shaped light with streamers going way above us, changing on the time scales of a second. Enormous bright streamers coming down, all green, and dancing curtains and light shooting up like the jets from a gas burner on your stove. After we had watched that for a long time, I looked up and saw the Milky Way right above it, with the Magellanic Clouds. Then I went back to an aft window, and saw the dawn. We flowed through the stuff, just south of Australia, with the stars above and the moonlit clouds below and the aurora all around us. Then the dawn came and we saw the aurora and the dawn at the same time."

The aurora occurs when charged particles trapped in Earth's magnetic fields are accelerated in balance with currents flowing out from the sun into the upper atmosphere over each magnetic pole, where they strike atoms and molecules and cause them to give off light. In a color television set's picture tube, a beam of electrons strikes the screen, making it glow in different colors according to the chemicals coating the screen. An aurora's colors depend on the type and height of atom or molecule struck by the electrons crashing into the polar atmosphere. Brilliant yellow-green is caused by light from oxygen atoms about 60 miles above the Earth. Oxygen atoms about 200 miles up produce rare, all-red auroras. Ionized nitrogen molecules (two nitrogen atoms with one missing electron) produce blue; neutral nitrogen produces red.

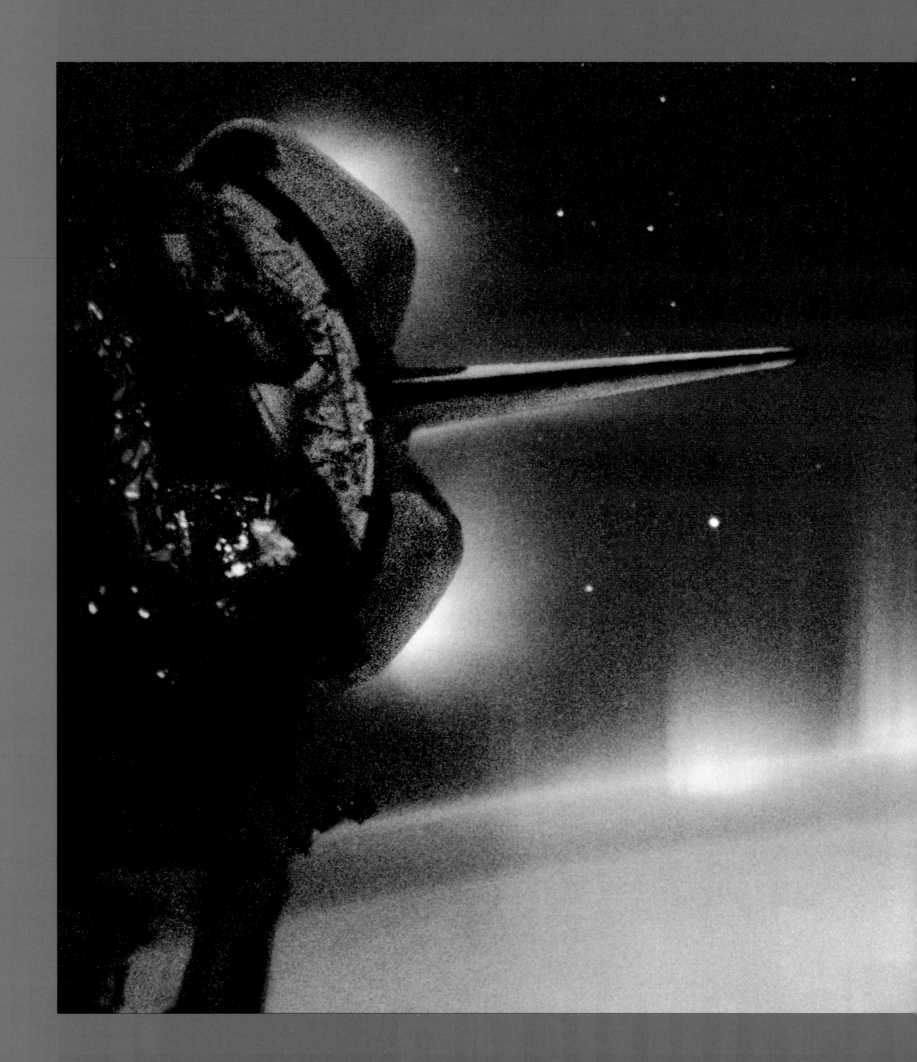

Discovery's twin engines have just been ignited to change her orbit in order to come alongside a small satellite the crew had released earlier. Photographs such as this one are rare, since our engines glow for only an instant when they are first lit.

Behind Discovery, the red aurora is particularly bright. It is created high in the slight atmosphere by the weakest of all electrons that create the aurora. The high altitude of the red aurora makes it visible from great distances. In the 1830s officials in London considered declaring a fire emergency when a large red auroral glow lit up the northern sky.

In 1773 James Cook aboard Resolution became the first to cross the Antarctic Circle. One of the purposes of his second voyage was to sail far enough south to see the aurora australis. He was an excellent scientist as well as a superb captain. Aboard the Discovery in 1991, a modern mixture of adventure and science brought seven Americans to space to study, among other things, the aurora.

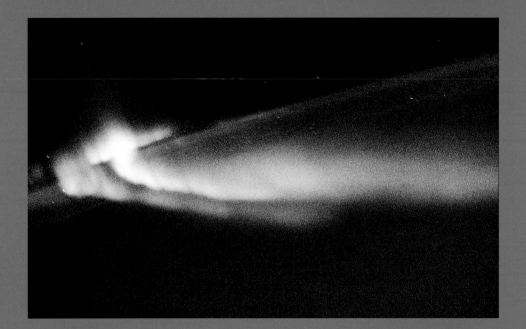

The aurora can change its form in moments. The folds in the arc in the middle photo at right are traveling vortices, caused by unstable electric fields in the atmosphere. The three parallel arcs in the lower right photograph extend roughly east-west. Native people of the North knew this, and used these arcs for navigation. The aurora can be as bright as moonlight. People can see by the aurora during subpolar nights.

We fly right through the aurora's 60- to 200-mile altitude range. There is another light in the night sky that is lower, 60 to 100 miles, called the airglow layer; it is visible in these photographs. On my first flight, it took me three days to figure out what it was. It looked like the ghostly bioluminescence that sometimes forms in a ship's wake. It is really a tenuous band of atoms (mostly sodium and nitrogen) that glow from sunlight. The glow persists after sunset, and can be about half as bright as starlight.

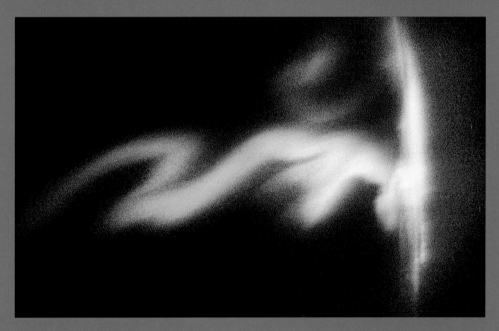

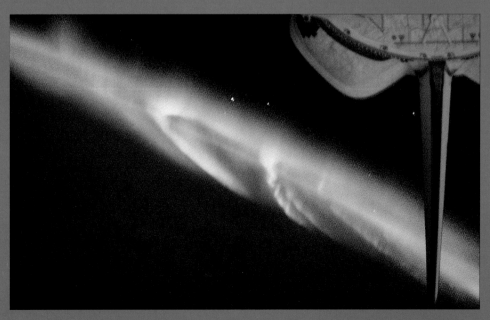

The rays of the aurora show nearly all their known colors as they dance in front of the constellation Orion. The stars in Orion's head and his left shoulder are seen through the orange airglow layer, giving the illusion that the stars are closer than the horizon.

The first accurate measurements of the aurora's altitude were made using pairs of photographs taken simultaneously from different locations that contained both the aurora and stars. Norwegian scientists were then able to triangulate the height of the aurora. Like all photographs in this chapter, this one was made with a handheld camera; this was a four-second exposure from the flight deck of Endeavour.

The moon (overexposed at the top of the photo) lights up the clouds over the southern Indian Ocean while the aurora dances around Discovery. In a trick of perspective, a shaft of the aurora appears to extend to the tops of the clouds. Until the mid-1800s most people thought that the aurora's light extended to the ground. A common theme in aurora mythology is that the aurora will descend to bop the heads of misbehaving children!

From 1645 through 1710 there was a great decrease in the electromagnetic activity of the sun, and so few disturbances excited the aurora. The auroras returned to northern Europe in 1716 with tremendous displays. Astronomer Edmond Halley, seeing the pattern of vertical rays, recognized a connection with Earth's magnetic field. Scientists still wonder if the quiet sun caused Europe's very cold winters in the late 1600s.

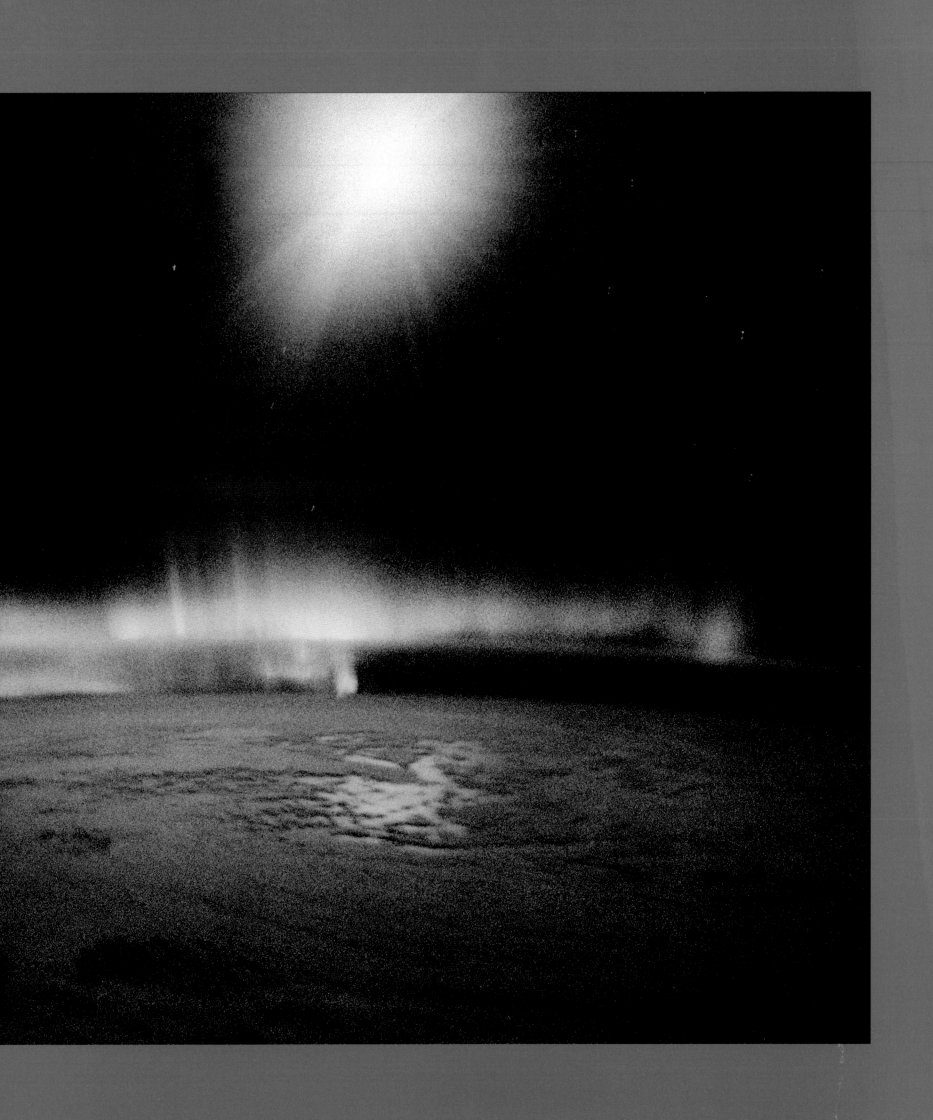

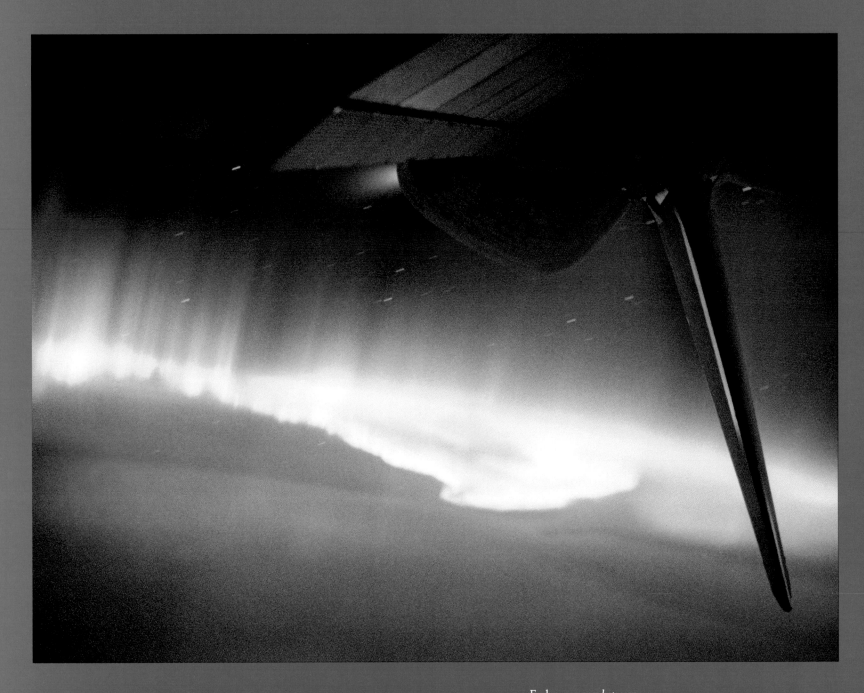

Endeavour *was between Tasmania and Antarctica when we flew through this auroral substorm. The moon was just past new, and the light from the aurora was brighter than the moonlight as it lit up our cargo bay. The flat plates illuminated by the aurora in our bay are three radar antennas.*
The plume from the rear of the Shuttle is one of our small steering jets.
The trails of the stars are due to the Shuttle's motion.

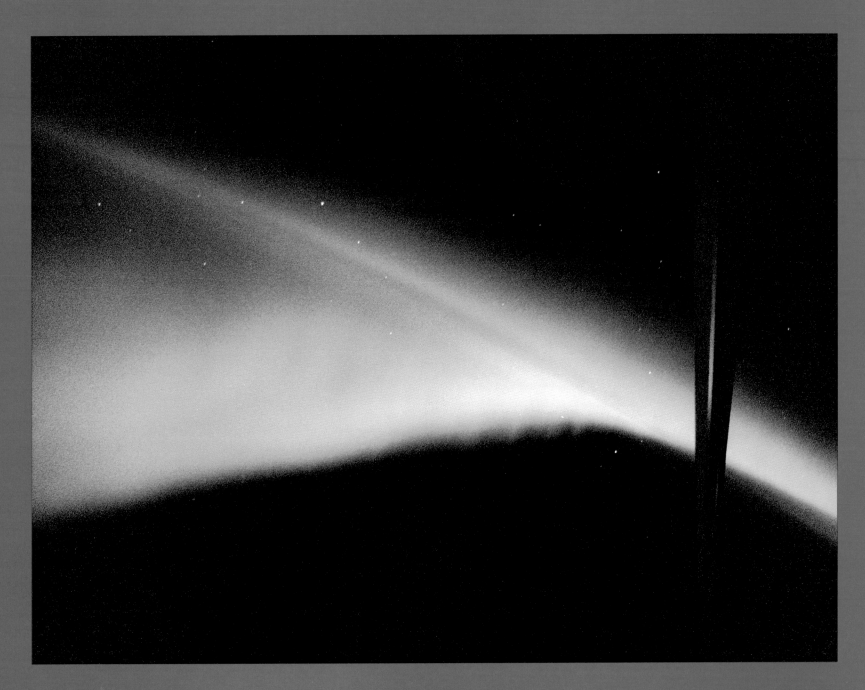

This photograph was the last I made of the aurora at the end of my second trip aboard Endeavour. *Dawn had been arriving earlier each day as we passed into the auroral oval, and on the last day of the mission we got only a brief glimpse of its beauty. I closed my eyelids, and saw white streaks made in my eyes by the fast-moving particles that create the aurora. Then, looking out at the power of the fields that create this splendor, I marveled at the people who made us a ship that can fly right through the aurora and survive.*

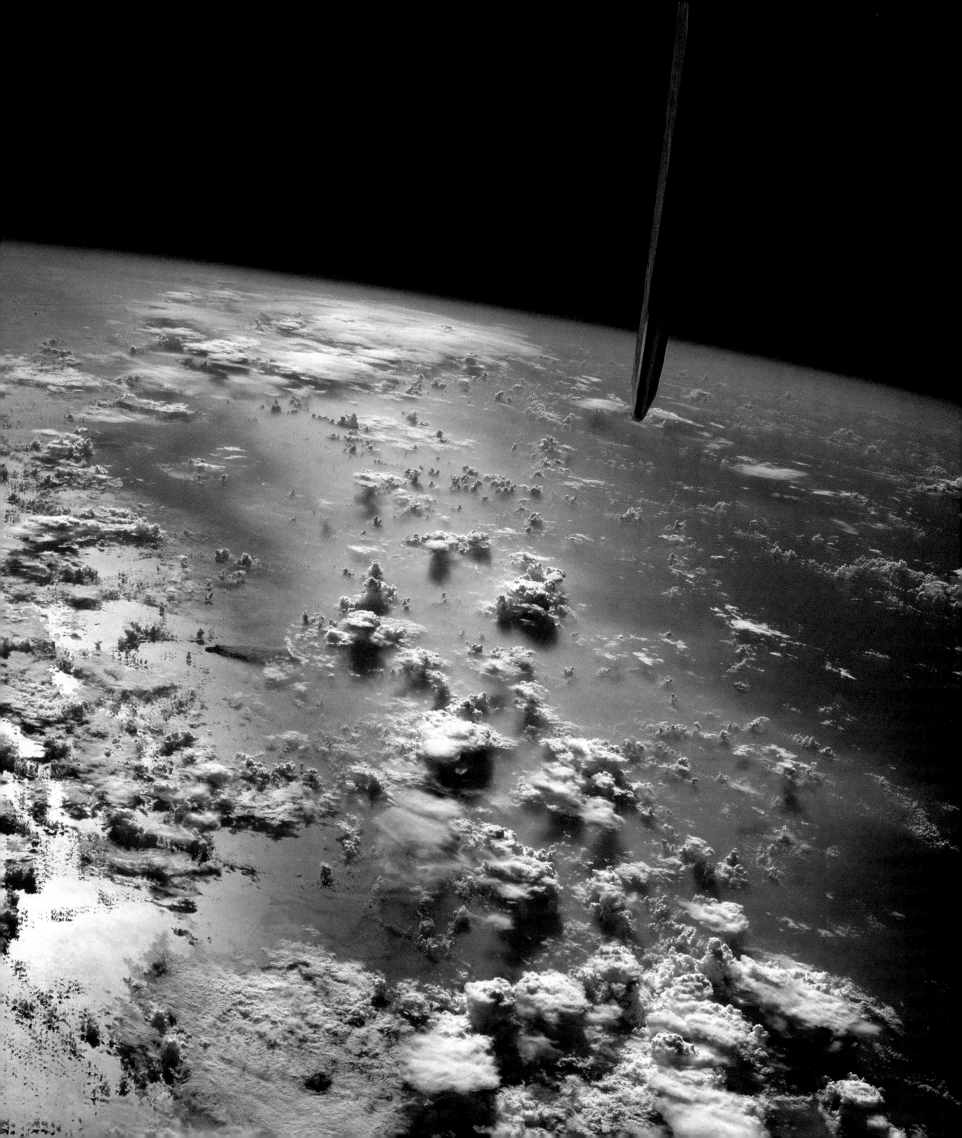

Pacific

Pacific

Blue Water and Volcanic Smoke

Discovery was 1,000 miles east of Manila when her crew noticed the smoke from the volcano Pagan along the rim of the Mariana Trench. Thunderstorms blast water from the ocean high into the air near many of the Pacific's 25,000 islands. Our eyes search for any break in the surface of an ocean that has a larger area than that of the entire surface of Mars.

I NEVER REALLY BELIEVED THAT 71 PERCENT OF THE EARTH'S surface is covered with saltwater until I flew over the Pacific. Sometimes it can take 35 minutes of our 90-minute orbit to cross the Pacific. One photograph taken on the way to the moon shows an entire side of Earth with only two small areas of land, New Guinea and the very western edge of California.

Under the Pacific, in the crust of the Earth, there are many cracks that ooze molten rock from the mantle, forming volcanoes. I had worked on top of one of these, at an astronomical observatory on Mauna Kea, Hawaii. It was a fantastic sight to see that familiar island slide by on my first mission. Outside, during my second space walk, I had time to study the island closely, and I saw the sun glinting off the domes of the observatory on the volcano's peak.

The Pacific is home to some of the biggest visible structures ever created by animals on this planet: coral reefs. Viewed through our windows, they look like enormous smoke rings. Some atolls form when coral reefs surround an island (in the Pacific, usually a volcano). If the island then is eroded away and if the seafloor underneath it sags, the reef organisms build on top of the slowly sinking volcanic core, creating a structure that can be as much as 6,000 feet thick and many miles across. The level of Earth's seas has risen and fallen in stages; when it rises (as during most of the past 18,000 years), the reef builds up to sea level. The central lagoon is filled in with sediment eroded from the reef and by new colonies of coral.

A Ring of Fire—volcanoes and earthquakes—occupies the rim of the Pacific Ocean. Giant arcs of islands are formed when huge pieces of crustal plates collide; one overrides another, driving it down into the hot interior, where its leading edge melts. Dense as it is, it is still lighter than the mantle's rock, so it rises up through the overriding pieces, creating volcanoes, which in time form island arcs. I've flown a small aircraft over some of the island arcs, but it is impossible to get a sense of what they really are until you look at them from 150 miles up. The Aleutians and the Kuril Islands north of Japan are dramatic arcs seen from far above.

The Ring of Fire is also a ring of people, from California to Japan, the Philippines, and New Zealand. Communicating by an amateur radio has been part of the group of experiments assigned to each of my Shuttle missions. I've used it to talk to the very active radio amateur hams around the Pacific Rim. I recall many conversations at night with hams in Australia and New Zealand who had gotten up in the wee hours just to talk to us as we flew overhead. I've been surprised by a call from a ham from Hilo, Hawaii, using a tiny radio in his car. I have seen the lights of the Palmer Research Station at the tip of Antarctica, and called the scientists there on our ham set. All these conversations make me feel more connected to the people and the lands we are flying over.

There is one very dry spot in the middle of all this water: Australia. Smack in the middle of the falling stream of dry air that descends from the upper troposphere at Australia's latitude all around the planet, the continent gets very little rain. From orbit, the green fringes where the large cities are located do appear green, but the interior is the reddest desert on Earth. During one mission we made pass after pass over the "red center" in daylight, but we saw very few farms or roads. Sydney is an oasis for the eyes in its green and blue beauty.

The Australian people have been fantastic supporters of the exploration of space from the time of John Glenn's flight, and we often thank the people working at the tracking stations as we pass by. One woman in northwest Australia even relayed my ham radio signals at two in the morning her time so I could talk from *Endeavour* to a doctor spending more than a year aboard the Russian *Mir* station.

We flew over the Coral Sea, the "slot" between New Guinea and the Solomon Islands, and Leyte Gulf in the Philippines. As we did, we talked among ourselves about the incredible logistics of World War II. Across the ocean beneath us, from depots in Australia and the United States, came the troops and matériel that liberated the Philippines in 1945.

Your eye is much more sensitive to the light than photographic film is. We can see details on the ground when there is not enough light to make a picture. On my third mission, we saw the fabulous mountains of the South Island of New Zealand in better light each day. Finally, on the last day of the flight, I thought there might be enough light for a picture. In the few tens of seconds we had, I took a light meter reading, set the aperture on our 4"x 5" camera, carefully composed the shot, and fired. A red light appeared—the huge camera had finally run out of film. We took over 12,000 photographs of the Earth that mission, but none of the Southern Alps.

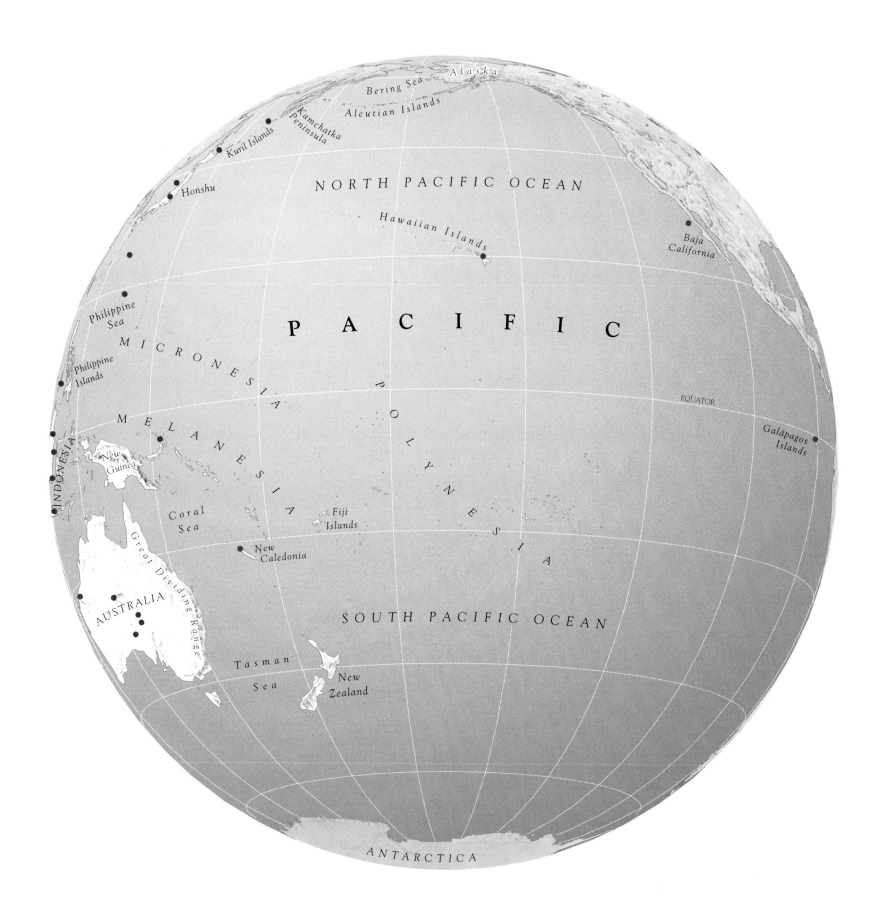

Alaska

Bering Sea

Aleutian Islands

Kamchatka
Peninsula

Kuril Islands

NORTH PACIFIC OCEAN

Honshu

Hawaiian Islands

Baja
California

Philippine
Sea

PACIFIC

MICRONESIA

Philippine
Islands

EQUATOR

INDONESIA

MELANESIA

Galápagos
Islands

POLYNESIA

New
Guinea

Coral
Sea

Fiji
Islands

New
Caledonia

Great Dividing Range

AUSTRALIA

SOUTH PACIFIC OCEAN

Tasman
Sea

New
Zealand

ANTARCTICA

● Center point of photograph

Ship Wakes in Sun Glint, Sea of Japan

The reflection of the sun off water surfaces provides oceanographers with a highly detailed view of the oceans. This Sea of Japan scene, along the coast of the main Japanese island of Honshu, has a large area of spinning water near the center, many wind slicks, and V-shaped ship wakes. The small angles of three of the wakes are probably caused by high-speed naval vessels. Two narrow-V, high-speed wakes are right of center; the third, barely visible, is at topmost center. The wider ship wakes are probably from larger, slower-moving vessels, such as freighters or tankers, in this heavily traveled seaway.

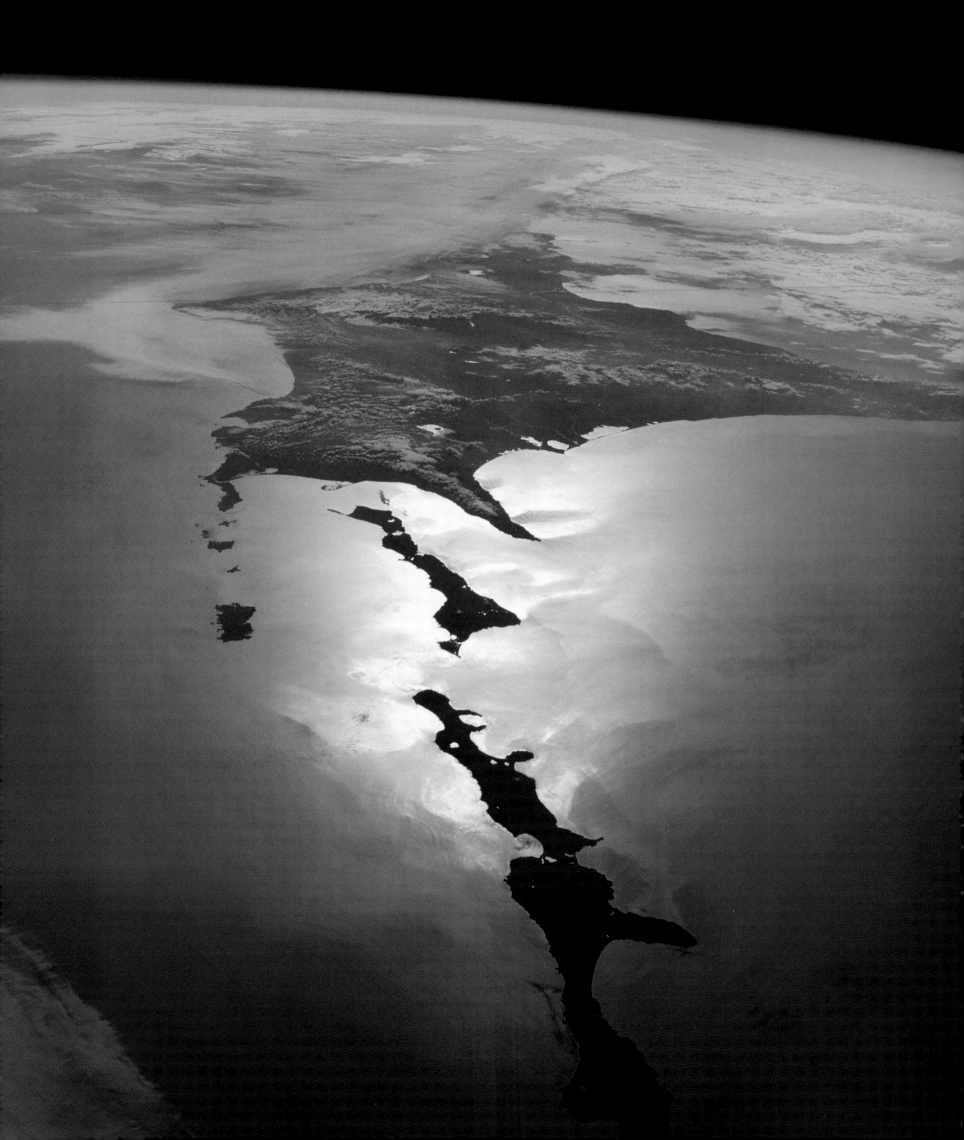

Hokkaido and the Kuril Islands

Color dances in the glint of the sun along one of the arcs of islands that mark the western Pacific. The islands in the foreground are part of a 750-mile-long chain, the Kurils, that stretches from the Kamchatka Peninsula's southern tip to the northeastern corner of Hokkaido Island. Just to the east (left) of the Kurils lies a trench in the ocean floor with a maximum depth of about 31,300 feet.

These island arcs and trenches are formed as part of the Pacific Ocean's floor moves westward. It collides with plates to the west, and is forced down in giant arcs and lines. Trenches are formed at the place the ocean crust is rammed down toward the mantle. Melted rock from Earth's crust is lighter than the mantle and wells to the surface, rising through the western plate to form arcs of volcanic islands and new volcanoes on older islands, such as Showa on Hokkaido (formed in this century). The chain of land created by the colliding plates extends through Hokkaido and beyond the tiny island of Kojima (photo at right).

MICHAEL S. YAMASHITA

Onekotan Island
PAGE 126

Two of the hundred volcanoes that pierced the Earth's crust in the Kuril Islands arc formed Onekotan Island. The circle of rock at the top of the photo is a caldera, formed when the upflow of lava into the volcano ceases; the land cools and sinks, then collapses into a pit. The grinding of pieces of the Earth here produces frequent earthquakes and huge waves called tsunamis (from Japanese words for "harbor" and "wave"). In 1737 a tsunami originating in the Kurils swept up a fjord, reaching a height of 210 feet. No vegetation peeks out from the snow, even in April, on this island at the same latitude as Vancouver.

Tokyo and Yokohama
PAGE 127

Major capital cities are seldom clear, unless winds are blowing soot out to sea. So this is a rare clear view of Tokyo–30 million people compressed into the ancient Japanese heartland, the Edo Plain of Honshu. The vibrant economic centers of Tokyo and Yokohama occupy the western shore of Tokyo Bay. They and their neighbors meld into one metropolis.

The unusually clear atmosphere allows an image in which, under magnification, at least 72 ships can be identified in the bay. The Imperial Palace of the Emperor of Japan is barely visible as a small green ring inland of the north central shore.

Some of Japan's forests are seen along the Chiba Peninsula on the eastern side of Tokyo Bay (right). Japan has preserved its forests by becoming one of the world's major timber importers.

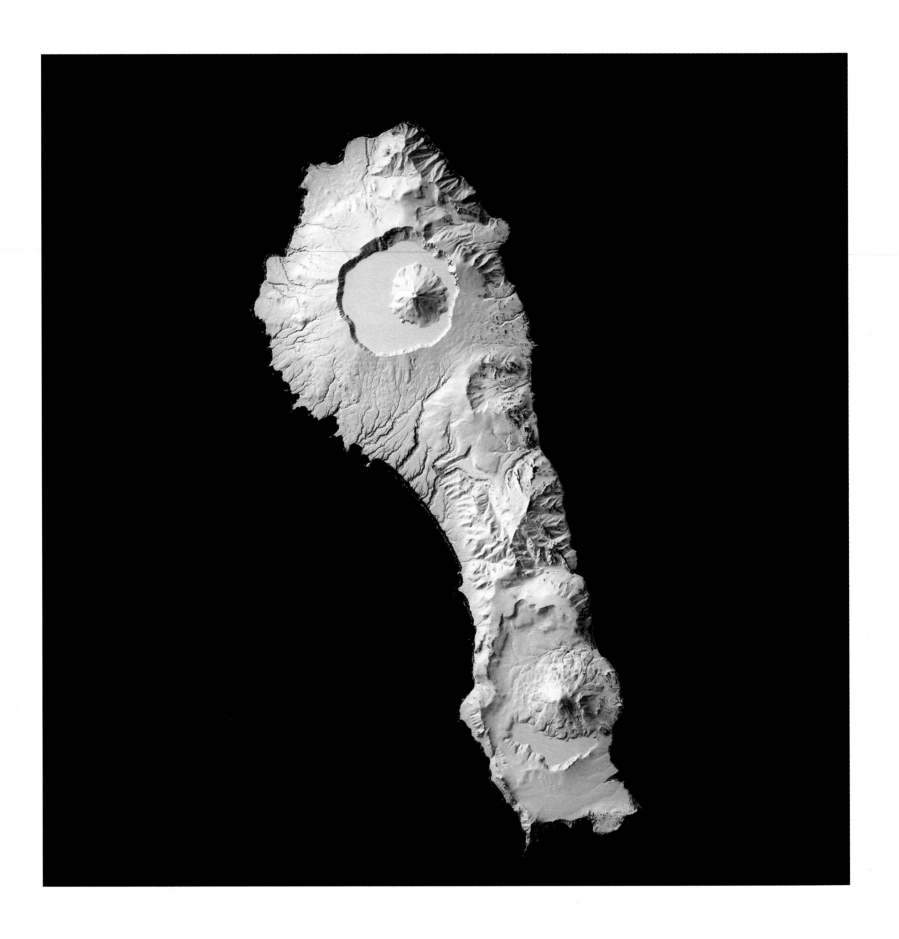

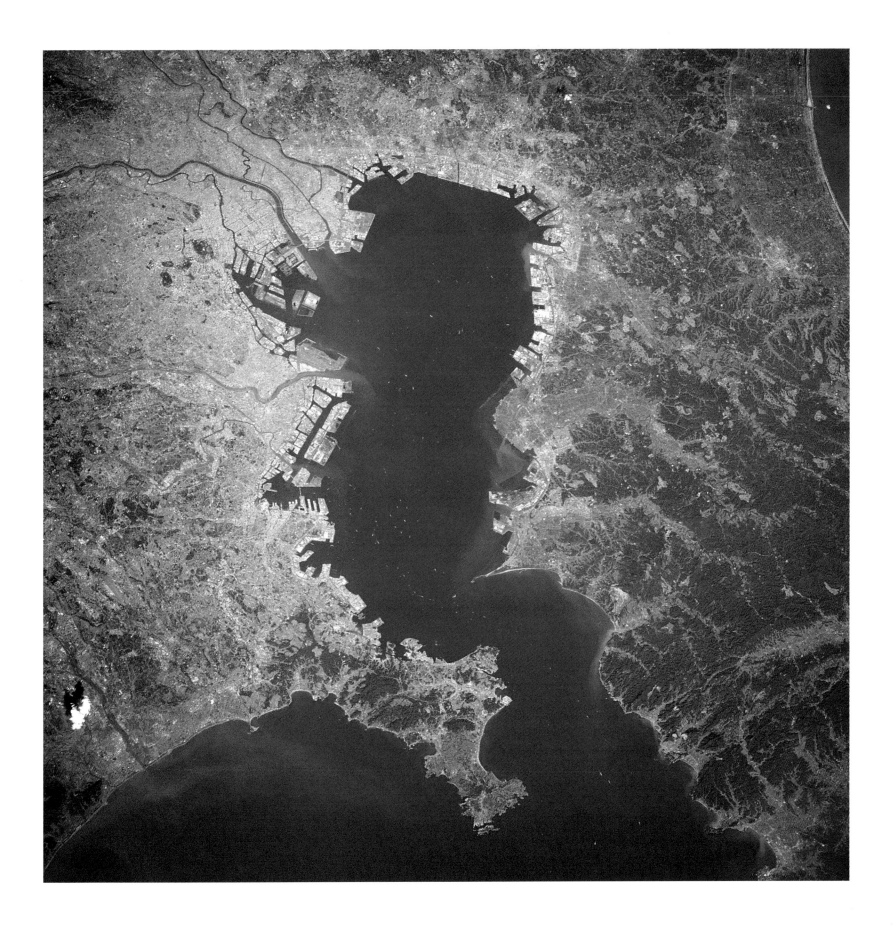

Ash at Sunset

On June 15, 1991, after a 600-year slumber, Mount Pinatubo, 55 miles northwest of Manila, exploded in one of this century's largest volcanic eruptions. Less than two months later, *Atlantis* sailed above the dirtiest atmosphere any astronaut could recall. Most of the volcano's dust was in two layers at about 100,000 feet. The roofs of the anvil-shaped thunderstorm clouds at 40,000 feet mark the ceiling of the troposphere. Ash and disease killed more than 700 people who had been lured by rich volcanic soil. The layers of ash take years to disappear, since their main route out of the stratosphere involves migrating to high latitudes in the Northern and Southern Hemispheres.

Only on the first of my missions, two months before the eruption, was our atmosphere crystalline.

Java

The eastern half of the Indonesian island of Java shows in this view, with the Indian Ocean down the right side and the Java Sea down the left. A line of volcanic peaks stretches down the middle of the picture, each peak surrounded by a white patch of cloud. The two largest volcanic eruptions on Earth in modern times occurred here. Tambora on the island of Sumbawa, at the top of the view, erupted in 1815, losing its top 4,500 feet and killing about 92,000 people—most from starvation after ash destroyed crops. Nearby Krakatau's smaller eruptions in 1883 killed 36,000 people.

pp 130-131

p 129

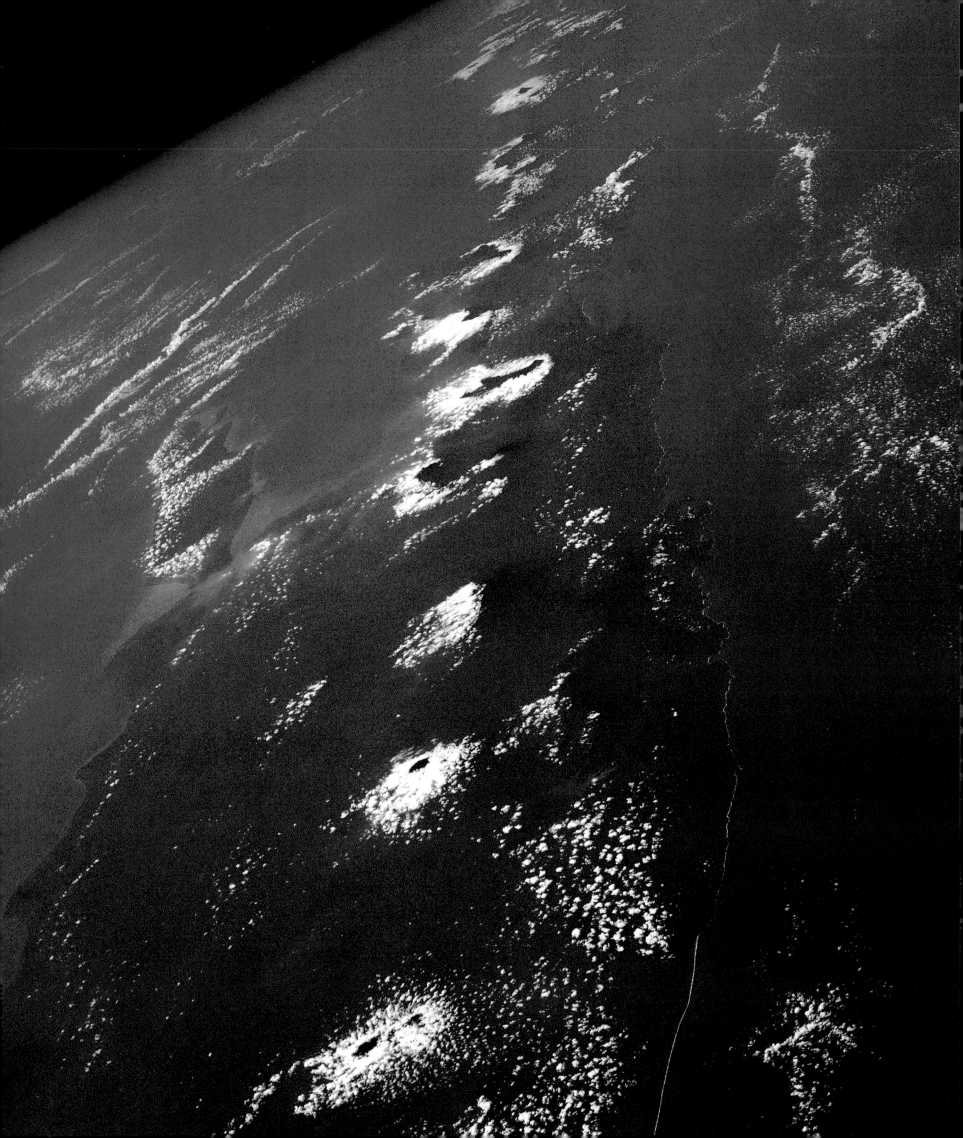

Rabaul, Papua New Guinea

Many people live near volcanoes on the Pacific Rim, but in Rabaul, 14,000 people live in the sea-level crater of an active volcano. On September 19, 1994, ash and pumice erupted around Blanche Bay, filling the viewfinder of the Shuttle's camera with a high cloud of steam and a lower, darker cloud of ash. The northeast coast of New Britain Island is just visible in the photograph, which was taken shortly after the beginning of the eruption.

The previous eruption in 1937 killed more than 500 people. Half a century of scientific study has improved our ability to predict eruptions, and timely warnings kept the death toll to five, despite ashfalls some three feet deep.

Heavy rains soaked the ash, collapsing all but a few buildings. Rabaul and the island of New Britain are part of the country of Papua New Guinea, which became independent of Australia in 1975.

Rabaul, rebuilt after the 1937 eruption, became a Japanese stronghold in World War II. U.S. war planners plotted in vain to destroy Rabaul with a scheme to activate the volcanoes by bombing their well-mapped surface vents.

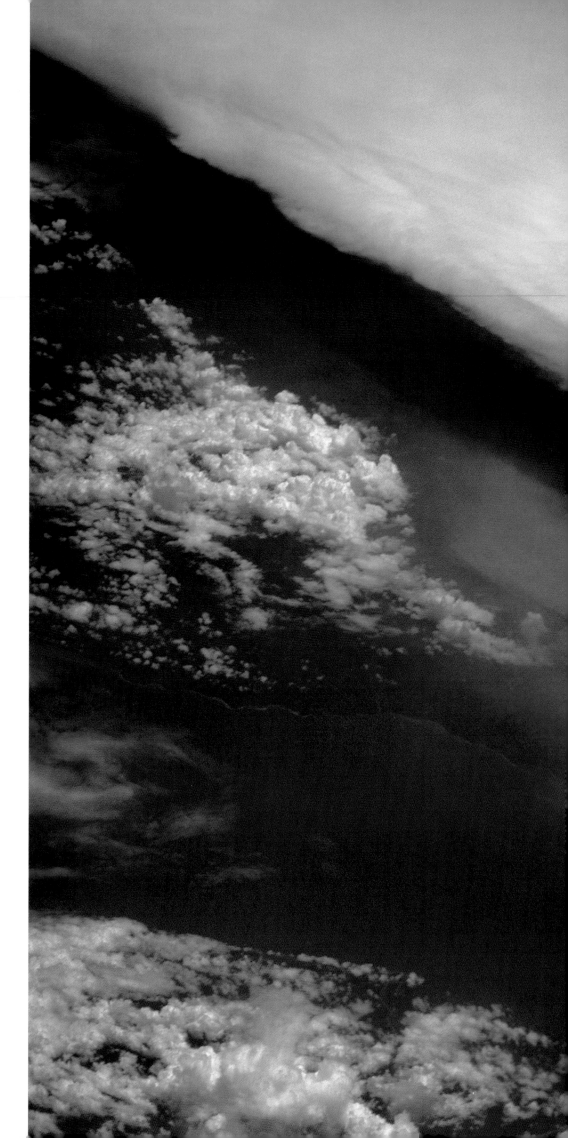

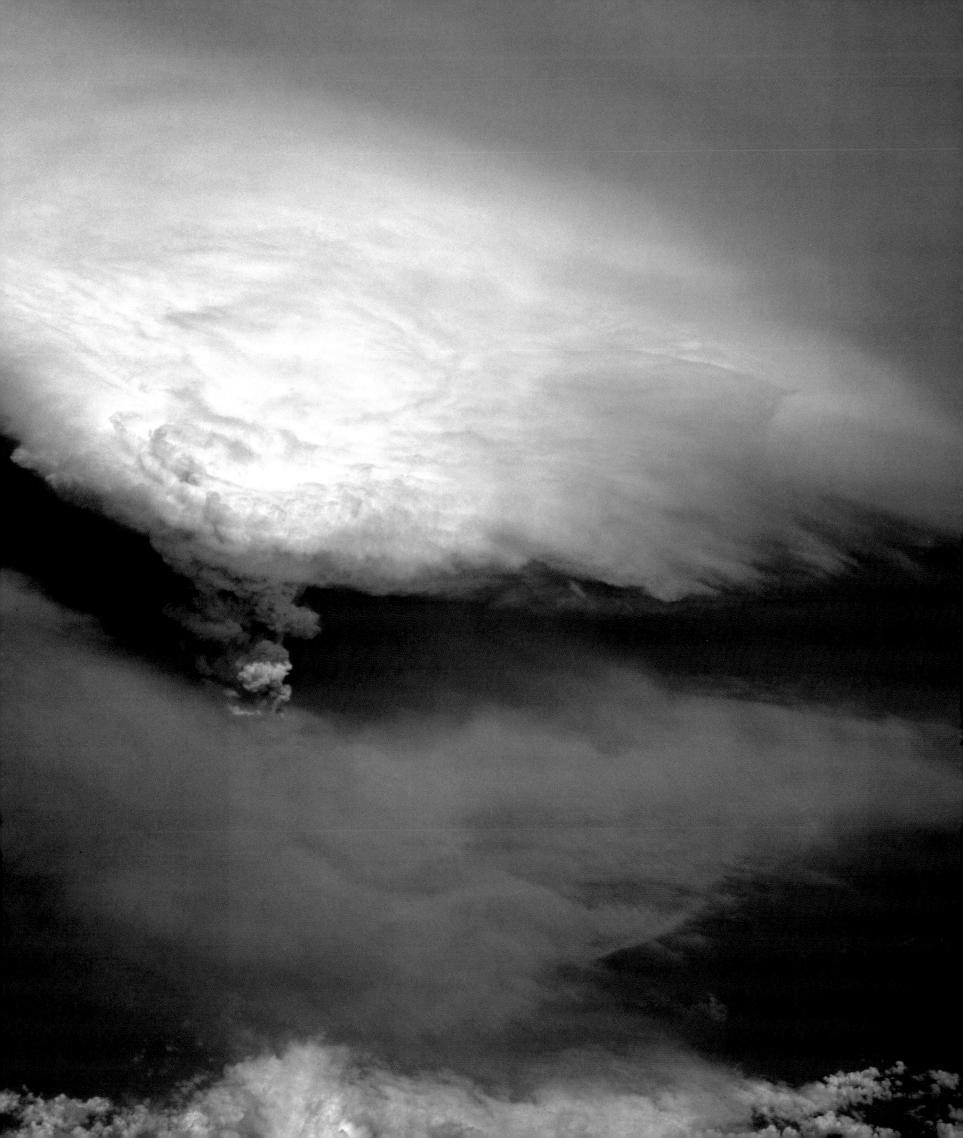

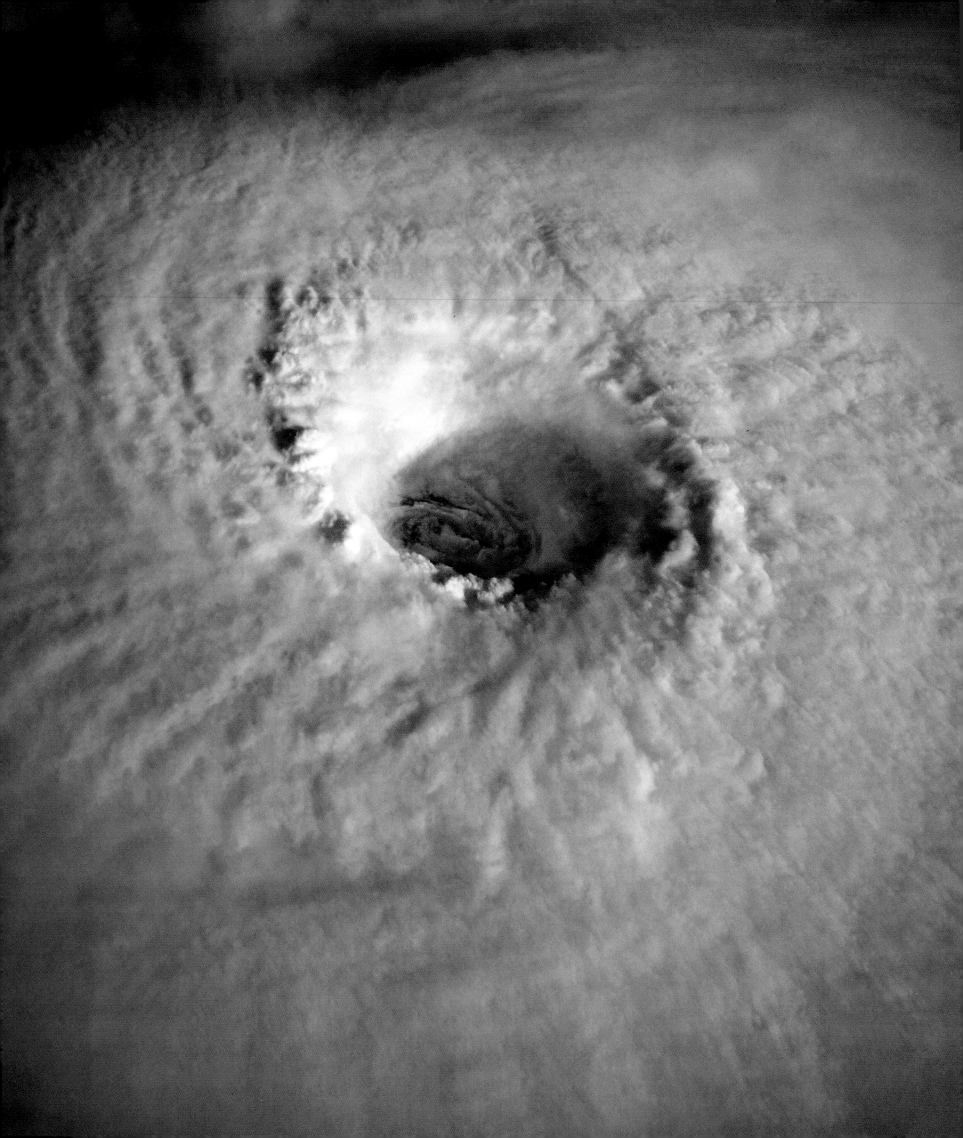

The Eye of Typhoon Odessa

Two hundred miles east of Okinawa, *Discovery*'s crew took a break from launching three satellites and repairing another to look down on the 17-mile-wide eye of a vicious storm. Dry air, rushing from high altitude into the low pressure at the center of the storm, plunges down to the surface in the eye, creating a region almost free of cloud. The wall of thunderstorms around the eye contains some of the heaviest rain and strongest wind in the entire storm. The western Pacific has more tropical storms with typhoon-force winds than anywhere else on Earth: in an average year three times as many typhoons form there as hurricanes form in the entire Atlantic.

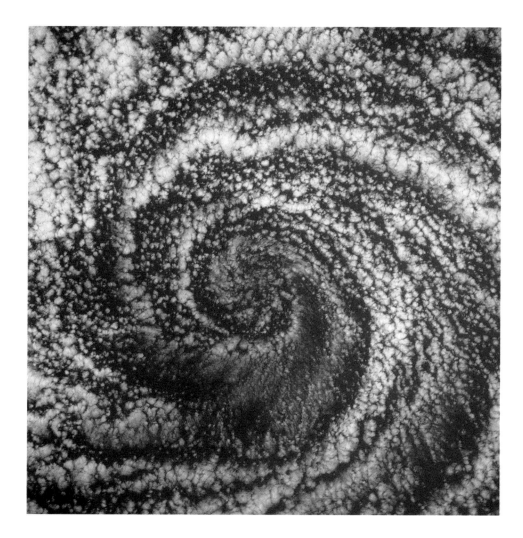

A Pacific Low
LEFT

The geometric beauty of this spiral of clouds is a result of the rotation of the Earth. As parcels of air flow from high pressure to low, they take with them the speed of rotation appropriate to their latitude: 1,000 miles per hour at the equator, 750 mph at Boston. The air at the bottom of this photo (at latitude 28.3° north) is moving to the east 5 mph faster than that at the top, 40 miles farther north. As the faster air parcels from the south flow in toward the low at the center, they move to the right of the slower parcels from the north. This, together with surface friction, creates the spiral.

Borneo Forest Fires
FOLLOWING PAGES

Hundreds of naturally caused forest fires were burning on Kalimantan in Indonesian Borneo in September 1991 as *Discovery* flew overhead. A drought had dried out the peat bogs underlying the rain forest. Hundreds of long-lived peat bog fires then spontaneously broke out and ignited the drying tropical rain forest. The smoke pall was so thick that it impeded airline traffic across Indonesia and into Malaysia and Burma.

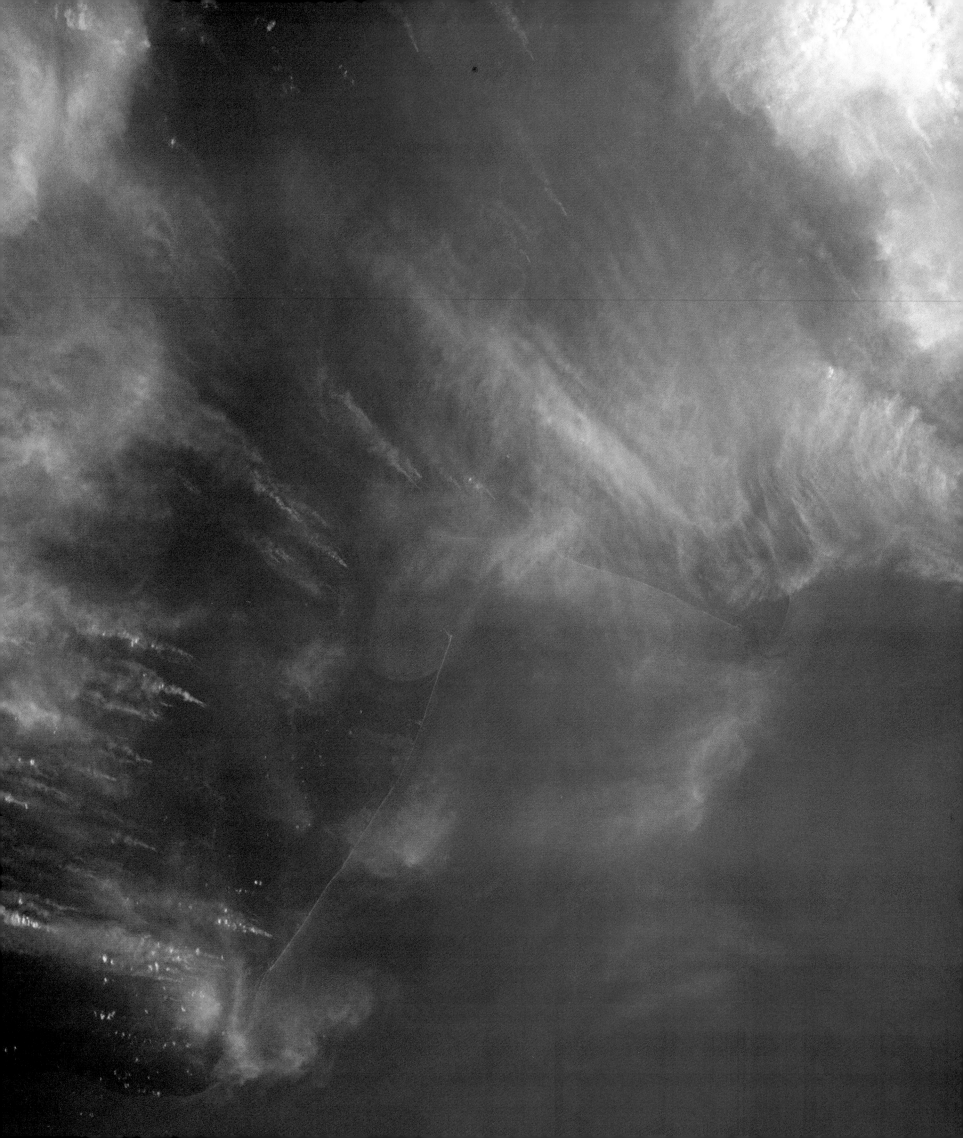

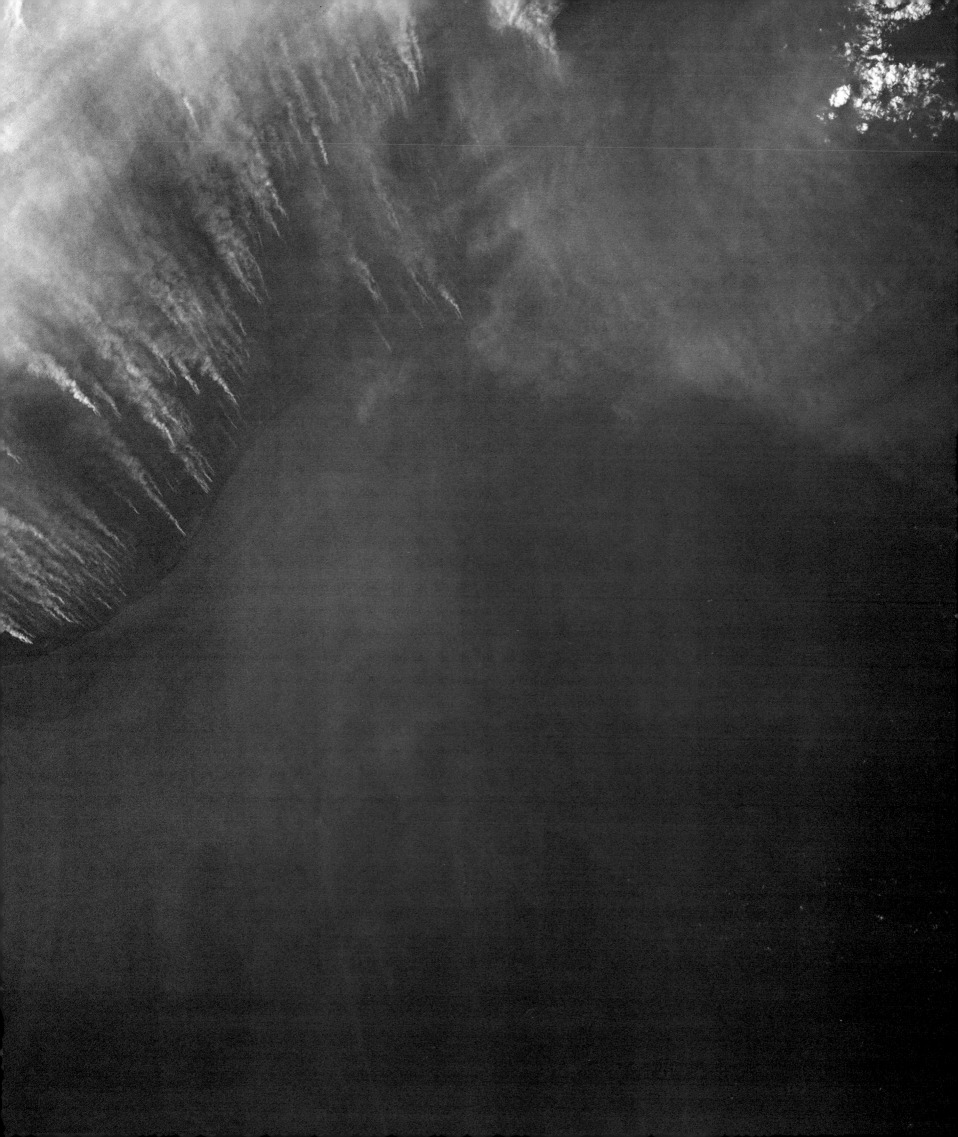

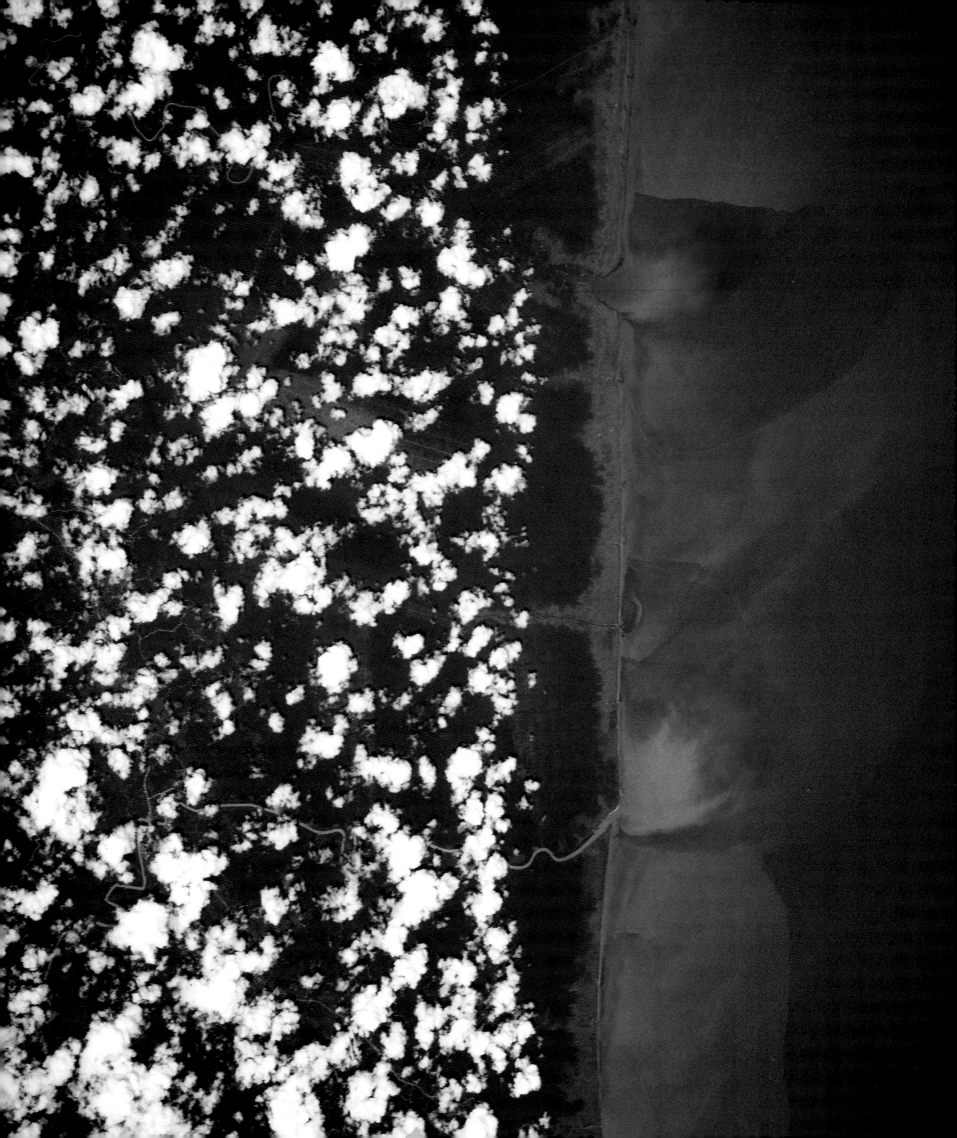

Sarawak's Coastal Forests
LEFT

Large areas of forest are being cut for timber exports from Sarawak, the Malaysian section of Borneo. This area of the Sarawak coast from the Kakus River (top) to the Balingian River (bottom) has the typical pattern seen when timber exploitation begins in a tropical forest. A coastal or river edge strip is first cut (light green). Forest cutting proceeds up the river valleys because there are no roads. Later, lumber seekers build roads to connect middle and upper river valleys and gain access to forests between the rivers. The rivers here drain seaward through tropical peat bogs from 3,500-foot mountains. Soil erosion has increased dramatically, muddying rivers all the way to the sea.

The Coast of Borneo

Eastern Kalimantan (Indonesian Borneo) has high-grade oil. The wellheads and service roads of two oil fields here lace the Mahakam River Delta. Inland is Samarinda (right center edge), the international center for training forest firefighters. It was threatened repeatedly by forest fires during the droughts of the 1980s and 1990s. One of these fires consumed an area nearly the size of Switzerland.

More than half of Indonesia's 200 million people live on the island of Java. Trying to redistribute the population, the government encourages families to move from Java north to Kalimantan, west to Sumatra, and east to Sulawesi and Irian Jaya.

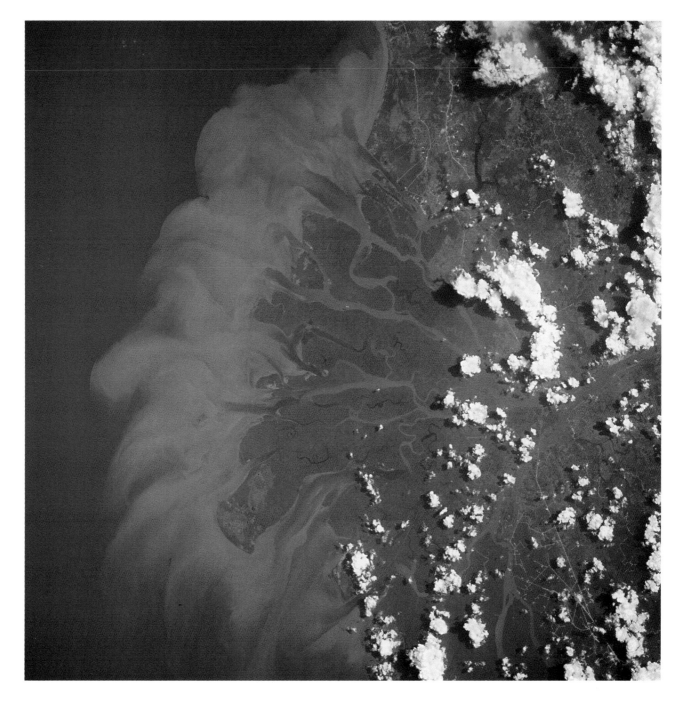

p 136
p 137

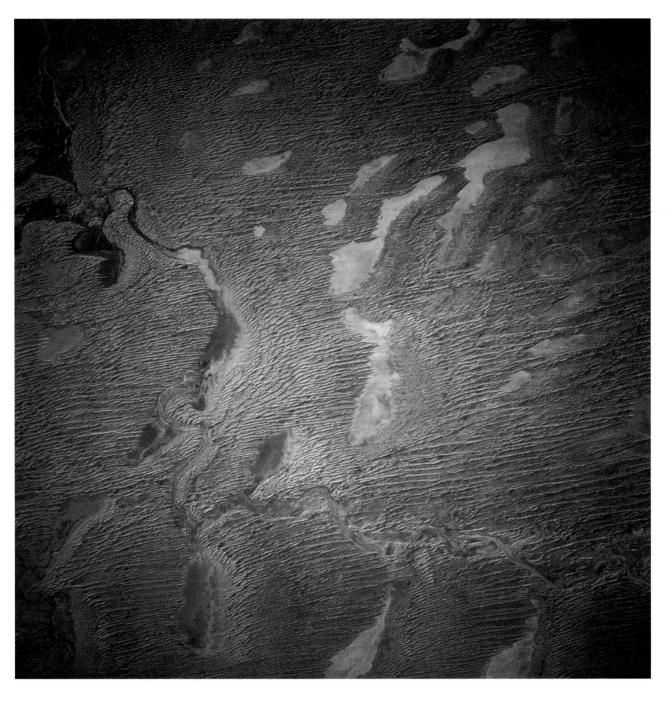

Simpson Desert, South Australia
LEFT

A small, dry creek bed snakes through a field of sand dunes just north of Lake Eyre (out of the view to left). Rivers here seldom flow. But through the millennia they have washed countless tons of sand into the Eyre Basin from the north. Southerly winds slowly blow the sand back toward the north (left to right). The wind has built the sand into long, straight dunes. Fine details—such as differing dune arrays following the outline of the dry lakes (white patches)—make this field of dunes one of the most beautiful anywhere. The dry lakes were full at times in the past, reminding us that most of the world has seen dramatic climatic changes many times in the last two million years.

Lake Eyre, South Australia

At 52 feet below sea level, multicolored Lake Eyre is the lowest point in Australia. The center of Australia is so dry that the huge area drained into Lake Eyre brought water to the lake only five times in this century. In this view one lobe of the lake still has water after unusually heavy rains in 1990. The red-brown color may be algae in the strongly salty water. The interior of Australia is still remote: the first time this area was crossed by an explorer was only a half century ago, in 1939. Australia's large cities all lie along the coasts in the wetter climates.

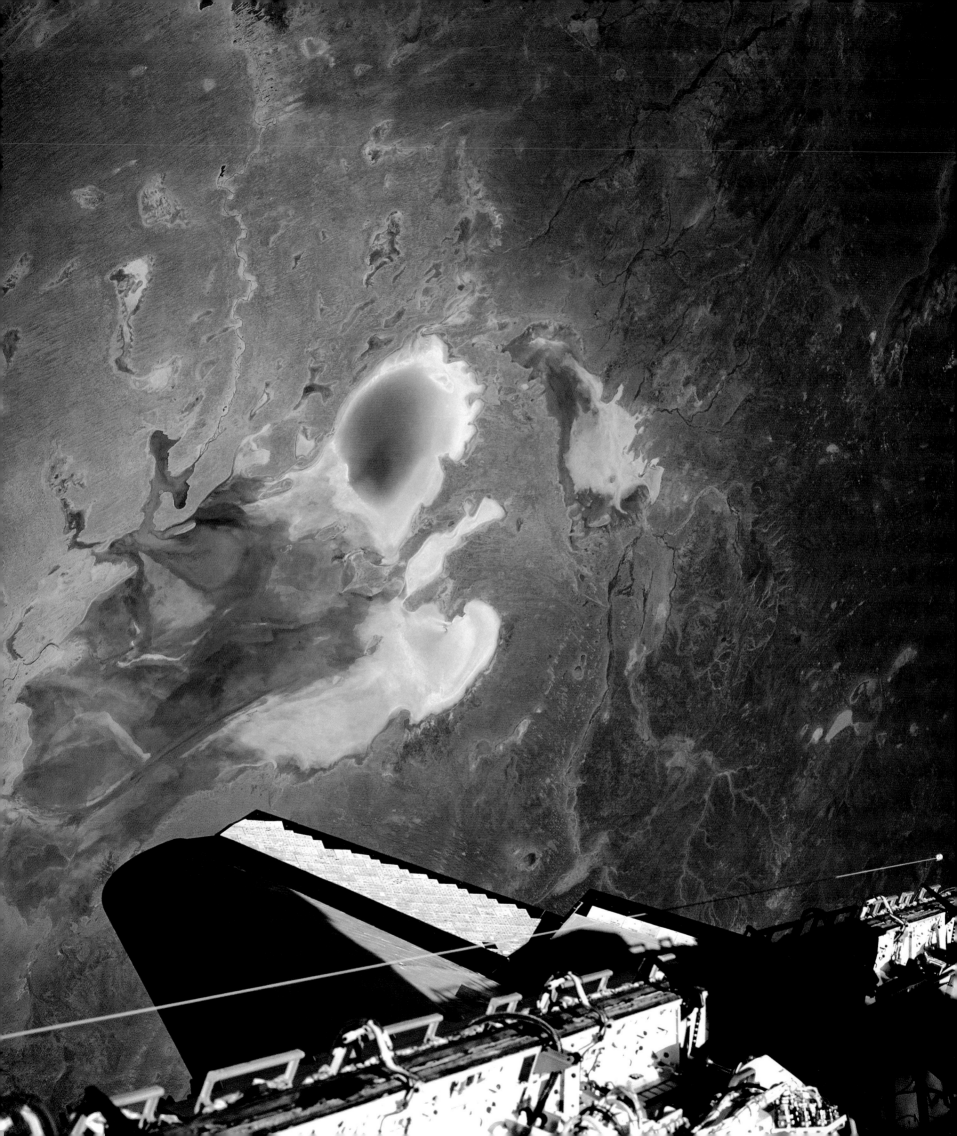

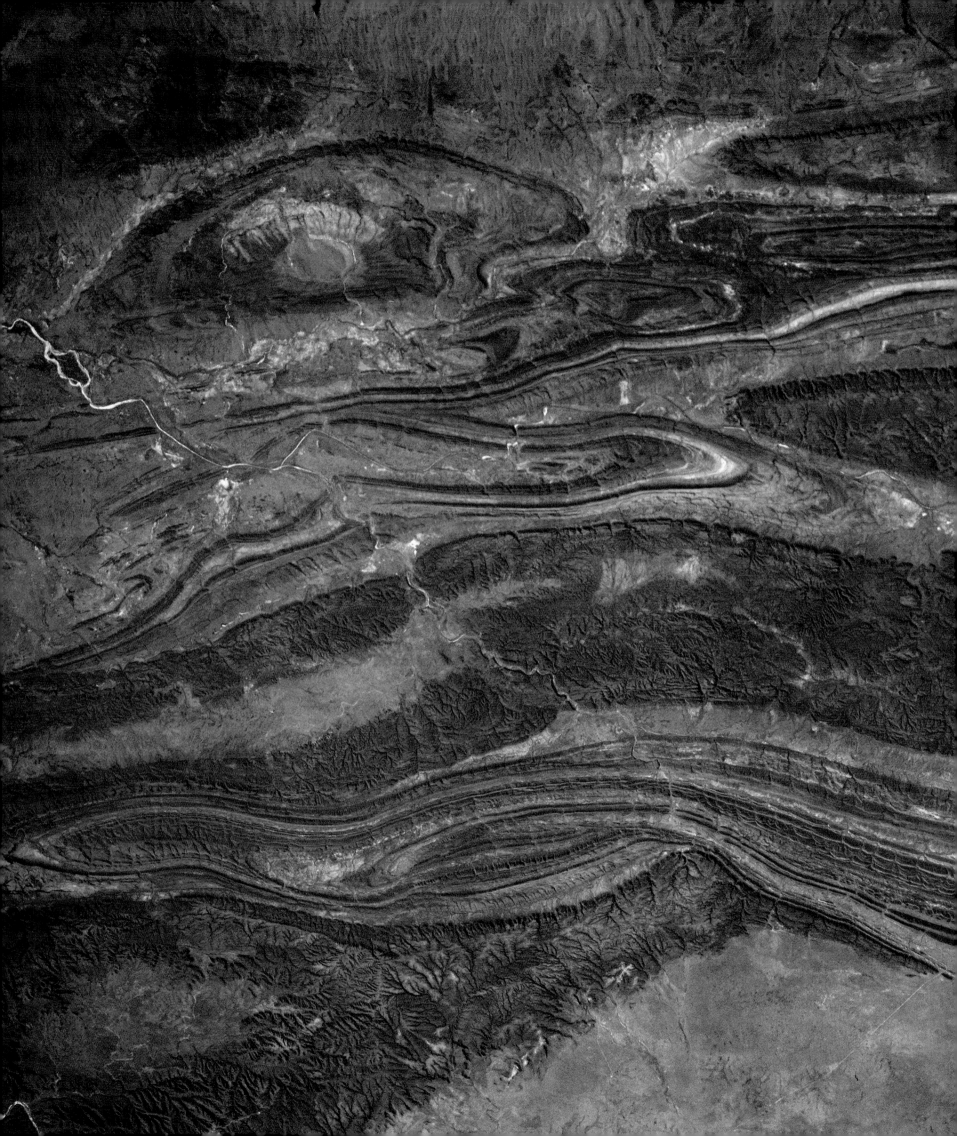

Macdonnell Ranges, Northern Territory, Australia

The Macdonnells are a landmark for astronauts in the middle of Australia because of the flowing lines these mountains draw in the desert. Patterns like these result after thin layers of rock are folded and faulted by forces within the Earth's crust. Tilted layers are then eroded by wind and water to reveal elaborate oval patterns of the sheared-off folds. The Macdonnell Ranges are the highest parts of Australia's arid center. Before the railway was built to Alice Springs (just east of here), Afghan camel drivers delivered everything from mail to passengers. Now tourism is the main industry. So far apart are cattle stations (ranches) in the red center of Australia that until recently schoolchildren attended class by tuning shortwave radios to the "School of the Air."

Time whittled away on the 370-million-year-old sandstone (above) to create "beehive" domes.

Cloud Waves, South Australia

When wind blows at right angles across a hill or mountain with a flat crest, a series of waves, like ocean waves, can be set up in the atmosphere on the downwind, or lee, side of the hill. The high parts of the waves are cooler and form clouds, but the lower parts are warmer and the cloud may evaporate. The result is a series of clouds parallel to the ridge crest. Here a long train of waves is being generated by wind blowing from bottom left to top right. Shadows from the clouds, falling on the ground beneath, add contrast to this striking pattern.

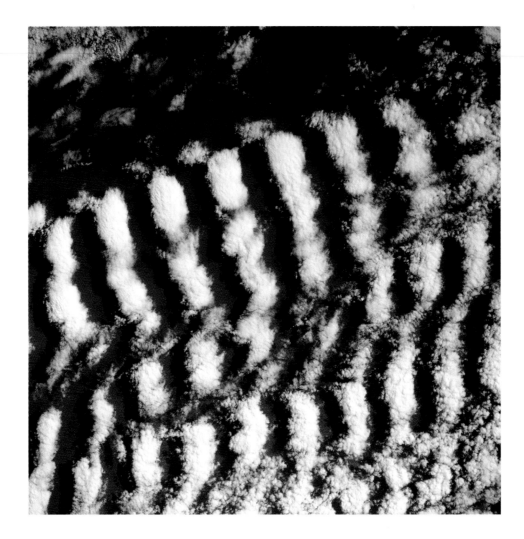

Vortex Clouds, Western Australia

Along the coast of Western Australia clouds take on dramatic shapes. Here the sea is cloud-free and reflects the sun brilliantly (top). But over the land, pointed clouds have formed as a result of southerly winds blowing over the Chichester Range (left side of the photo). The pointed clouds appear to be vortices—horizontal spirals of air—with each spiral related to the highest parts of the mountains directly upwind. Mountains locally disturb the smooth flow of air enough to generate clouds. Although this effect is common, pointed clouds are not. The small town of Dampier lies under the cloud at top right, 190 miles east of Australia's North West Cape, and north of the remote Hamersley Range. Some small mountain-lee cloud waves can be seen below and to the right of the center of the photo.

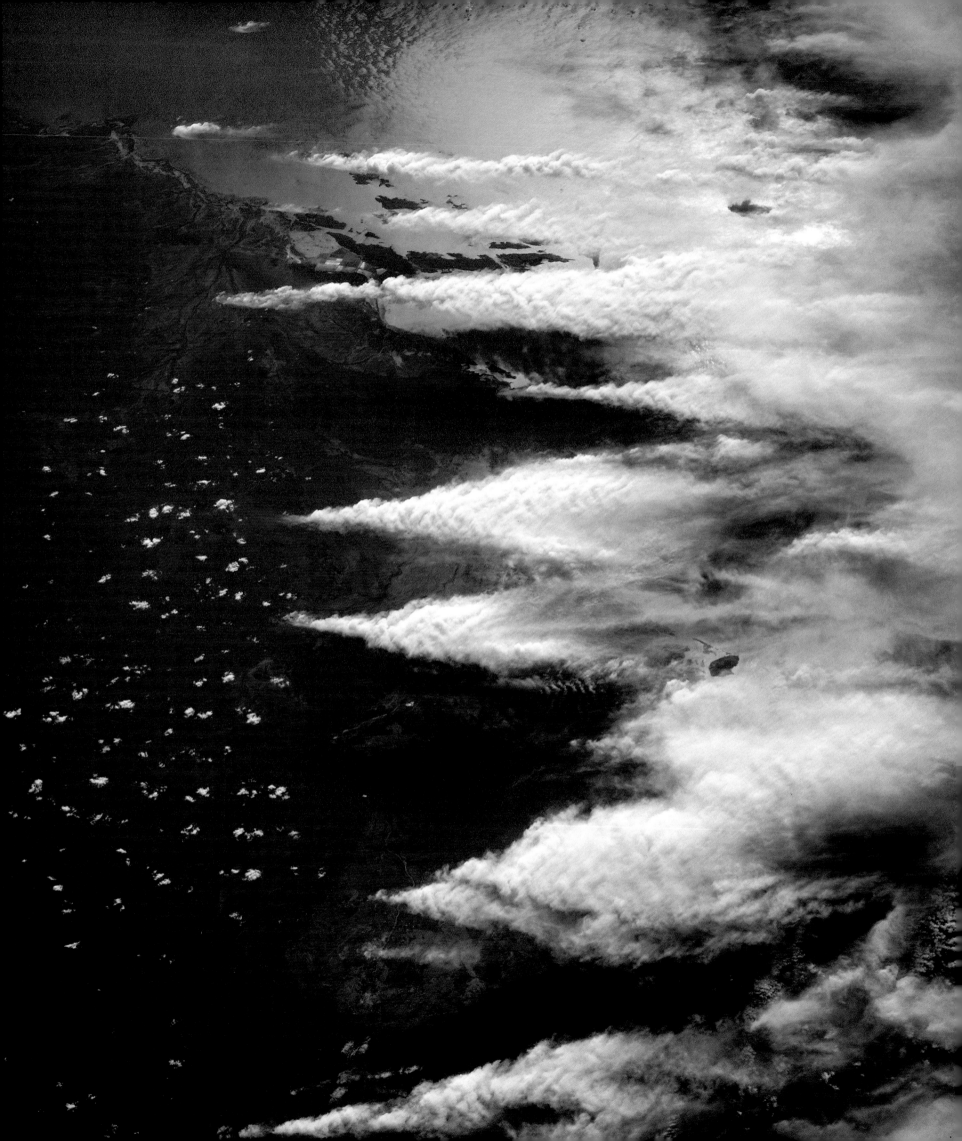

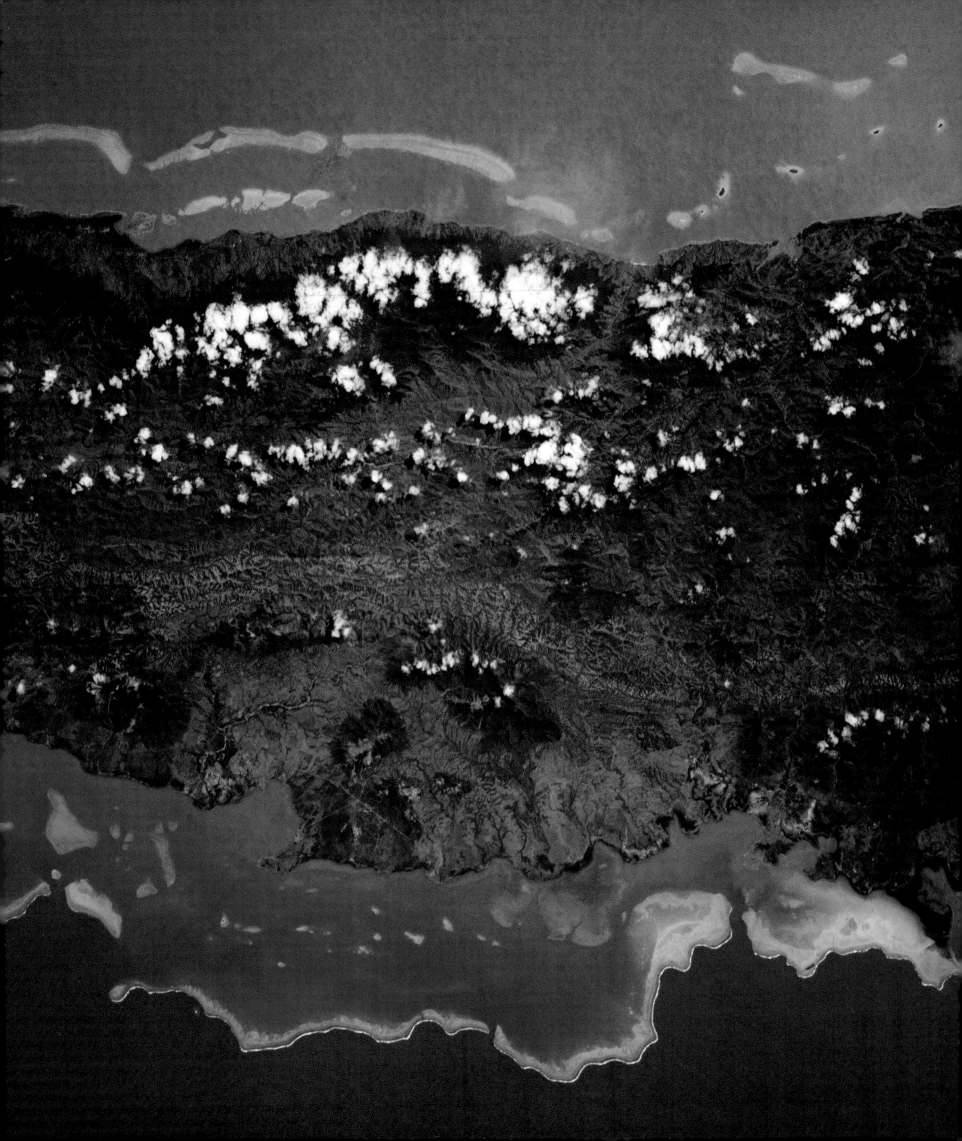

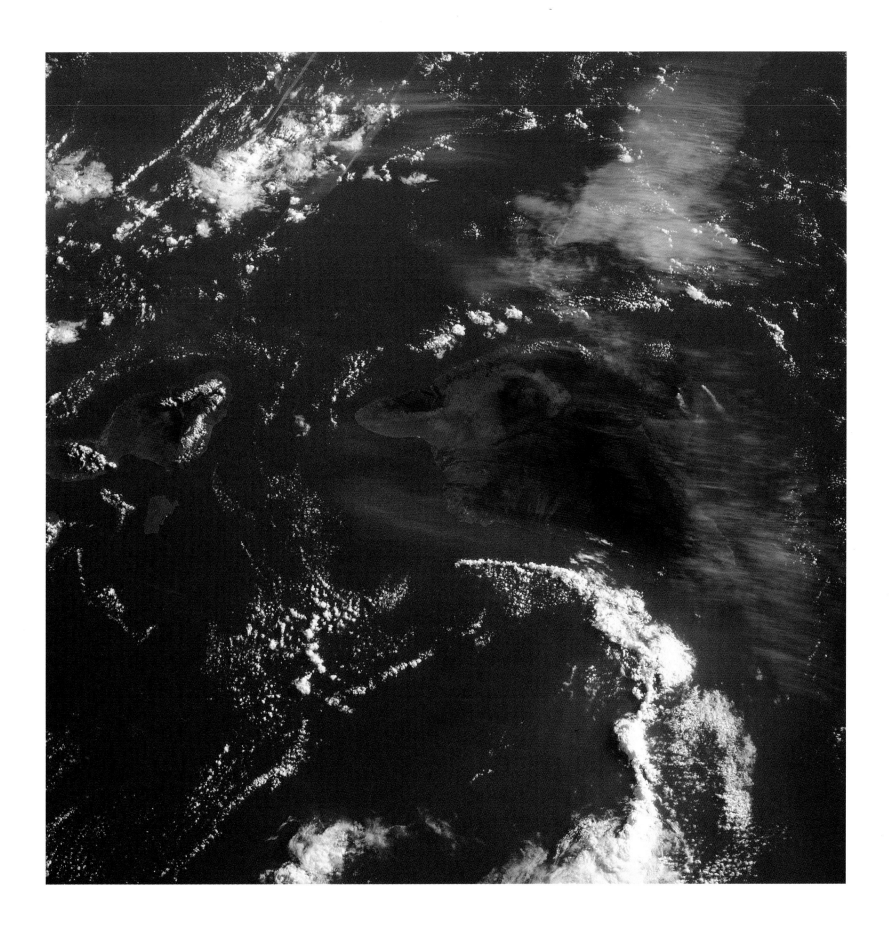

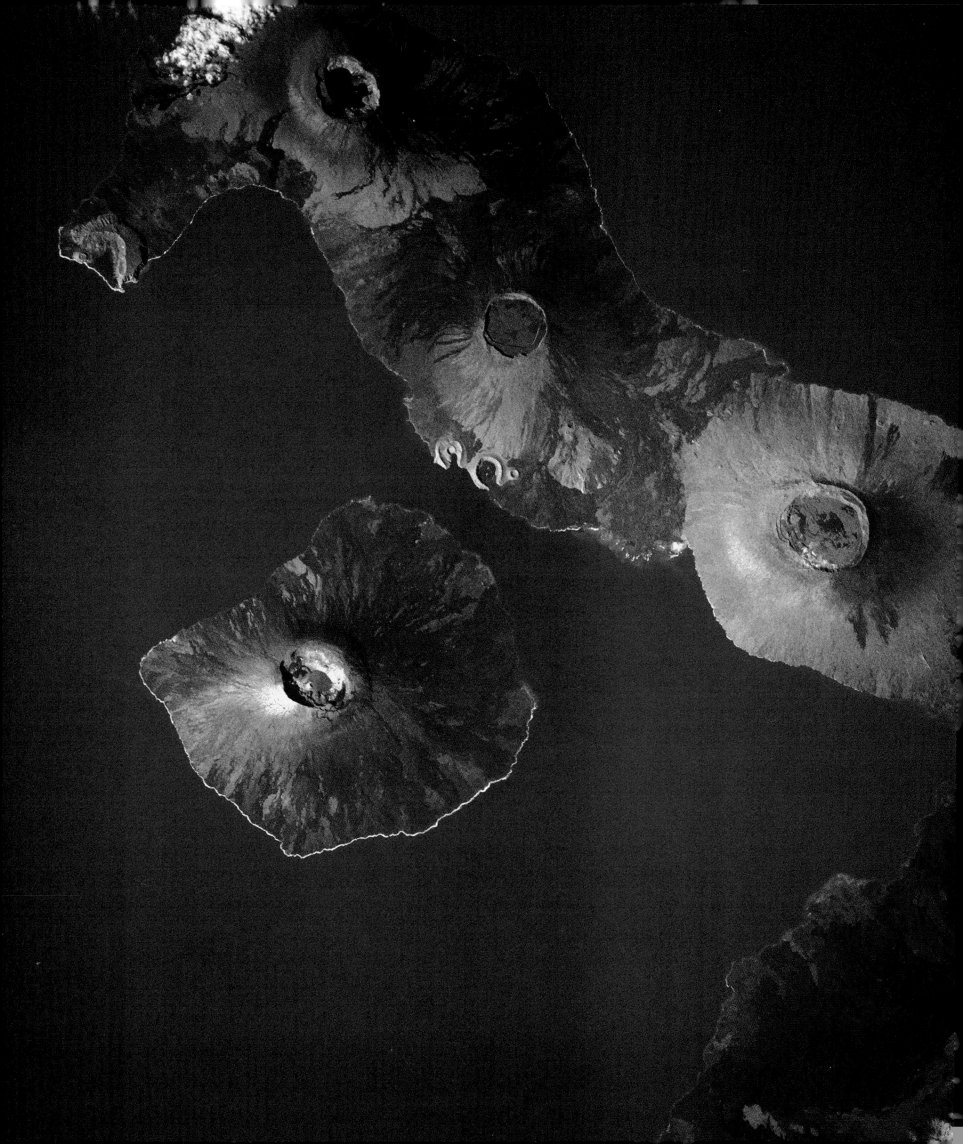

The Galápagos Islands

Modern scientists have a special place in their hearts for the Galápagos Islands. Adaptations by finches, 600 miles from their origins on the South American mainland, were some of the most striking examples of natural selection that Charles Darwin found on his explorations in the 1830s. Insect-eating finches were the first to arrive. From these more than twelve species have since evolved. Some now eat fruit and some eat seeds. The finches use a variety of habitats, from trees to cacti, and have even adapted to life on the hard ground. Flightless cormorants and giant tortoises have also evolved in the special conditions of the islands. (Galápagos is an archaic Spanish word for tortoise).

Volcano Darwin is the middle volcano on the big island of Isabela, which is made up of a line of coalesced volcanoes. Lava recently flooded down to the sea from Fernandina (the smaller island in the photo), burning cacti and killing fish. Marine iguanas, attracted by the heat of the lava, climbed onto the hot lava and died there. Two volcanic craters are seen in a seabird's-eye view (photo at right) on Genovesa Island.

DIETER & MARY PLAGE

October Thunderstorms

FOLLOWING PAGES

The crew of the first three-person U.S. spacecraft (Apollo 7) flew in 1968, at a time when Earth's atmosphere was exceptionally clear, as this photo shows. Astronaut photographs taken today, using much the same optical systems and recording films, seldom have this level of detail all the way to the horizon, leading scientists to believe that the atmosphere has been less transparent in the 1980s and 1990s than it was a quarter century ago.

Thunderstorms stretch to the horizon, mixing water vapor from the ocean into the air. In all the solar system, only Earth is of the proper size and is located at just the correct distance from the heat of the sun to have ice, liquid water, and water vapor, all existing above her surface.

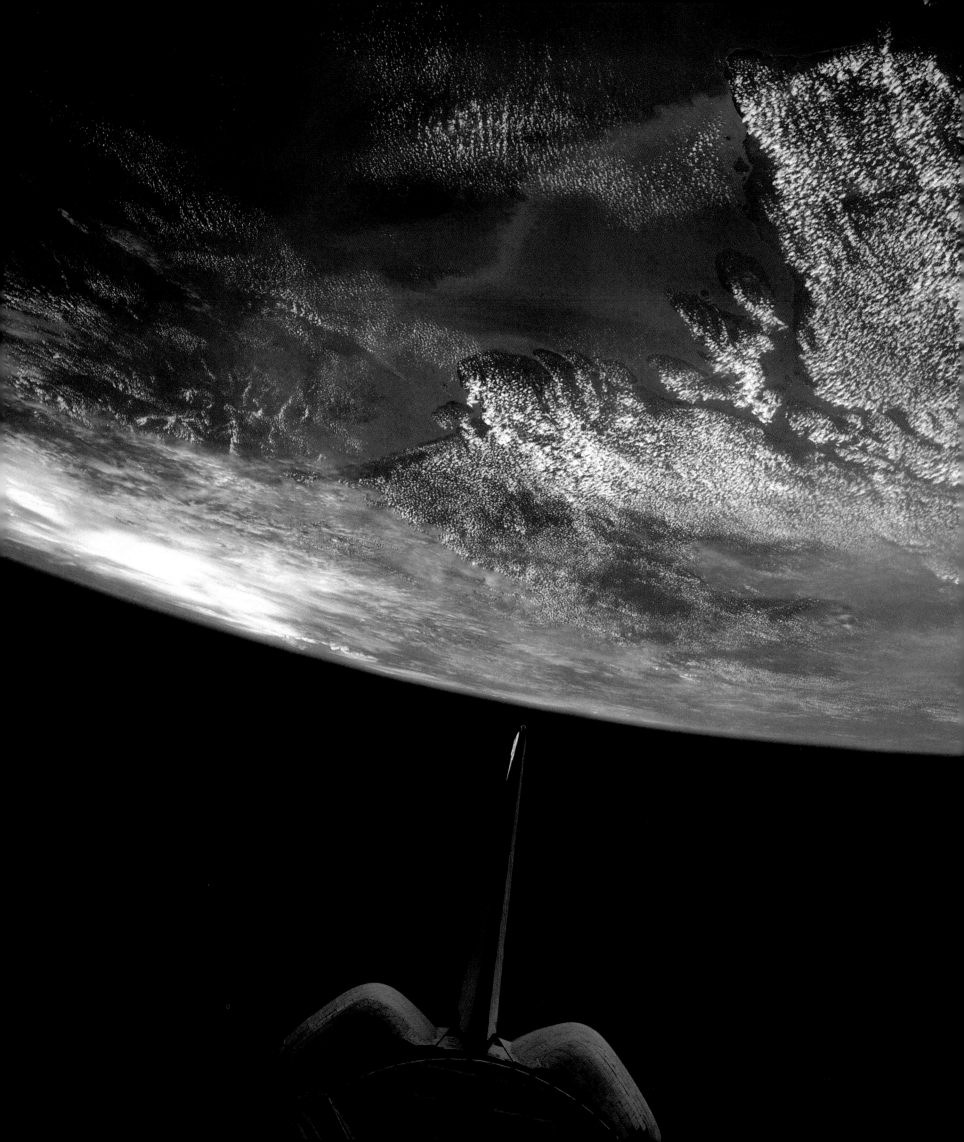

Middle and South America

Mouth of the Amazon

The 4,000-mile-long Amazon carries more water to the ocean than the seven next largest rivers combined. Its muddy mouth is 200 miles wide. Strong ocean tides back up the slow waters of the Amazon more than 400 miles inland, slowing the formation of a delta at its mouth. An ancient delta, formed when glaciers reduced sea level, lies submerged on the continental shelf. As on most days in this part of South America, clouds cover the land but do not hover over rivers.

THE COLORS OF THE CARIBBEAN ARE THE MOST BEAUTIFUL of any oceanic colors seen from orbit. As we watch, the waters of the Caribbean change from shallow turquoise banks to the cobalt blue of the abyss. I remember, as we flew directly along Central America, how thin the land looked with the Caribbean on one side and the Pacific on the other. From inside the Shuttle's cabin, you have a pretty good view of the Earth. Outside, though, the field of view is much wider. Jerry Ross and I were outside, testing equipment for the international space station, when we stopped, looked around, and yelled to Steve Nagel, Ken Cameron, and Linda Godwin (who were inside) to get out the camera with the infrared-sensitive film.

Before the flight, Mike Helfert had said that there was a case of beer waiting for the first crew to get a cloud-free infrared picture of the area around the Panama Canal. (He is especially interested in the ecology there.) Astronauts are easily motivated. There were radio calls that must have puzzled our control team on the ground: "It's clear! Shoot! Shoot! I think I got it. I got it! Tell Mike the beer better be cold." Whatever the ground control team thought, they passed along the information. And the beer was great!

As Steve was shooting the canal, I was watching below. We were flying down the last of the thin band of Central America and into what seemed like a huge wall—the spectacular mountains of Colombia.

Jerry and I got back to work. One of our tasks was to put our boots into retaining clips that allowed us to "stand" on a platform and then test a hand-cranked generator to produce electricity. The work was hard, and produced quite a bit of pressure on our feet. That pressure created the only sensation of "down" that I had on my space walks. For an instant it really seemed that we were impossibly suspended in midair hundreds of miles above the huge forests of Brazil.

Three hours later, I was able to watch as the Andes passed by at sunset. I was near the rear of the cargo bay, and I saw the mountains in their brown and white glory directly over the crew cabin, where my friends were. Just as the full moon appears much larger when it is low enough in the sky so that your eye can compare it with houses and trees, so the Andes appeared huge over the cabin.

Some geologists would tell me that the Andes shouldn't be there. The lighter continent should be sliding west, relatively gently over the heavier rock that makes up the floor of the Pacific. We should have been looking down at a chain of low volcanic islands like the Aleutians and the rest of the Pacific Ring of Fire. But the Andes are 20,000-foot mountains in a range more than 4,000 miles long. One recent idea to explain this mystery is this: The continent is being shoved westward so forcefully by the spreading seafloor in the South Atlantic that its roots collide with the descending ocean plate hundreds of miles below ground, crumpling the leading edge of South America.

When we look over the brown seacoast to the west of the Andes and then over the mountains themselves, we think that there is another ocean to the east long before we can see the Atlantic. A blue haze masks the green forest canopy, fooling our eyes as it stretches as far as we can see. It takes some time to pick out details in the landscape, even after we recognize that it is indeed land. Rivers are the easiest things to see, since they are usually clear of puffy clouds. As we fly from the western highlands to the east, the rivers become larger, and finally they dominate the view as they dump huge quantities of mud into the Atlantic from the young mountains 2,000 miles to the west.

I got the chance to fly over South America at night often during my third mission. The tip of the continent was covered with pinpoints of light and smoke: fires in Tierra del Fuego and Patagonia. Farther north, Brazil's interior was covered with a spider's web of city lights and road lights. I thought of the early airmail pilots, and how much comfort they would have drawn from these friendly lights if they had existed 50 years ago. We flew over Montevideo and Buenos Aires on the last night pass of the flight. I could pick out city street lights. We had run out of high-speed film by that time. I turned on the amateur radio and talked to some amateur radio operators who were still awake on the Pampas below us.

After the space walks were finished, Jerry Ross, Linda Godwin, and I stayed up very late one night to look out the windows. We floated "upside down" in the front windows so the Earth appeared "below" us as we flew along. It happened that during our hour together we passed over South America at night. There was a half moon, and it seemed to us that we were floating in the gondola of a giant balloon as we drifted without any vibration across the moonlit continent. We stayed there, whispering to each other, and watching meteors burn up below us until dawn's blue glow showed over the Persian Gulf.

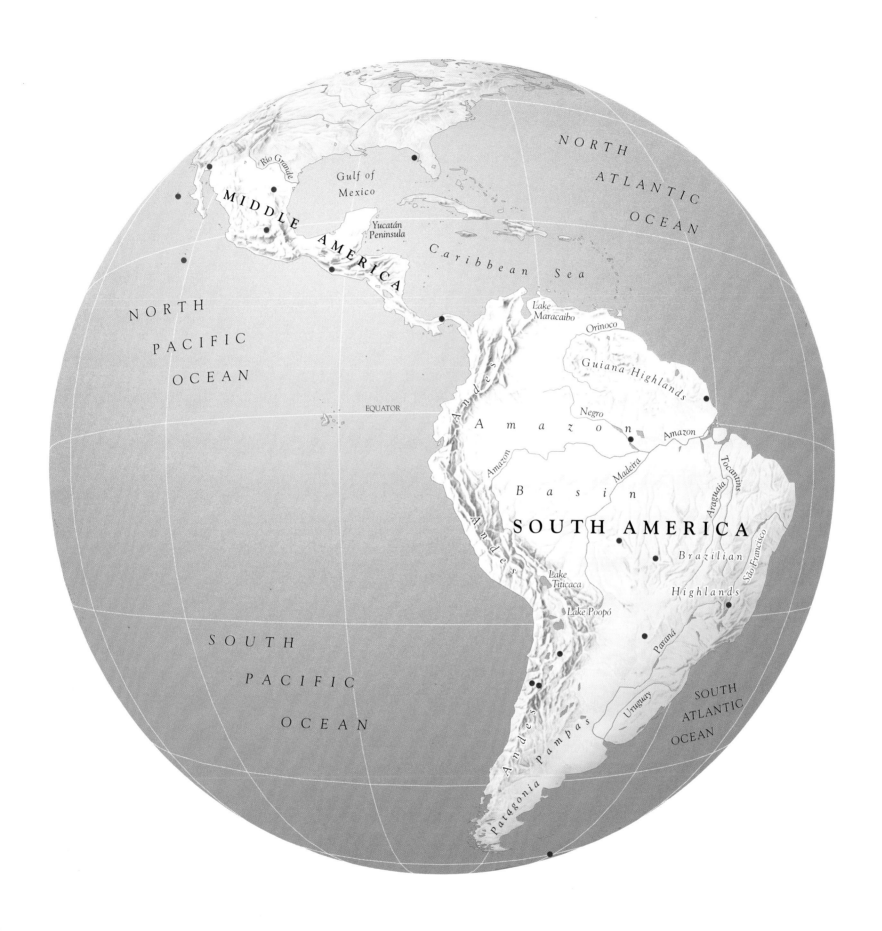

NORTH ATLANTIC OCEAN

NORTH

MIDDLE AMERICA

Río Grande

Gulf of Mexico

Yucatán Peninsula

Caribbean Sea

NORTH

PACIFIC

OCEAN

Lake Maracaibo

Orinoco

Guiana Highlands

Negro

Amazon

Amazon

Andes

A m a z o n

Madeira

Tocantins

EQUATOR

B a s i n

Araguaia

SOUTH AMERICA

Andes

Brazilian

São Francisco

Lake Titicaca

Highlands

Lake Poopó

SOUTH

Paraná

PACIFIC

Andes

Pampas

Uruguay

SOUTH ATLANTIC OCEAN

OCEAN

Patagonia

● Center point of photograph

TOMASZ TOMASZEWSKI

Volcanoes of Central America

In this east-looking photo of Guatemala, the Pacific Ocean is at the bottom and left and Guatemala City is the light patch near the right center.

Most of Central America's cities are in the highlands. Central America is a raft of land floating westward. At its western edge, it is riding up over another small raft of crust (the Cocos Plate). As Central America shoves the plate down into the hot upper mantle, plate material is melted and floats back up to the surface in a chain of volcanoes that rises to 13,846 feet just inland of the narrow Pacific coastal plain. Throughout Central America rich soils from volcanoes, such as El Salvador's San Vicente (above), provide excellent farmland.

pp 156-157
p 152

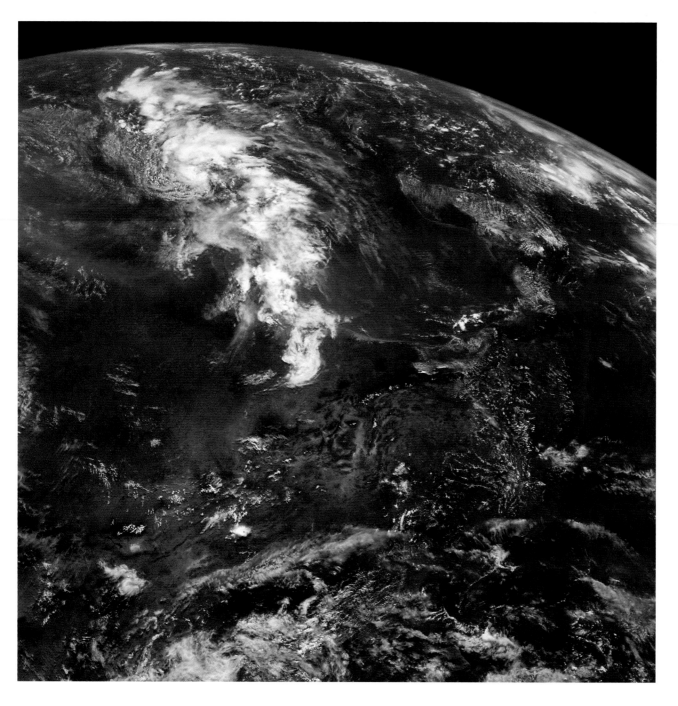

Panorama of Middle America

LEFT

The crew of the first mission to land on the Moon took this photo. It spans more than 2,000 miles–from the Rio Grande in northern Mexico, southeast down the spine of the Sierra Madre Oriental to the Gulf of Mexico and the Yucatán Peninsula (top center). The bulge of Nicaragua appears beyond that. Then the land disappears under thick thunderclouds over Costa Rica (top right). Cuba is the island beyond the Yucatán. The light-blue waters are the Bahama Banks. White Sands and the Carrizozo lava field in New Mexico and Texas oil fields are at the bottom left.

Monterrey, Mexico

Mexico's third largest city, Monterrey, lies at the foot of the Sierra Madre Oriental where the mountains make a unique bend. This makes the city easy to find from orbit. Monterrey is ideally located between Mexico City and the U.S. border, with extensive rail, road, and air connections. The city has benefited from government efforts to attract industry from Mexico City to outlying states. Mexico's second largest industrial center, Monterrey has a population of around 3 million; little more than a century ago, only 30,000 people lived here.

p 159
p 158

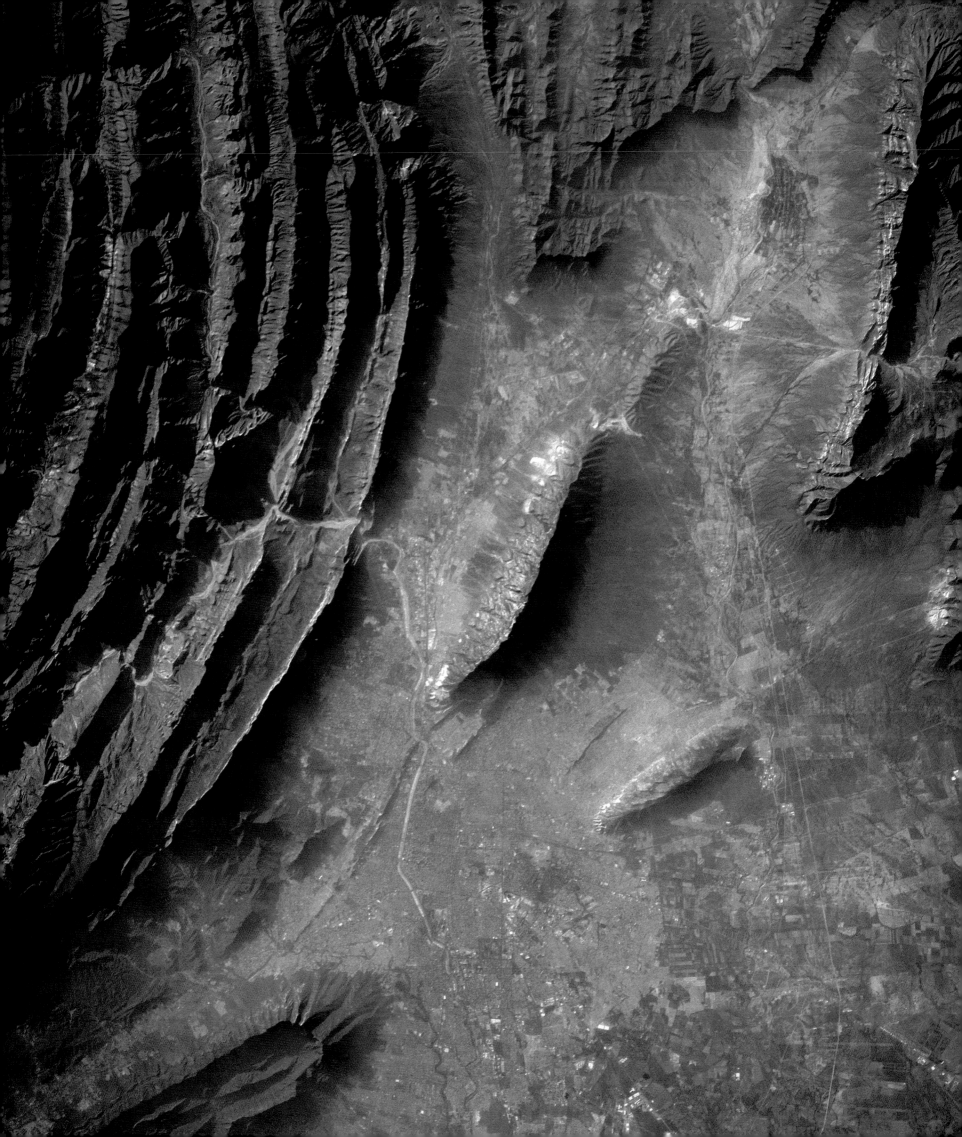

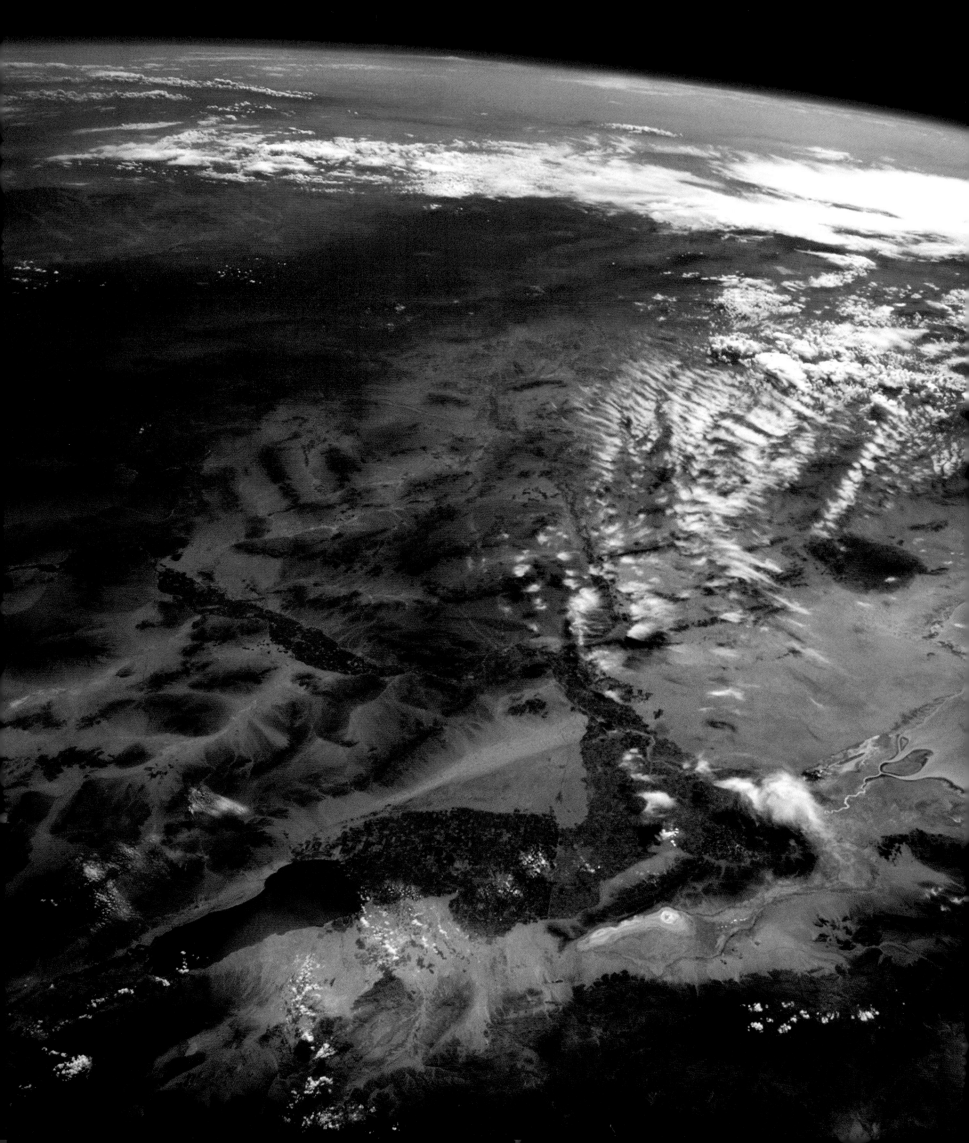

Mouth of the Colorado

The motions of Earth's crust have forced the U.S. Southwest up, and the land cracked as it expanded. It bleaches in the sun except where it is watered by the mighty Colorado. The river (flowing into the picture from the left) irrigates farmlands in the United States, and empties into the north end of the Gulf of California (right). Seven states from Wyoming to Arizona, as well as Mexico and certain Native American tribes, all have legal claims to some of the water supply of the Colorado River Basin. Only a salty trickle now flows all the way into the Gulf of California. In contrast to the yellow dune sands of the Altar Desert (center), the farmlands appear as green areas along the river and to the south of the 30-mile-long Salton Sea, the pear-shaped lake at the lower left.

Islands in the Wind
FOLLOWING PAGES

Wind flows around islands in much the same way that water flows around the hull of a ship. Clouds like the low ones in these two photos allow us to see the flow of air in the wake of the islands. The eddies and swirls in the wake captured behind Mexico's Guadalupe Island (page 162) cover 150 miles. Those from Socorro Island (page 163), 700 miles to the southeast, cover 40 miles. The phenomenon is the same for both islands.

The rotating air that spills off the sides of the islands is a type of turbulence that was first studied in connection with aircraft and rockets by Dr. Theodore von Kármán at the Aachen Technical University in Germany. He later cofounded the California Institute of Technology's Jet Propulsion Laboratory, NASA's center that sends spacecraft to explore the exotic worlds of our solar system.

pp 160-161
p 162
p 163
pp 164-165

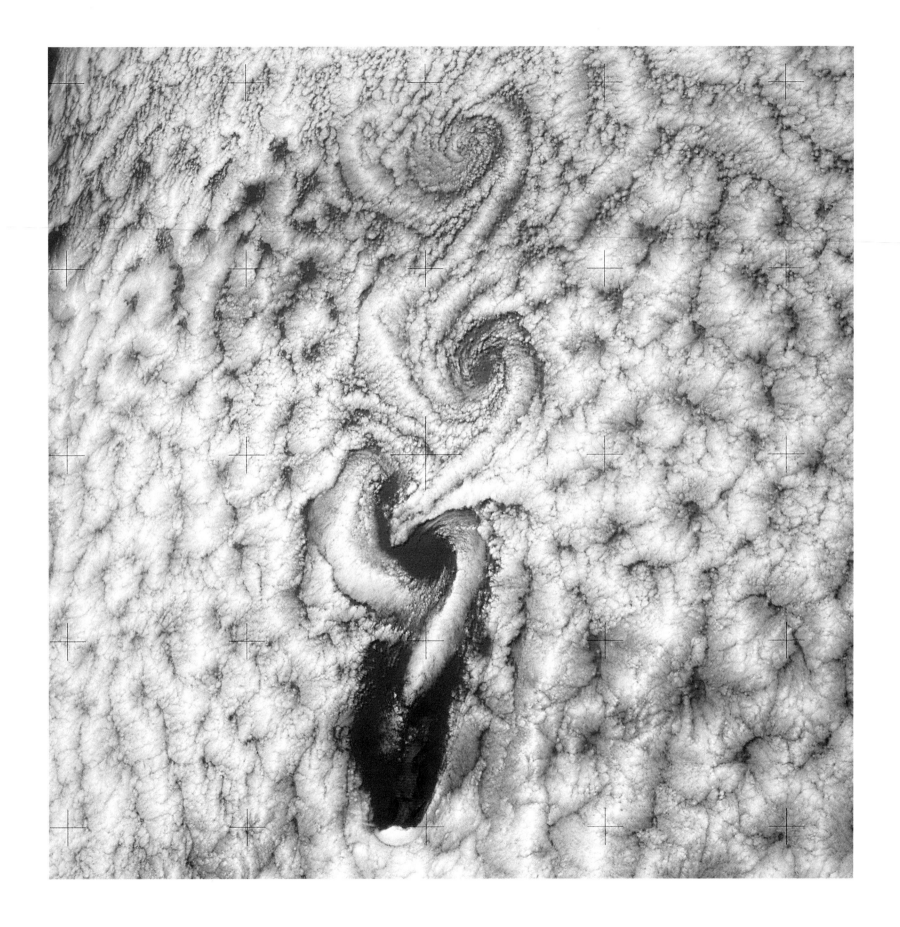

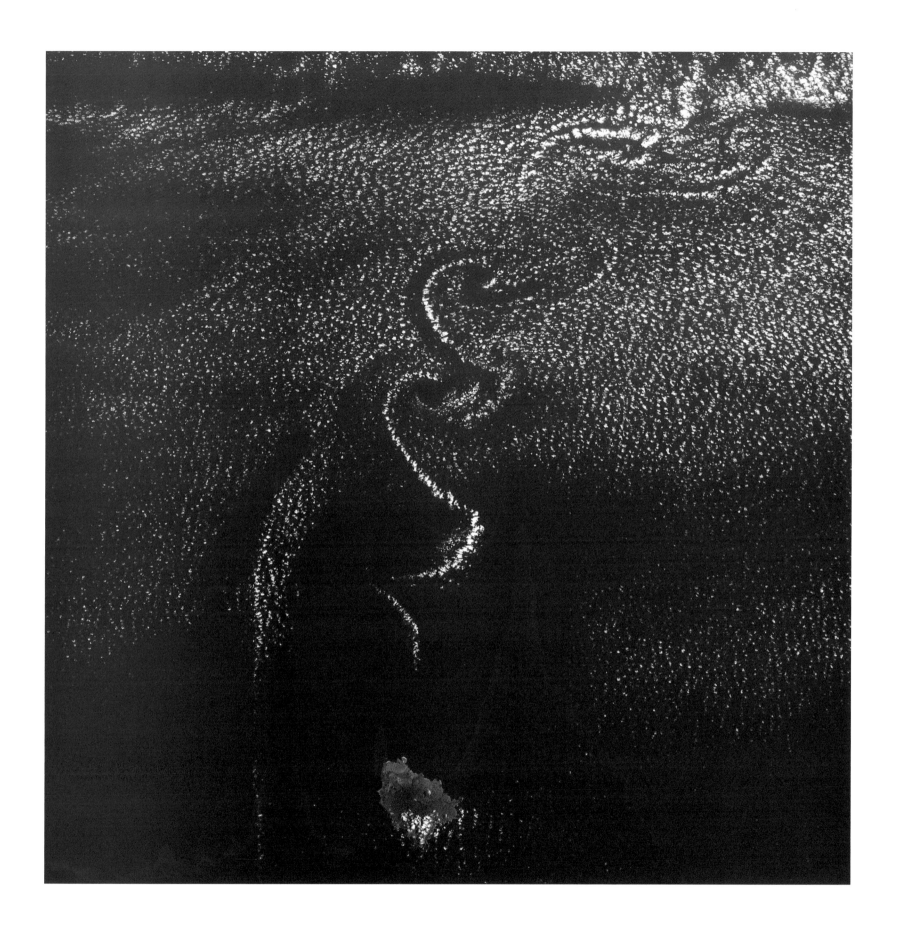

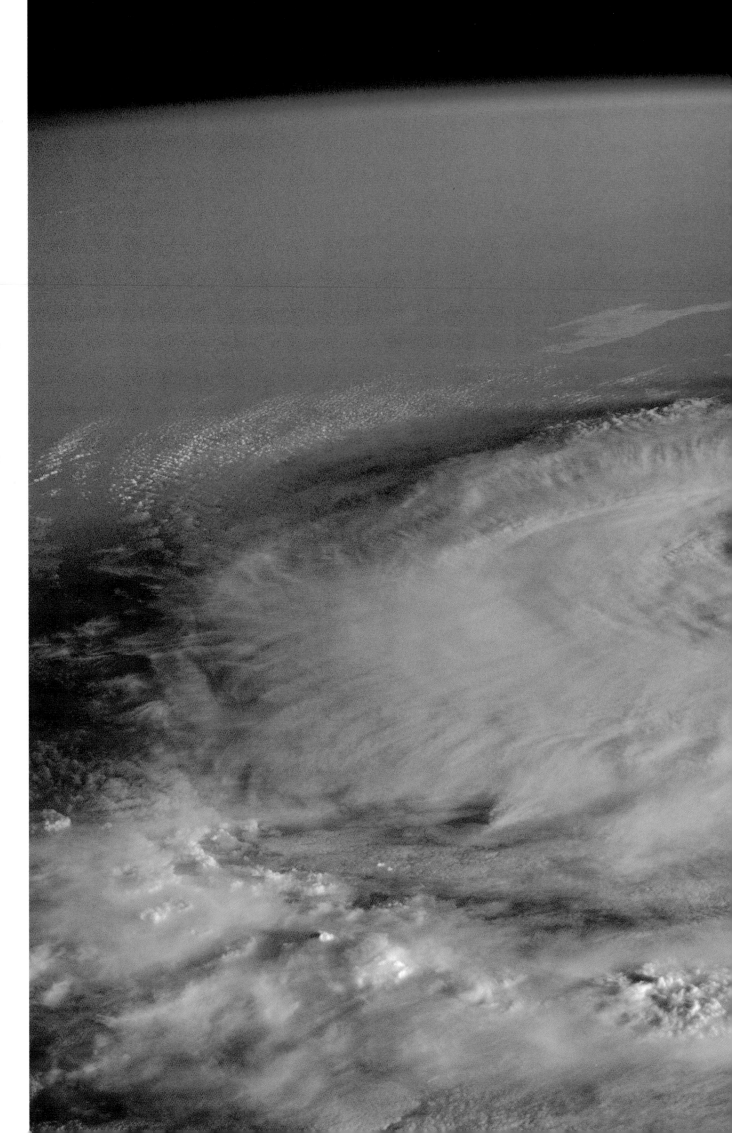

Hurricane Elena

On Wednesday, August 28, 1985, this hurricane passed over Cuba, just south of Havana. Then, strengthening, it moved northwest into the Gulf of Mexico. By dawn Friday it was headed directly for New Orleans, and residents of the upper Florida coast began to relax. But Friday night Elena headed due east, coming to a stop just west of Tampa. Satellite measurements taken through the night gave residents the warning they needed to secure their property for the onslaught of wind and flooding that lasted through Sunday afternoon. The crew of *Discovery* took this photo an hour after dawn on Sunday. Elena then changed course again and came ashore in Mississippi on Monday morning.

Many lives and uncounted billions of dollars in property damage have been saved by timely storm warnings from the U.S. network of weather satellites. Scientists and spacecraft engineers are continually improving these satellites to give better early warnings of storms, as well as track air and water poisons, and climate changes.

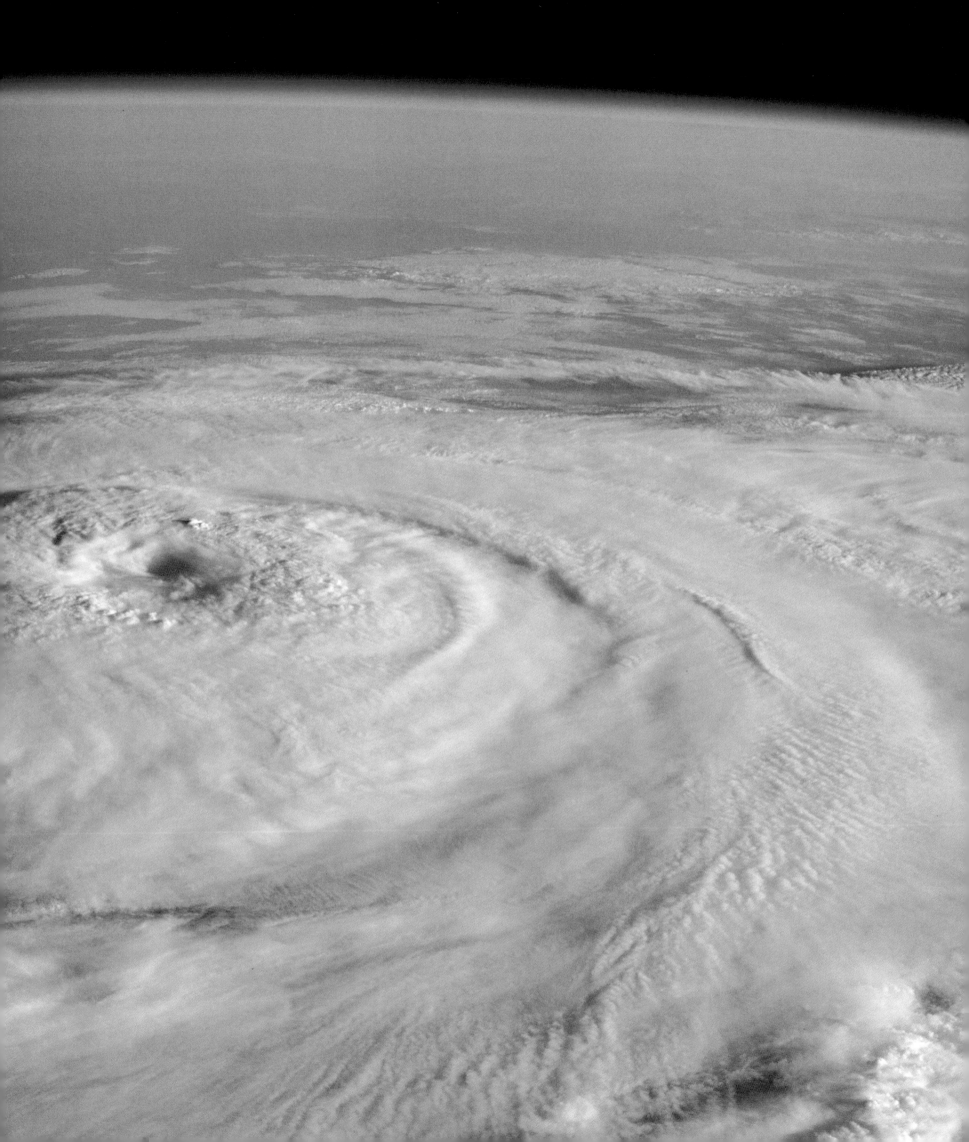

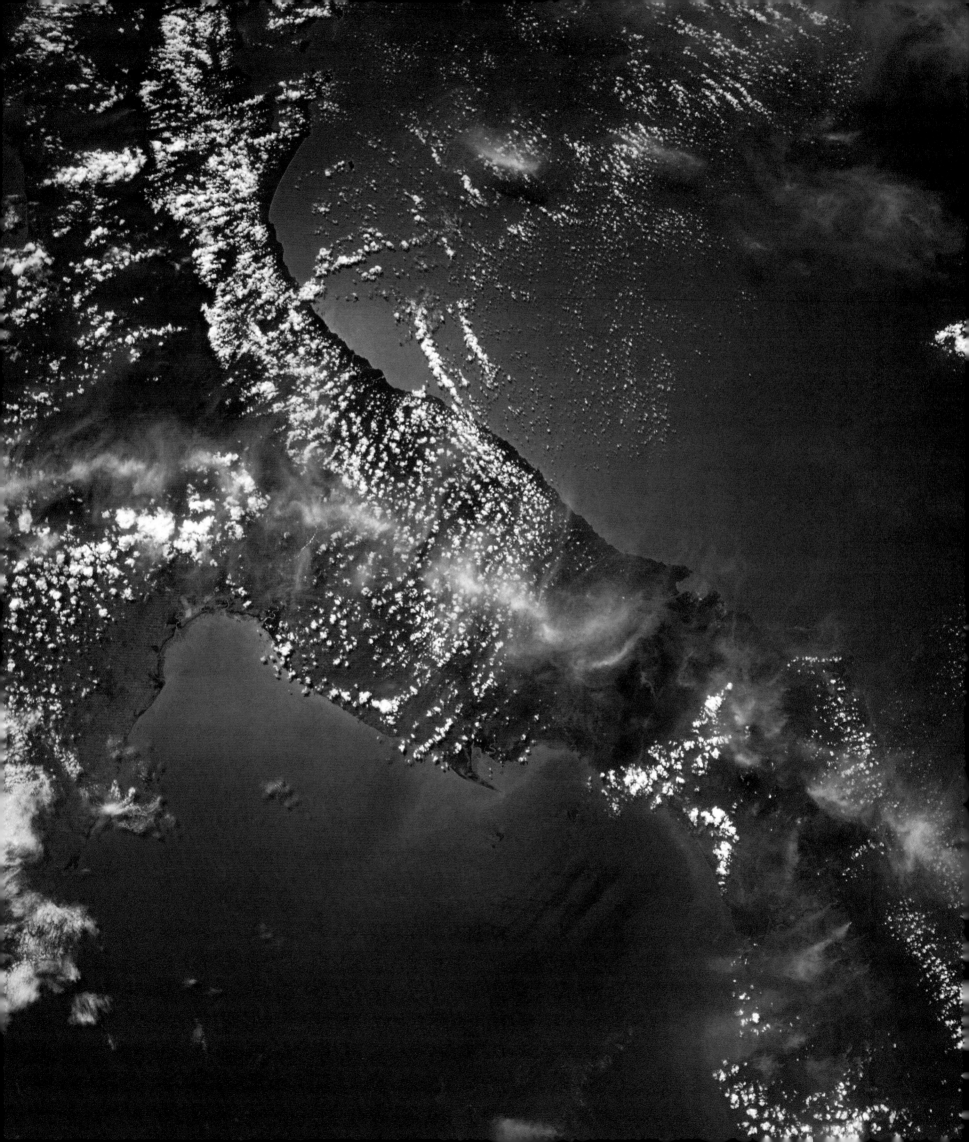

Panama and the Panama Canal

The narrow Isthmus of Panama connects the Americas. This slender land is pierced by the Panama Canal, the important sea-link through which 35 to 40 ships pass each day. Water necessary for the lock-filling operations of the canal comes from two main storage reservoirs; the larger is Gatun Lake (photo at right). Deforestation in lowland areas of Panama has been extensive since the 1950s except along the ten-mile width of the Panama Canal area. Only about one-third of the forests in the canal's watershed remain undisturbed. When tropical rains come to the isthmus, the unprotected soil washes into the Gatun Lake reservoir, which may reduce its capacity in the future. As Panama City's population grows, so does the city's need for water, which could compete with canal water needs in the future.

GEORGE F. MOBLEY

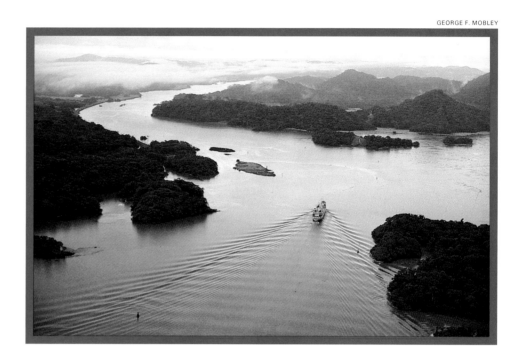

Snowy Altiplano Volcanoes, Argentina
FOLLOWING PAGES

The low early morning sun casts long shadows from volcanoes along the border of Argentina and Chile. The high desert is known as the Altiplano, a plain mostly above 12,000 feet. Most peaks in the picture—many of them volcanoes—reach 20,000 feet. The highest in the view (center top) rises 23,240 feet above sea level. Very few people live in this dry, cold, inhospitable mountain country. Farther north, the Altiplano becomes the wetter homeland of native Andeans, descendants of the Incas.

pp 166-167

pp 168-169

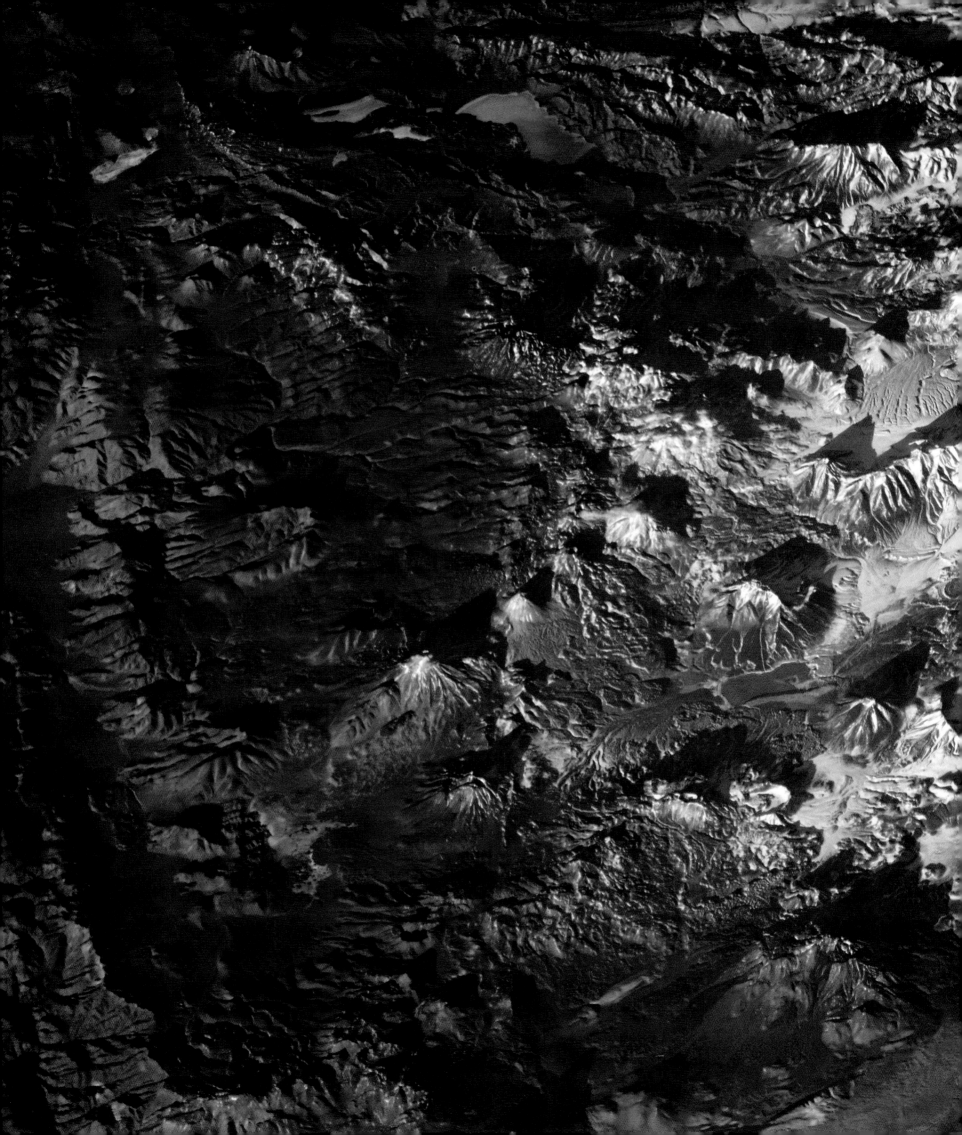

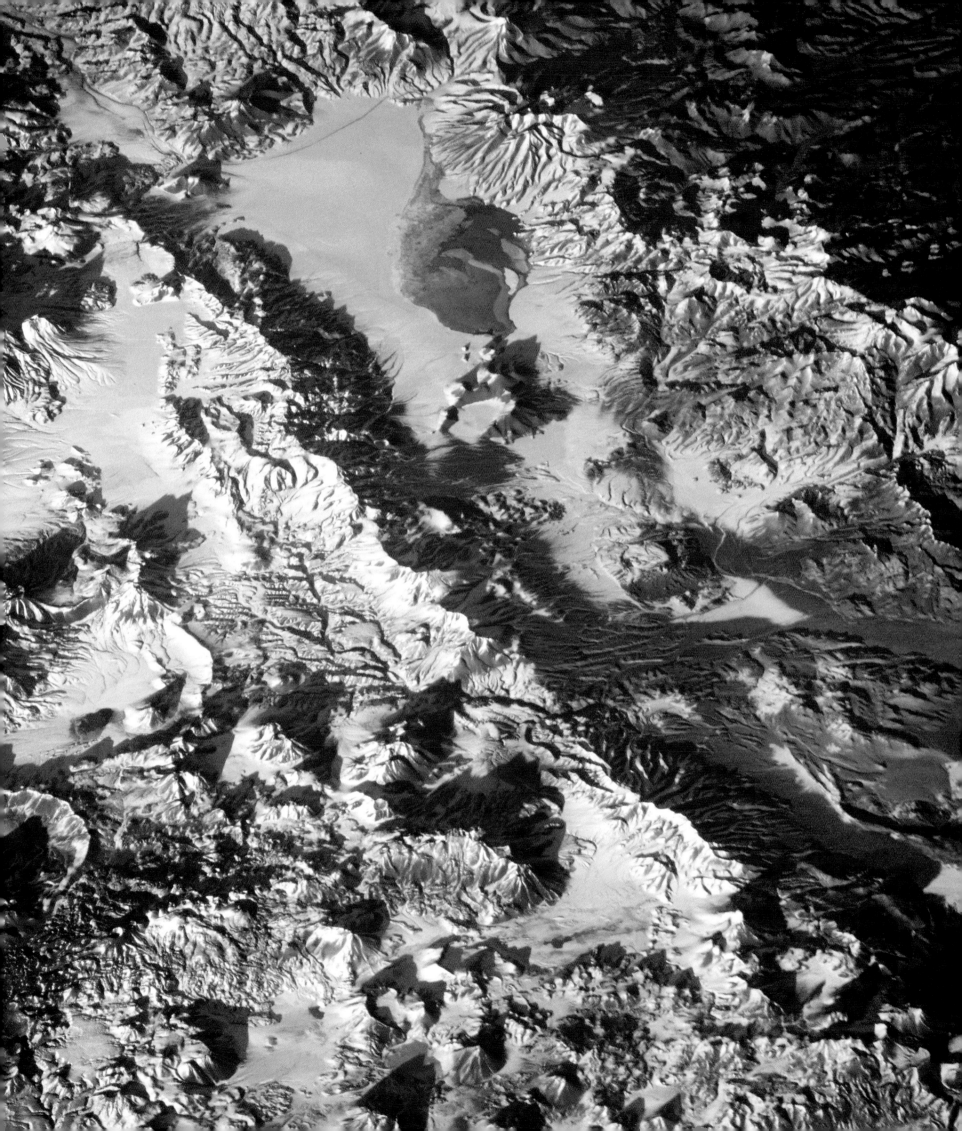

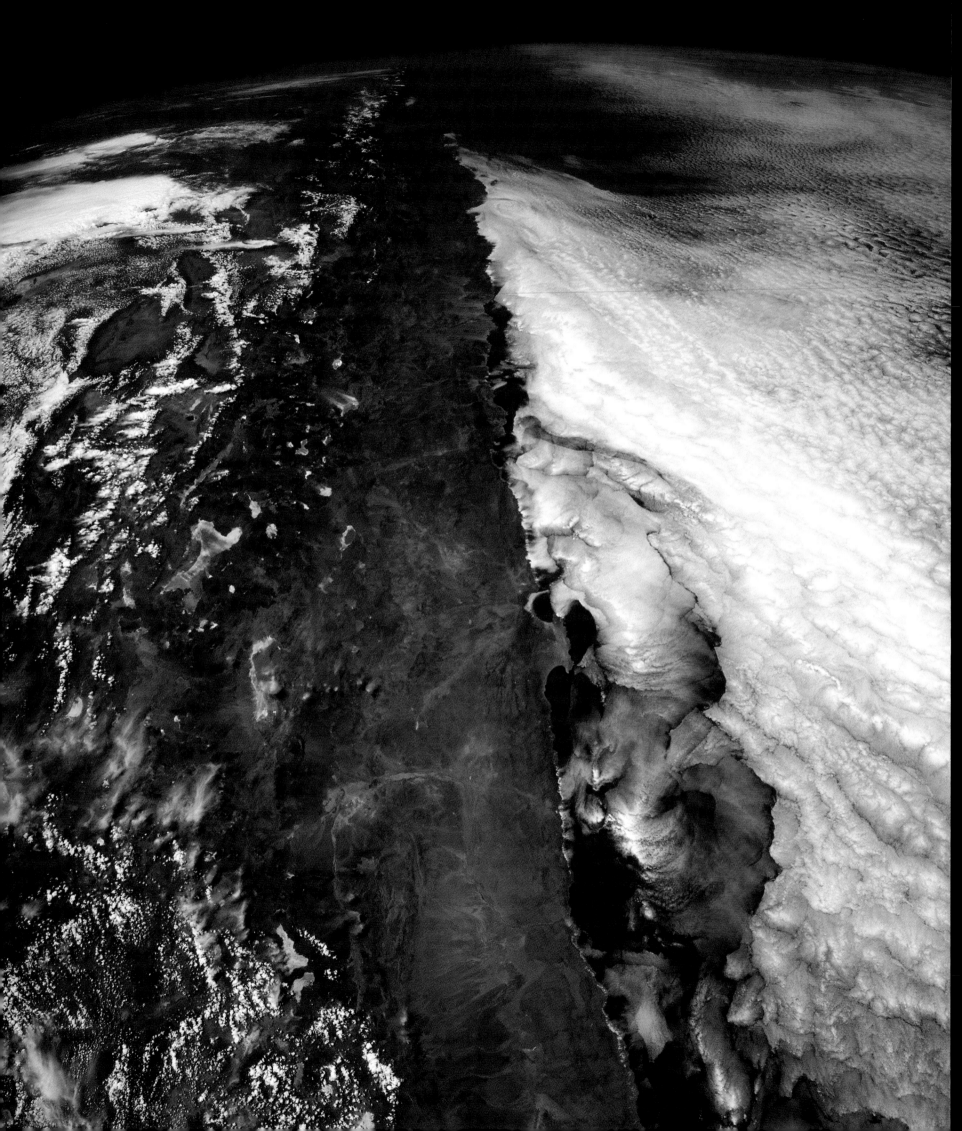

Central Andes
LEFT

Looking directly south down the Pacific coast of South America from 369 miles up, the crew that repaired the Hubble Telescope photographed the straight boundary between the Nazca and South American tectonic plates. The volcanoes, related to the collision of these plates, occupy the left side of the view, with the lowlands of Argentina at top left. The smooth strip along the coast is Chile's Atacama Desert, the driest region on the planet. Mineral riches are often found at plate boundaries. The world's largest known copper deposit, at Chuquicamata, lies in the foreground on the inner edge of the desert. Antofagasta, at the hammerhead cape near the middle of the view, is one of Chile's main ports.

Alpha-24 Iceberg, South Atlantic

This vast iceberg, from an ice shelf in Antarctica, had an area larger than the size of Rhode Island. More than five times as much ice (365 cubic miles) enters the oceans from Antarctica than from Greenland and elsewhere in the Northern Hemisphere. Icebergs can carry rocks frozen into their undersides, and the seafloor is littered with rocks "ice-rafted" north into the Southern Ocean. This material was carried there in great quantity during the ice ages, when Antarctic ice regularly floated much farther north than it does today.

Upper Rio São Francisco, Brazil
PAGE 172

The Rio São Francisco is the most important river of eastern Brazil. The river basin provides transportation and a source of water for an area that often suffers from extreme drought. Large forest tracts along the river have been converted for ranching, crops, and timbering. This land use changes soil chemistry. If not controlled, such changes can produce hard, impermeable soils after the richer forest topsoil is eroded. This erosion generates the muddy water and fine-scale gullying in the upper left and lower right. The bright tan reservoir shoreline ring in this 1984 dry-season photograph indicates a low water level.

Ranches in Western Mato Grosso, Brazil
PAGE 173

The state of Mato Grosso spans much of the mid-section of Brazil. Shown in this 40-mile square scene is typical, relatively new forest clearing. Large ranches occupy the Serra do Tombador Plateau, where drainage is better than in the lowlands and there is less risk of flooding during the wet season. Soils are richer and not leached of organic material. In contrast, the forests near Rio Sangue (bottom) are flooded to depths of 10 to 40 feet for three months of the year. These lower areas are occupied only in the dry season.

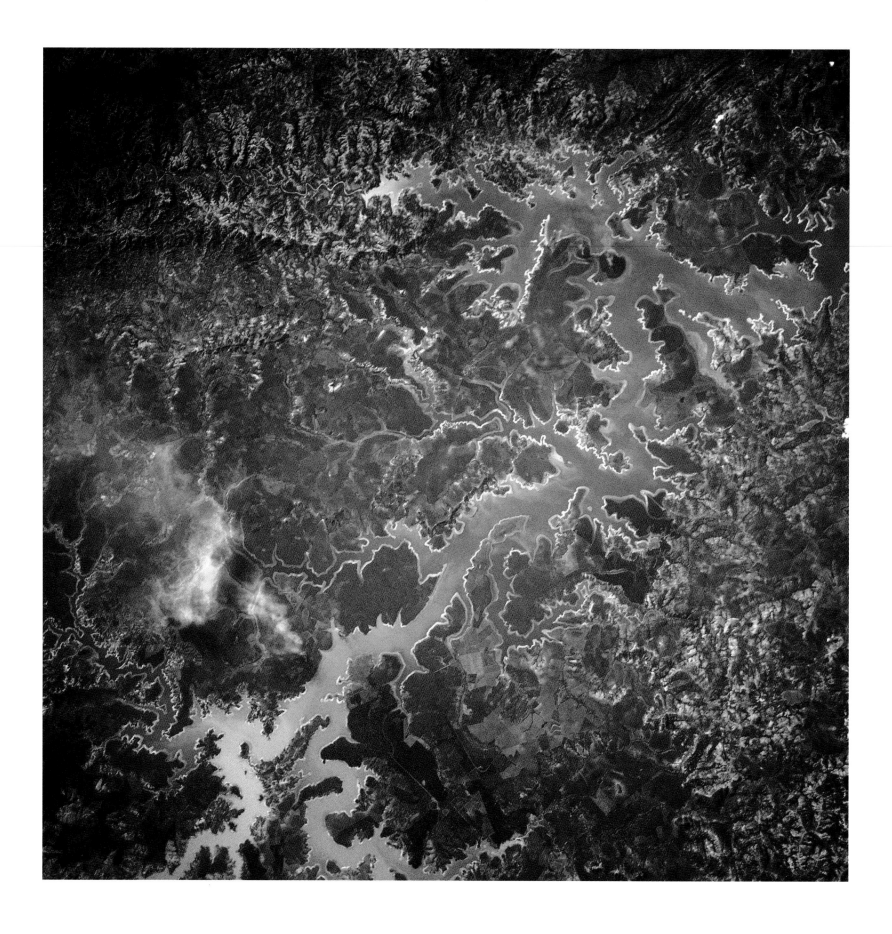

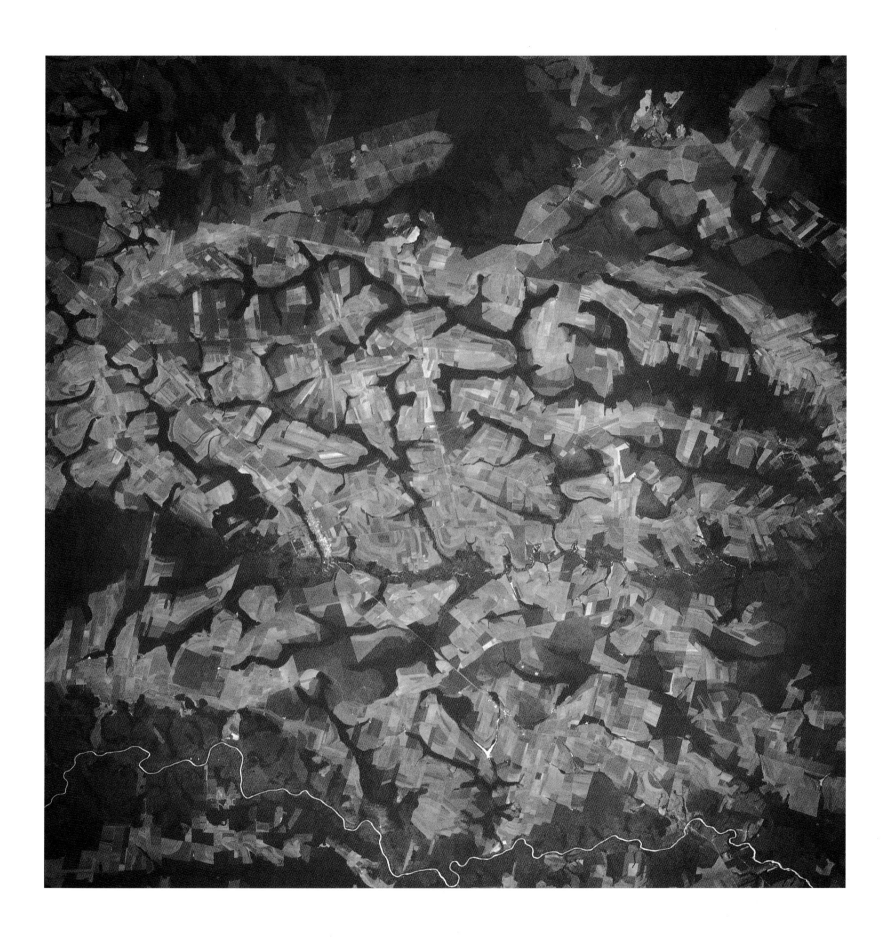

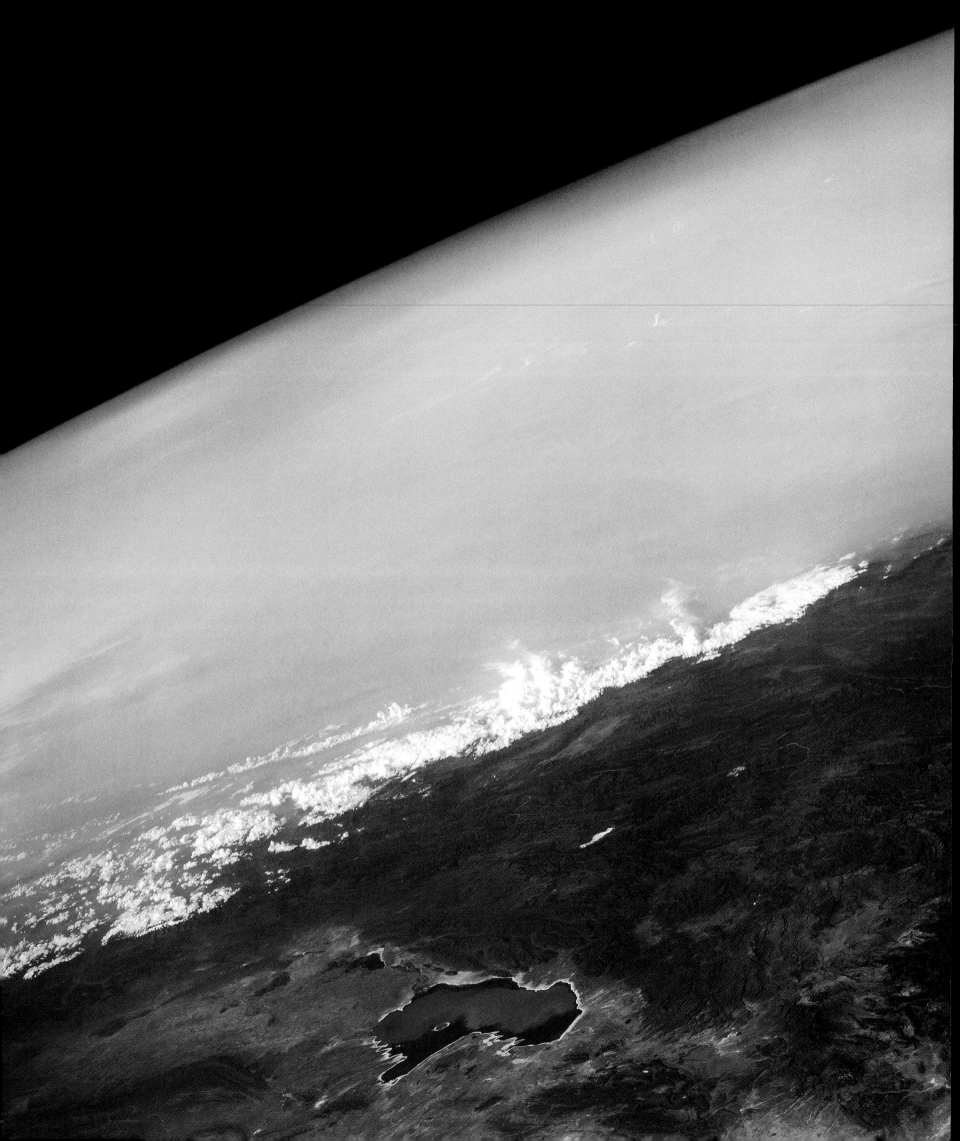

Burning Season in the Amazon Basin
LEFT

Nowhere else on Earth is there such extensive forest burning as in the Amazon. It has been photographed for two decades by satellites as well as by American astronauts and Russian cosmonauts. The annual smoke pall from Amazonian forest fires, measured from astronaut photography, can cover a million square miles. It lasts for six to ten weeks during the dry season. *Discovery* was 338 miles above the Andes in September 1991, when her crew made this photograph across 1,500 miles of Amazon smoke pall to the eastern horizon. High-level Lake Poopó in the Bolivian Altiplano, is in the lower foreground.

Clearing the Land

The fires photographed here are on the boundary between the uplands of Serra da Bodoquena and the Pantanal, the great South American interior swamp, along the Brazil-Paraguay-Bolivia border. The Pantanal, shared by the three nations, is the largest wetlands on Earth. The Pantanal ecosystem is being compressed by land clearing around its periphery primarily for the growing of soybeans.

The Polonoroeste Project, Rondônia State, Brazil

One of the most densely populated of the forest conversion areas in the Brazilian Amazon was created by the Polonoroeste Project along Brazilian Road 364 (photo at right). Until the late 1970s, this area was part of upland Amazonia's large contiguous forest and held some of the best soils in the Amazon. The road-building and settlement project covers a large area and continues to grow haphazardly. Migrants were encouraged to come here from rural areas of southeastern Brazil. Rondônia's population is 13 times larger than it was 20 years ago. The hatched grid pattern grows as the forest is gradually pinched out between adjoining ranches and farms. In 1974 Skylab photographs, this area was a carpet of virtually unbroken forest, each acre of which withdrew about one ton of carbon dioxide from the atmosphere each year.

LOREN McINTYRE

Rios Negro and Camanaú, Amazonas State, Brazil
FOLLOWING PAGES

In northwestern Brazil, primarily along the upper Amazon and along the major tributary of the Rio Negro, we could see immense areas of unbroken forest. This stretch of the Rio Negro has only a few small river towns as a sign of human passage. Native peoples, explorers, prospectors, rubber-tappers and trappers, a few scientists, and ecotourists live here or pass through this region. Viewed from space, the Rio Negro seems to run clear with very dark blue to black water. When cupped in your hand the Rio Negro water looks tea-colored, due to a large amount of tannin and humic acid in the water. Both are derived from the vigorous leaching of organic material out of decayed vegetation and soils. The soils in this river basin are sandy and not conducive to lasting agriculture, so it is unlikely that many people will settle here in the near future.

pp 178-179
pp 176-177

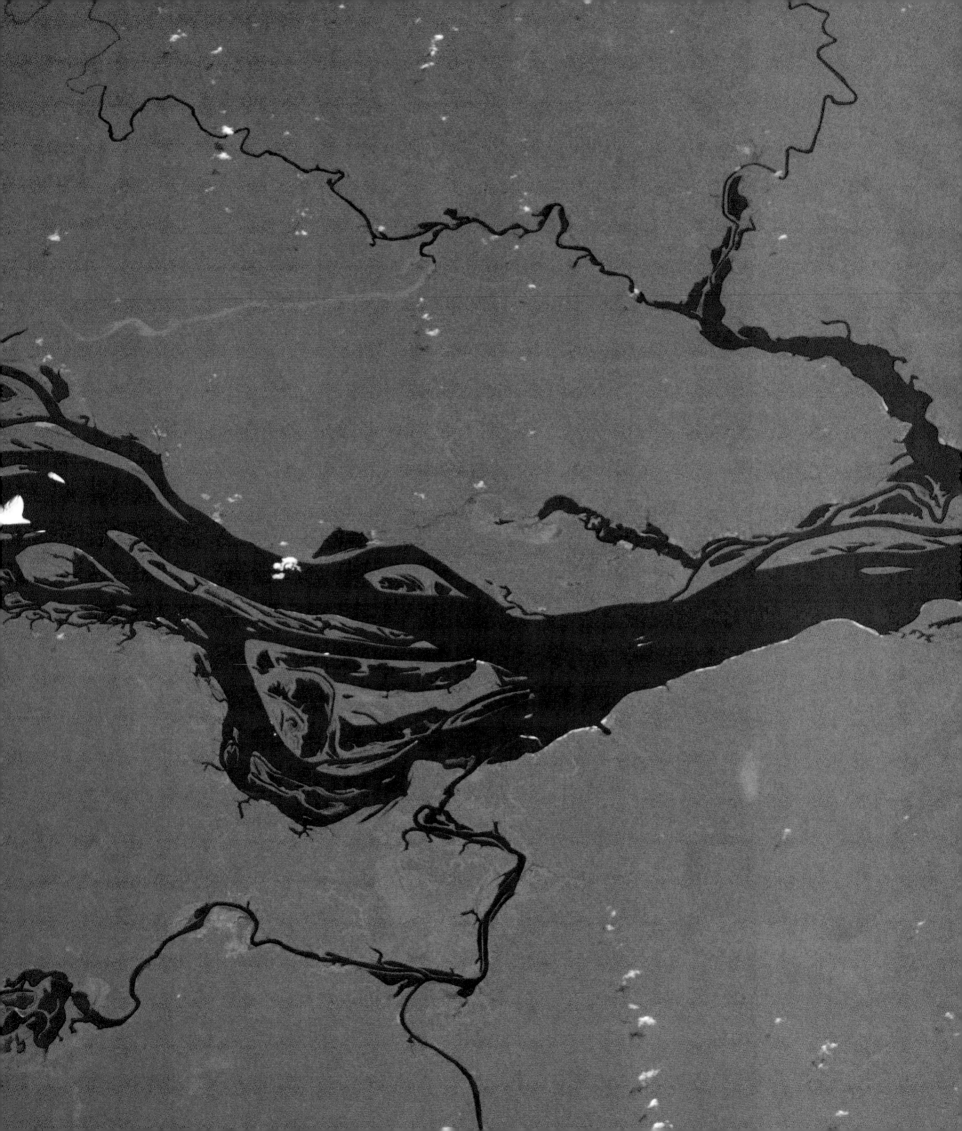

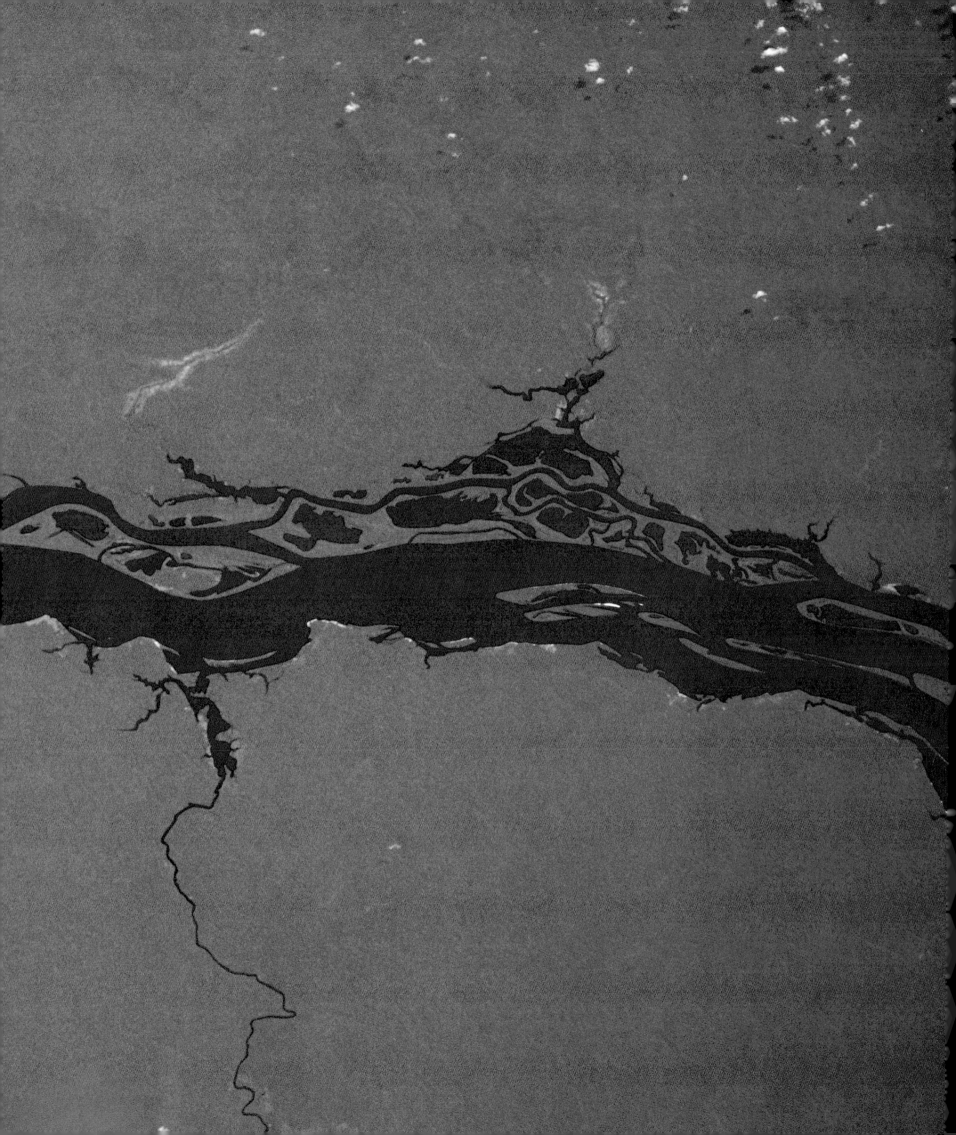

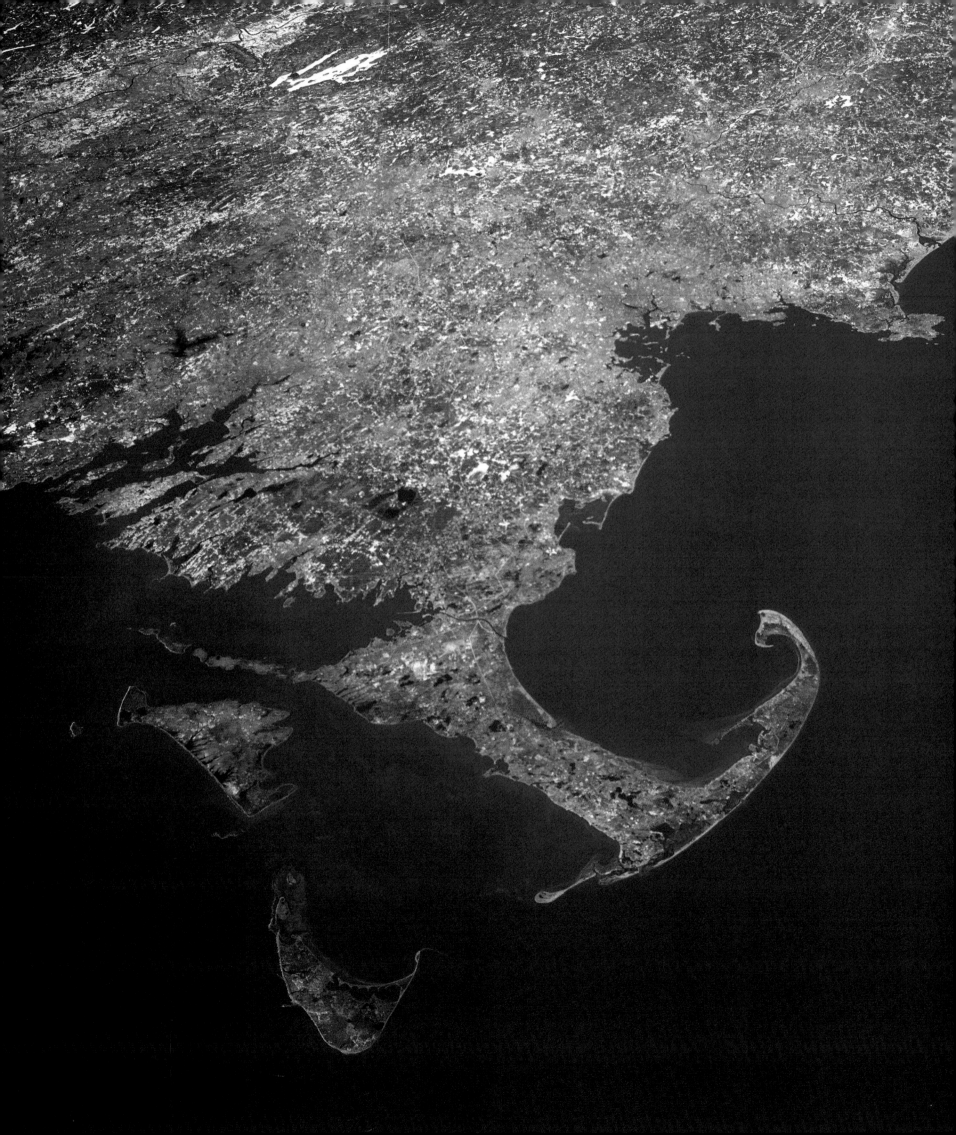

North America

rth America

Southeast
New England

Huge glaciers swept across
Cape Ann in the upper right
through Boston, and on to
Providence in the left center.
They left Cape Cod on one of
their retreats. Martha's
Vineyard and Nantucket
mark the glaciers' most
southern advance. March
snow highlights New
England's lakes and villages.

IN APRIL 1991 THE EARTH'S ATMOSPHERE WAS AS CLEAR AS it has been in many years. The explosion of Mount Pinatubo in the Philippines was still two months in the future, and the dust from Mexico's El Chichon eruption in 1982 had finally settled out. *Atlantis* was 280 miles above northern Mexico when we looked north. We were able to see the mountainous western United States, from New Mexico up to the Black Hills in South Dakota. What impressed me the most about that quick glimpse was the boundary that the Rockies marked between the fertile plains to the east and the arid high desert of the West.

We could see that the West is a geologically active area. The bulk of the continent is slowly being pushed westward, and it has overridden a portion of old ocean floor. That floor is melting as it is being forced down into the hot interior of the Earth. Plumes of light rock float slowly upward, puncturing the West and Southwest with volcanoes, from the Cascades in Washington to the cinder cones near Flagstaff, Arizona. On my second flight, we spotted the drifting ash from an Alaskan volcano, Mount Spurr, when we were over Boston. On another orbit, we glided down the west coast of British Columbia. I spent almost a minute looking at the crumpled ranges of the Canadian Rockies. Then I struggled to find the remains of Mount St. Helens in the heart of the active belt of explosive volcanoes. On the next day, we saw Yellowstone National Park—site of an ancient volcanic explosion a thousand times larger than Mount St. Helens's—where hot lava still turns water to steam just beneath the surface.

The enormous amount of hot rock rising from the melted ocean plate is inflating the crust of the entire West. On a pass down the West Coast, we look to the east and see the Basin and Range territory. The basins are the valleys where the rising crust has cracked and fallen down.

To the north, in Canada, we can see some of the world's oldest rocks, exposed to erosion over several hundreds of thousands of years. Glaciers pushed the topsoil south, and when they stopped, they left debris heaped up like snow at the end of a snowplow. The debris became Long Island, Martha's Vineyard, Nantucket, and Cape Cod. The glaciers also gouged the Earth. From orbit the Finger Lakes of New York seem to have been made by a giant rake. South of the Finger Lakes, we can see the gentle parallel curves of the ridges in the Appalachians. The last collision of North America and Africa created these mountains.

One day Mission Control called us to be on the lookout for a small hurricane off the East Coast of the United States. As we rapidly took photos, we saw that even this dwarf hurricane could make an enormous circle of ocean waves, all moving counter-clockwise. On the next pass over the East Coast, we looked down at the effects of thousands of storms like this one—the line of barrier islands that stretches from New Jersey to Florida. On the orbit after that one, we passed over Houston, and we could see the Gulf Coast's barrier islands as well. People live on most of these islands, but they must evacuate during the very storms that transport the sand along the coast.

I have flown in space in April and in September. In those months, at least, the rivers and cities in North America appear to have much less visible pollution than those in many other parts of the world. When my father was in college, his shirt would get so stained by soot during the day that he had to change it before dinner. That doesn't happen any more in North America. When people decide that a problem is important, they can go out and fix it. It is good to see the results from space.

I have seen North America in daylight from the Shuttle only by stealing time from my sleep period. Night passes are a different story. We had many during the heart of my awake periods on both my missions aboard *Endeavour*. On one mission, we looked down at the brilliant gas flares from oil wells in the Bay of Campeche, then flew over the Florida Panhandle, up the entire East Coast, and over Nova Scotia.

I looked at the weather in Florida, where city lights lit up the low clouds. I gave a weather report to the meteorology folks on the ground and privately decided we would probably not be landing there in the morning. (We didn't; we went to California instead.) My crewmates and I picked out the lights of Atlanta, Roanoke, Washington, Baltimore, Philadelphia, and Pittsburgh. Directly over New York City, we could see the dark rectangle of Central Park and the avenues of Manhattan. Boston passed by just to our east. Over Nova Scotia we looked for meteors just before dawn allowed us to get back to our scientific studies. Three hours later, we passed over San Francisco and were able to pick out the lights on the towers of the Golden Gate Bridge before the morning fog rolled in.

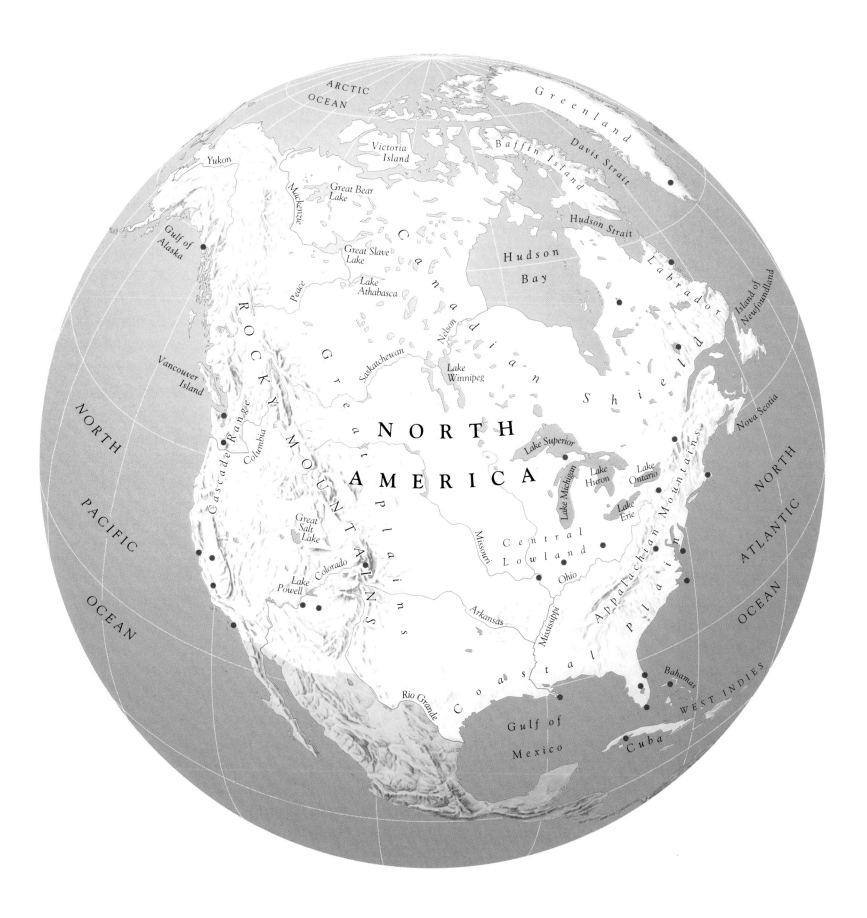

ARCTIC
OCEAN

Greenland

Yukon

Victoria
Island

Baffin Island

Davis Strait

*Great Bear
Lake*

Mackenzie

Hudson Strait

Gulf of
Alaska

*Great Slave
Lake*

Hudson

Labrador

Peace

*Lake
Athabasca*

Bay

Island of
Newfoundland

C
a
n
a
d
i
a
n

Nelson

Vancouver
Island

Saskatchewan

*Lake
Winnipeg*

G
r
e
a
t

S
h
i
e
l
d

Nova Scotia

NORTH

Columbia

R
O
C
K
Y

Lake Superior

**NORTH
PACIFIC
OCEAN**

Cascade Range

P
l
a
i
n
s

AMERICA

Lake Michigan

*Lake
Huron*

Lake
Ontario

Appalachian Mountains

**NORTH
ATLANTIC
OCEAN**

M
O
U
N
T
A
I
N
S

*Great
Salt
Lake*

Colorado

Missouri

*C e n t r a l
L o w l a n d*

*Lake
Erie*

*Lake
Powell*

Ohio

Arkansas

Mississippi

C o a s t a l

P l a i n

Bahamas

Rio Grande

WEST INDIES

Gulf of

Mexico

Cuba

● Center point of photograph

Mount Fairweather, Southeast Alaska

Just west of Alaska's Glacier Bay stands 15,320-foot Mount Fairweather (center right). Its glacier has been squeezed out to the Gulf of Alaska, like toothpaste from a tube, forming Cape Fairweather (bottom). As these tidewater glaciers advance, slowly cutting a deep fjord, they often push a wall of rubble ahead of them, forming shallows in the water. These shallows protect the face of the glacier from erosion, allowing further advance. But, if for some reason the glacier starts to retreat, deep water in its own fjord causes an increase in iceberg calving, and the glacier may shrink many miles in a few years. That is exactly what happened to open Glacier Bay at the average rate of 1,700 feet per year from 1794 to now.

The long shadows and sense of perspective are the result of *Endeavour*'s very low altitude course over southeast Alaska an hour after sunrise on her April 1994 voyage to study the Earth's surface.

Mount St. Helens

For two months in early 1980 Mount St. Helens rumbled as melted rock rose up through ancient caverns beneath the mountain. The force of the thick paste of rock and gas made a mile-wide bulge on the side of the old volcano. On May 18 a large earthquake sent a huge part of the bulge–millions of tons of rock–moving downhill. As the avalanche accelerated, the landslide became a hurricane of rock that rushed downhill at 150 mph. The part of the mountain that was blown away is on the side facing the bottom of the photo. The explosion killed 57 people, and blew 1,300 feet of rock and debris off the top of the cone. Trees covering 230 square miles were uprooted or snapped off at the ground. Ash fell inches deep more than 200 miles away.

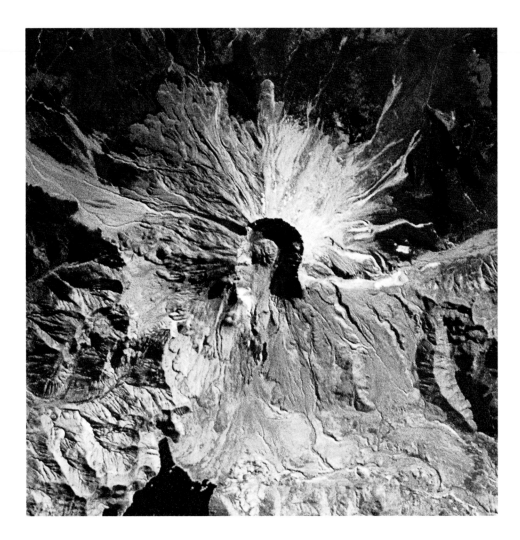

Puget Sound

Endeavour's tail points south to Victoria, the city at the southern tip of Vancouver Island known for its English way of life. In the wooded countryside of British Columbia, Vancouver and neighboring towns stand out as a gray triangle on the broad delta of the Fraser River, left of the tail. Seattle lies farther away on the left side of Puget Sound, the long arm of the sea stretching toward the top of the view. The Olympic Peninsula (right) receives enough rainfall–160 inches in some places–to be considered a temperate rain forest. Ports of the Pacific Northwest prospered from the gold rushes in the Yukon and the opening of the Panama Canal. They benefit now from trading across the Pacific Basin.

pp 184-185
p 187
p 186
p 180

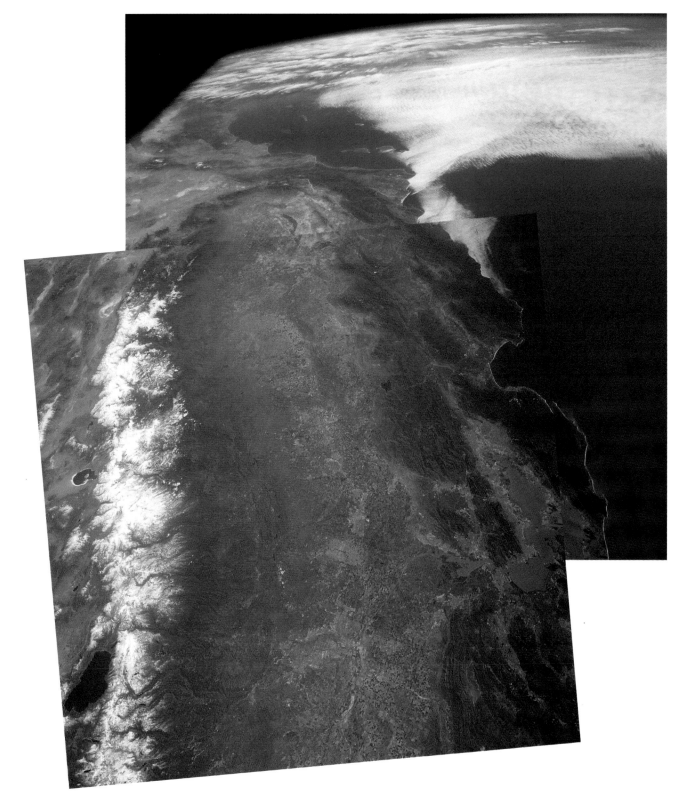

San Francisco Bay Area
LEFT

In 1848, when the California Gold Rush began, a thousand people lived in San Francisco. The population around the bay has reached more than six million. Large areas of the bay are now solar evaporation ponds or were filled or diked for the urban expansion. New islands and extensions of river deltas were created when the marshes were diked and filled for agriculture. Berkeley and Oakland sit on the mainland facing San Francisco on the narrow rectangular peninsula south of the Golden Gate Bridge. The San Andreas Fault runs in a straight line from bottom right to left (south to north). The fault is particularly visible inland of the Point Reyes National Seashore, the prominent white-shored cape to the left.

Central Valley and the Sierra Nevada

The great Central Valley of California has accumulated rich soil from erosion of the Sierra Nevada to the east (left) and Coast Range to the west. This basin, one of the world's most productive farm areas, is fed by irrigation and the snowmelt of the Sierra. Lake Tahoe is at lower left. Mono Lake is the small round lake on the left, with 14,494-foot Mount Whitney just to the southwest. Directly west of Mono Lake is Yosemite National Park. The ocean fog is generated by the cold California Current. Faults of the San Andreas system appear as parallel lines along the coast.

p 188
p 189 center
p 189 top

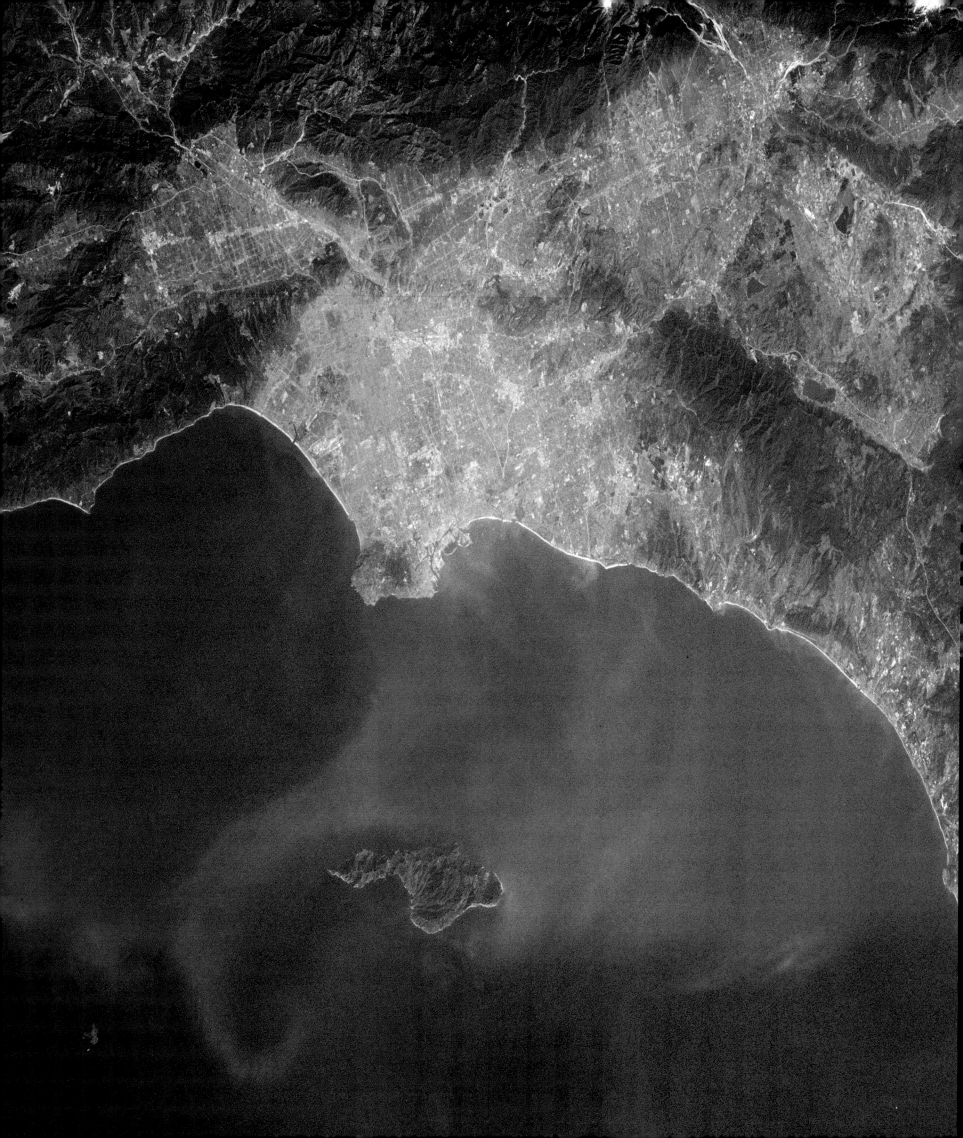

Los Angeles and San Diego

The weather of the Los Angeles basin is controlled by the cool California Current and a high-pressure system offshore. The benefit is the stable climate of sunshine and little rain. A consequence is smog. The cool moist air pushed into the valley by the ocean winds is held in place by warm air descending from the high-pressure system. This warm layer on top of the cool marine air forms a natural lid—an inversion layer—that holds the air pollutants near the ground. These chemical emissions are trapped and thicken into smog (photo at right). Smog is not new: Spanish explorers saw Indian fires forming a light smog capped and held in place by an inversion layer in the 1500s. In this December 1983 scene, smog is wafting offshore from Point Vicente across Santa Catalina Island and out into the Pacific north of San Diego. Reduced emissions from factories and vehicles have lessened the severity of the smog in the last decade.

WILLARD CLAY

The Grand Canyon and Lake Powell

The Colorado River, now dammed to form Lake Powell (at upper right in space photo), has cut through a mile of rock to create the Grand Canyon (also shown in photo above). The river falls 1,900 feet through the 277 miles of the canyon. Although the rocks at the bottom are almost two billion years old, the river has cut the canyon only in the last five or six million years, as the land here rose. A light powdering of snow highlights where the land broke as the area was shoved upward. The Bright Angel fault, running into the South Rim of the canyon from the lower center, provided the first tourist route into the canyon.

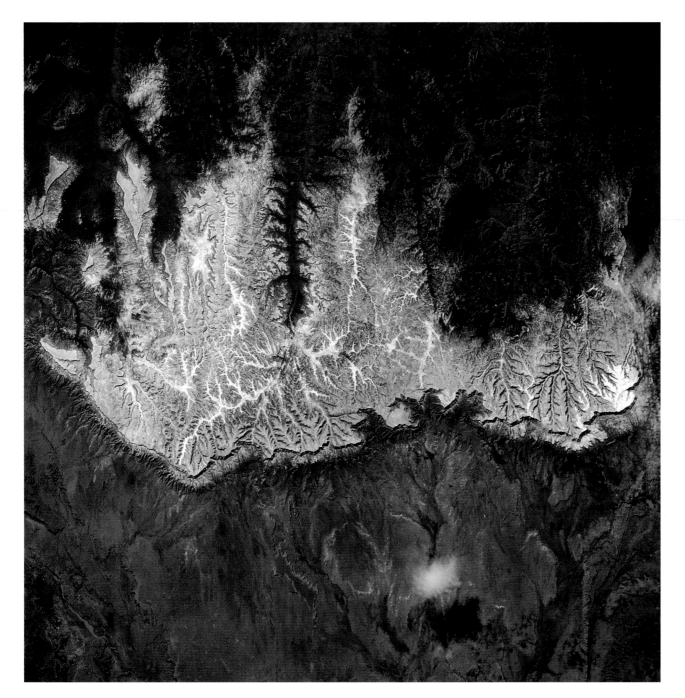

Black Mesa, Arizona
LEFT

Snow dusts the highest parts of Black Mesa, a remote ridge of hills in northern Arizona used by both the Navajo and Hopi. In the 13th century the Hopi collected coal from hillside outcrops for firing pottery and heating their pueblos. Today the longest coal-slurry pipeline in the world originates in Black Mesa. Since 1970, this 273-mile pipeline has fed 4.8 million tons of coal each year to a power station in Nevada. Coal is an important source of fuel for electrical generating stations in the Southwest.

Rocky Mountains and the Western Plains

In January 1974 there were two to four feet of snow in the Rockies and a few inches in Denver as the *Skylab 4* crew looked west. Denver is the smudge near the east (bottom) of the mountains. To its north (right) lies the Front Range and the snow-covered curve of the Medicine Bow Mountains, which form the eastern boundary of North Park. Pikes Peak is the only snow-covered mountain south of Denver, near the left edge of the photo. Behind Pikes Peak lies South Park, a high basin. Farther to the west is the Sawatch Range, which has Colorado's highest peak, 14,433-foot Mt. Elbert.

p 195

p 194

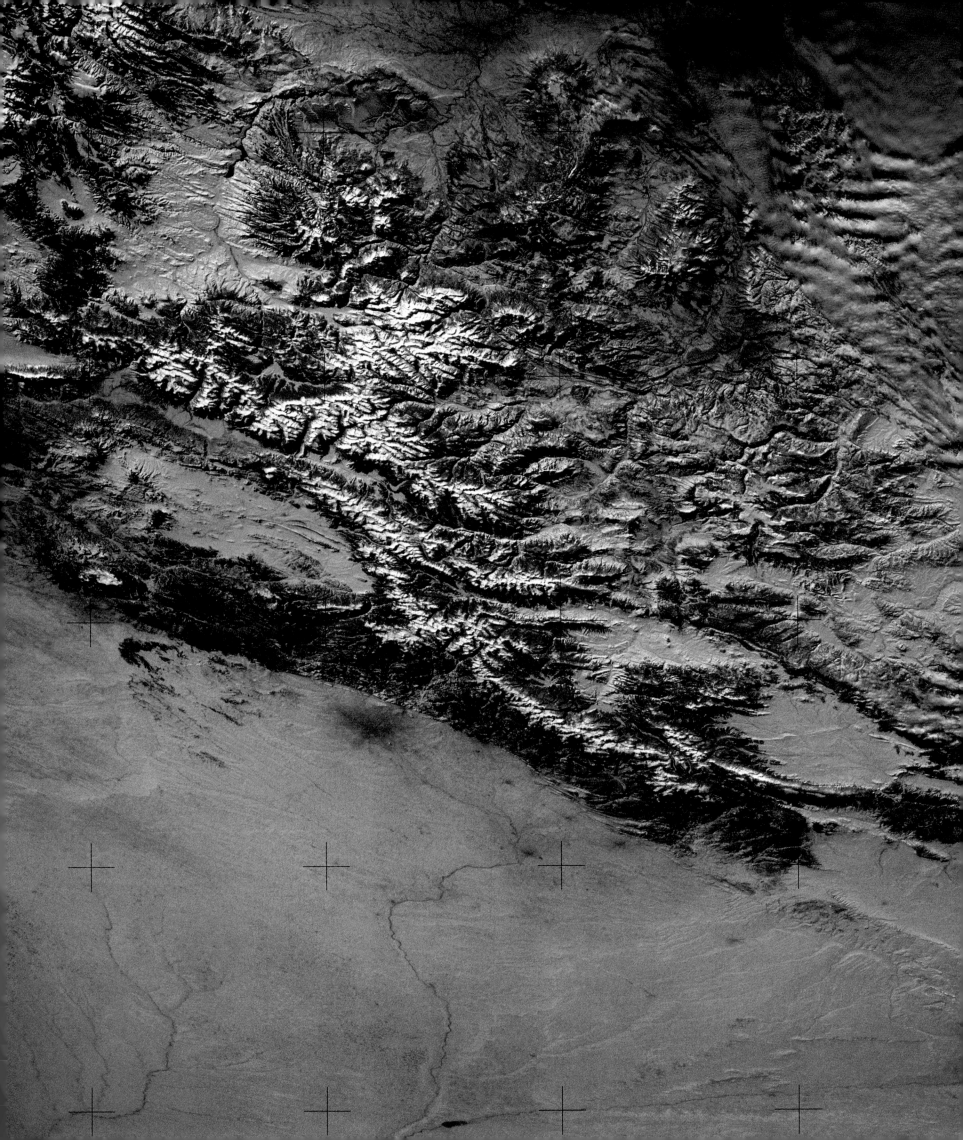

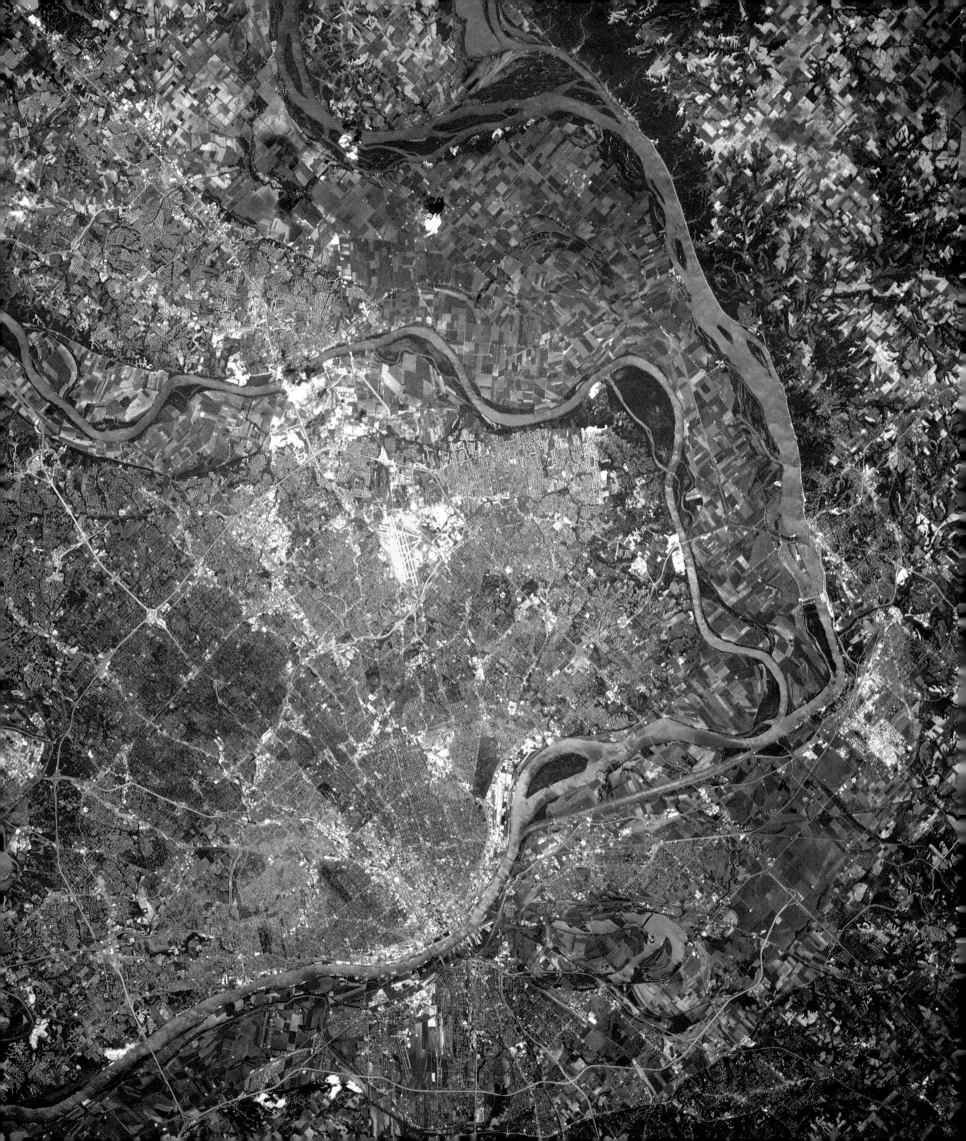

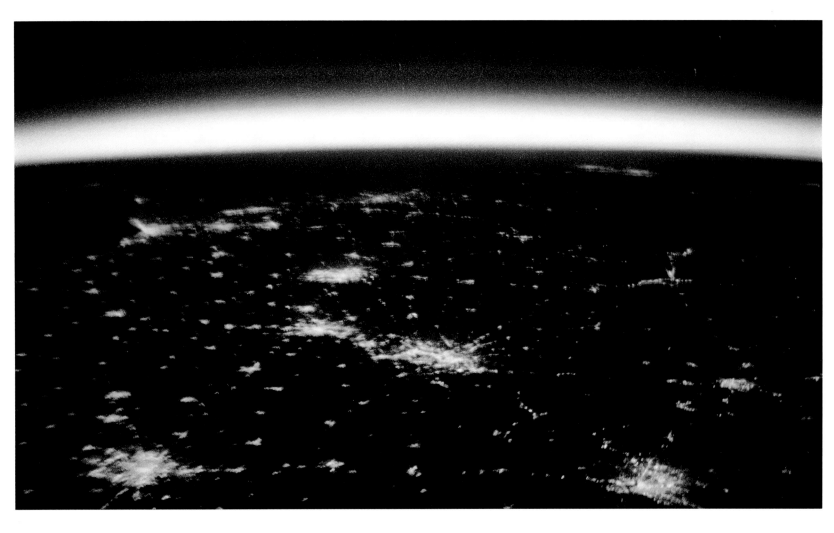

St. Louis
LEFT

The Mississippi River separates St. Louis, Missouri, from East St. Louis, Illinois. At the top of the photo (northwest), the Illinois and Mississippi Rivers join; the Missouri adds its flow just above the city. The rich land between the rivers is heavily farmed. Periodic floods lavish new soil on the farms but devastate farmers and city dwellers alike when the waters roll over the flat land.

Founded in 1764 as a French fur-trading post, St. Louis was transferred to Spain, then back to France, and finally became part of the United States following the 1803 Louisiana Purchase. The city has been a transportation hub since steamboats arrived on the rivers in the early 1800s.

Dawn over the Eastern States

Columbia was traveling east at 300 miles per minute late on a clear March night when her crew looked out at the awakening cities below. Indianapolis is in the lower left, and Interstate 65 crosses the foreground to Louisville in the lower right. Cincinnati, Dayton, and Columbus are in the center, with Pittsburgh beyond. The curve of the Ohio River is traced out by the lights of towns on its banks from Louisville and Cincinnati to Pittsburgh. Youngstown, Akron, and Cleveland are to the left of Pittsburgh, next to dark Lake Erie. In the distance at the top right are Baltimore and Washington, about to be touched by the blue dawn.

America's Heartland
FOLLOWING PAGES

Lake Michigan dominates this grand panorama, with Lake Superior across the horizon at top left. The Mississippi River snakes down the left. The farms and reservoirs of Illinois, Indiana, and Ohio occupy the foreground. The great industrial region centered on Chicago wraps around the south end of Lake Michigan, with a population numbering more than seven million. Milwaukee lies up the coast from Chicago and Indianapolis in the middle of the right page. Toledo is at the tip of Lake Erie and Detroit just to its north, top right. The Heartland's fertile soil was deposited here in the last ice age.

pp 198-199 · p 197
p 196

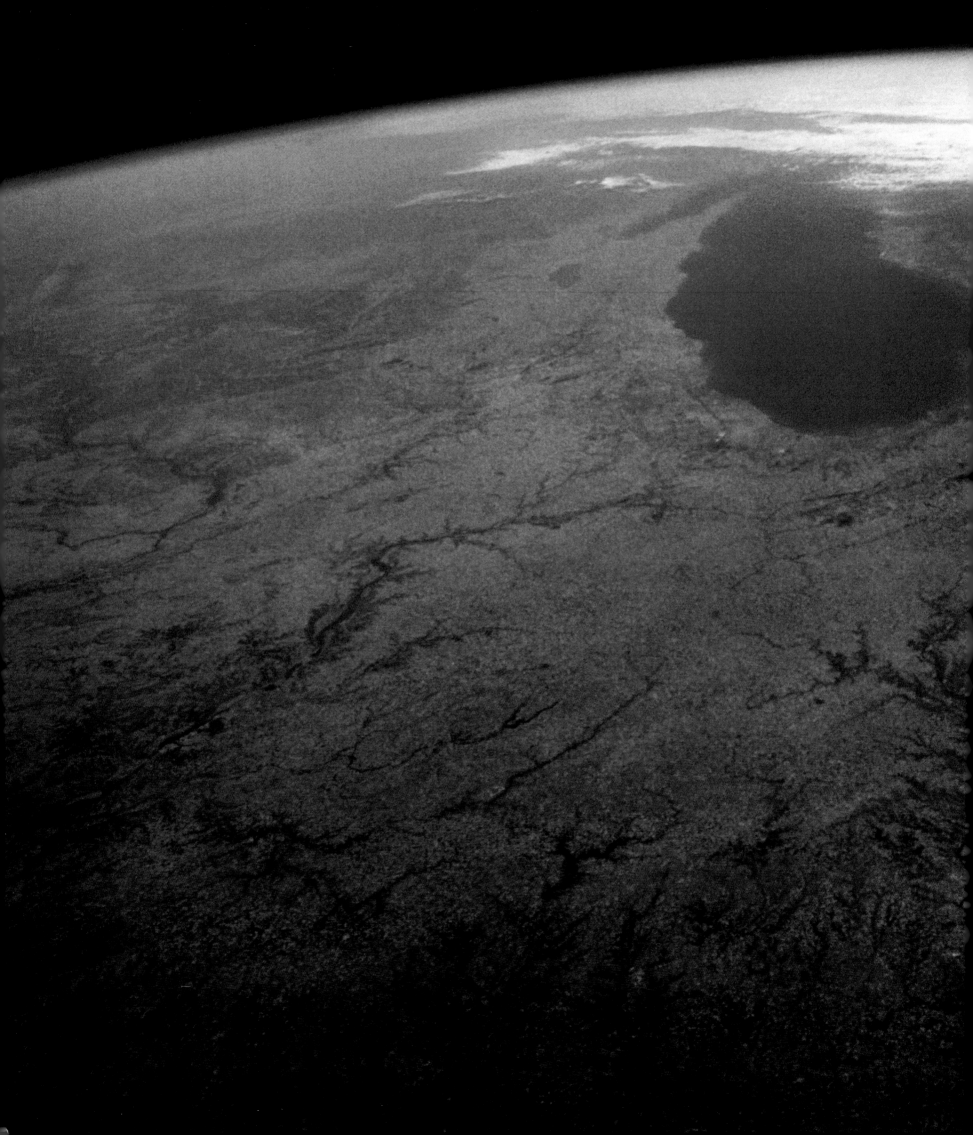

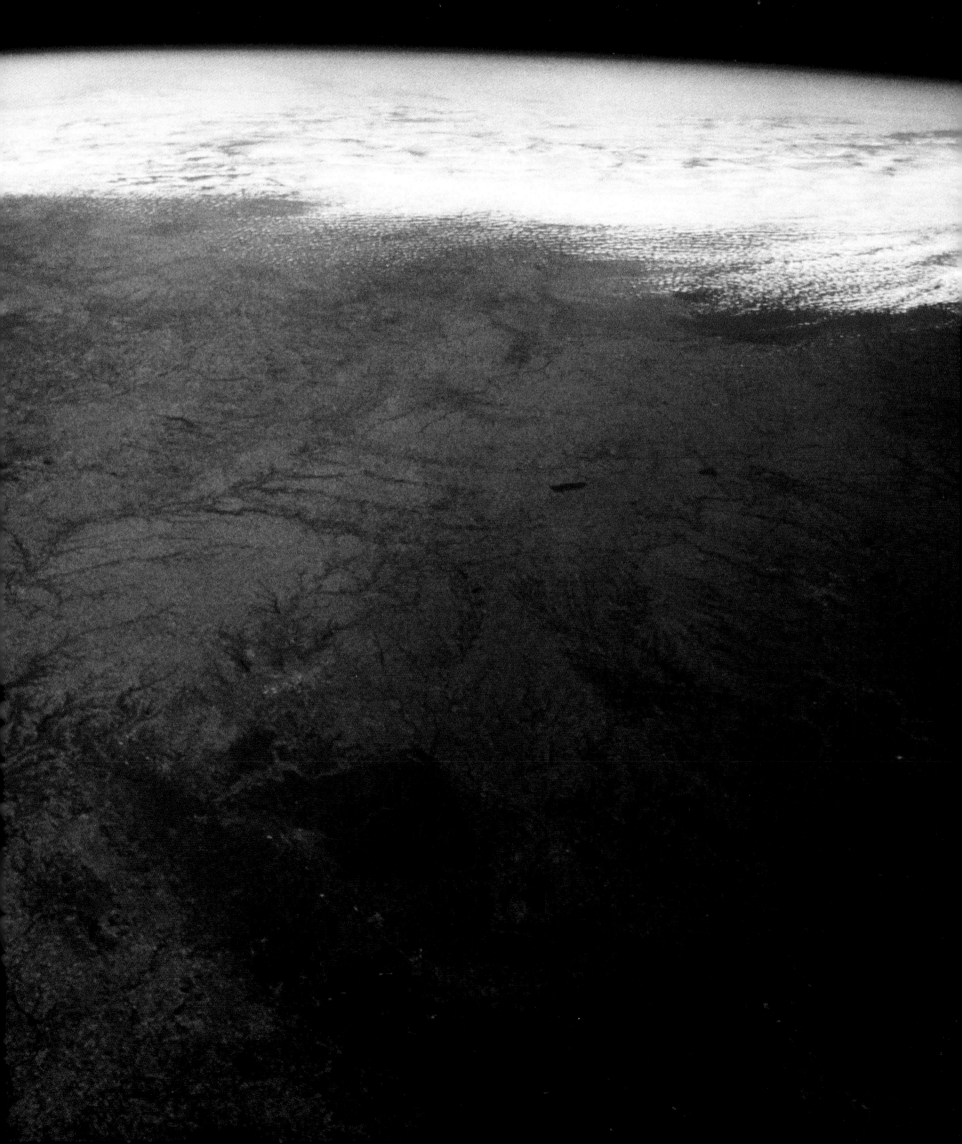

Montreal

LEFT

When Montreal has heavy snowfalls, as in this February 1994 photo, citizens take to an underground city of shops and walkways. One of Montreal's two airports, runways cleared of snow, appears in the center of the view. Montreal lies on the St. Lawrence Seaway, one of the world's leading trading arteries, serving 78 U.S. and Canadian ports along the shores of the Great Lakes and the St. Lawrence itself. It is the second largest metropolitan region in Canada—3.3 million people, two-thirds of them native French speakers.

Lake Superior

In late March 1992, when *Atlantis* flew overhead, Lake Superior still had ice, which prevailing westerly winds packed into Whitefish Bay in the foreground. Green Bay, an arm of Lake Michigan, was also still ice-covered (at left margin). Like Lake Michigan, the north end of which is visible on the left, Lake Superior drains into Lake Huron, bottom left. The prominent spike of land in Lake Superior is Keweenaw Peninsula in upper Michigan. Isle Royale National Park is the island off the Canadian shore of the lake (top right). Iron ore is shipped at Duluth on the distant tip of Lake Superior. At Sault Ste. Marie, Canada (foreground), locks facilitate the flow of ship traffic between Lakes Superior and Huron.

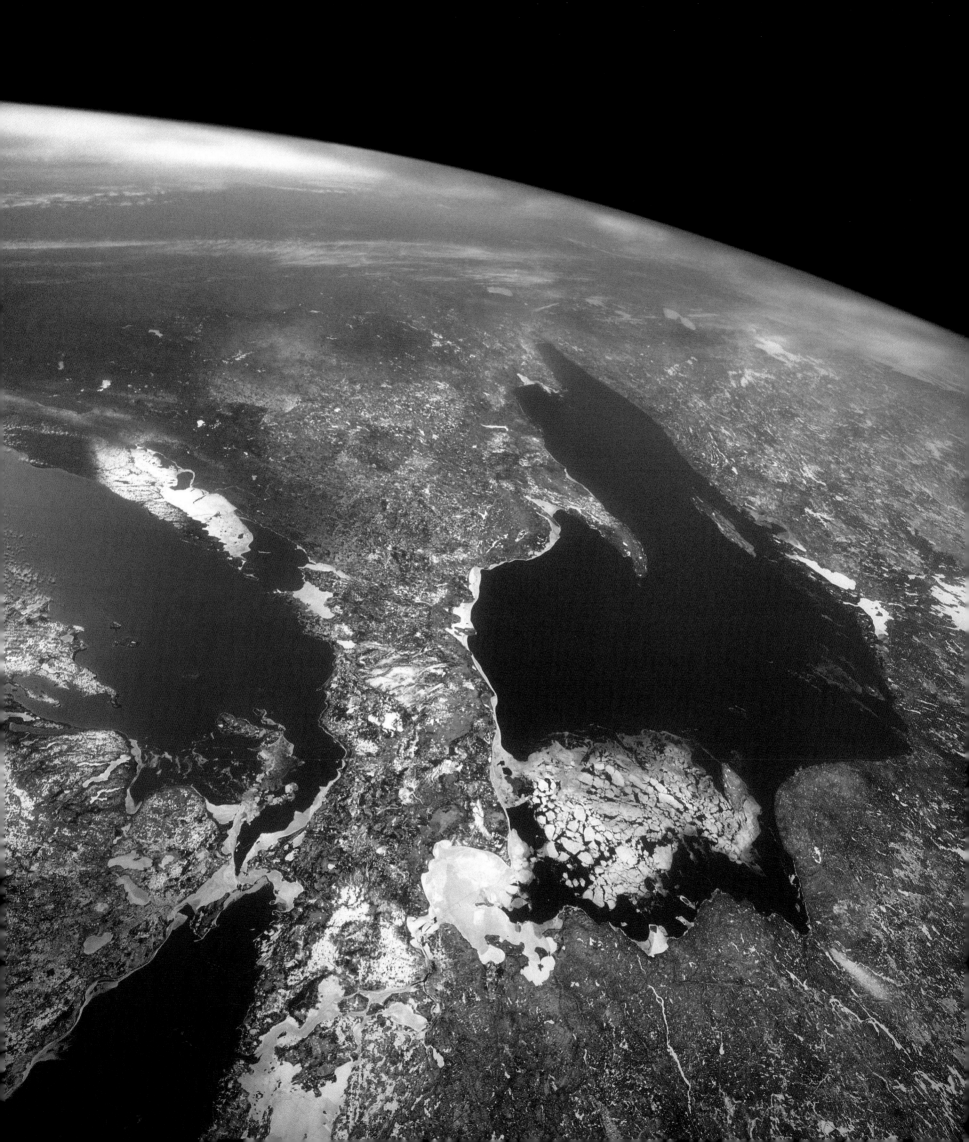

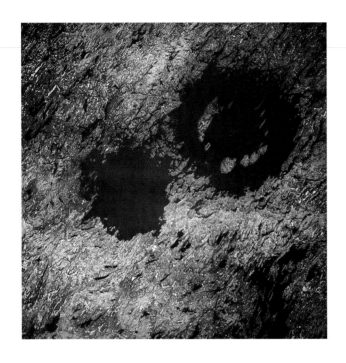

Target: Earth

When I grew up, science fiction writers wrote about assaults on our planet from outer space. Truth is stranger than fiction: We now know that all planets in our solar system are bombarded by huge rocks that leave craters such as these. Quebec's 40-mile-wide Manicouagan Crater (right) is marked by a lake outlining the crater's rim. The rim has long since eroded, leaving the circular trench, now used as a reservoir for a hydroelectric dam. In the crater's center lies a 600-foot-high plateau of rock melted into glass by the force of the impact 210 million years ago. Less than 400 miles northwest lie two craters (left), the Clearwater Lakes. They were formed simultaneously by an asteroid and its moon or by a 1,500-foot-wide stony meteoroid that broke up as it entered our atmosphere 290 million years ago. West Clearwater Lake (at upper right) is 18 miles in diameter. One theory holds that the islands in the lake are the remains of circular waves of melted rock that froze after the impact. Future generations must find ways to detect such invaders from space and change their courses before they change the course of history.

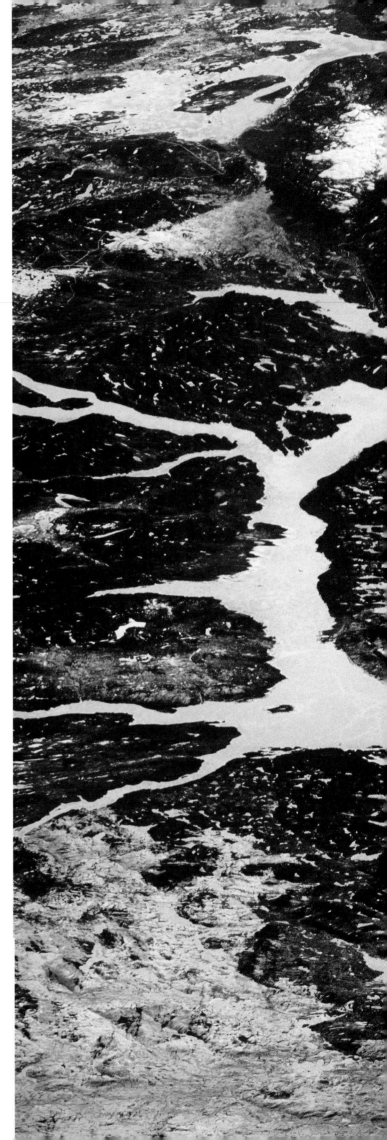

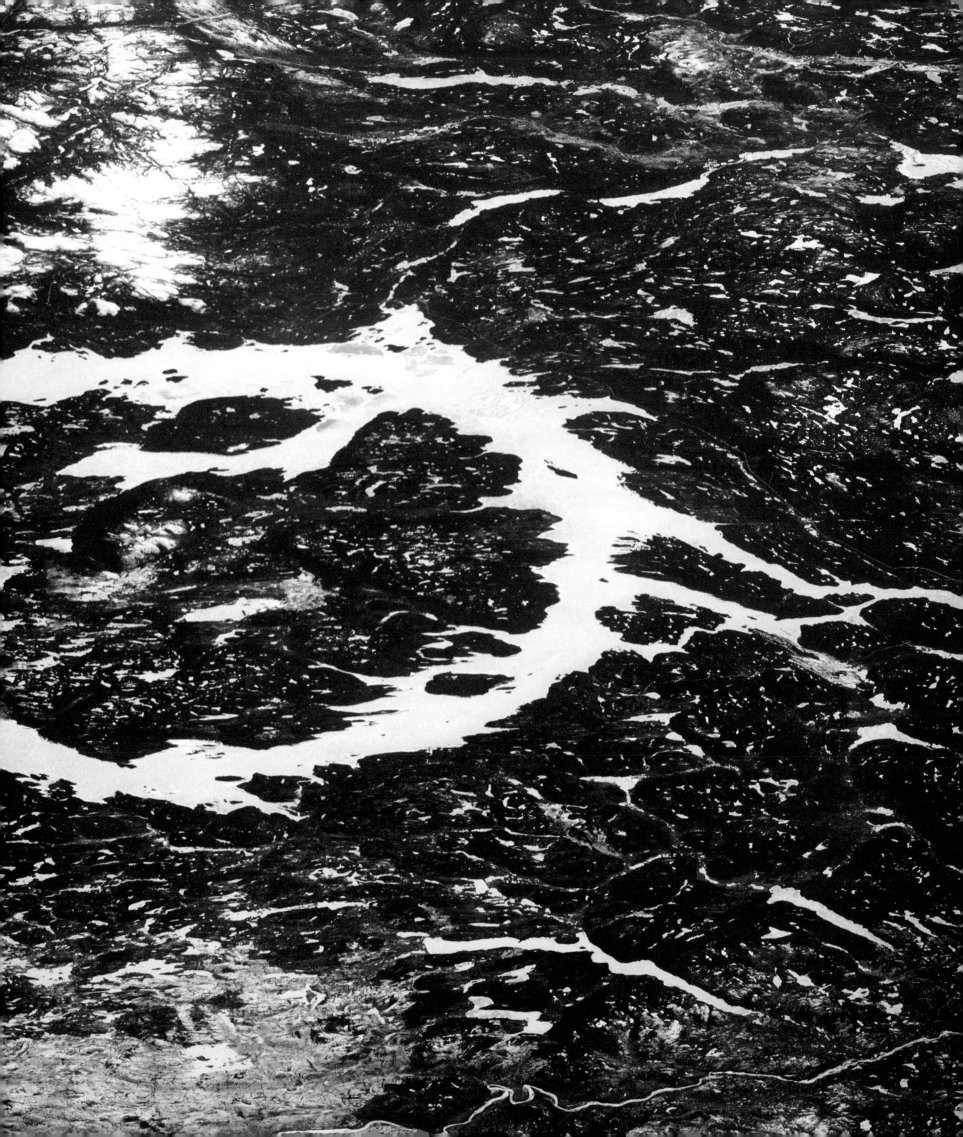

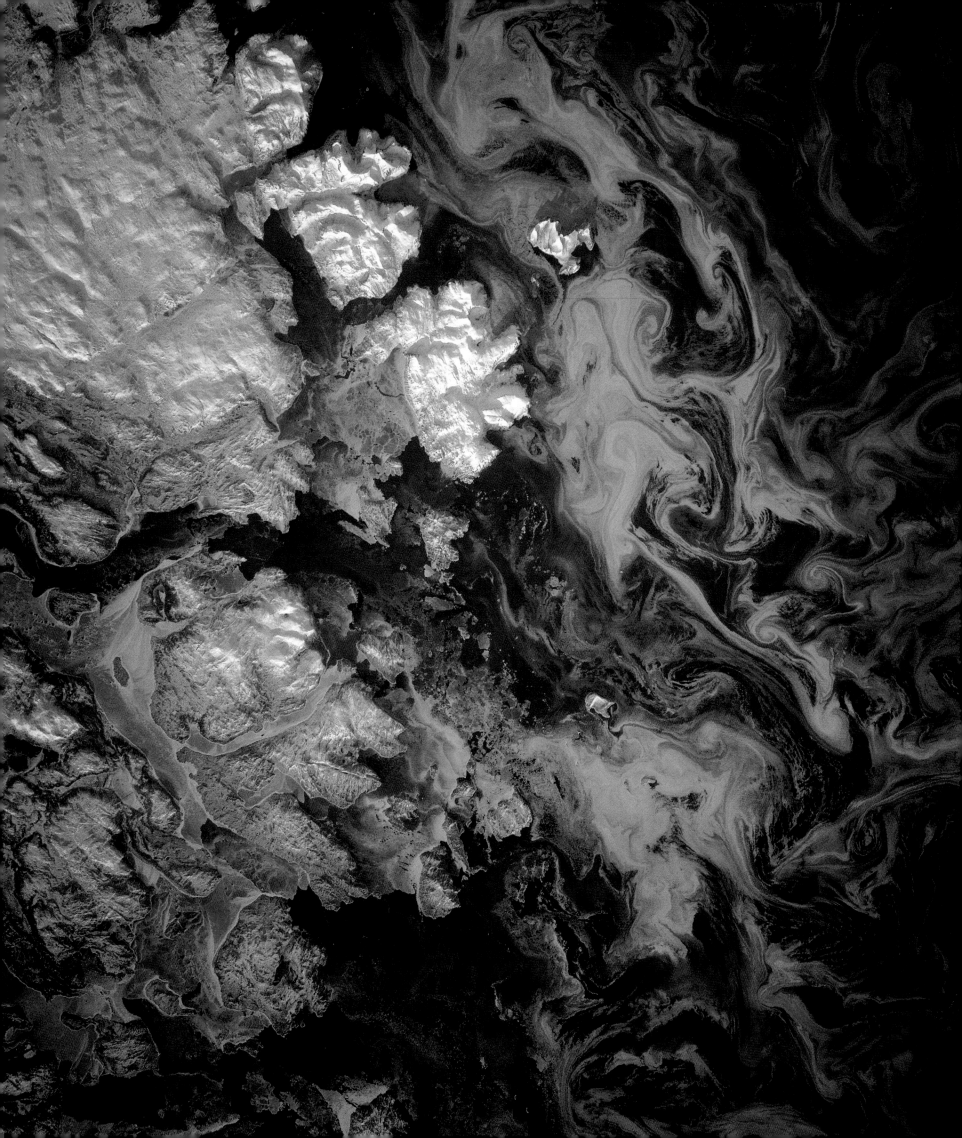

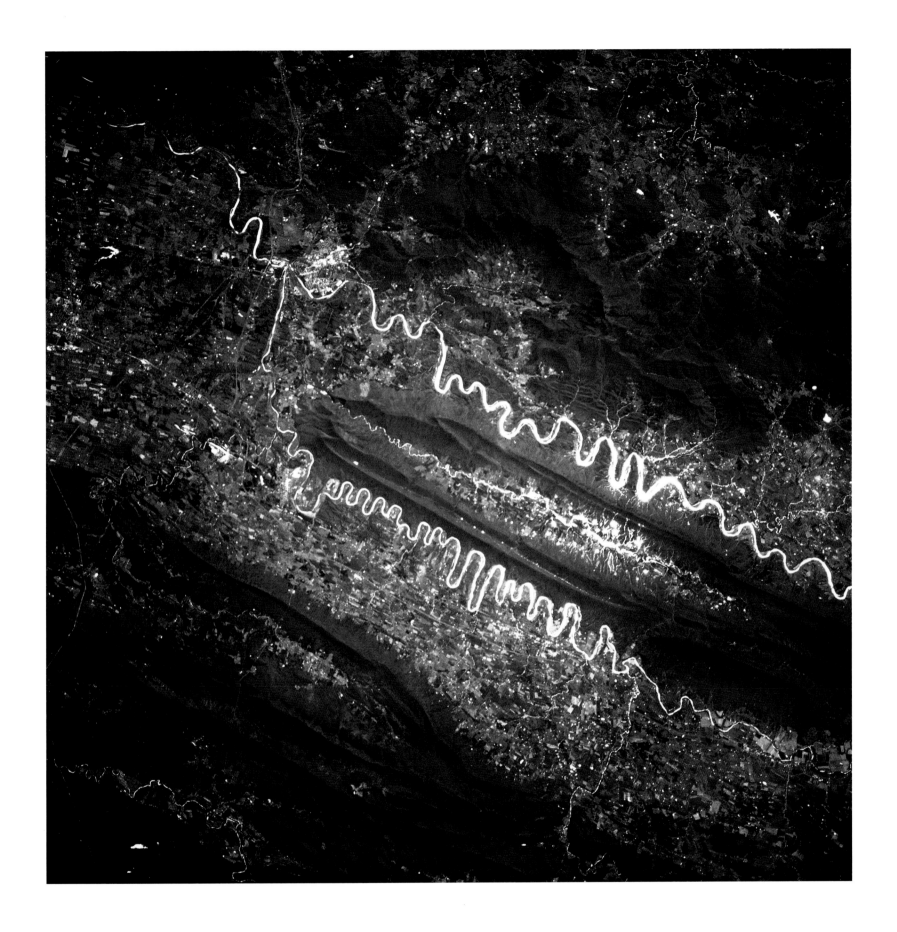

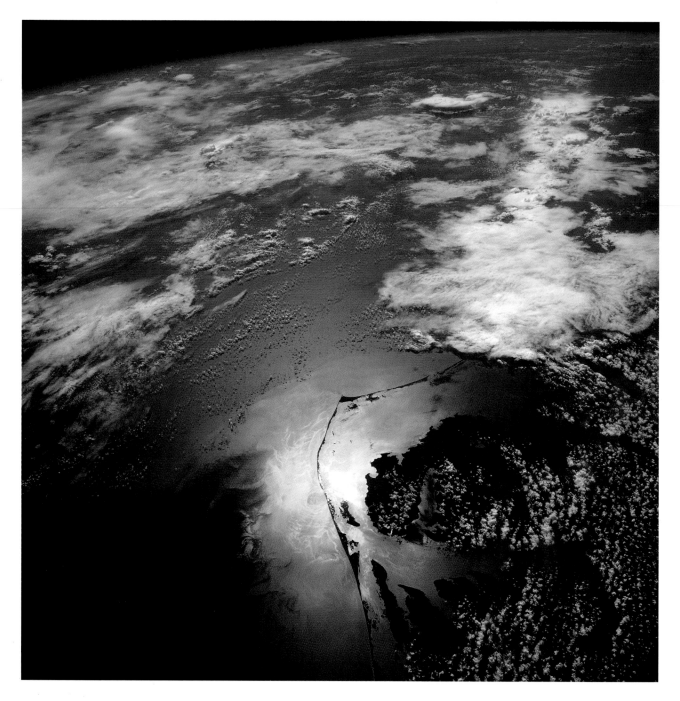

Cape Hatteras and the Gulf Stream
LEFT

Swift ocean currents and storms sculpted these barrier islands and their landward lagoons. The easternmost point of these islands is Cape Hatteras, just seaward of Pamlico Sound. Kill Devil Hills, where the Wright brothers' first powered aircraft flew in December 1903, is on the thin island caught in the brightest part of the sun's reflection. Eddies in the sunglint reflection mark passage of the Gulf Stream. Here the velocity of the Gulf Stream is three to five knots.

Lower Chesapeake Bay

The wetlands of the peninsula on the Eastern shore of Chesapeake Bay are highlighted by the glint of the sun for *Columbia*'s camera. The Chesapeake Bay Bridge is interrupted by two underwater tunnels to provide channels for ships and submarines. Norfolk and Virginia Beach are south of the bridge. Offshore, eddies indicate an area where bay and inlet waters mix with the coastal ocean.

p 209
p 208

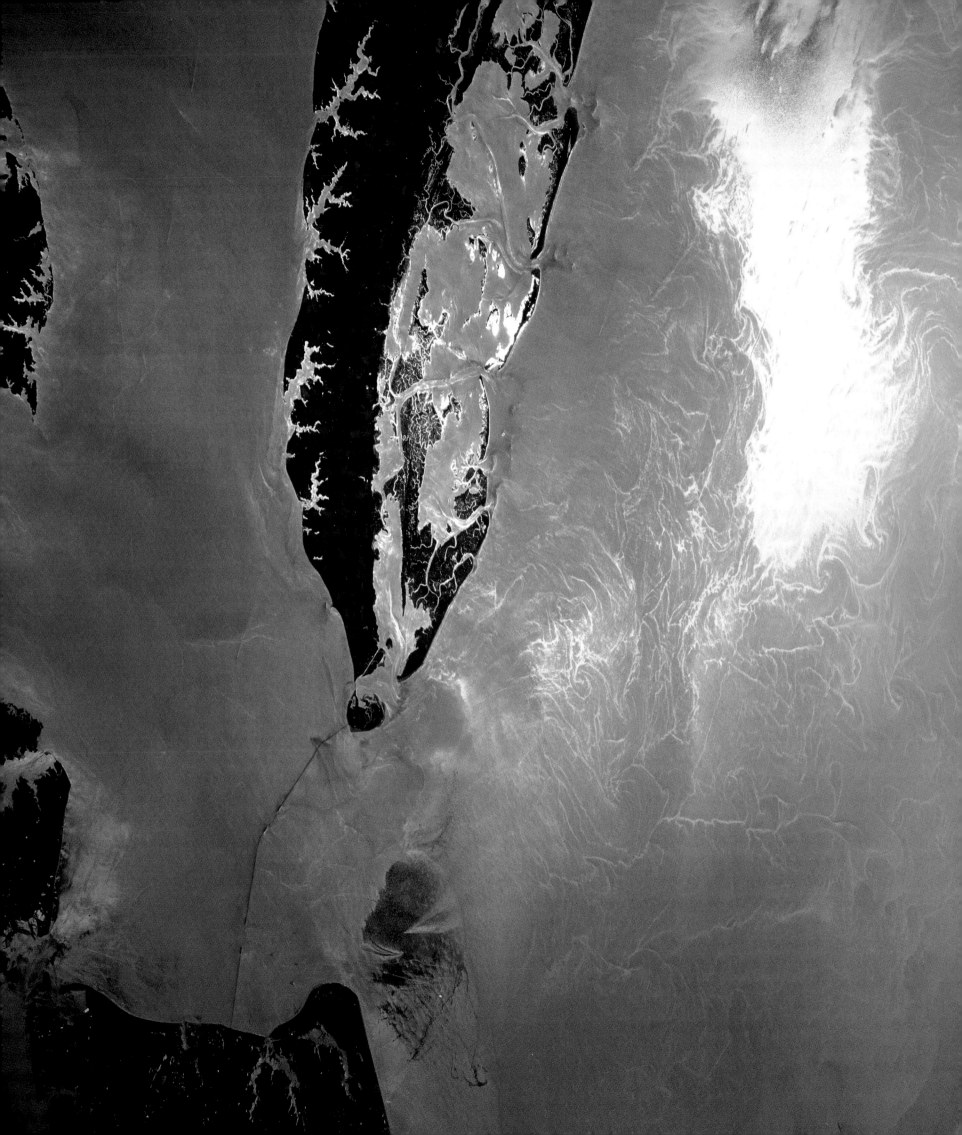

Mississippi River Delta

Rain that falls on 31 of the
United States ends up here.
The immense mud pile
dumped into the abyss by the
Mississippi—note the flow of
sediment in the photo
above—would be thousands
of feet thick if it had not been
compressed by its own
weight. Tides and waves are
small here, so the delta has
developed a delicate structure
resembling a bird's foot. Ships
use three distinct channels
just below the town of
Venice, Louisiana (near the
center of the photo from
space). Rivers don't like
flowing up hills created by
their own sediment, and the
Mississippi is trying hard to
cut a new channel to the
west—connecting with the
Atchafalaya River—and build
a new delta.

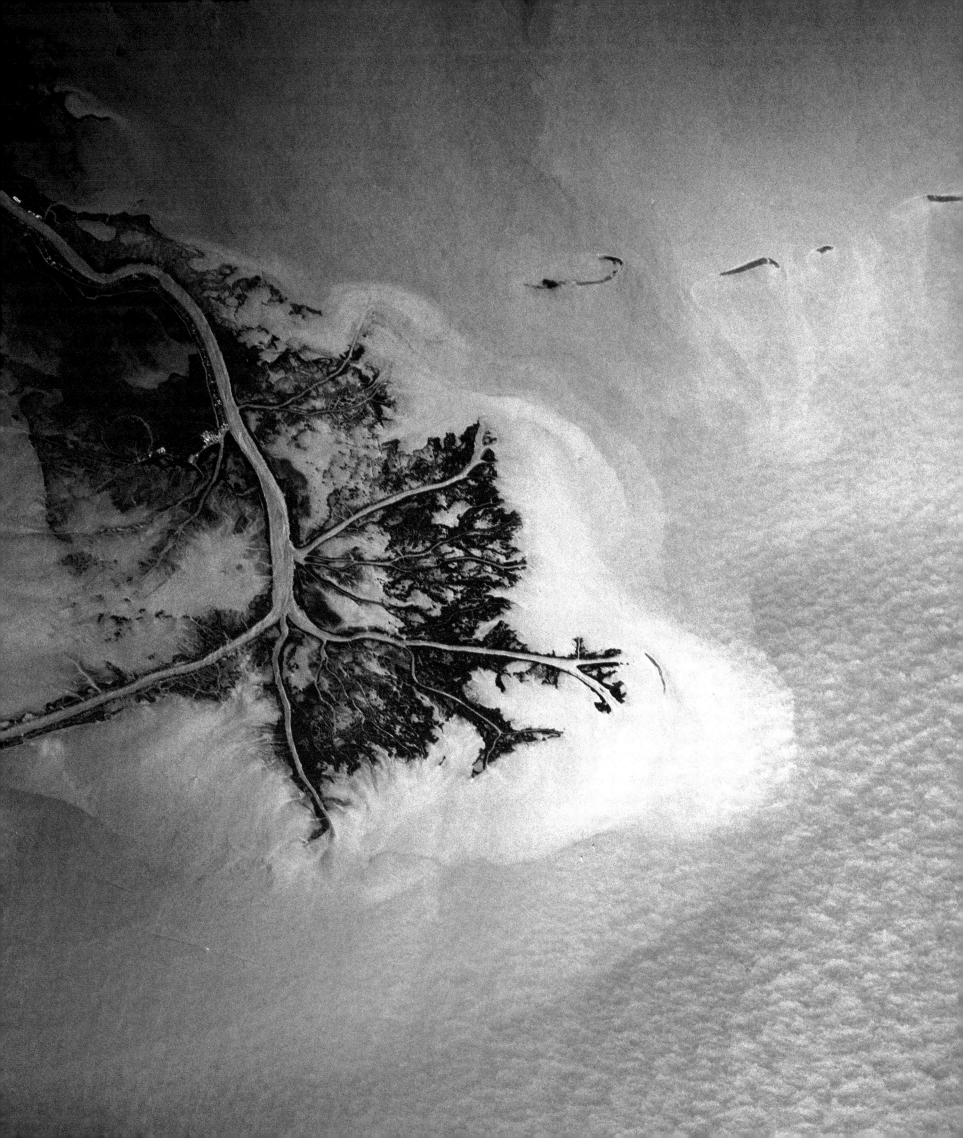

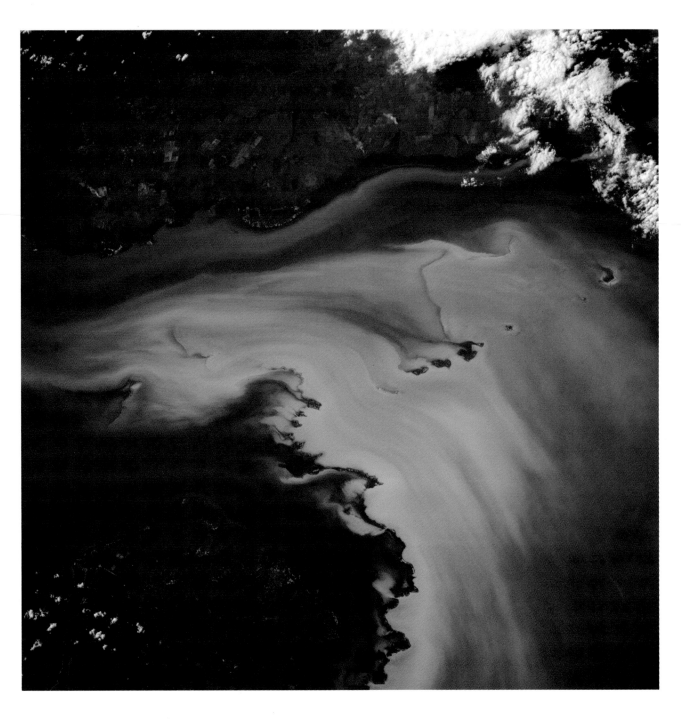

Golfo de Batabano, Cuba

LEFT

Currents force water through the 35-mile-wide channel between Cuba (top) and the Isle of Pines, home to a species known as the Cuban pine. Renamed in 1978 the Isle of Youth, the island once had a penitentiary whose political prisoners included Fidel Castro. From studying photos of this area, our observation is that the coral in this channel has become lighter in color in the past few years. Determining the cause will require that samples be taken of the coral, but the bleaching may be due to disease or to a change in the sea environment.

Little Bahama Bank

In this view of Grand Bahama Island, water over the Little Bahama Bank in the middle of the photo is no more than 30 feet deep. The sea bottom drops off steeply to depths of more than 3,000 feet at the bottom of the photo. Light, V-shaped lines (bottom right) are fingers of white sand. These move over time as tides wash back and forth across the lip between the bank and deep water. Smaller smudges (center right) are called whitings because of their color. Most are collections of calcium carbonate precipitating out of the seawater. Whitings are seen on almost every Shuttle flight. They may be natural dumps for the increasing carbon dioxide in our atmosphere.

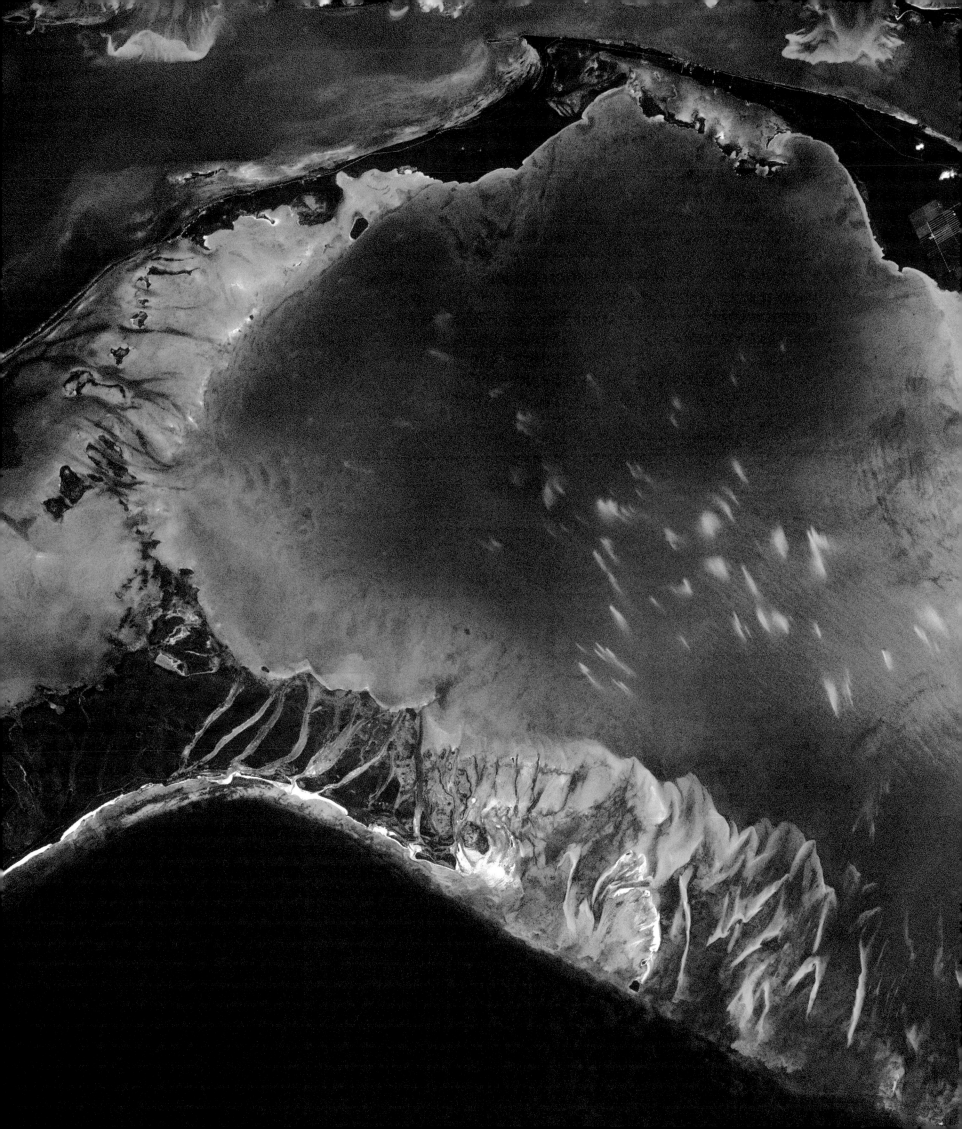

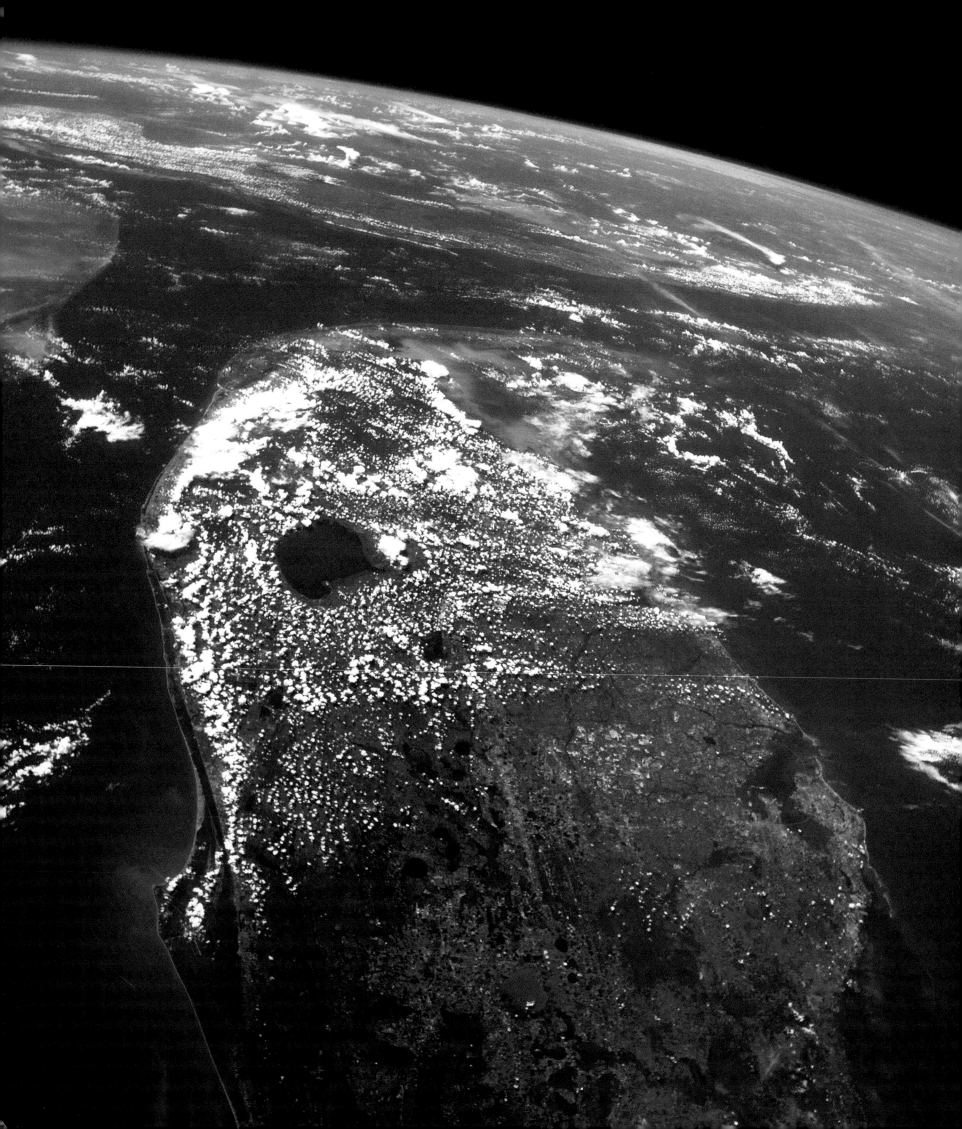

Florida from the North

LEFT

While scientists performed medical research in *Columbia*'s laboratory, her pilot captured this view, from Cape Canaveral in the lower left southward to the curving horizon. Lake Okeechobee is the large cloud-free lake. Elsewhere, the sea breeze combines with moisture breathed into the air by the wetlands' water and vegetation to create cumulus clouds that water the southern half of the peninsula. Miami is the large city to the east (left) of Lake Okeechobee; the Everglades are to the south. On the west coast the port cities of Tampa and St. Petersburg are clustered around Tampa Bay. Ninety miles to the south of the Florida Keys is the narrow island of Cuba.

Florida Bay and the Keys

South of the Everglades, Florida Bay is frequently choked with brown algae; at other times it may be clear. Since 1987 the bay's sea grass habitat has drastically shrunk, the water has been murky, and pink shrimp populations have declined. The algae blooms seen here were fueled by nutrients released by dead and decaying sea grass. Because of water management practices in south Florida, less fresh water is flowing into the bay, making the bay saltier. This has killed the sea grass and allowed bottom sediments to be stirred by winds and currents.

Cape Canaveral and the Eureca Satellite

FOLLOWING PAGES

Europe's first reusable spacecraft sails above Kennedy Space Center five hours after the crew of *Atlantis* released it. Ten months later, *Endeavour* left Earth from a launch pad just to the left of the prominent cape in the photo to retrieve the satellite. Whenever we sail into space from here, we expect to be called on to do whatever it takes to accomplish our mission. Two hours of hard work in space suits outside the Shuttle awaited *Endeavour*'s crew, as they had to latch down Eureca's 66-foot-long solar panels by hand when robotic systems commanded from the ground failed during the flight.

When humans finally reach out to the stars, some of the crew will leave Earth from here.

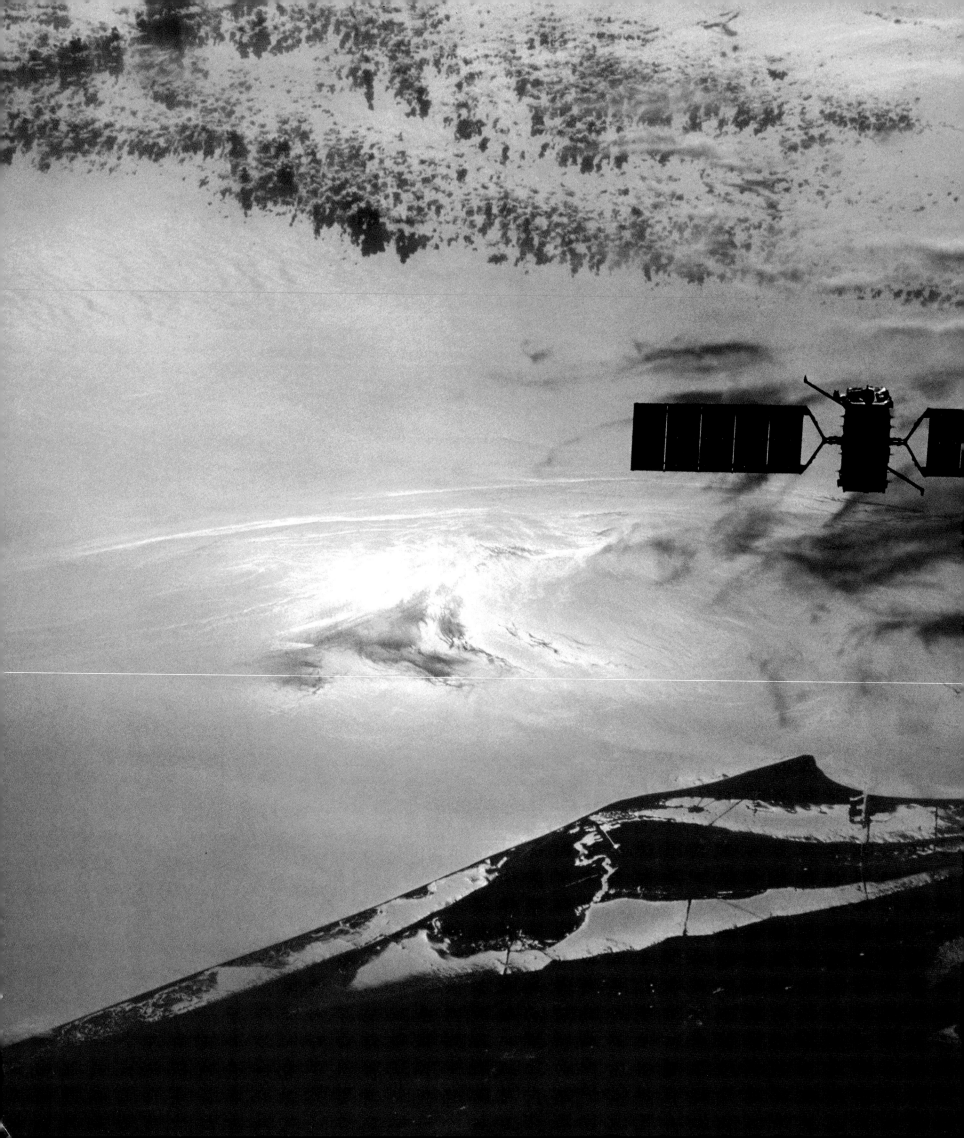

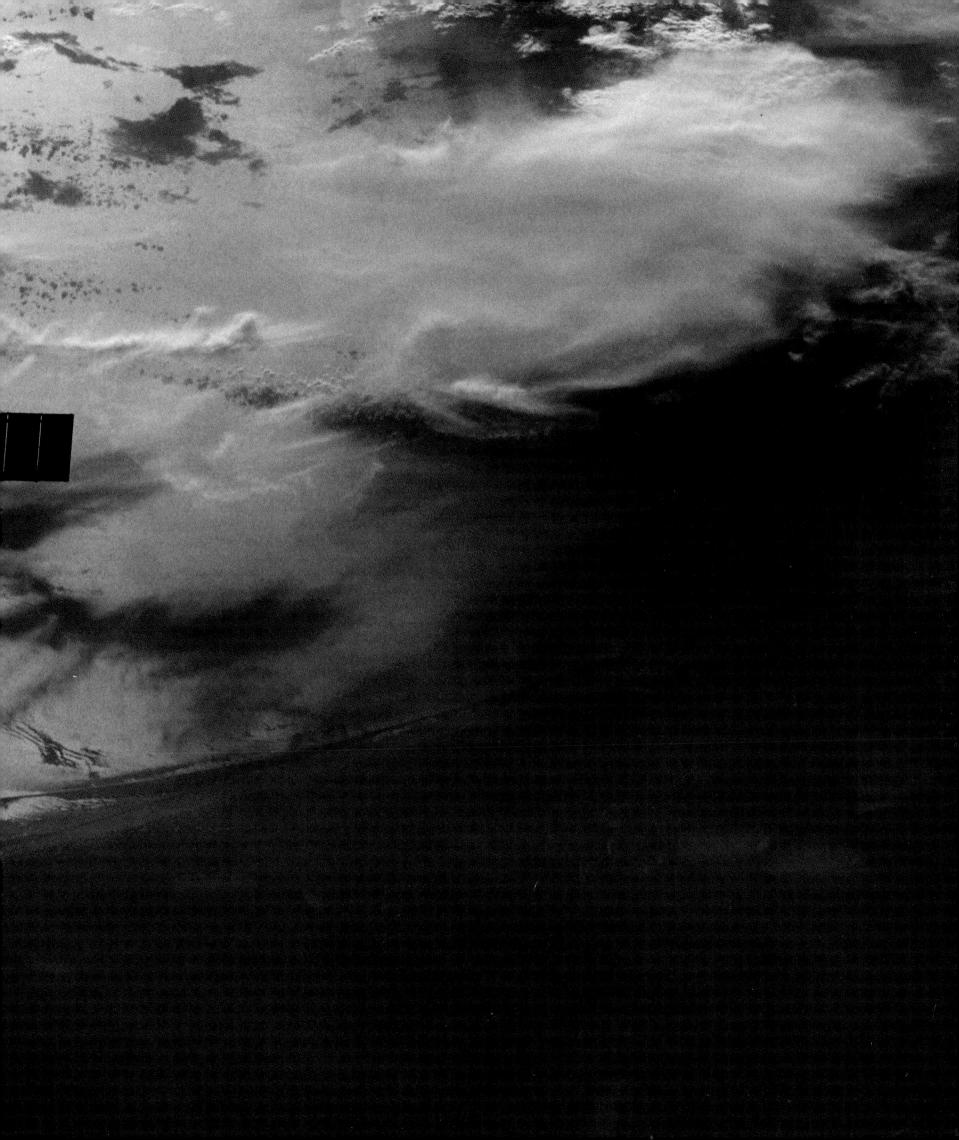

About the Photographs

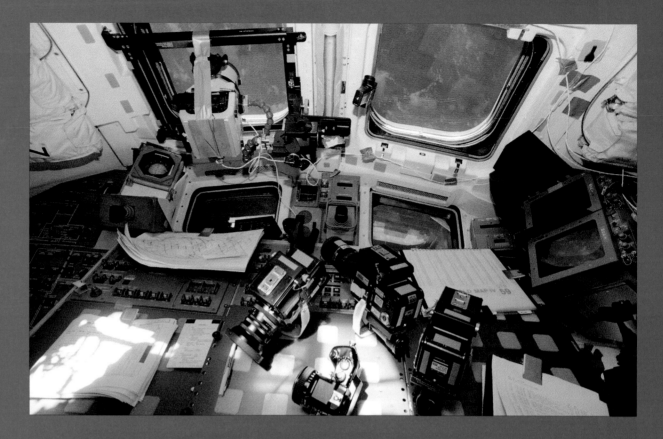

The Gear

The workhorse camera for our Earth observation program is a Hasselblad 553ELS 70mm format (the negatives are 55mm on a side). This single-lens-reflex body is a derivative of the commercial 553ELX model. We use a DM-100/200 magazine so that we can bulk-load 100 exposures per magazine. On the film below the frames, we record the time and date that each picture was taken with a DE-32 data module. We often use a 250mm Zeiss lens on the Hasselblad (a medium telephoto, equivalent to a 135mm lens on a 35mm format camera), but many of us prefer to pick up a camera with a 100mm or 40mm lens to capture the grand sweep of the land.

My favorite camera is the 4"x 5" format Linhof Aero Technika, a 14-pound marvel of engineering (above, upper left). A small vacuum pump holds the film absolutely flat for maximum sharpness. The 250mm and 90mm lenses are specially corrected for aerial photography. One exposure stores the equivalent of 880 megabytes of data on the negative in 1/250th of a second!

Most of the aurora photographs (pages 108-117) were taken with a Nikon F4 35mm camera and a 55mm f/1.2 lens (usually stopped down to f/1.4). We also use the Nikon with a 300mm lens for close-ups of mountains and cities. The 300mm lens is superb for catching the layers in the atmosphere that we see at sunrise and sunset.

Until recently, almost all our photographs were made on Kodak Ektachrome 64 film. We are now able to use films which record the colors we see more faithfully than did the older films. Kodak Lumiere 100 or Fuji Velvia 50 do not have the blue cast of the older films, and the new chemistry of the emulsions allows us to share with you photographs of exceptional sharpness.

Top: Cameras, maps, and lists of sites stand by for Earth observations from the aft flight deck of Endeavour. *Above: Thick shuttle windows offer protection from vacuum and meteoroids.*

Page 94 STS047-153-193 Location: 40.0 N 91.0 E Date: 9/15/92 Altitude: 193 mi. Camera: Linhof Lens: 250mm Field of view: 73x94 mi. Film: Kodak Ektachrome 64 Professional Film in 5" roll format on thin base

Crew: Robert L. Gibson, Curtis L. Brown, Jr., Mark C. Lee, Jay Apt, N. Jan Davis, Mae C. Jemison, Mamoru Mohri

Page 95 STS040-609-24 Location: 38.0 N 78.0 E Date: 6/5//91-6/14/91 Altitude: 178 mi. Camera: Rolleiflex Lens: 100mm Film: Kodak Ektachrome 64 Professional Film 5017 (Daylight) (EPR)

Crew: Bryan D. O'Connor, Sidney M. Gutierrez, James P. Bagian, Tamara E. Jernigan, M. Rhea Seddon, Francis A. Gaffney, Millie Hughes-Fulford

Page 97 STS059-90-98 Location: 53.0 N 107.0 E Date: 4/9/94-4/20/94 Altitude: 131 mi. Camera: Hasselblad Lens: 100mm Field of view: 72x72 mi. Film: Kodak Ektachrome Lumiere 100 Professional Film (LPP)

Crew: Sidney M. Gutierrez, Kevin P. Chilton, Jay Apt, Linda M. Godwin, Michael R. Clifford, Thomas D. Jones

Page 98 STS059-81-95 Location: 57.5 N 161.5 E Date: 4/12/94 Altitude: 133 mi. Camera: Hasselblad Lens: 40mm Film: Kodak Ektachrome Lumiere 100 Professional Film (LPP)

Crew: Sidney M. Gutierrez, Kevin P. Chilton, Jay Apt, Linda M. Godwin, Michael R. Clifford, Thomas D. Jones

Page 99 left STS068-214-43 Location: 55.0 N 162.0 E Date: 10/1/94 Altitude: 136 mi. Camera: Hasselblad Lens: 250mm Film: Kodak Ektachrome Lumiere 100 Professional Film (LPP)

Crew: Michael Baker, Terrence Wilcutt, Thomas D. Jones, Stephen Smith, Dan Bursch, Peter J.K. Wisoff

Page 99 right STS068-214-45 Location: 56.0 N 160.5 E Date: 10/1/94 Altitude: 136 mi. Camera: Hasselblad Lens: 250mm Field of view: 30x30 mi. Film: Kodak Ektachrome Lumiere 100 Professional Film (LPP)

Crew: Michael Baker, Terrence Wilcutt, Thomas D. Jones, Stephen Smith, Dan Bursch, Peter J.K. Wisoff

Page 100 STS009-33-1276 Location: 22.5 N 114.5 E Date: 11/28/83-12/8/83 Altitude: 155 mi. Camera: Hasselblad Lens: 250mm Field of view: 34x34 mi. Film: Kodak Ektachrome 64 Professional Film 5017 (Daylight) (EPR) in 120/220 format

Crew: John W. Young, Brewster H. Shaw, Jr., Owen K. Garriott, Robert A. Parker, Byron K. Lichtenberg, Ulf Merbold

Page 102 STS61A-32-27 Location: 10.0 N 106.5 E Date: 10/31/85 Altitude: 203 mi. Camera: Hasselblad Lens: 250mm Field of view: 45x45 mi. Film: Kodak Ektachrome 64 Professional Film 5017 (Daylight) (EPR)

Crew: Henry W. Hartsfield, Jr., Steven R. Nagel, James F. Buchli, Guion S. Bluford, Jr., Bonnie J. Dunbar, Ernst Messerschmid, Wubbo Ockels, Reinhard Furrer

Page 103 STS038-92-77 Location: 17.5 N 97.0 E Date: 11/19/90 Altitude: 137 mi. Camera: Hasselblad Lens: 250mm Field of view: 30x30 mi. Film: Kodak Ektachrome 200 Professional Film 5036 (Daylight) (EPD)

Crew: Richard O. Covey, Frank L. Culberton, Jr., Robert C. Springer, Carl J. Meade, Charles D. Gemar

Page 104 STS033-76-61 Location: 9.0 N 79.5 W Date: 11/24/89 Altitude: 167 mi. Camera: Hasselblad Lens: 250mm Field of view: 37x37 mi. Film: Kodak Ektachrome 64 Professional Film 5017 (Daylight) (EPR)

Crew: Frederick D. Gregory, John E. Blaha, F. Story Musgrave, Kathryn C. Thornton, Manley L. Carter

Page 105 GEM11-8-54677 Location: 11.0 N 79.0 E Date: 9/12/66-9/15/66 Altitude: 38mm

Crew: Charles Conrad, Jr., Richard F. Gordon, Jr.

Page 106-107 STS062-102-135 Location: 22.0 N 89.5 E Date: 3/9/94 Altitude: 186 mi. Camera: Hasselblad Lens: 40mm Field of view: 256x256 mi. Film: Kodak Ektachrome Lumiere 100X Professional Film (LPZ)

Crew: John H. Casper, Andrew M. Allen, Charles D. Gemar, Pierre J. Thuot, Marsha S. Ivins

THE AURORA

Page 108-109 STS047-19-34 Date: 9/12/92-9/20/92 Altitude: 188 mi. Camera: Nikon Lens: 55mm Film: Kodak Ektapress Gold 1600 Professional Film (PPC)

Crew: Robert L. Gibson, Curtis L. Brown, Jr., Mark C. Lee, Jay Apt, N. Jan Davis, Mae C. Jemison, Mamoru Mohri

Page 110-111 STS039-342-26 Date: 4/28/91-5/6/91 Altitude: 161 mi. Camera: Nikon Lens: 35mm Film: Kodak Ektapress Gold 1600 Professional Film (PPC)

Crew: Michael L. Coats, L. Blaine Hammond, Gregory J. Harbaugh, Donald R. McMonagle, Guion S. Bluford, Jr., Charles L. Veach, Richard J. Hieb

Page 112-113 STS039-23-20 Date: 4/28/91-5/6/91 Altitude: 161 mi. Camera: Nikon Lens: 35mm Film: Kodak Ektapress Gold 1600 Professional Film (PPC)

Crew: Michael L. Coats, L. Blaine Hammond, Gregory J. Harbaugh, Donald R. McMonagle, Guion S. Bluford, Jr., Charles L. Veach, Richard J. Hieb

Page 113 top right STS047-14-19 Date: 9/12/92-9/20/92 Altitude: 188 mi. Camera: Nikon Lens: 55mm Film: Kodak Ektapress Gold 1600 Professional Film (PPC)

Crew: Robert L. Gibson, Curtis L. Brown, Jr., Mark C. Lee, Jay Apt, N. Jan Davis, Mae C. Jemison, Mamoru Mohri

Page 113 bottom right STS059-60-14 Date: 4/9/94-4/20/94 Altitude: 132 mi. Camera: Nikon Lens: 55mm Film: Kodak Ektapress Plus 1600 Professional Film

Crew: Sidney M. Gutierrez, Kevin P. Chilton, Jay Apt, Linda M. Godwin, Michael R. Clifford, Thomas D. Jones

Page 113 left STS045-29-3 Date: 3/24/92-4/2/92 Altitude: 184 mi. Camera: Nikon Film: Kodak Ektapress Gold 1600 Professional Film (PPC)

Crew: Charles F. Bolden Jr., Brian K. Duffy, Kathryn D. Sullivan, David C. Leestma, C. Michael Foale, Dirk D. Frimout, Byron K. Lichtenberg

Page 114 left STS059-52-29 Date: 4/9/94-4/20/94 Altitude: 132 mi. Camera: Nikon Lens: 55mm Film: Fuji Fujicolor Super G 800

Crew: Sidney M. Gutierrez, Kevin P. Chilton, Jay Apt, Linda M. Godwin, Michael R. Clifford, Thomas D. Jones

Page 114-115 STS039-377-13 Date: 4/28/91-5/6/91 Altitude: 161 mi. Camera: Nikon Lens: 35mm Film: Kodak Ektapress Gold 1600 Professional Film (PPC)

Crew: Michael L. Coats, L. Blaine Hammond, Gregory J. Harbaugh, Donald R. McMonagle, Guion S. Bluford, Jr., Charles L. Veach, Richard J. Hieb

Page 116 STS059-58-18 Date: 4/9/94-4/20/94 Altitude: 132 mi. Camera: Nikon Lens: 55mm Film: Kodak Ektapress Plus 1600 Professional Film

Crew: Sidney M. Gutierrez, Kevin P. Chilton, Jay Apt, Linda M. Godwin, Michael R. Clifford, Thomas D. Jones

Page 117 STS059-51-8 Date: 4/9/94-4/20/94 Altitude: 132 mi. Camera: Nikon Lens: 55mm Film: Fuji Fujicolor Super G 800

Crew: Sidney M. Gutierrez, Kevin P. Chilton, Jay Apt, Linda M. Godwin, Michael R. Clifford, Thomas D. Jones

PACIFIC

Page 118 STS41D-43-27 Location: 19.1 N 139.5 E Date: 9/4/84 Altitude: 182 mi. Camera: Hasselblad Lens: 100mm Film: Kodak Ektachrome 64 Professional Film 5017 (Daylight) (EPR) in 120/220 format

Crew: Henry W. Hartsfield, Jr., Michael L. Coats, Judith A. Resnik, Steven A. Hawley, Richard A. Mullane, Charles D. Walker

Page 122-123 STS040-72-99 Location: 38.3 N 139.0 E Date: 6/7/91 Altitude: 180 mi. Camera: Hasselblad Lens: 250mm Field of view: 39x39 mi. Film: Kodak Ektachrome 64 Professional Film 5017 (Daylight) (EPR)

Crew: Bryan D. O'Connor, Sidney M. Gutierrez, James P. Bagian, Tamara E. Jernigan, M. Rhea Seddon, Francis A. Gaffney, Millie Hughes-Fulford

Page 124 STS047-89-25 Location: 44.0 N 146.0 E Date: 9/14/92 Altitude: 196 mi. Camera: Hasselblad Lens: 100mm Film: Fuji Velvia 50 Color Positive Film

Crew: Robert L. Gibson, Curtis L. Brown, Jr., Mark C. Lee, Jay Apt, N. Jan Davis, Mae C. Jemison, Mamoru Mohri

Page 126 STS059-219-65 Location: 49.5 N 155.0 E Date: 4/14/94 Altitude: 133 mi. Camera: Hasselblad Lens: 250mm Field of view: 29x29 mi. Film: Kodak Ektachrome Lumiere 100X Professional Film (LPZ)

Crew: Sidney M. Gutierrez, Kevin P. Chilton, Jay Apt, Linda M. Godwin, Michael R. Clifford, Thomas D. Jones

Page 127 STS034-78-54 Location: 35.5 N 140.0 E Date: 10/20/89 Altitude: 201 mi. Camera: Hasselblad Lens: 250mm Field of view: 44x44 mi. Film: Kodak Ektachrome 64 Professional Film 5017 (Daylight) (EPR)

Crew: Donald E. Williams, Michael J. McCulley, Ellen S. Baker, Franklin R. Chang-Diaz, Shannon W. Lucid

Page 128 STS043-22-11 Date: 8/2/91-8/11/91 Altitude: 184 mi. Camera: Nikon Lens: 300mm Film: Kodak Ektapress Gold 1600 Professional Film (PPC)

Crew: John E. Blaha, Michael A. Baker, James C. Adamson, G. David Low, Shannon W. Lucid

Page 129 STS046-90-29 Location: 8.0 S 112.0 E Date: 8/8/92 Altitude: 143 mi. Camera: Hasselblad Lens: 100mm Film: Kodak Ektachrome 64X Professional Film (EPX)

Crew: Loren J. Shriver, Andrew M. Allen, Jeffrey A. Hoffman, Franklin R. Chang-Diaz, Claude Nicollier, Marsha S. Ivins, Franco Malerba

Page 130-131 STS064-116-55 Location: 4.0 S 152.0 E Date: 9/19/94 Altitude: 150 mi. Camera: Hasselblad Lens: 250mm Field of view: 33x33 mi. Film: Fuji Velvia 50 Color Positive Film

Crew: Richard N. Richards, L. Blaine Hammond, Jr., Carl J. Meade, Mark C. Lee, Susan J. Helms, Jerry M. Linenger

Page 132 STS51I-37-79 Location: 25.9 N 136.2 E Date: 8/28/85 Altitude: 232 mi. Camera: Hasselblad Lens: 250mm Field of view: 51x51 mi. Film: Kodak Ektachrome 64 Professional Film 5017 (Daylight) (EPR)

Crew: Joe H. Engle, Richard O. Covey, James D. Van Hoften, John M. Lounge, William F. Fisher

Page 133 STS065-104-44 Location: 28.6 N 117.0 W Date: 7/12/94 Altitude: 183 mi. Camera: Hasselblad Lens: 250mm Field of view: 40x40 mi. Film: Kodak Ektachrome Lumiere 100X Professional Film (LPZ)

Crew: Robert D. Cabana, James D. Halsell, Jr., Richard J. Hieb, Carl E. Walz, Leroy Chiao, Donald A. Thomas, Chiaki Naito-Mukai

Page 134-135 STS048-151-70 Location: 3.5 S 113.5 E Date: 9/13/91 Altitude: 337 mi. Camera: Linhof Lens: 250mm Field of view: 128x163 mi. Film: Kodak Ektachrome 64 Professional Film in 5" roll format on thin base

Crew: John O. Creighton, Kenneth S. Reightler, Jr., Charles D. Gemar, James F. Buchli, Mark N. Brown

Page 136 STS038-86-76 Location: 3.0 N 112.5 E Date: 11/19/90 Altitude: 144 mi. Camera: Hasselblad Lens: 100mm Film: Kodak Ektachrome 64 Professional Film 5017 (Daylight) (EPR)

Crew: Richard O. Covey, Frank L. Culberton, Jr., Robert C. Springer, Carl J. Meade, Charles D. Gemar

Page 137 STS050-97-65 Location: 0.5 S 117.5 E Date: 6/30/92 Altitude: 184 mi. Camera: Hasselblad Lens: 250mm Field of view: 40x40 mi. Film: Kodak Ektachrome 64 Professional Film 5017 (Daylight) (EPR)

Crew: Richard N. Richards, Kenneth D. Bowersox, Bonnie J. Dunbar, Ellen S. Baker, Carl J. Meade, Lawrence J. Delucas, Eugene H. Trinh

Page 138 STS032-79-48 Location: 27.5 S 137.5 E Date: 1/15/90 Altitude: 209 mi. Camera: Hasselblad Lens: 250mm Field of view: 46x46 mi. Film: Kodak Ektachrome 64 Professional Film 5017 (Daylight) (EPR)

Crew: Dan C. Brandenstein, James Wetherbee, Bonnie J. Dunbar, G. David Low, Marsha S. Ivins

Page 139 STS035-502-4 Location: 28.7 S 137.4 E Date: 12/2/90-12/10/90 Altitude: 219 mi. Camera: Rolleiflex Film: Kodak Ektachrome 64 Professional Film 5017 (Daylight) (EPR)

Crew: Vance D. Brand, Guy S. Gardner, John M. Lounge, Jeffery A. Hoffman, Robert A. Parker, Samuel T. Durrance, Ronald A. Parise

Page 140-141 STS067-723-50 Location: 24.0 S 132.0 E Date: 3/7/95 Altitude: 219 mi. Camera: Hasselblad Lens: 100mm Field of view: 120x120 mi. Film: Kodak Ektachrome Lumiere 100 Professional Film (LPP)

Crew: Stephen Oswald, William G. Gregory, John Grunsfeld, Wendy Lawrence, Tamara E. Jernigan, Ron Parise, Sam Durance

Page 142 STS048-616-30 Location: 30.0 S 134.0 E Date: 9/16/91 Altitude: 353 mi. Camera: Rolleiflex Lens: 250mm Field of view: 79x79 mi. Film: Kodak Ektachrome 64 Professional Film 5017 (Daylight) (EPR)

Crew: John O. Creighton, Kenneth S. Reightler, Jr., Charles D. Gemar, James F. Buchli, Mark N. Brown

Page 143 STS055-151A-240 Location: 21.5 N 117.5 E Date: 5/3/93 Altitude: 185 mi. Camera: Linhof Lens: 250mm Field of view: 70x90 mi. Film: Kodak Ektachrome 64 Professional Film in 5" roll format on thin base

Crew: Steven R. Nagel , Terence T. Henricks, Jerry L. Ross, Bernard A. Harris, Jr., Charles J. Precourt, Jr., Hans W. Schlegel, Ulrich Walter

Page 144-145 STS033-73-62 Location: 21.0 S 164.5 E Date: 11/23/89 Altitude: 266 mi. Camera: Hasselblad Lens: 250mm Field of view: 58x58 mi. Film: Kodak Ektachrome 64 Professional Film 5017 (Daylight) (EPR)

Crew: Frederick D. Gregory, John E. Blaha, F. Story Musgrave, Kathryn C. Thornton, Manley L. Carter

Page 146 STS049-71-42 Location: 9.0 N 120.0 E Date: 5/8/92 Altitude: 174 mi. Camera: Hasselblad Lens: 250mm Field of view: 38x38 mi. Film: Kodak Ektachrome 64 Professional Film 5017 (Daylight) (EPR)

Crew: Daniel Brandenstein, Kevin P. Chilton, Pierre J. Thuot, Kathryn C. Thornton, Richard J. Hieb, Thomas D. Akers, Bruce E. Melnick

Page 147 STS027-32-38 Location: 20.0 N 156.0 W Date: 12/2/88 Altitude: 276 mi. Camera: Hasselblad Lens: 100mm Field of view: 152x152 mi. Film: Kodak Ektachrome 64 Professional Film 5017 (Daylight) (EPR)

Crew: Robert L. Gibson, Guy S. Gardner, Richard M. Mullane, Jerry L. Ross, William M. Shepherd

Page 148 STS51J-41-32 Location: 0.5 S 91.5 W Date: 10/3/85 Altitude: 293 mi. Camera: Hasselblad Lens: 250mm Field of view: 65x65 mi. Film: Kodak Ektachrome 64 Professional Film 5017 (Daylight) (EPR)

Crew: Karol J. Bobko, Ronald J. Grabe, Robert L. Stewart, David C. Hilmers, William A. Pailes

Page 150-151 AS07-7-1825 Date: 10/11/68-10/22/68 Altitude: 165 mi. Camera: Hasselblad Lens: 80mm Film: Kodak Aerial Color Reversal Film (thin base, very fine grain)

Crew: Walter M. Schirra, Jr., Donn F. Eisele, Walter Cunningham

MIDDLE AND SOUTH AMERICA

Page 152 STS51I-37-6 Location: 2.5 N 51.5 W Date: 8/28/85 Altitude: 222 mi. Camera: Hasselblad Lens: 50mm Film: Kodak Ektachrome 64 Professional Film 5017 (Daylight) (EPR)

Crew: Joe H. Engle, Richard O. Covey, James D. Van Hoften, John M. Lounge, William F. Fisher

Page 156-157 STS51C-38-30 Location: 14.5 N 91.5 W Date: 1/27/85 Altitude: 232 mi. Camera: Hasselblad Lens: 100mm Field of view: 128x128 mi. Film: Kodak Ektachrome 64 Professional Film 5017 (Daylight) (EPR)

Crew: Thomas K. Mattingly II, Loren J. Shriver, James F. Buchli, Ellison S. Onizuka, Gary E. Payton

Page 158 AS11-36-5305 Location: 20.0 N 100.0 W Date: 7/16/69-7/24/69 Camera: Hasselblad

Crew: Neil Armstrong, Edwin E. Aldrin, Jr., Michael Collins

Page 159 STS038-86-12 Location: 25.5 N 100.5 W Date: 11/18/90 Altitude: 133 mi. Camera: Hasselblad Lens: 250mm Field of view: 29x29 mi. Film: Kodak Ektachrome 64 Professional Film 5017 (Daylight) (EPR)

Crew: Richard O. Covey, Frank L. Culberton, Jr., Robert C. Springer, Carl J. Meade, Charles D. Gemar

Page 160-161 STS040-73-37 Location: 32.5 N 114.5 W Date: 6/5/91 Altitude: 177 mi. Camera: Hasselblad Lens: 50mm Film: Kodak Ektachrome 64 Professional Film 5017 (Daylight) (EPR)

Crew: Bryan D. O'Connor, Sidney M. Gutierrez, James P. Bagian, Tamara E. Jernigan, M. Rhea Seddon, Francis A. Gaffney, Millie Hughes-Fulford

Page 162 SL3-122-2497 Location: 28.5 N 118.0 W Date: 7/28/73-8/25/73 Altitude: 270 mi. Camera: Hasselblad Lens: 100mm Field of view: 149x149 mi.

Crew: Owen K. Garriott, Alan L. Bean, Jack R. Lousma

Page 163 STS049-76-2 Location: 18.0 N 111.0 W Date: 5/8/92 Altitude: 173 mi. Camera: Hasselblad Lens: 250mm Field of view: 38x38 mi. Film: Kodak Ektachrome 64 Professional Film 5017 (Daylight) (EPR)

Crew: Daniel Brandenstein, Kevin P. Chilton, Pierre J. Thuot, Kathryn C. Thornton, Richard J. Hieb, Thomas D. Akers, Bruce E. Melnick

Page 164-165 STS51I-44-52 Location: 28.5 N 83.5 W Date: 9/1/85 Altitude: 269 mi. Camera: Hasselblad Lens: 100mm Film: Kodak Ektachrome 64 Professional Film 5017 (Daylight) (EPR)

Crew: Joe H. Engle, Richard O. Covey, James D. Van Hoften, John M. Lounge, William F. Fisher

Page 166-167 STS41C-32-1073 Location: 9.0 N 80.0 W Date: 4/6/84-4/13/84 Altitude: 308 mi. Camera: Hasselblad Lens: 50mm Field of view: 339x339 mi. Film: Kodak Ektachrome 64 Professional Film 5017 (Daylight) (EPR) in 120/220 format

Crew: Robert Crippen, Francis R. Scobee, Terrence J. Hart, James D. Van Hoften, George Nelson

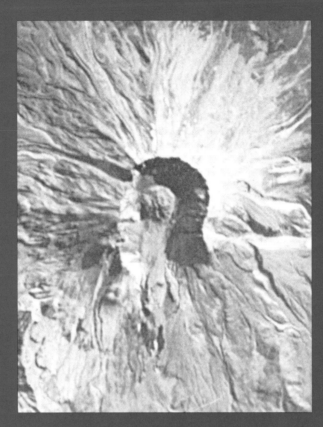
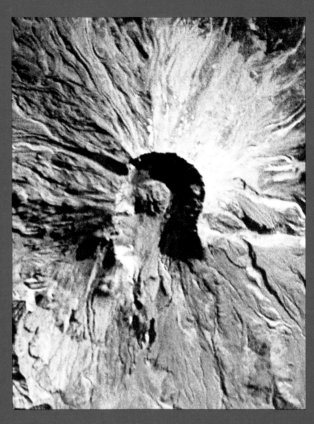

Images for This Book

When Jay Apt and Roger Ressmeyer planned *Orbit*, they decided to pursue a modern method to reproduce NASA photographs: They would use computers to create digital images of original flight film and then process these images to match the view from space.

The procedure is ground-breaking because it provides the readers of *Orbit* with Earth images of unparalleled detail and accuracy. Previously, publishers have used fourth- or fifth-generation slides of original NASA film. With each successive duplication, quality was lost. By comparison, digital images allow for accurate reproduction without information loss.

Ressmeyer, an expert in the digital reproductions of original film, has worked closely with NASA over the years. NASA decided to use *Orbit* for a test of digital scanning of flight photographs.

Corbis Corporation, a digital photo archive and multimedia company, sponsored the scanning project. Under Ressmeyer's direction, Corbis set up a lab at Johnson Space Center in Texas. NASA technicians handled the film and placed it in Corbis's scanner, a Leica DSW200. The resulting digital files ranged from 90 to 340 megabytes.

Ressmeyer, an editor at Corbis, cleaned, color- corrected, and adjusted each image at the company's lab, using Macintosh computers equipped with 278 megabytes of RAM. To ensure accuracy, Apt studied the images and either confirmed that each image matched the view from space or provided Ressmeyer with instructions to make it so.

The results of these efforts appear on these pages and are preserved for all time in digital form.

© CORBIS

Top left: A faithful reproduction of a particularly bad NASA dupe of a dupe of a dupe. Top right: a Corbis scan of the original flight film. (See page 186.) Above, Ressmeyer with all the color original flight film from the first five Apollo moon missions.

Further information on the photographs and access to the resources of the NASA Johnson Space Center Space Shuttle Earth Observations Project is available from http://eol.jsc.nasa.gov/sseop.html on the Internet.

About the Maps On the large maps introducing chapters, and on smaller maps accompanying photos, positions of spacecraft photographs are depicted by red point symbols. The red dots represent the center of the original photographs.

Index

Boldface indicates illustrations.

Acknowledgments

This book would not be in your hands without the tenacious professionalism of Roger Ressmeyer at every stage from finding a publisher to final image processing. We are also deeply grateful to our scientist and astronaut colleagues at the Johnson Space Center for shaping our view of this planet. Kam Lulla, Dave Pitts, and Cindy Evans, all in the Flight Science Support Branch, each saw something in the photographs that we would have missed. Professor Charles F. Kennel took time out of his busy schedule as head of NASA's Mission to Planet Earth to expertly explain the aurora, his original field of research, to Jay during the writing of that chapter.

Astronaut Marsha Ivins and Kodak's Dick Wien, by their single-minded devotion to quality, ensure that we fly the best equipment and film. Judy Alexander and Don Carico provide wonderful training in using the cameras. We would not have been able to review all of the images taken from the Shuttle without the two superb laser videodiscs produced by the JSC Image Sciences Division. James Heydorn maintains the Earth Observation data base on the Internet; without his painstaking work Jay could not have extracted the data we needed for the book. Corbis Corporation made it feasible to realize our dream of digitizing the original film to bring you the very best possible quality images for Orbit.

Thanks, too, for the dedication and hard work of the following great people: At the National Geographic Society: Leah Bendavid-Val, David Griffin, Tom Allen, Kevin Craig, Joyce Marshall, Lise Sajewski, Tom Kennedy, Bob Poole, William Allen, Gil Grosvenor, Charles Kogod, Will Gray, and Bob Madden; at Corbis: Bill Gates, Lisa Vazquez, Karen Akiyama, Steve Davis, Sabine Süsstrunk, Charlie Sliwoski, Tony Rojas, Steve White, Bruce Watermann, Charles Mauzy, Doug Rowan, Thor Radford, and David Sinn; at Johnson Space Center: Dave Billingsley, Jeff Carr, Frank Zehentner, Juan Zamora, Mike McGuyer, Doug Ward, Jane Stearns, Bill Larsen, Hank Flagg, and Dan Remmington; at Leica/Image Scan: George Southard, Susan Dlin, and Terrell Williams.

Roger Ressmeyer and National Geographic researchers wish to especially thank Todd Billett, Robert Dill, Paul D. Lowman, Jr., John McHone, Daniel J. Stanley, Robert Stern, and Bill Stringer. Other consultants who aided the Geographic researchers were Terrence Jach, Luiz Carlos Joels, Joseph M. Moran, Christopher Uhl, and G. Bruce Williamson. Organizations that provided help were the National Institute for Amazonian Studies, the Smithsonian Institution, the U.S. Department of Agriculture, and the U.S. Geological Survey.

Our wonderful wives Ebe Emmons-Apt, Kathleen Eisenbeis, and Sally Antrobus have endured our dedication to this project over the last three years with good humor and love. We love them in return, and hope that they and our dear children will like this book.

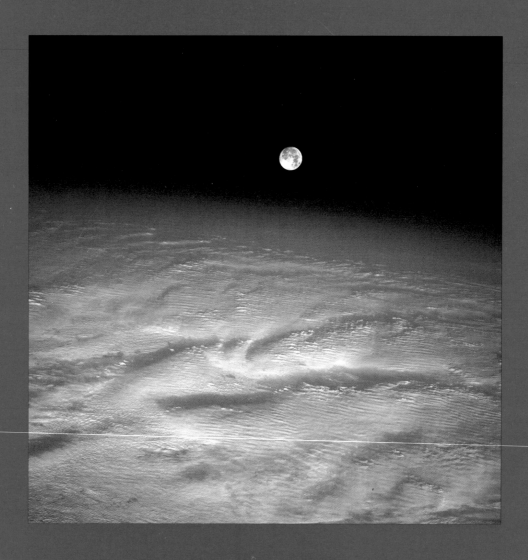

From 200 miles above Earth, Columbia's crew photographed the full moon setting over the Pacific Ocean. Wherever in the universe people go, they will take the technology to share the experience with their friends back home. And we will go outwards—there is no turning back. For if we fail to accept the challenge of the space above Earth, we will be less human than our ancestors who left the rich soil of Africa for the unknown ends of the Earth. Their journey took tens of thousands of years. Ours will take no less, but we have made a beginning.